SEASONS IN THE
ROCKIES

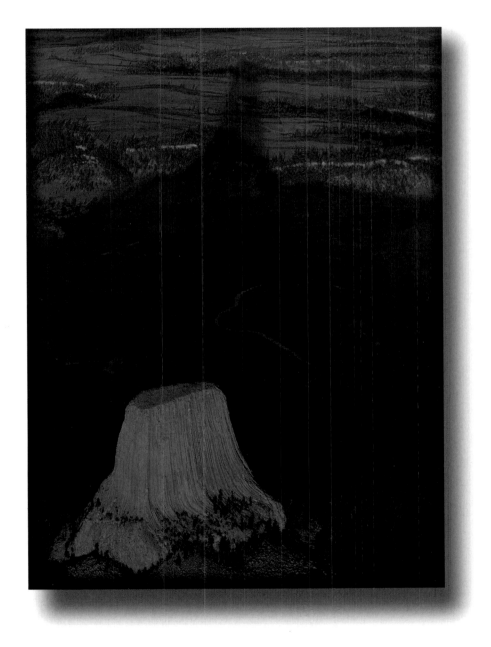

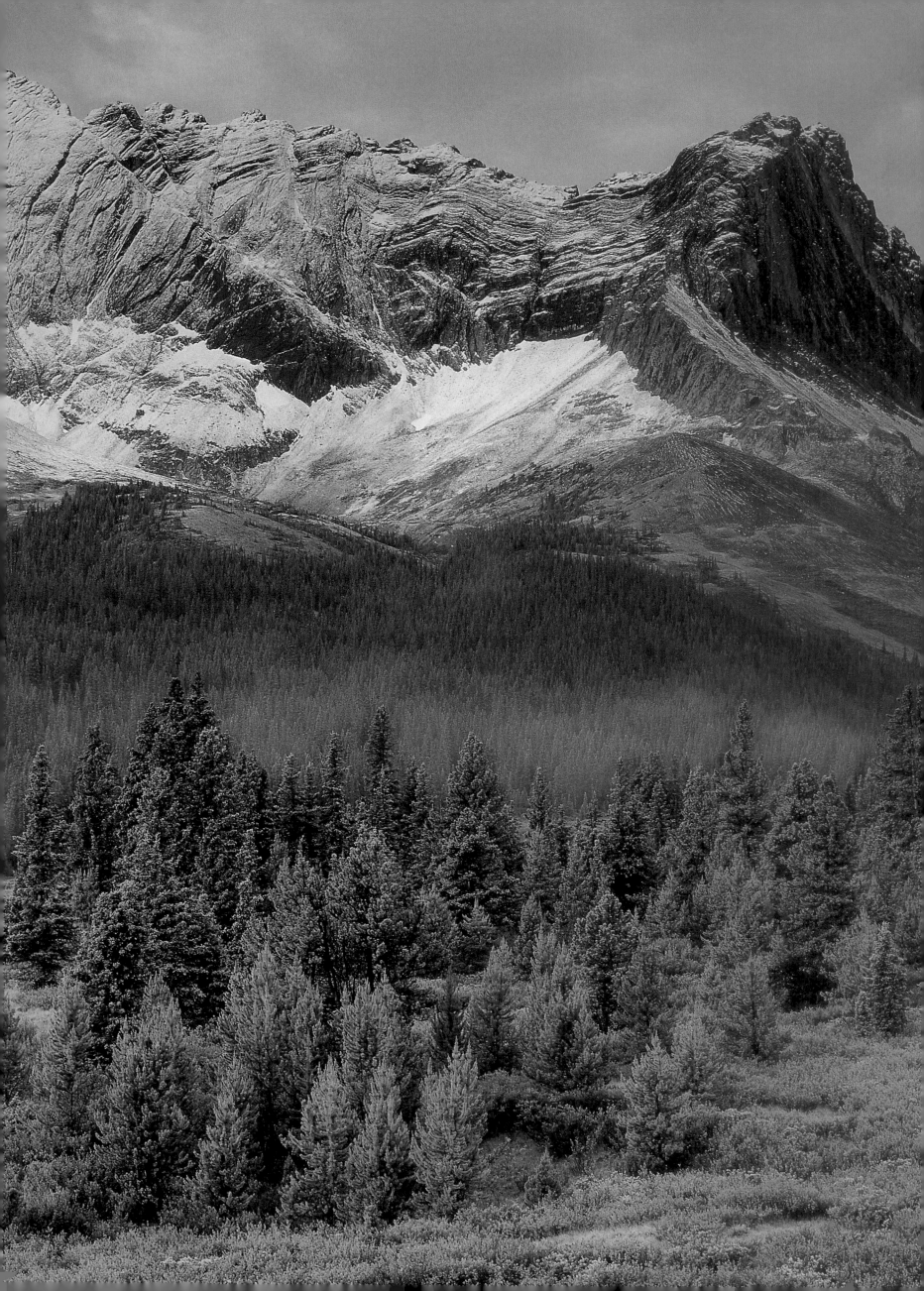

SEASONS IN THE
ROCKIES

Photographs by Darwin Wiggett and Tom Till
Text by Rebecca L. Grambo

WHITECAP BOOKS
TORONTO / VANCOUVER / NEW YORK

Text by Rebecca L. Grambo
Edited by Elaine Jones
Proofread by Elizabeth Salomons
Cover design by Peter Cocking
Interior design by Margaret Lee

Printed and bound in Canada.

Canadian Cataloguing in Publication Data
Wiggett, Darwin. 1961-
Seasons in the Rockies

 Includes index.
 ISBN 1-55285-106-0

 1. Rocky Mountains--Pictorial works. 2. Landscape photography--Rocky
Mountains. 3. Nature photography. 4. Wiggett, Darwin, 1961- I. Till, Tom.
II. Grambo, Rebecca L. III. Title.
FC219.W568 2000 779'.3678'092 C00-911071-2
F721.W53 2000

The publisher acknowledges the support of the Canada Council and the Cultural
Services Branch of the Government of British Columbia in making this publication
possible. We acknowledge the financial support of the Government of Canada through
the Book Publishing Industry Development Program for our publishing activities.

For more information on other Whitecap Books titles,
please visit our web site at www.whitecap.ca

page 1: **Devils Tower National Monument, Wyoming**

page 2: **Willmore Wilderness Park, Alberta**

page 5: **Elk**

page 6: **Mount Robson Provincial Park, British Columbia**

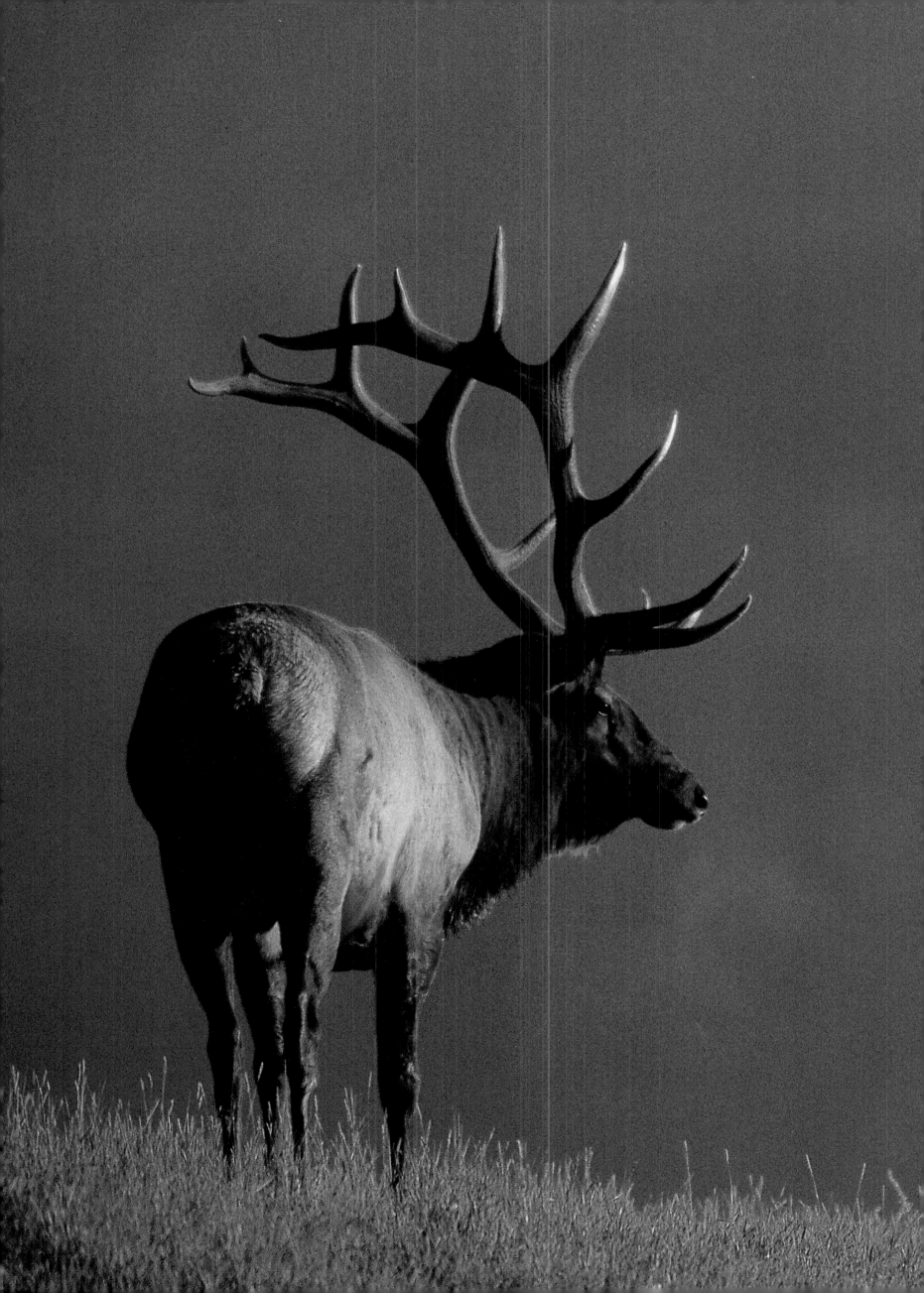

THE ROCKY MOUNTAINS

APPROXIMATELY SIXTY RANGES

INTRODUCTION

The Rocky Mountains—approximately sixty ranges and thousands of peaks—are part of a great chain of mountains that stretches from north to south across two continents. About 70 million years ago, two of Earth's tectonic plates collided, forcing the crust to fold, crumple, and break: the Rockies began to rise. From the moment of their birth, the forces of erosion have been working to make the mountains disappear. Wind, water and, most of all, ice scoured and scrubbed the rocks wherever uplift exposed them. The Rockies stand today because they rose faster than erosion could wear them down.

About 2 million years ago, a series of ice ages began sculpting the Rockies into the mountains we see today. Snow accumulated on the peaks and eventually grew into great moving sheets of ice. When the last glacial episode ended about 10,000 years ago, the retreating ice revealed a changed landscape: knife-shaped ridges, sharply pointed peaks, and waterfalls pouring from stream valleys cut short by the ice.

For many people, the image that comes to mind when they think of the Rocky Mountains is majestic snow-covered peaks. As you are about to see, however, the vast expanse of the Rockies includes not only peaks but desert-like plateaus, lushly vegetated valleys, glaciers, geysers and areas of barren rock that resemble a moonscape. The character and countenance of these remarkable landscapes continually change as the waves of the seasons wash over them.

AND THOUSANDS OF PEAKS

As you enjoy the beautiful images that follow, please keep in mind that much of what you see is threatened. Yellowstone, the oldest national park in the United States, is also its most endangered, due to pressures from urban expansion, proposed mining projects and landfills, in addition to the wear and tear created by huge numbers of visitors. In Canada, Banff National Park faces similar problems. The damage to the park and its wildlife caused by tourism development may soon be irreversible. Elsewhere throughout the Rockies, logging, exploration for oil and gas, heavy use by off-road vehicles, urban developments, and other stresses are placing the future of much of this great wilderness in jeopardy.

The formidable Rocky Mountains were once a barrier to movement across the continent. Today they are a haven. We journey there to refresh our spirits. In *Our National Parks*, ardent preservationist John Muir wrote of Yellowstone, "Stay . . . and spend the night under the stars. Watch their glorious bloom until dawn and get one more baptism of light. Then, with fresh heart, go down to your work, and whatever your fate, . . . you will remember these fine wild views and look back with joy. . ."

Take pleasure in these images of the many faces of the Rockies, and, when you seek peace, return to them with joy.

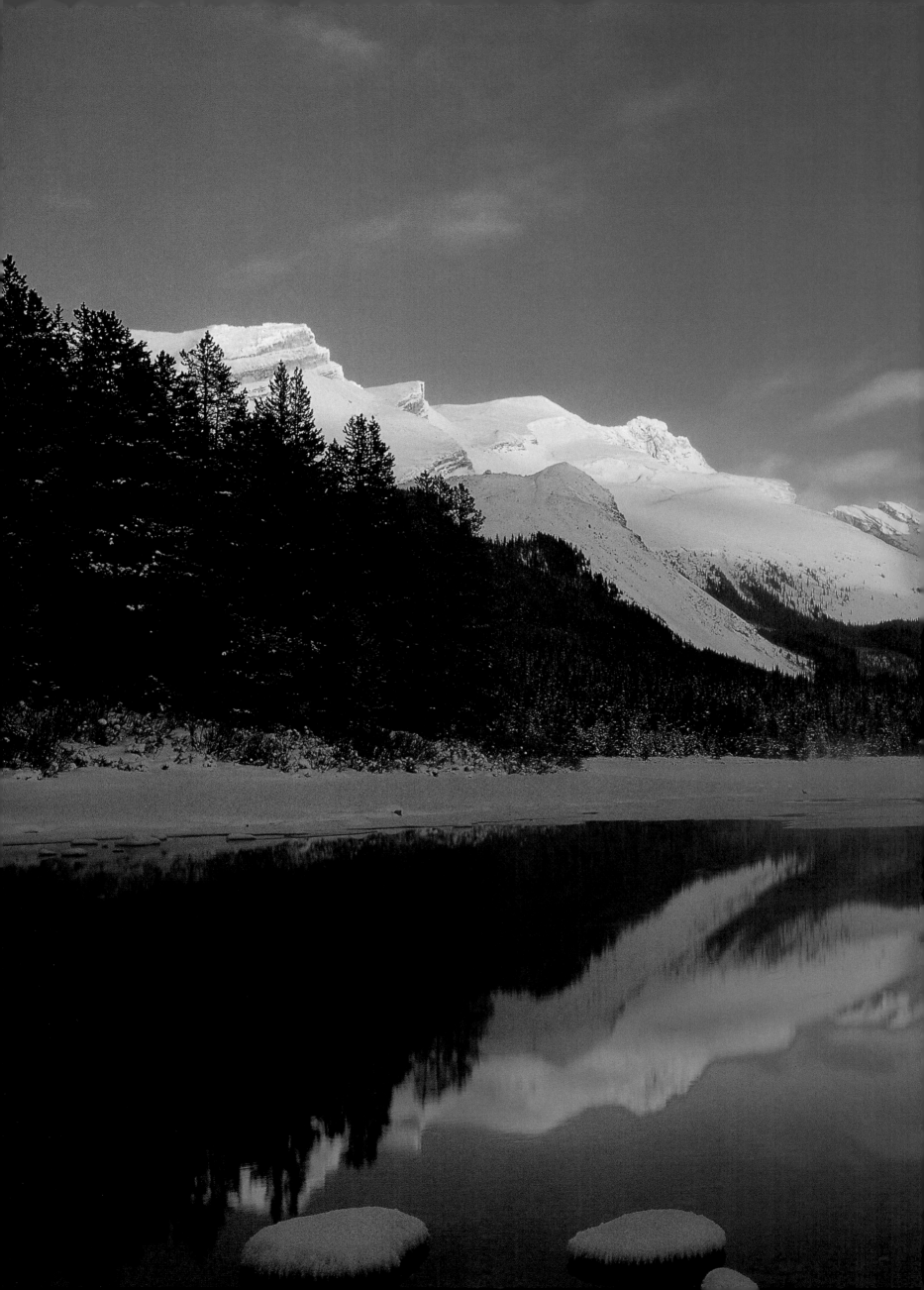

SPRING
IN THE ROCKIES

IT BEGINS QUIETLY

WITH A THIN TRICKLE OF WATER

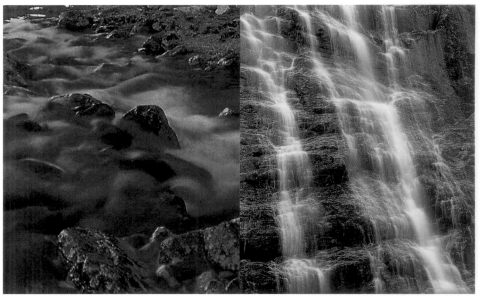

SPRING

It begins quietly with a thin trickle of water creeping from the edge of the snow. Coaxed forth by the increasingly strong rays of the sun, streams and creeks appear, ducking in and out of snowbanks as if hesitant to emerge completely. The volume of water working its way down the mountains will continue to grow until icy torrents cascade over rock faces and thunder through the valleys.

The water's ultimate destination depends on where its journey began. An imaginary line called the Continental Divide zigzags its way among the peaks of the Rockies. Water to the west of the Divide eventually drains into the Pacific Ocean; to the east, water wends its way to the Atlantic. From one unique point in the Rockies, high atop the Columbia Icefield in Banff National Park, water flows to three oceans: Atlantic, Pacific and Arctic.

Spring provides an excellent illustration of the fact that the seasons in the Rockies often depend more on location than on what the calendar says. Across the length and breadth of the Rocky Mountains, spring arrives at many different times. It never tarries too long in one spot, but continually moves on to higher elevations and latitudes. To those of us accustomed to reckoning spring's beginning by when our tulips begin to bloom, its arrival in the mountain meadows appears extremely tardy. The middle of July finds some of the best locations for viewing alpine wildflowers still tucked beneath snow cover, even though it is already summer in other parts of the mountains.

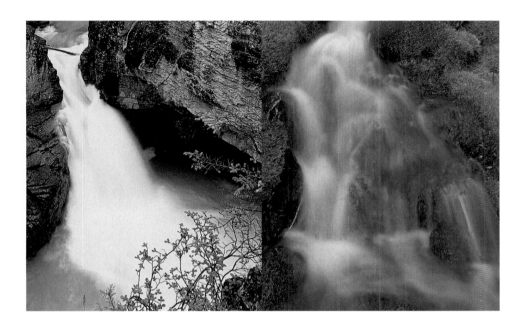

Glacier and Waterton national parks meet each other at the U.S.–Canada border. In this part of the Rockies, you can actually watch spring advance up the mountains by looking for the large, cream-colored blooms of beargrass. The first blossoms appear at lower elevations; as the days lengthen and the season advances, beargrass flowers farther and farther up the slopes open. Beargrass near the timberline blooms last and may not flower until September. Other alpine plants follow a similar pattern.

In late spring, the moving feast provided by this progressive growth of vegetation beckons herds of elk and mule deer to begin their annual trek up to high mountain pastures. Along streams and on sun-warmed slopes, bears recently emerged from hibernation feed on tender new shoots.

Glacier lilies bloom in alpine meadows just as spring matures into summer. These plants store the food they make during a very short growing season in their bulbs. The following spring, the plants use this energy reserve to produce a rapid spurt of new growth. However, a bulb's precious protein cache may be appropriated by another consumer: grizzly bears enjoy the bulbs so much that they sometimes dig up whole meadows to find them.

Lilies and bears are responding to an age-old voice. For, as its warm breath spreads across the Rockies, spring calls softly, "Awaken and rejoice: the cold, hungry days are finally at an end."

previous pages: **Maligne Lake, Jasper National Park, Alberta**

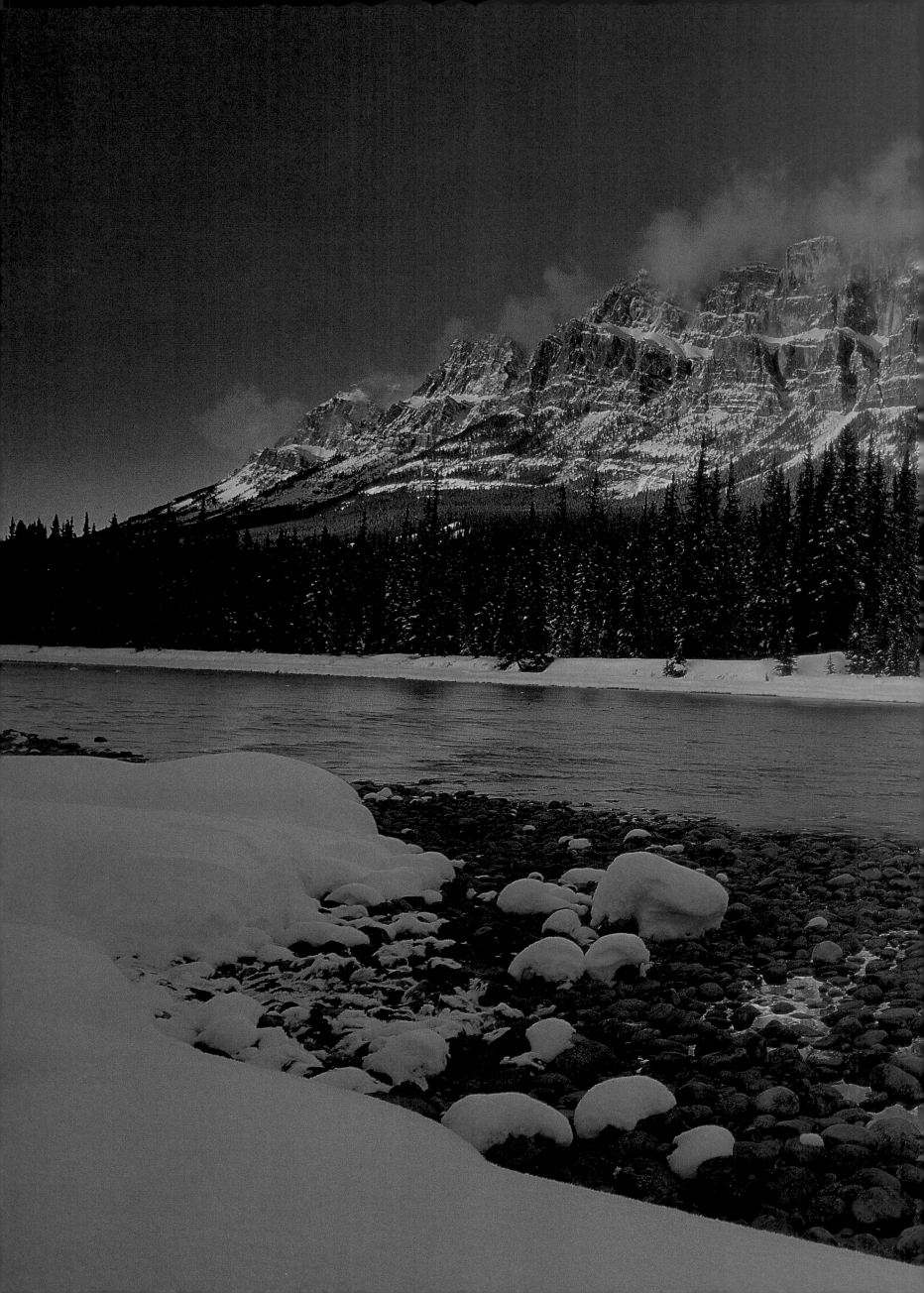

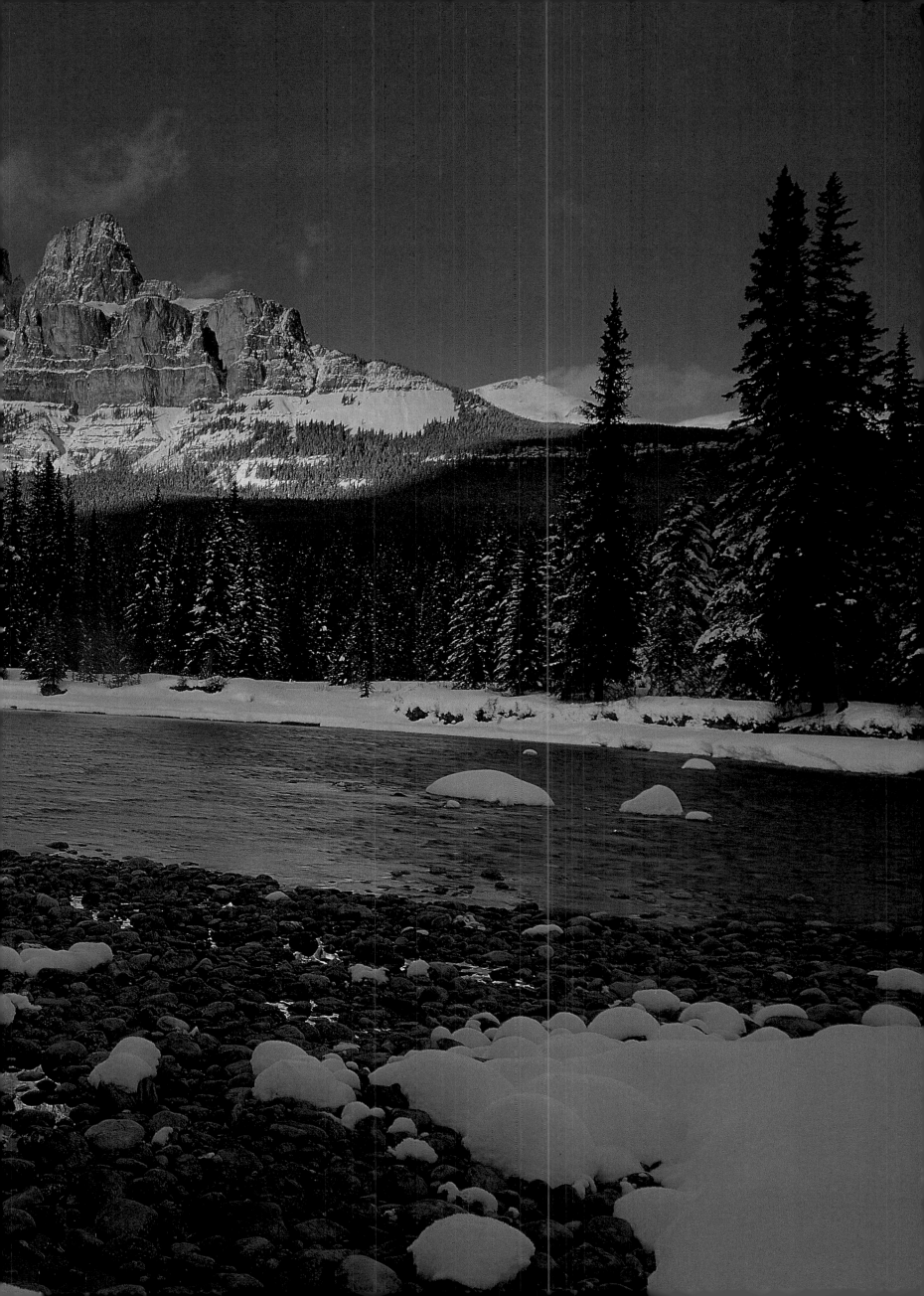

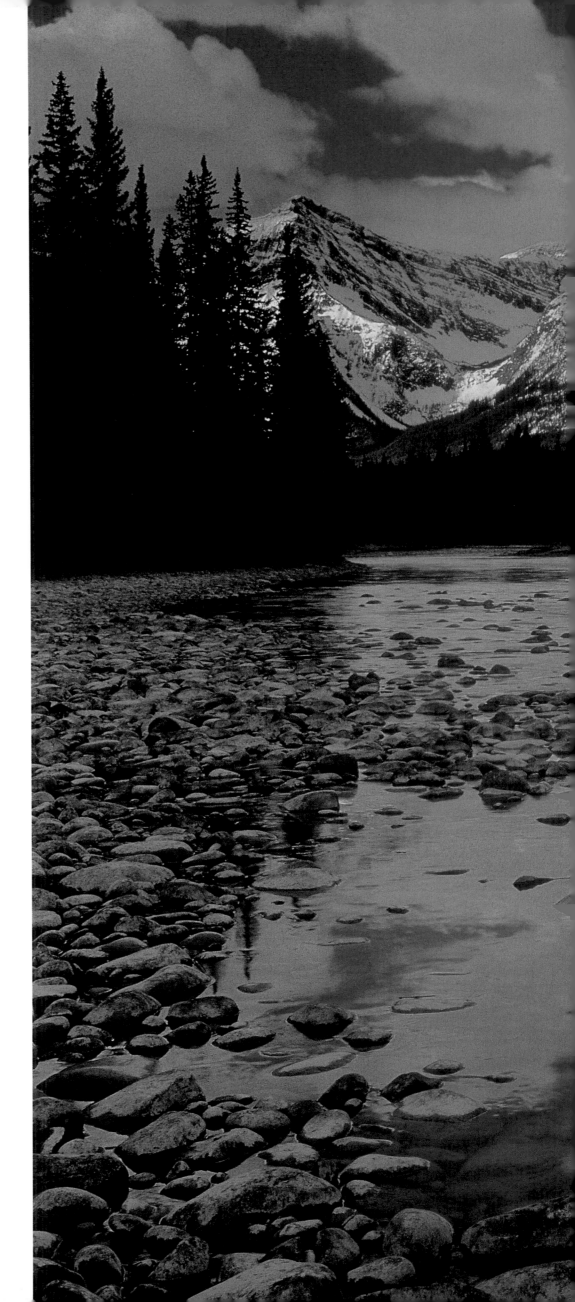

Mount Fryatt, Jasper National Park, Alberta With the help of its tributaries, the Athabasca River drains more than four-fifths of Jasper National Park. The portion of the river that lies within the park has been declared a Canadian Heritage River.

previous pages: **Castle Mountain, Banff National Park, Alberta** In 1946, politicians renamed Castle Mountain to honor Dwight D. Eisenhower, commander-in-chief of European forces during World War II and U.S. president. Canadians lobbied against the name change and the original name was finally restored in 1979.

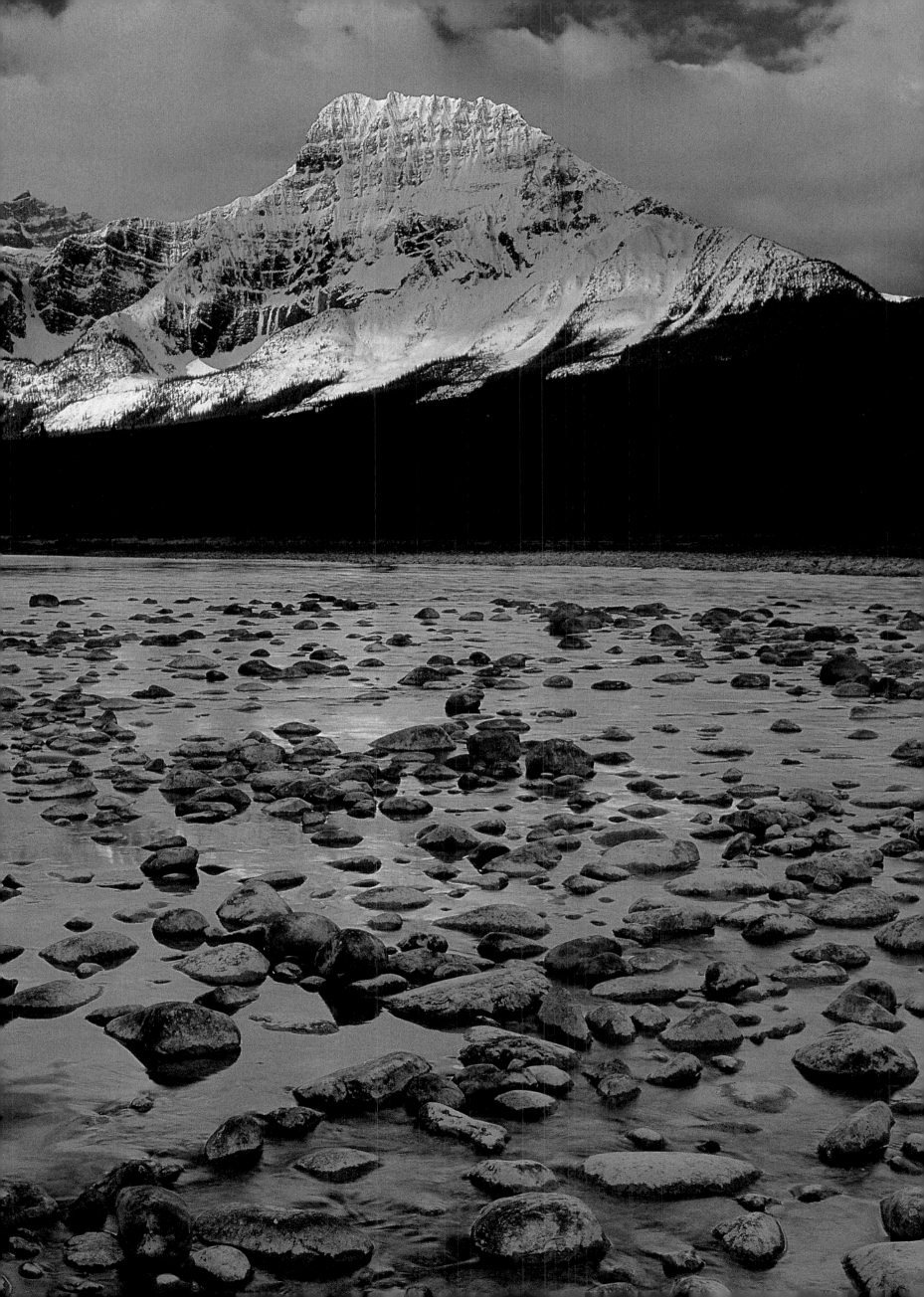

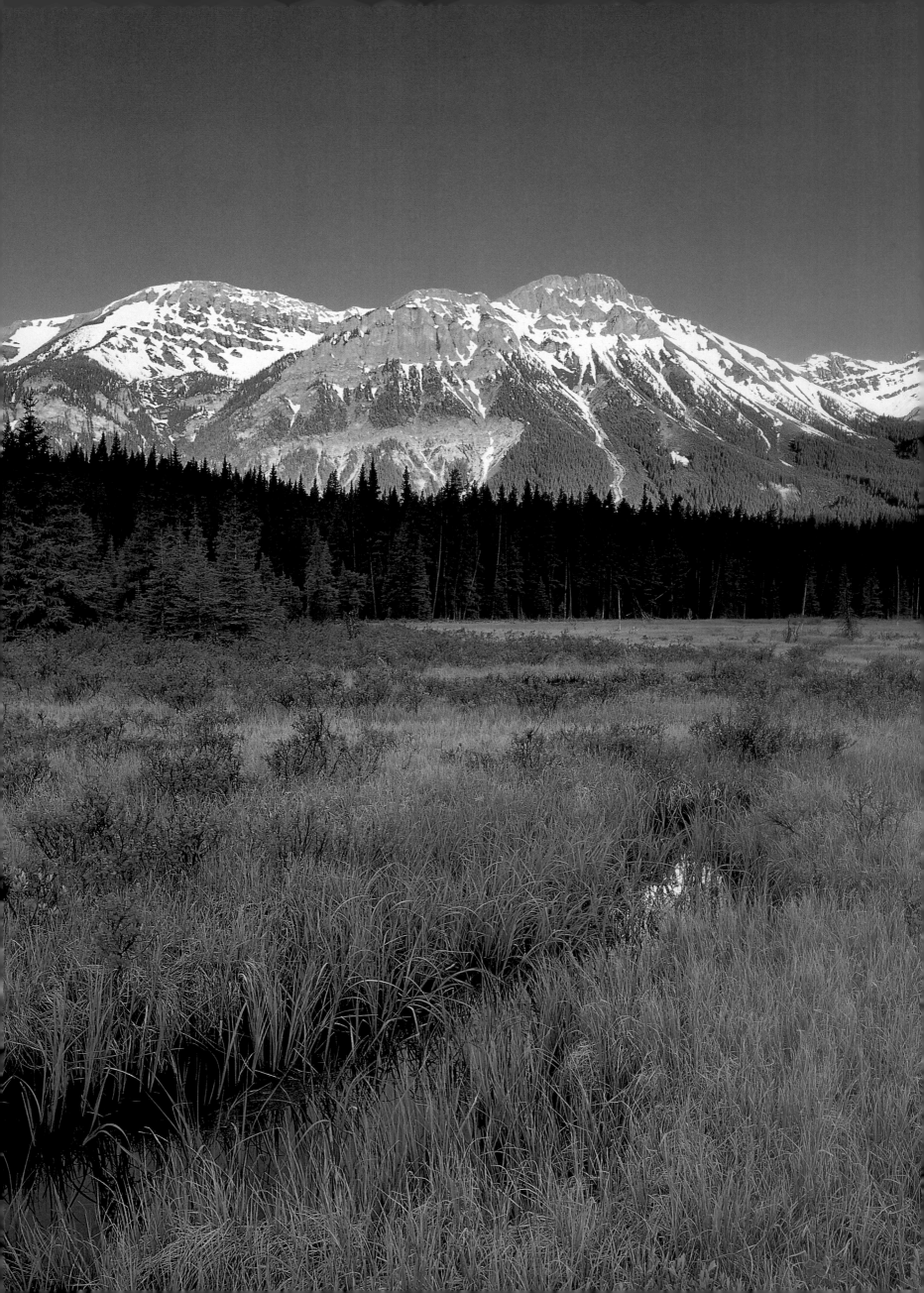

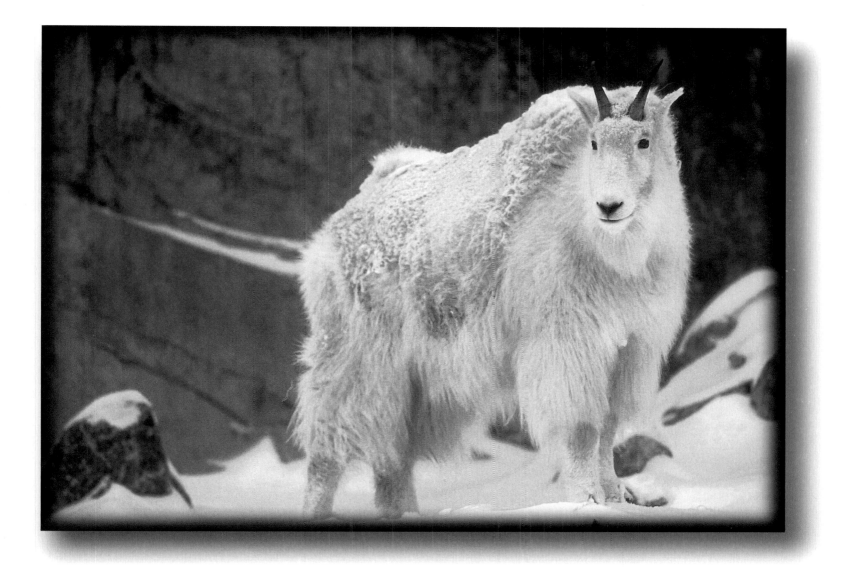

Mountain Goat

Making its home in the northern half of the Rocky Mountains, the mountain goat
is well-adapted for climbing around on rugged peaks. The sharp outer rims of its
hooves give a good grip on rough surfaces, while the rubbery soles supply traction
on smooth or steep slopes.

left: **Peter Lougheed Provincial Park, Alberta**

Between the Kananaskis Lakes, Mount Indefatigable rises to 8,760 feet (2,670 meters).
The mountain was named for a British warship sunk by German shells during
the Battle of Jutland.

Verdant Valley, Jasper National Park, Alberta In the Rockies, winter cedes ground to spring reluctantly. Many of the first gaps in winter's armor of snow appear in valleys and along watercourses.

overleaf: **Verdant Valley, Jasper National Park, Alberta** Even after the snow has almost disappeared in the valleys, it still clings tenaciously to the peaks and highlights the folds in the rocks.

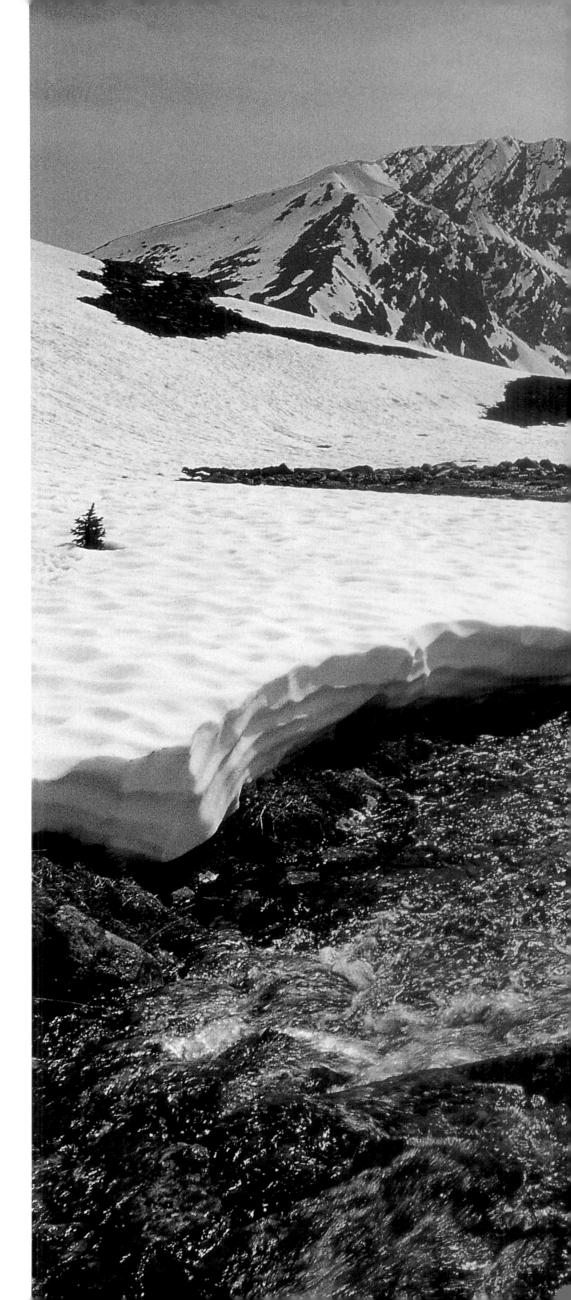

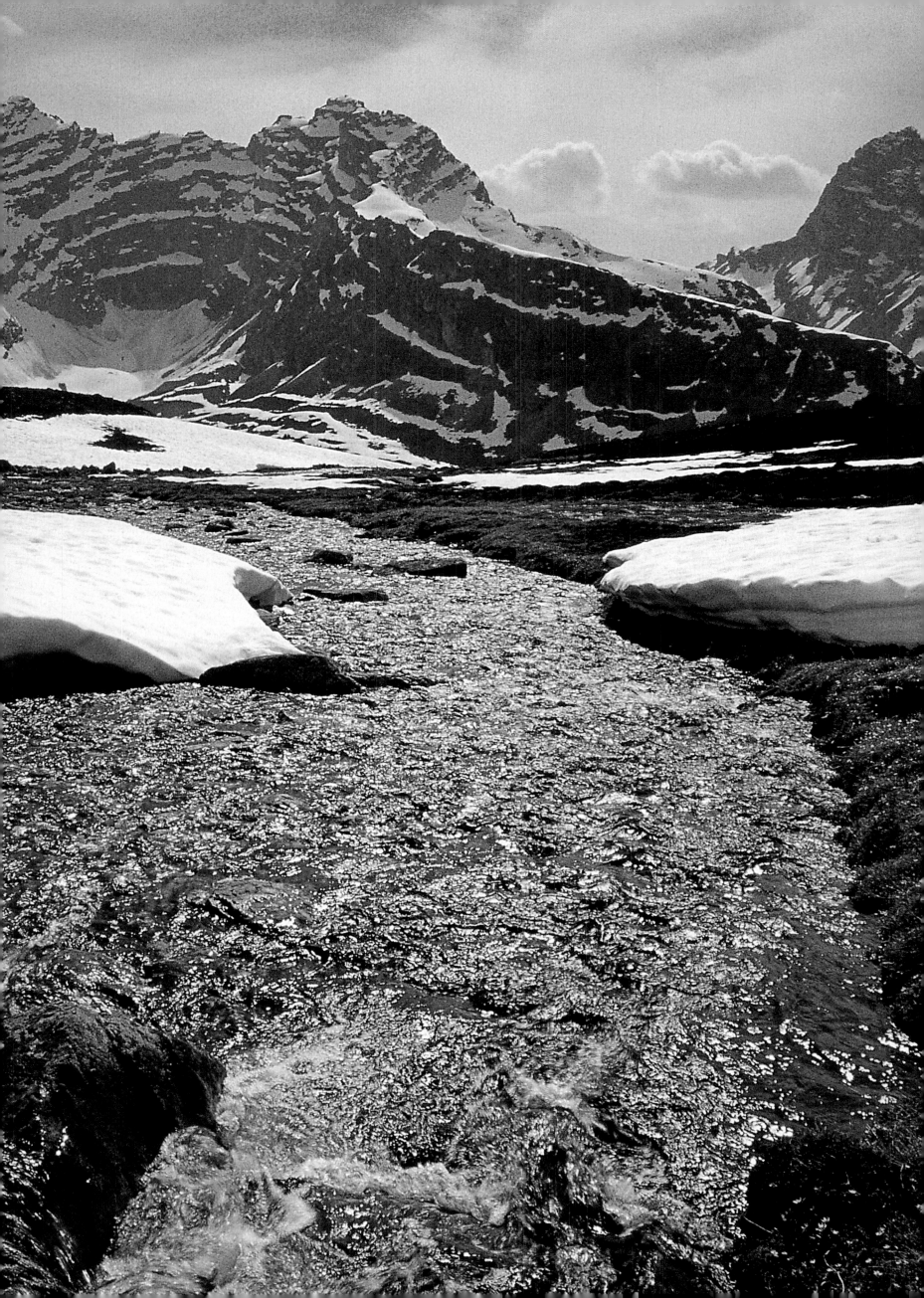

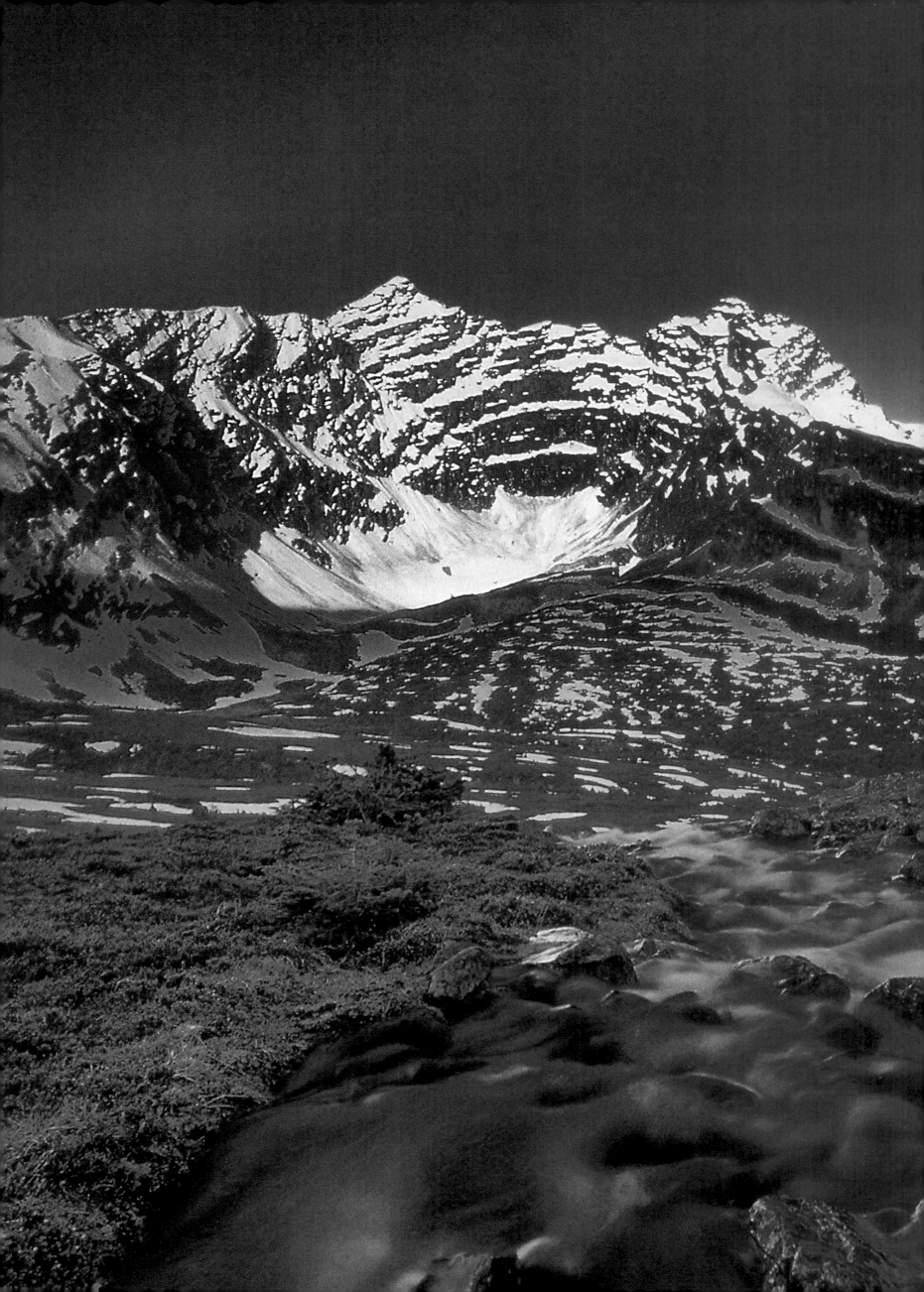

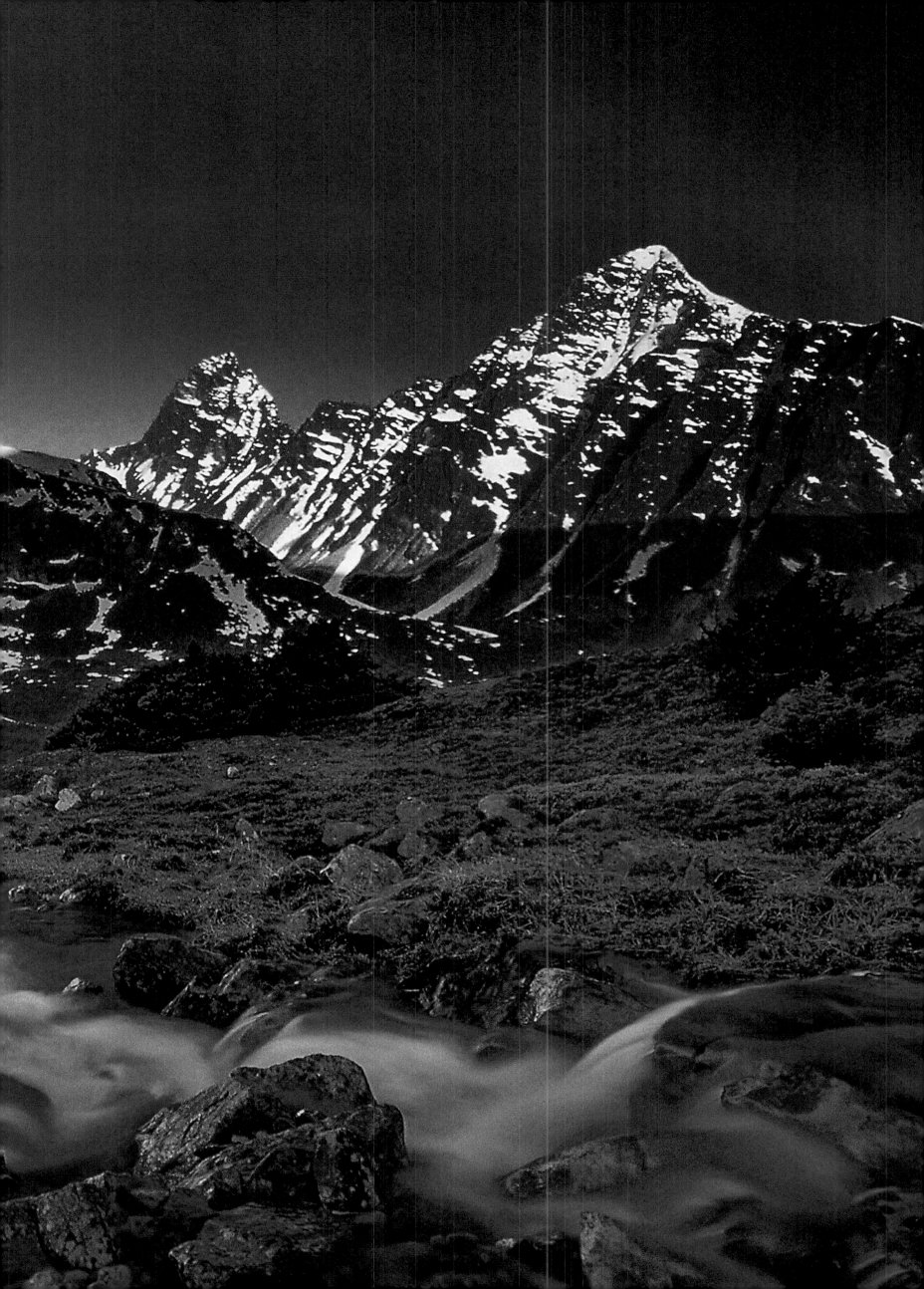

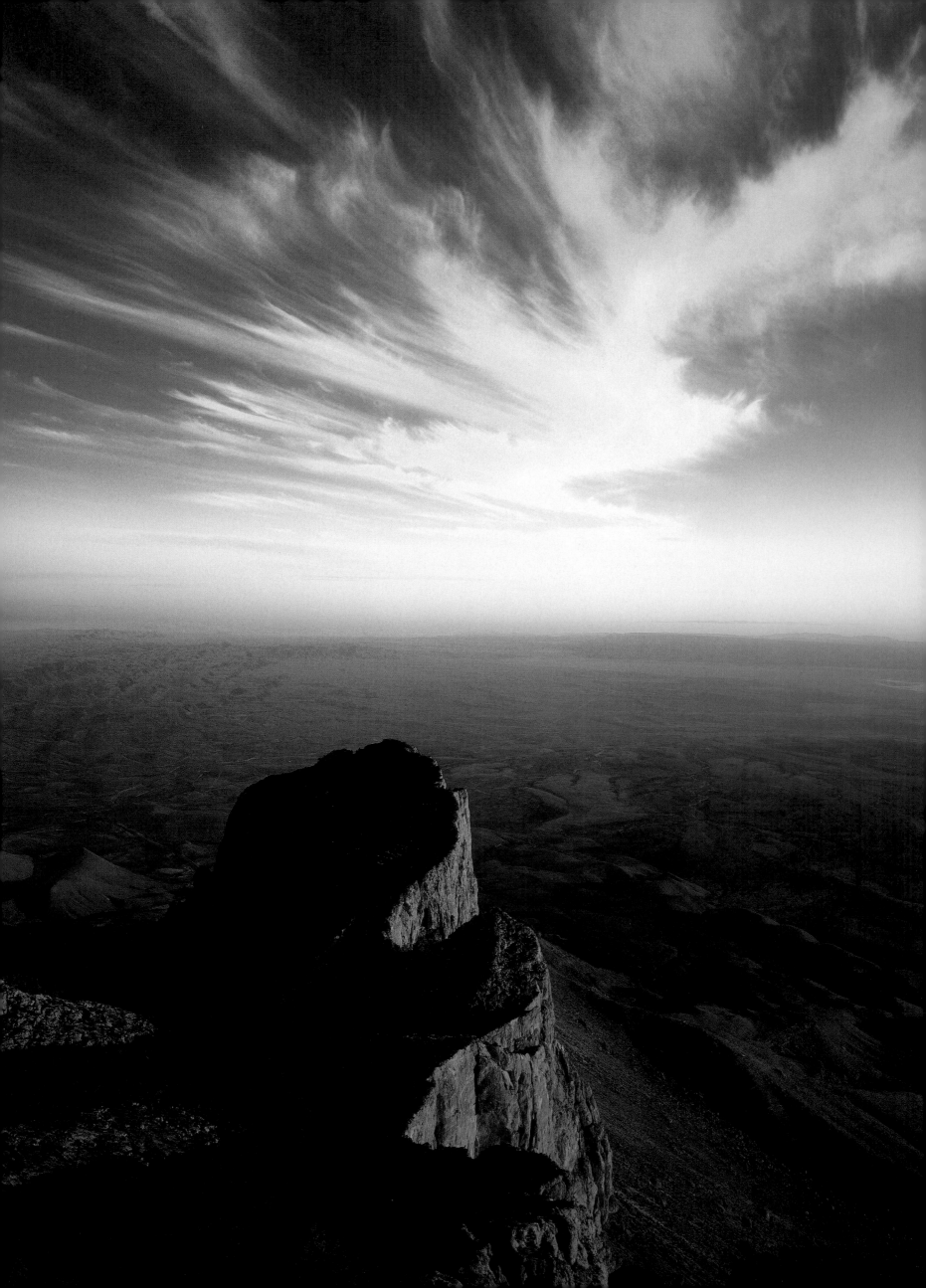

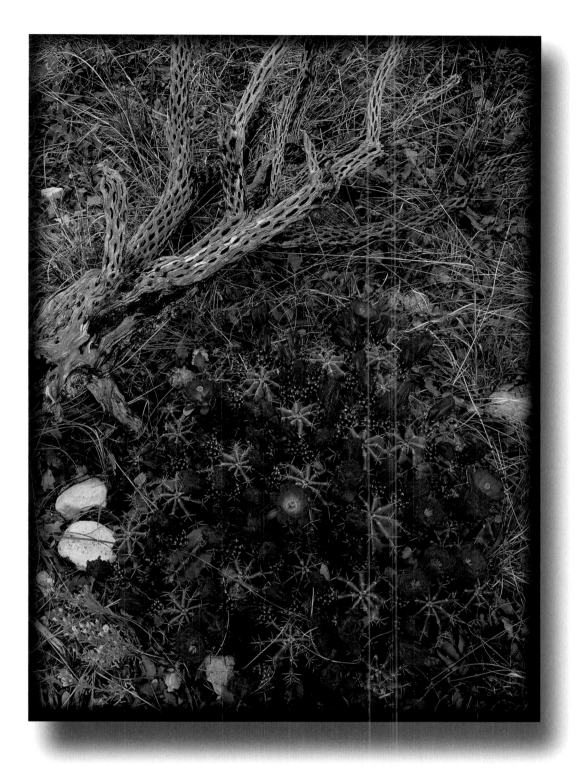

Guadalupe Mountains National Park, Texas
The glowing blossoms of white-spined claret cup make a lively contrast with
the withered skeleton of a cholla cactus.

left: **Guadalupe Mountains National Park, Texas**
Like the last fortress guarding the border of an empire, the ancient reef now called
El Capitan stands at the the boundary between mountain and plain. The limestone
of El Capitan formed about 230 million years ago, when west Texas was a patchwork
of lagoons, reefs and basins: the remnants of a vast inland sea.

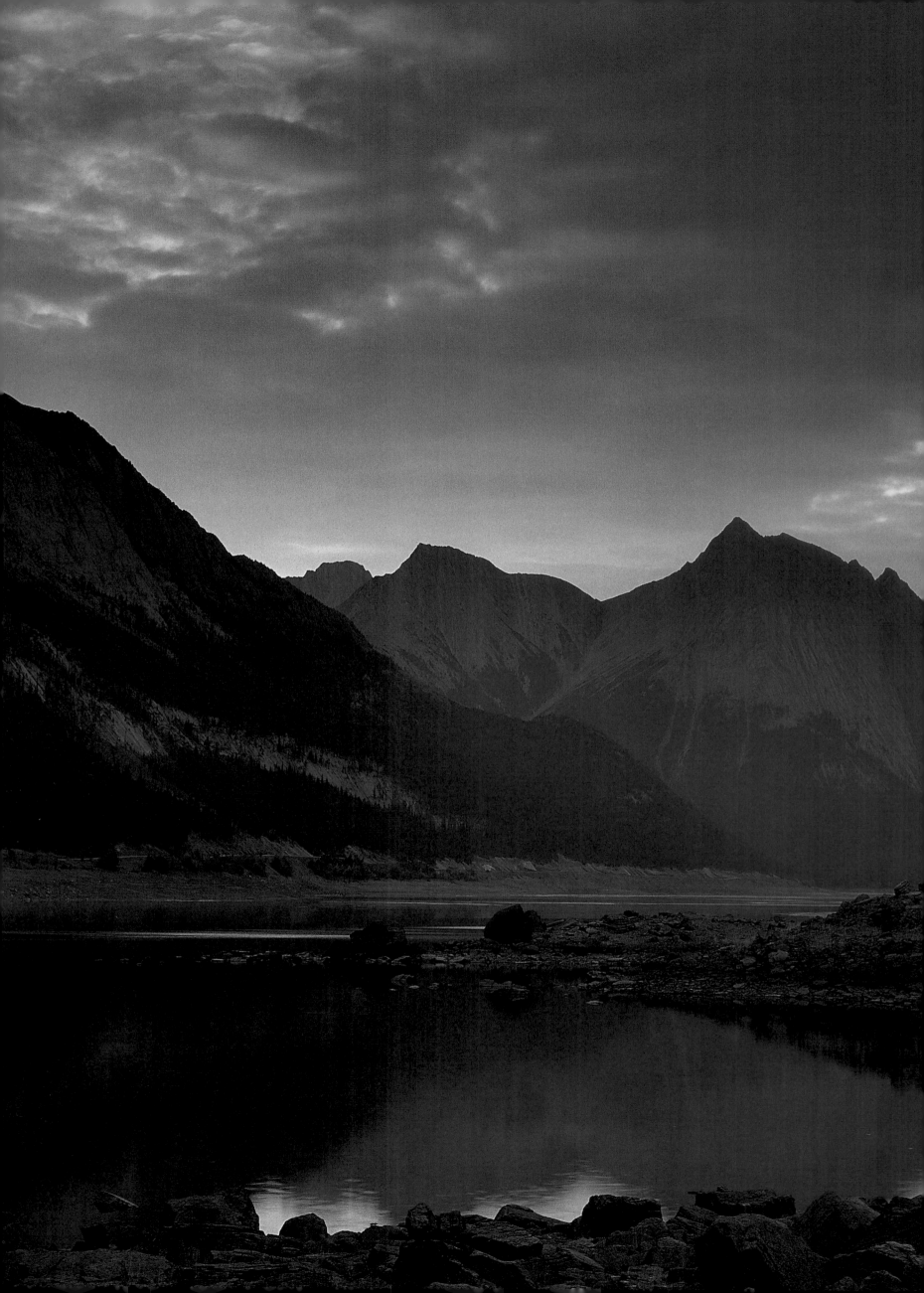

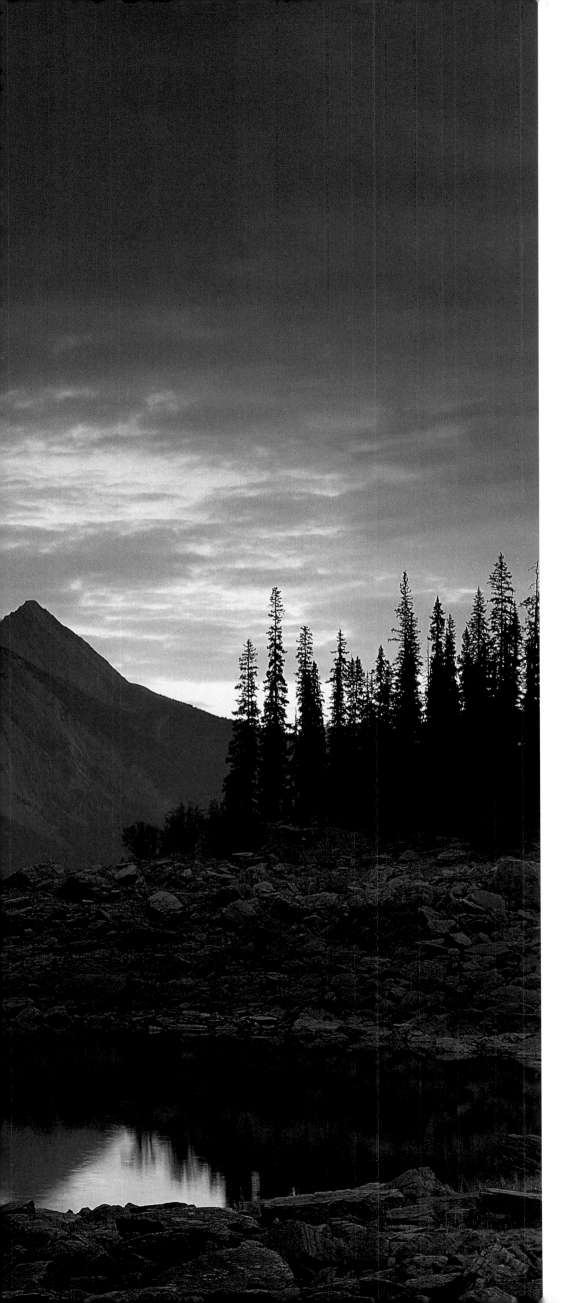

Jasper National Park, Alberta
Medicine Lake's water level varies considerably due to its unique underground drainage system. When the amount of water flowing into the lake is less than that draining away, the lake level drops. At times the lake disappears altogether, revealing its muddy bottom.

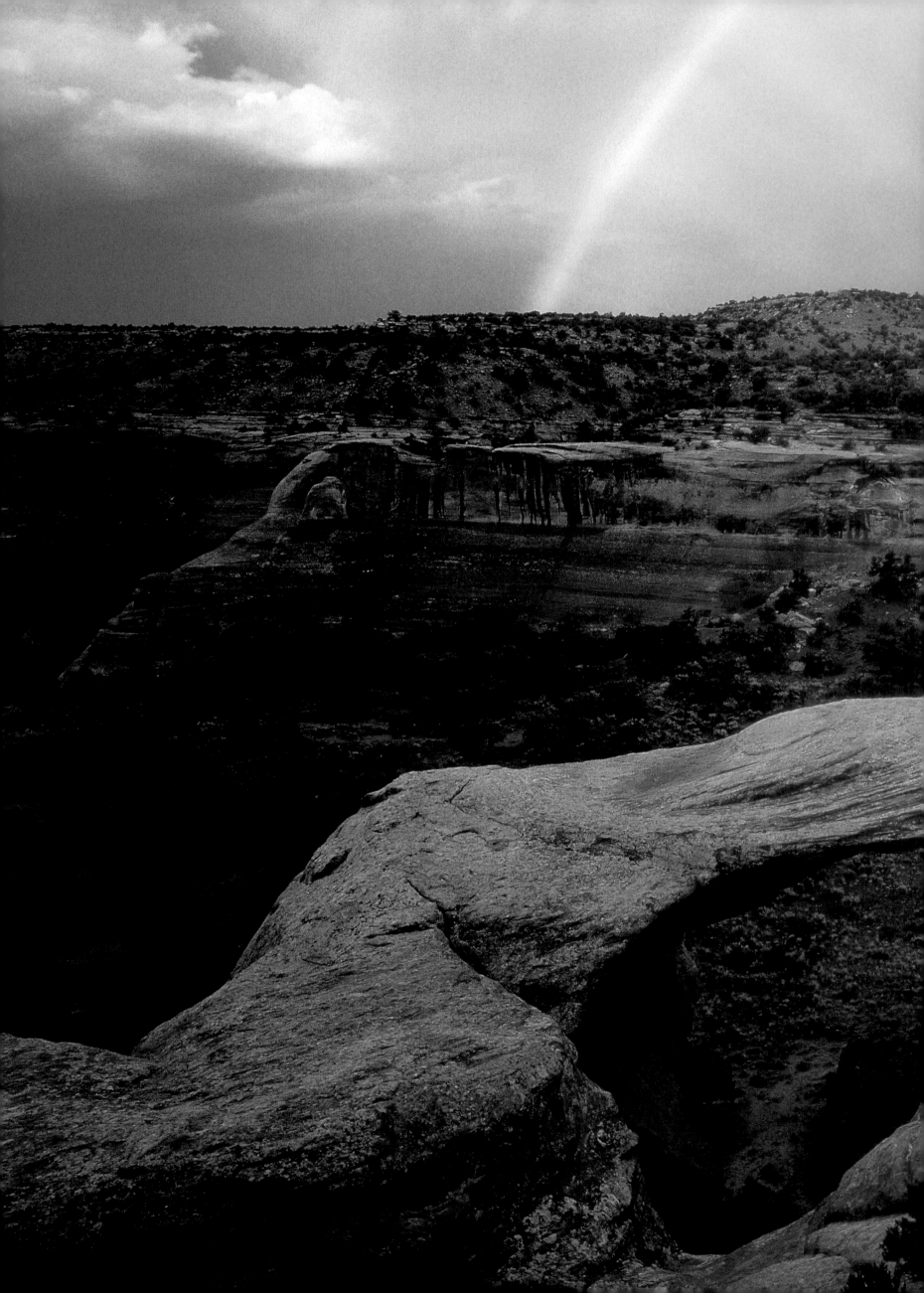

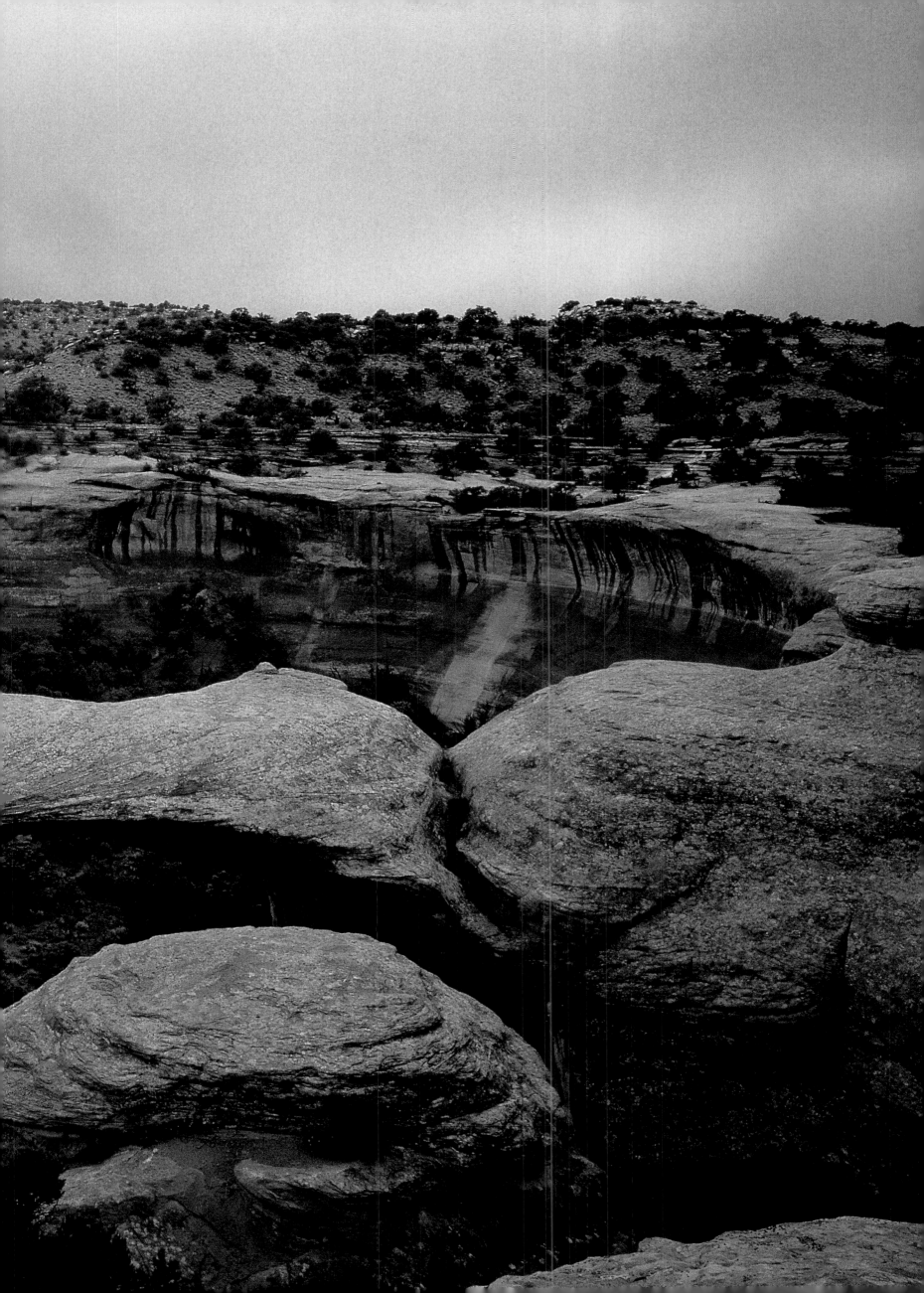

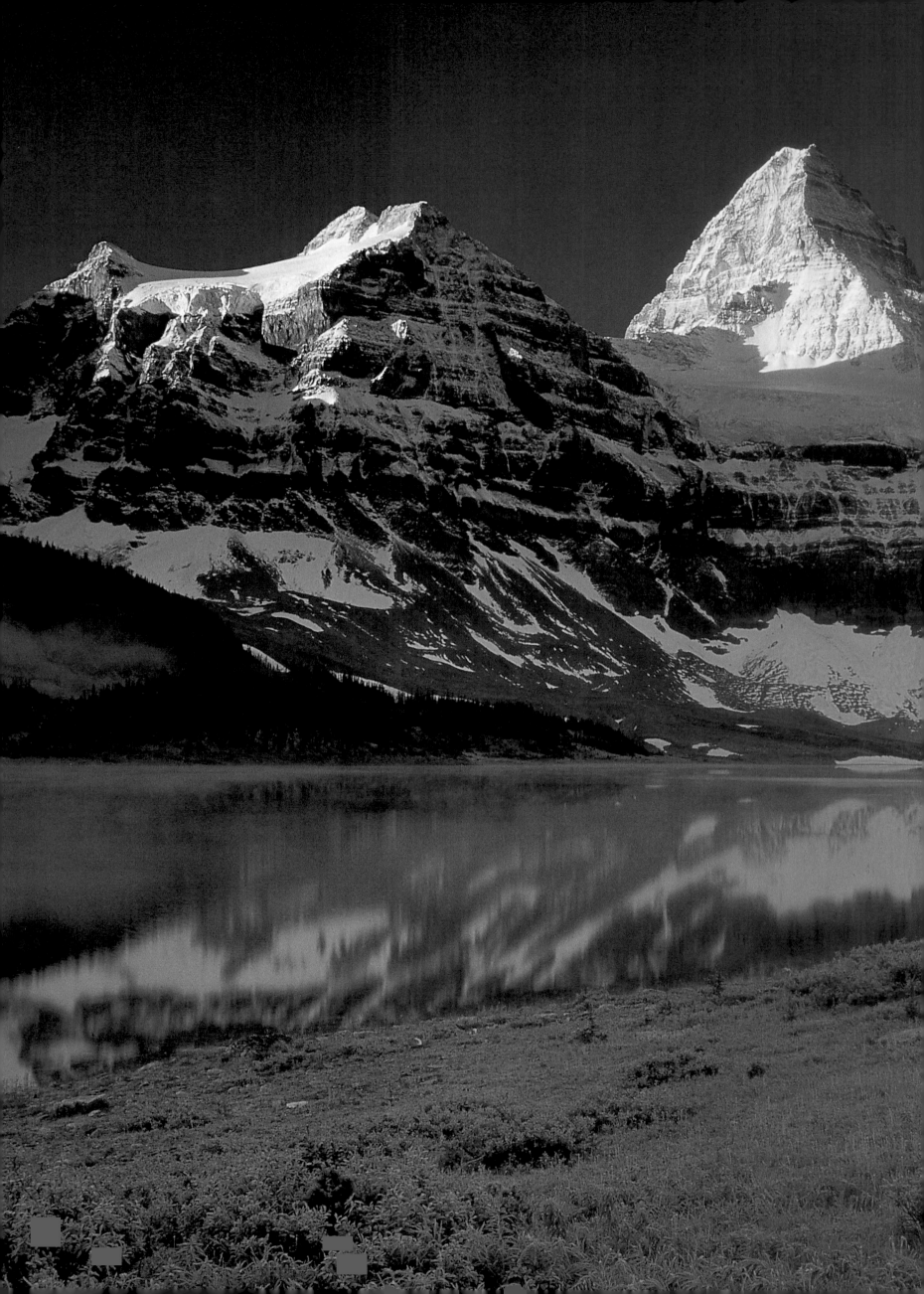

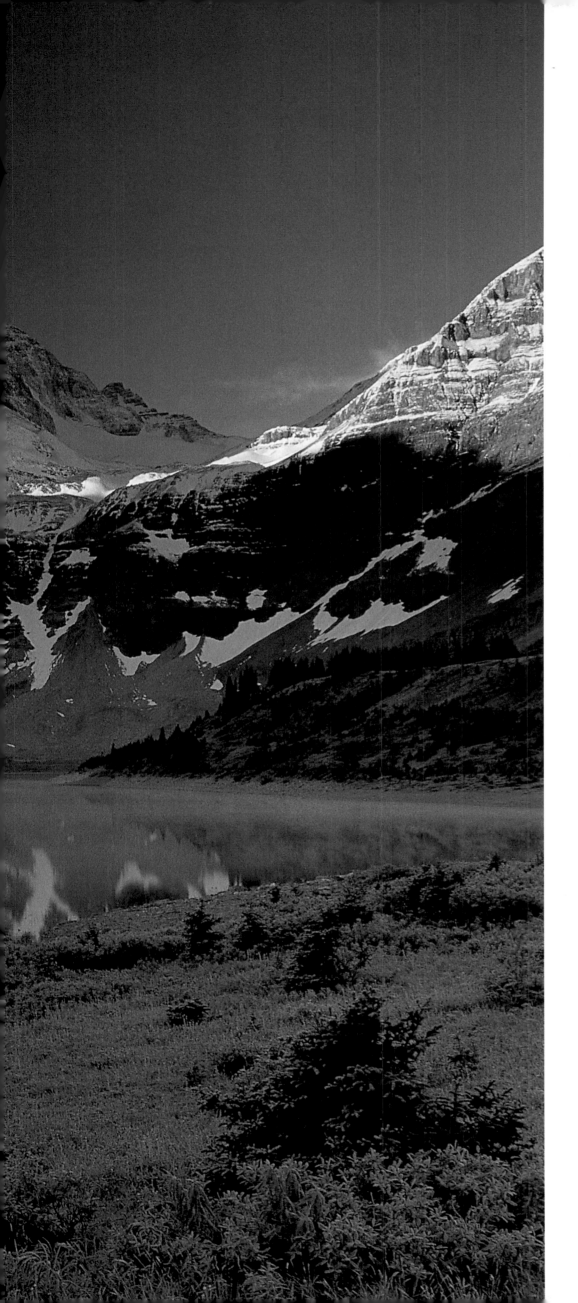

Mount Assiniboine Provincial Park, British Columbia Glaciers relent-lessly wearing away at the sides of the mountain eventually created the majestic peak of Mount Assiniboine. It resembles Switzerland's famous Matterhorn, which was formed in the same manner.

previous pages: **Rattlesnake Canyon Wilderness Study Area, Colorado** A rainbow in the sky over Rattlesnake Canyon echoes the shape of a stone arch below. There are a total of nine natural arches in the canyon—the second-highest concentration of these geologic wonders in the U.S.

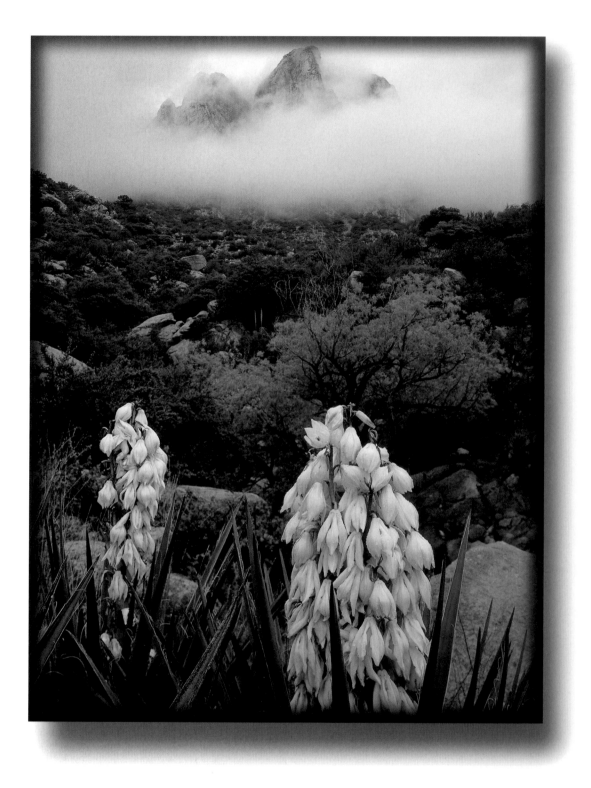

Aguirre Springs National Recreation Area, New Mexico

The yucca plant was important for native peoples throughout its range. They ate its fruits raw or cooked, and dried them for later use. Some people also extracted a soap-like substance from the yucca's roots.

right: **Banff National Park, Alberta**

The same blaze that killed these lodgepoles is the key to a new generation arising to take their place. Only a fire's heat can melt the resin that seals lodgepole seeds within their cones and allow them to grow.

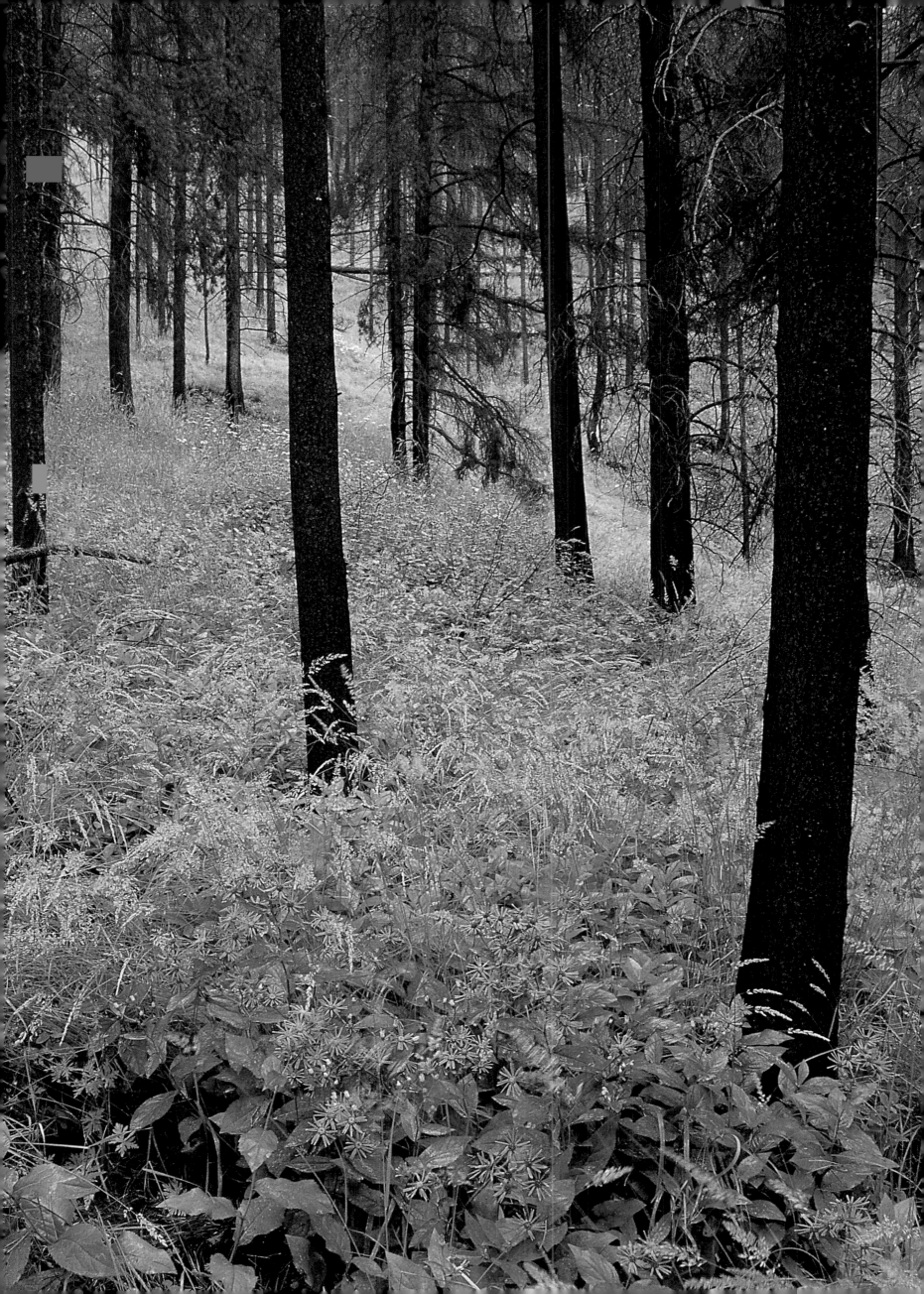

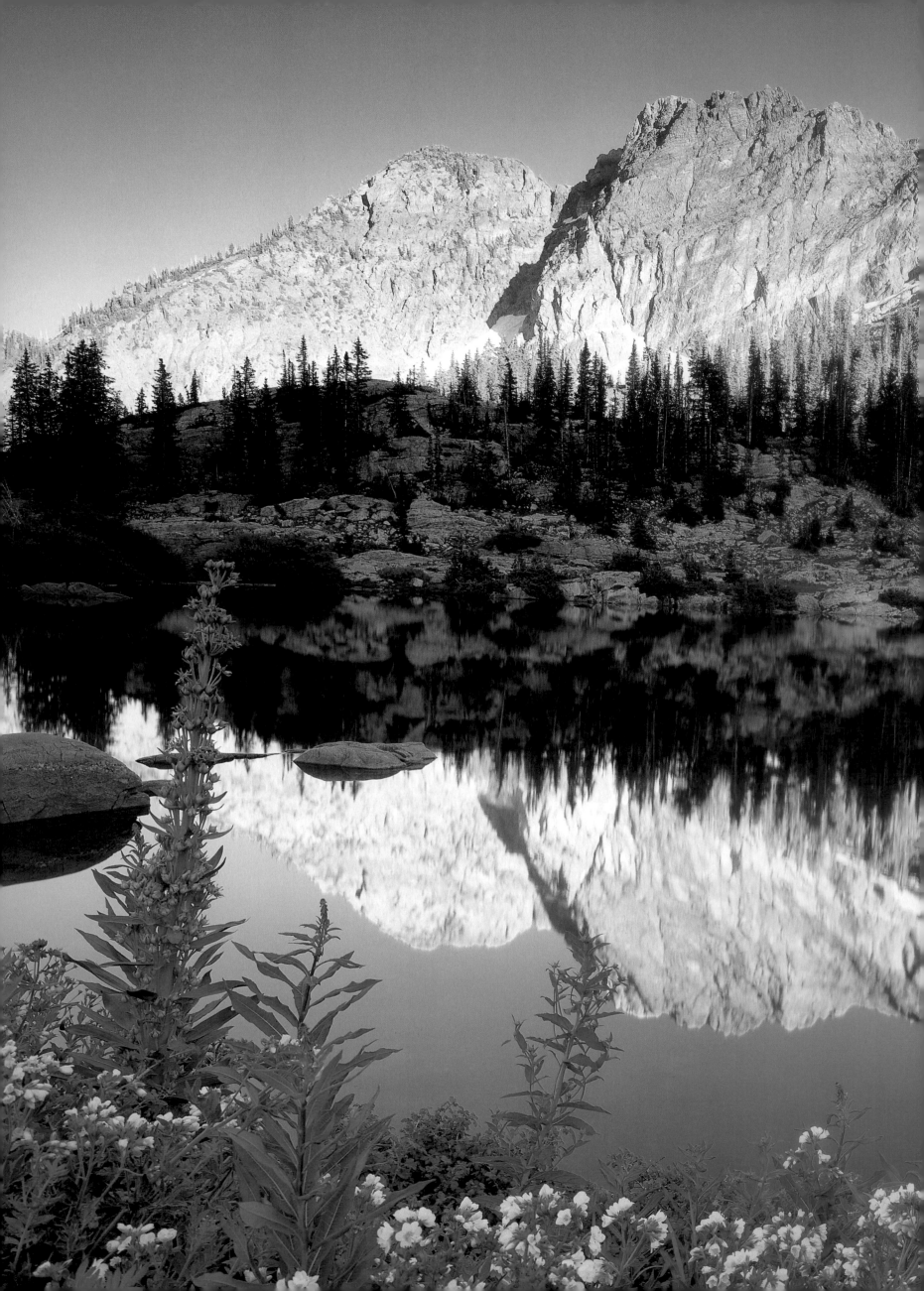

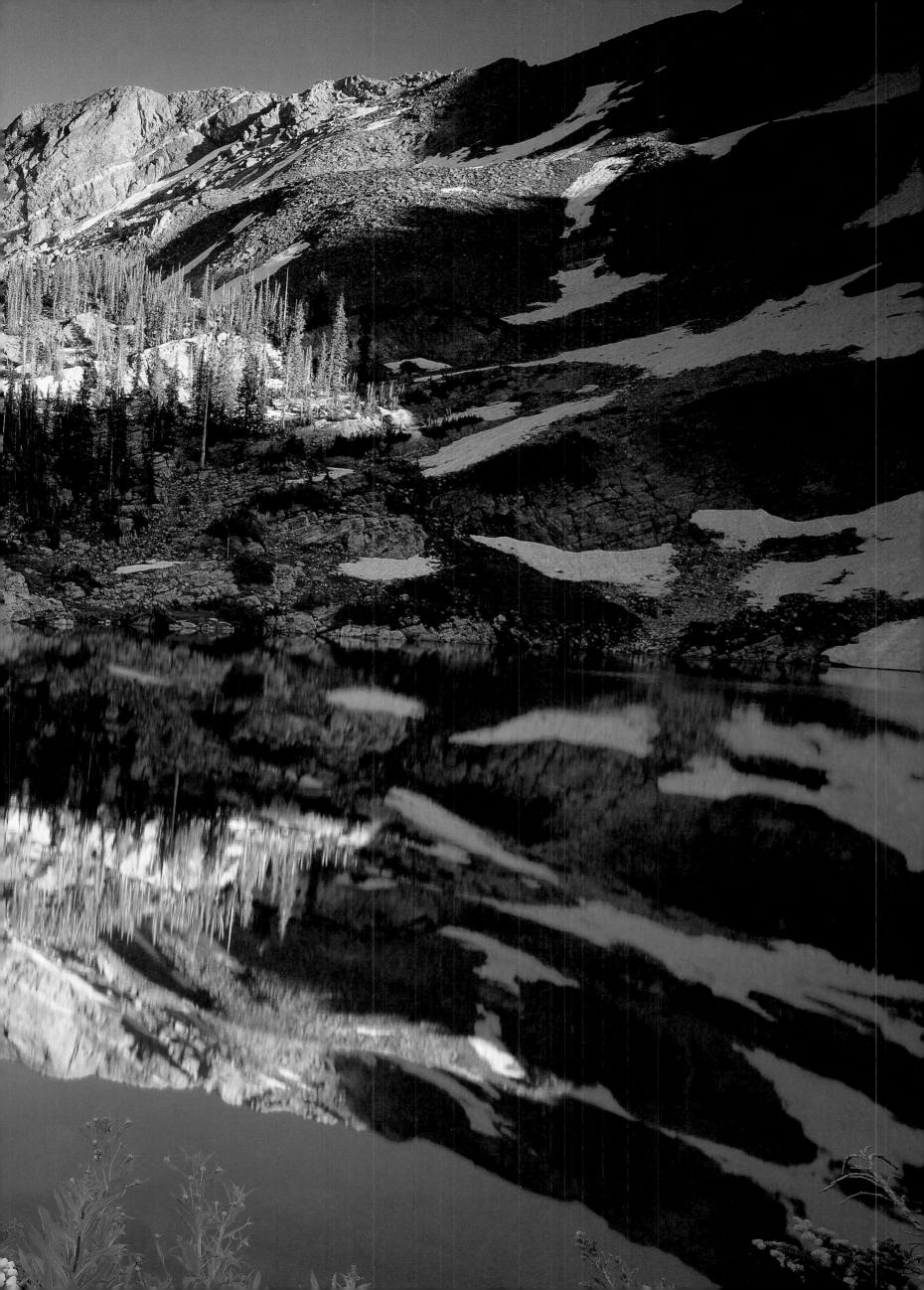

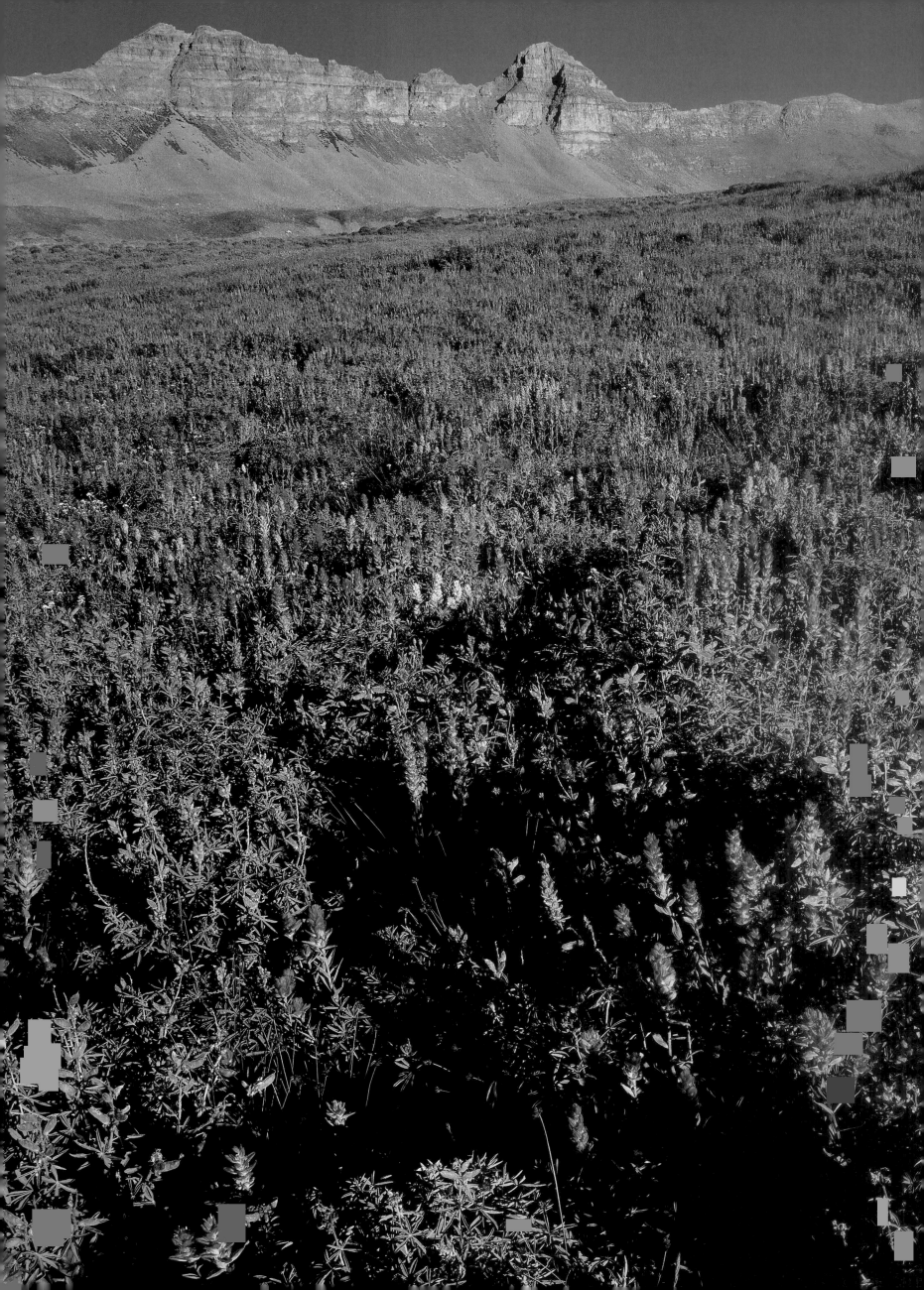

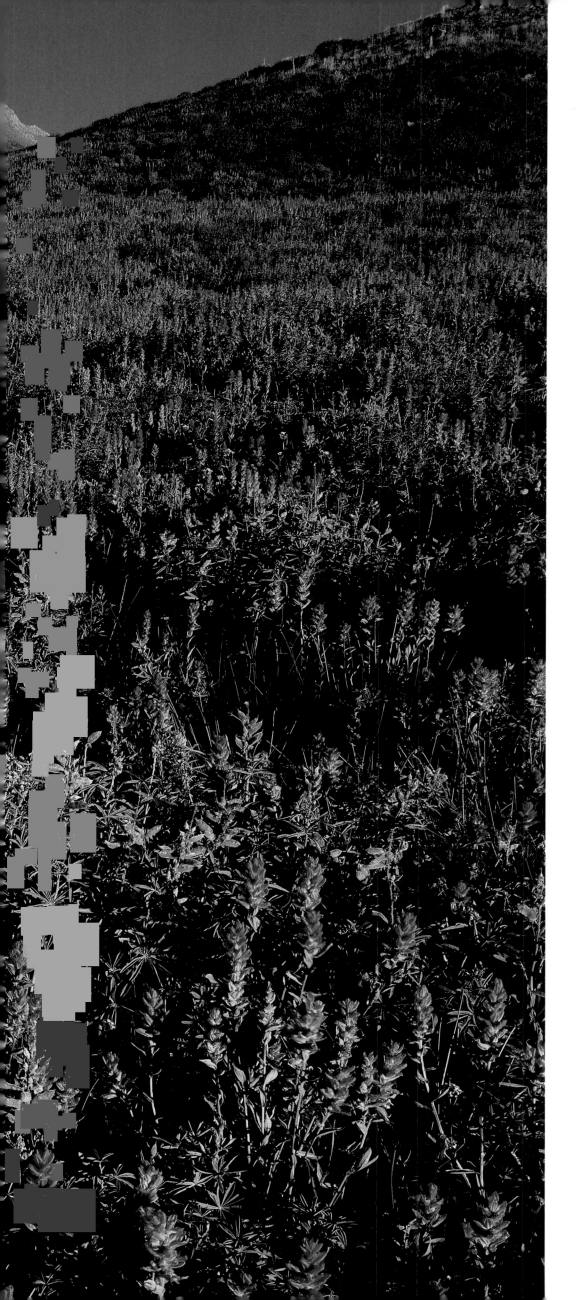

Timpanogos Wilderness, Utah
The time at which Indian paintbrush
and other wildflowers bloom varies
throughout the Rockies. Plants at
lower latitudes and altitudes are
usually the first to flower.

previous pages: **Wasatch National Forest,
Utah** Cecret Lake's name, complete
with strange spelling, came from an
old mining claim. The lake sits at the
top of Little Cottonwood Canyon and
is a popular destination for hikers.

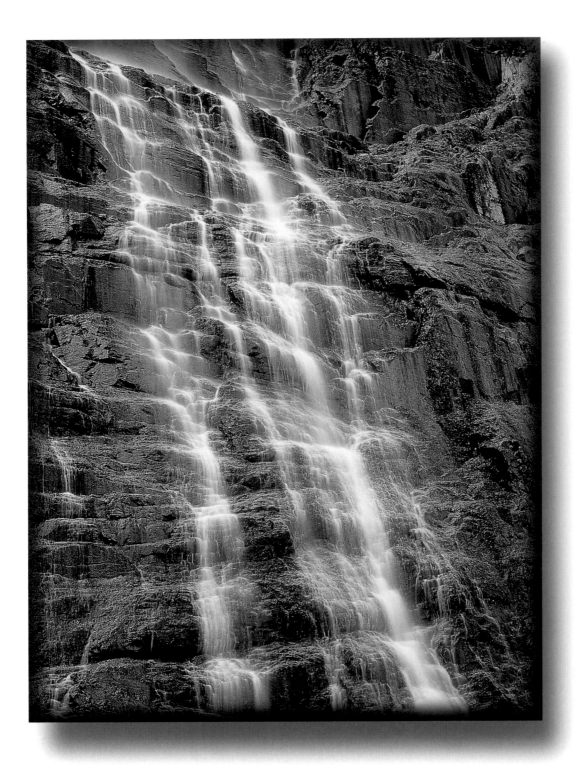

Weeping Wall, Banff National Park, Alberta
Across rock faces throughout the mountains, spring meltwaters form
ever-shifting veils.

right: **Bow Lake, Banff National Park, Alberta**
Spring is a time of promise in the mountains: a promise that snows will recede,
new life will come forth, food will once again be abundant, and the hardships
of winter will be only a memory.

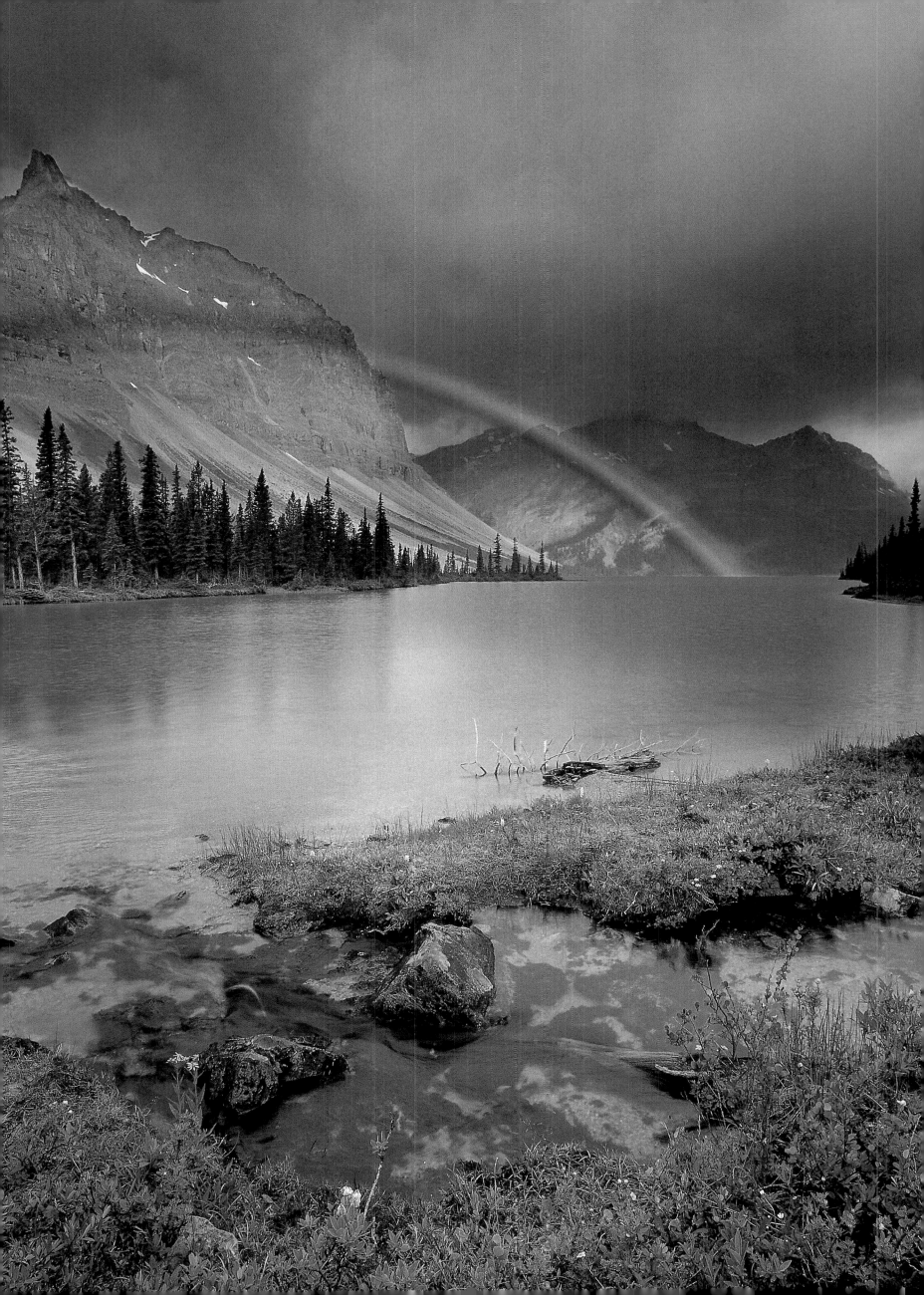

Cirque Peak, Banff National Park, Alberta The dish-shaped face, or cirque, for which Cirque Peak is named was carved by glaciers during the ice ages of the last 2 million years.

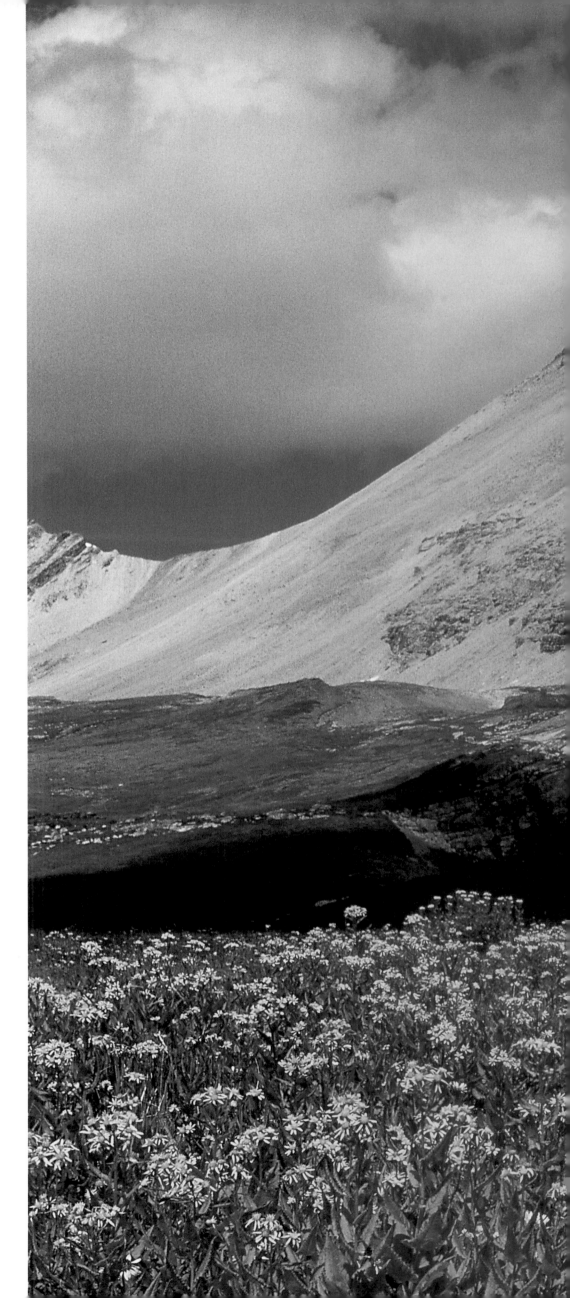

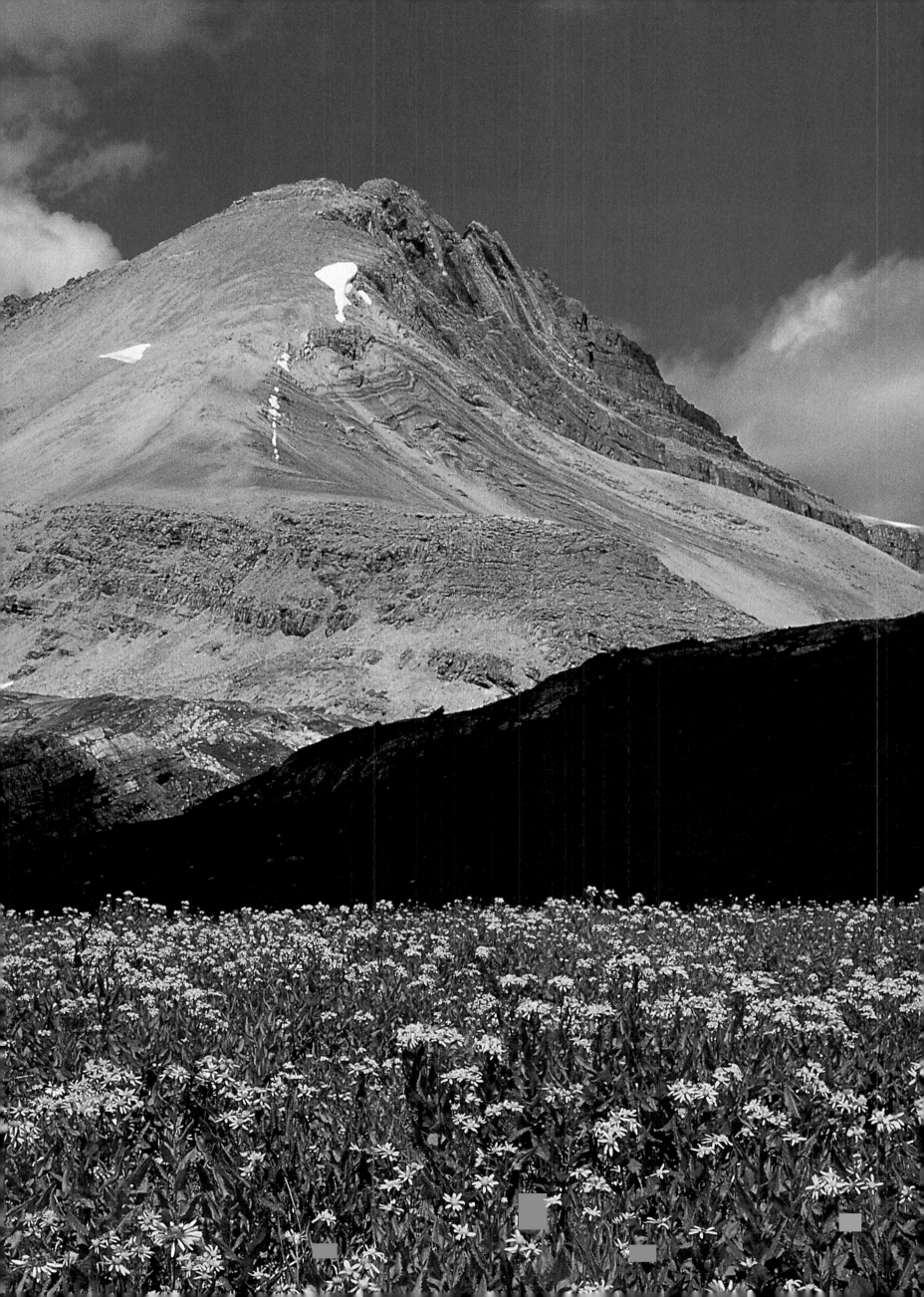

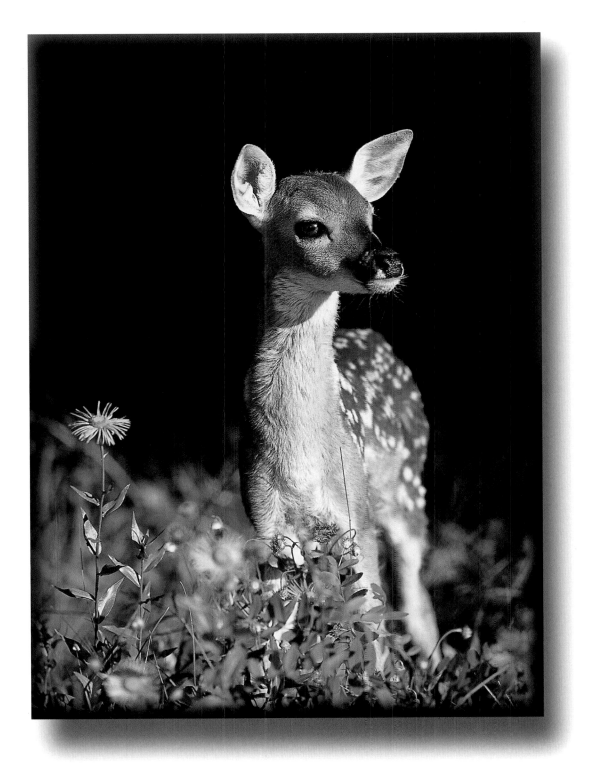

White-tailed Deer

Even while grazing, this fawn remains alert. An alarmed whitetail raises its
tail to display a large, white flash that signals danger to other deer. The tail flash
of a doe also gives her fawn an obvious marker to follow when fleeing.

left: Grand Mesa National Forest, Colorado

Lupines bloom atop Grand Mesa, which is the world's largest flat-top mountain.
The top of the lava-capped plateau lies more than a mile (1.6 kilometers) above the
valleys of the Colorado and Gunnison rivers below. There may still be snow on the
mesa when the valley bottoms are hot and dry.

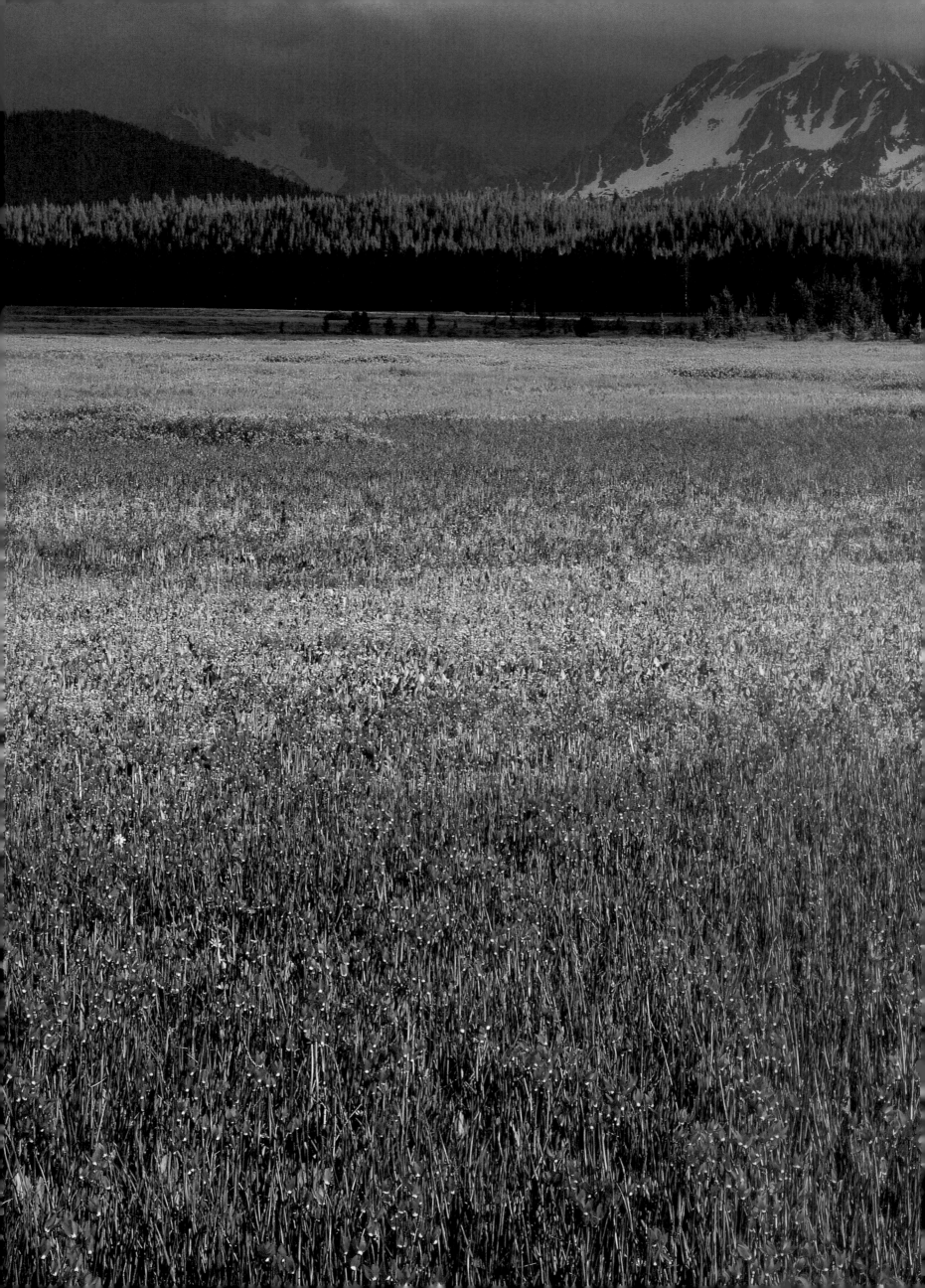

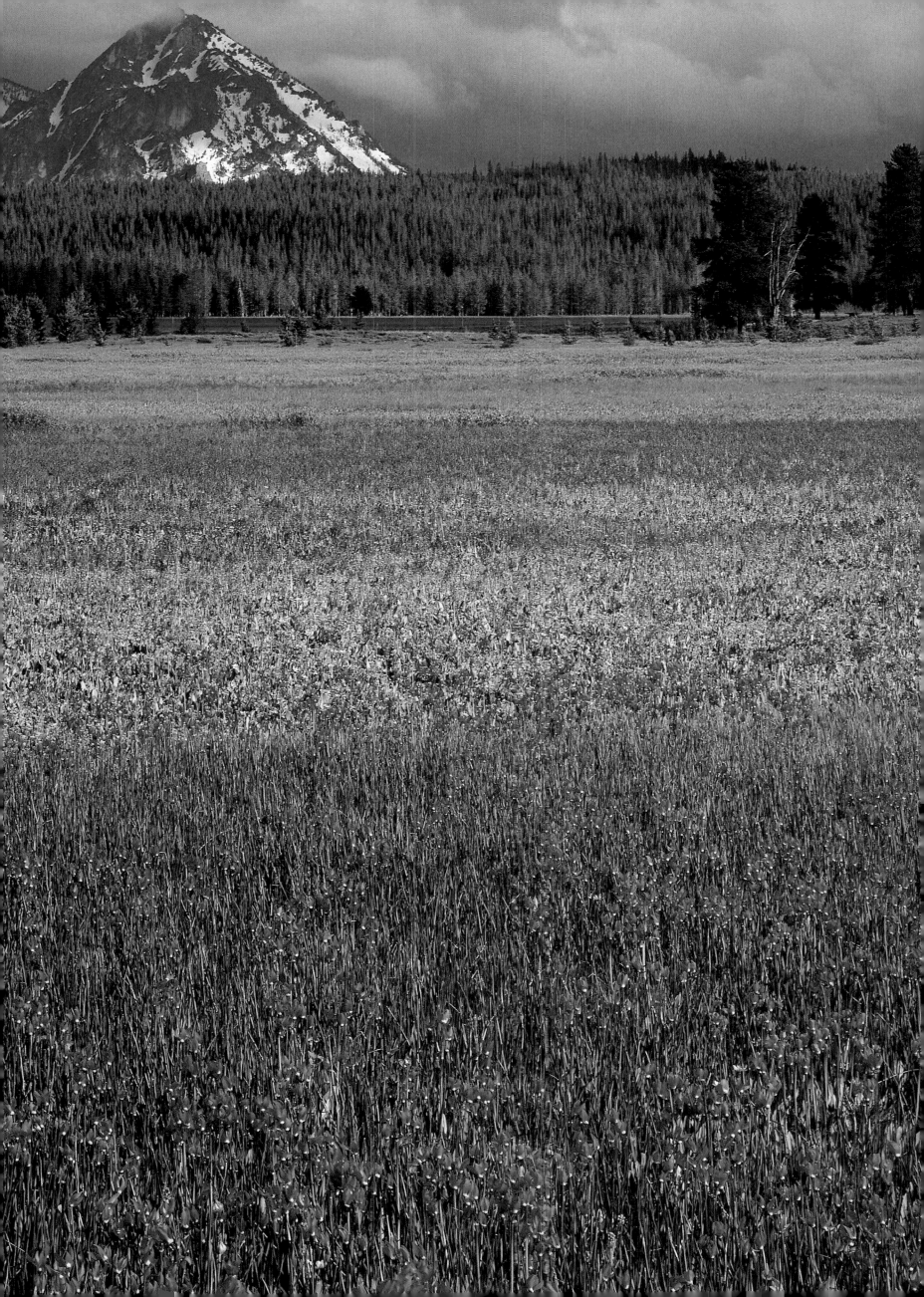

Mount Sneffels, San Juan Mountains, Colorado Despite their delicate beauty, wild columbines are hardy plants capable of growing among the inhospitable rocks of a talus slope, where few other plants can survive. In more welcoming terrain, such as this, they flourish.

previous pages: **Sawtooth Mountains, Idaho** At about the same time red-tailed hawks are laying their eggs and steelhead salmon are migrating to their spawning beds, galaxies of shooting stars spread blankets of pink across mountain meadows.

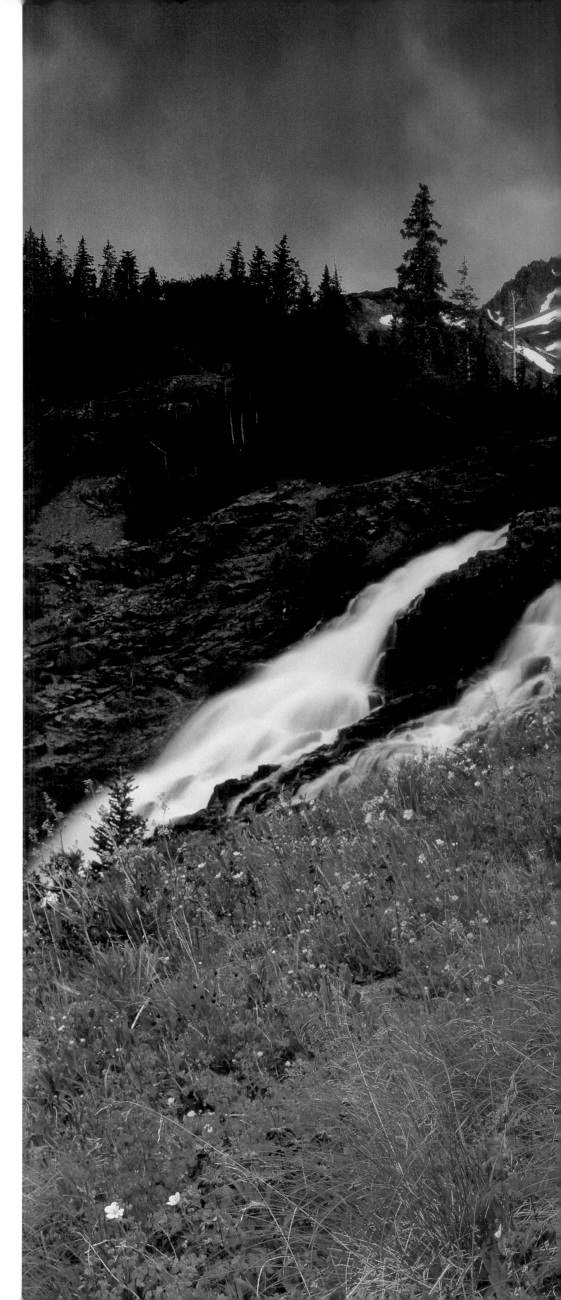

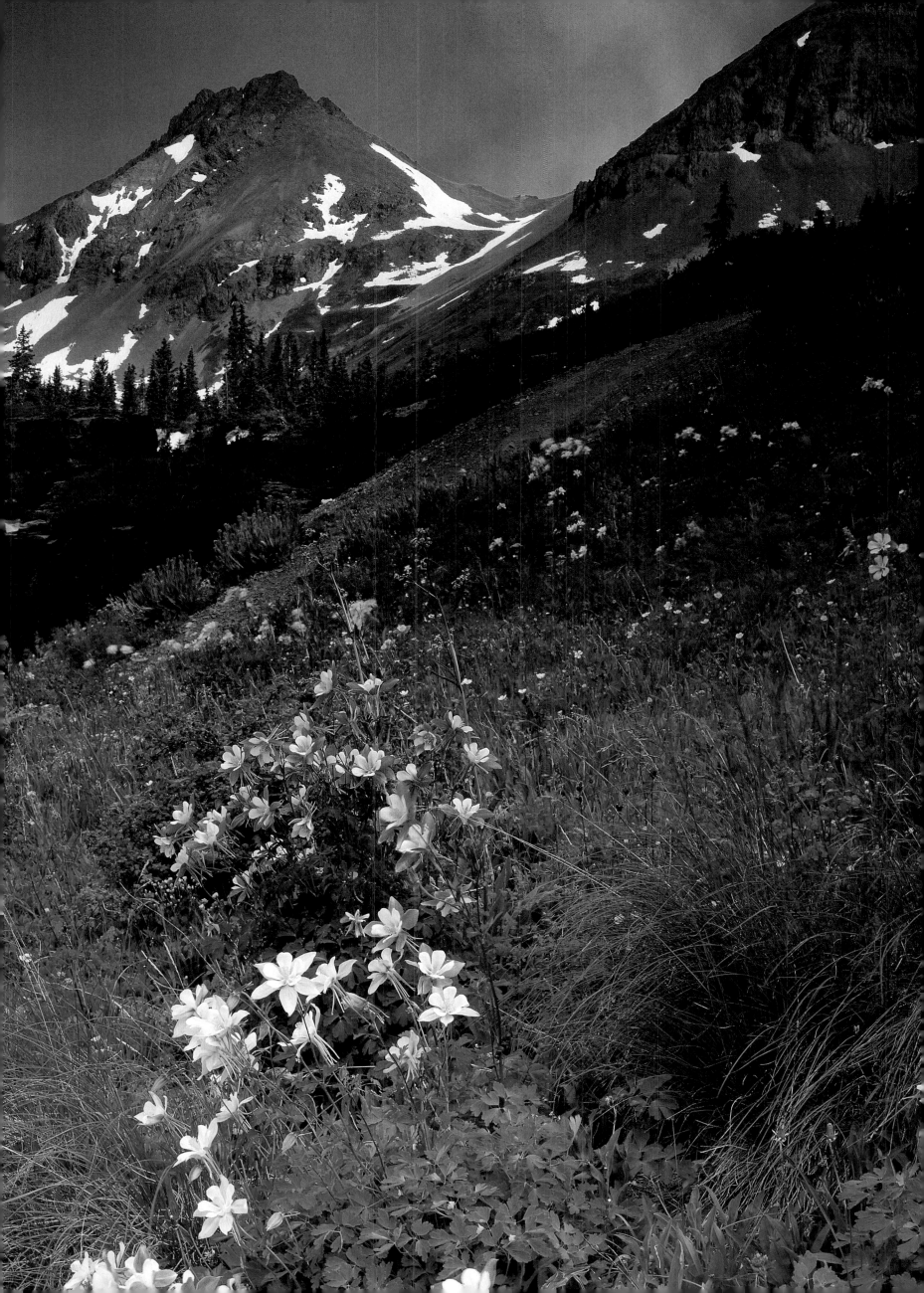

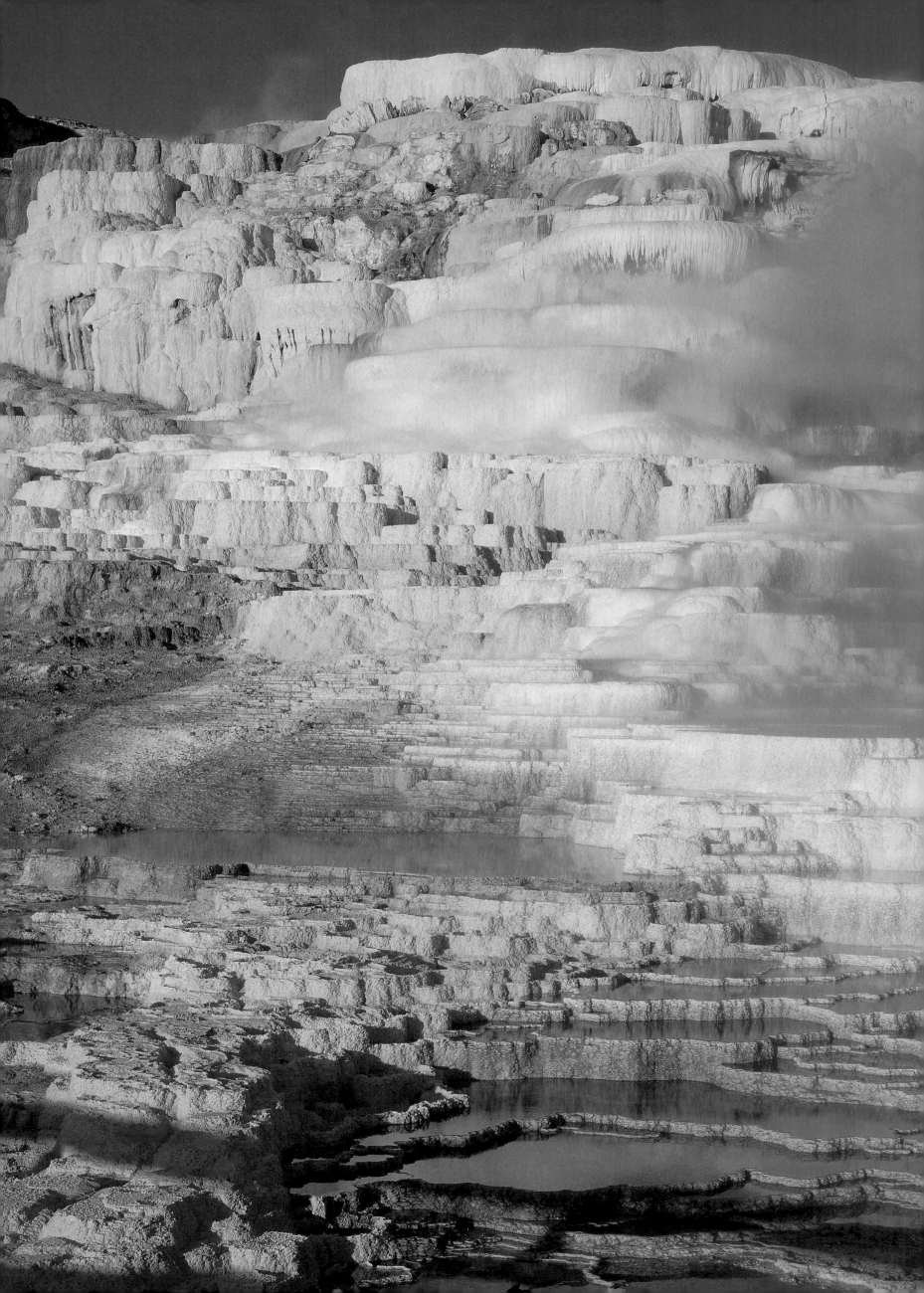

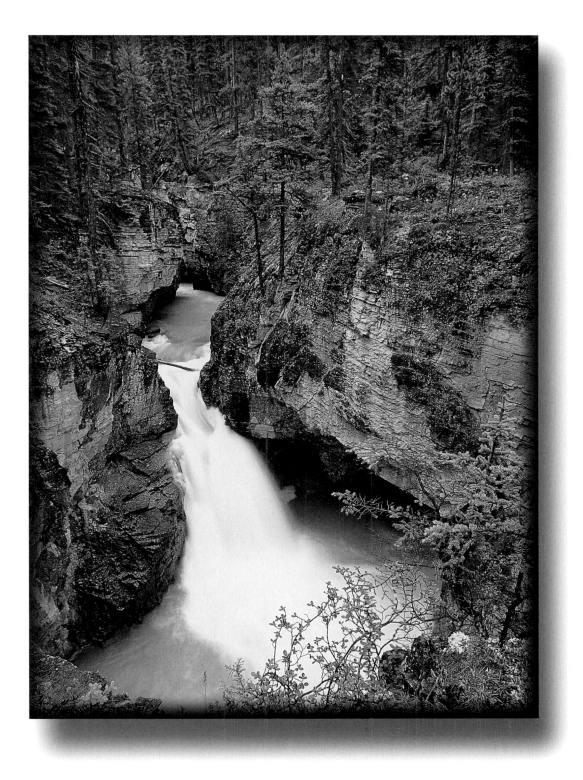

Jasper National Park, Alberta

Over millions of years, the Maligne River has gouged a narrow, steep-walled canyon in the limestone bedrock. In places the canyon is more than 150 feet (46 meters) deep.

left: Mammoth Hot Springs, Yellowstone National Park, Wyoming

This magical landscape is formed of travertine, which s calcium carbonate.
Hot carbonic acid carries the dissolved mineral fro n underground. Once on the surface, the acid cools and loses carbon dioxide, causing i to release the travertine.
This process happens most quickly at pool edges and so creates a rim.

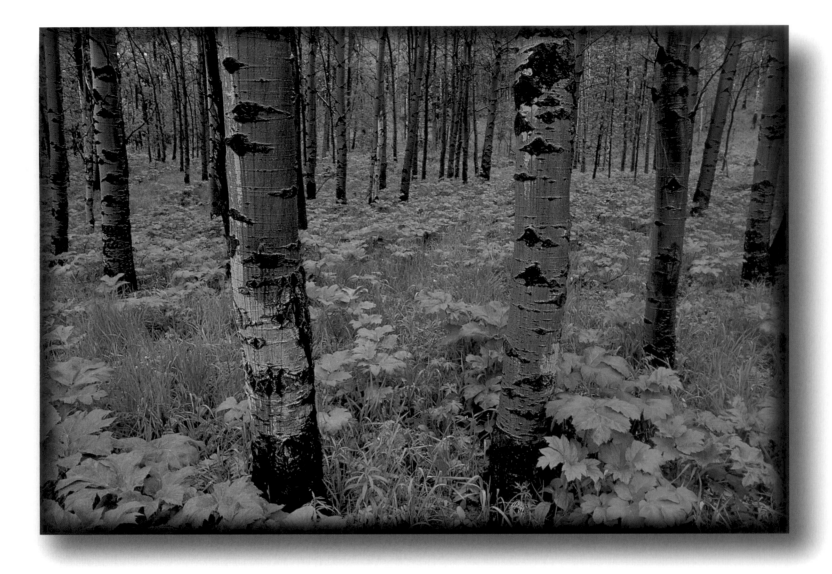

Sheep River Valley, Alberta

Each spring aspen trees release huge quantities of seeds, each attached to a tiny bit of
fluff, which may be carried by the wind for miles. Only a few of these seeds ever take
root, but the aspen has an additional reproductive strategy: along its roots lie hundreds
of buds that begin to grow when stimulated by sunlight and warmth. In some cases,
all the aspens in a grove may have sprung from a single tree.

right: Selway-Bitterroot Wilderness, Idaho

As the spring melt progresses, small streams swell with life-giving waters and rush head-
long down the mountainsides, tumbling recklessly over rocks in their haste to join others.

previous pages: Crowsnest Pass, Alberta

As air rises over mountains and then drops on the other side, it is sometimes shaped
into a series of nearly stationary waves. Smooth-sided clouds form at the tops of the
waves and stream downwind from the mountain.

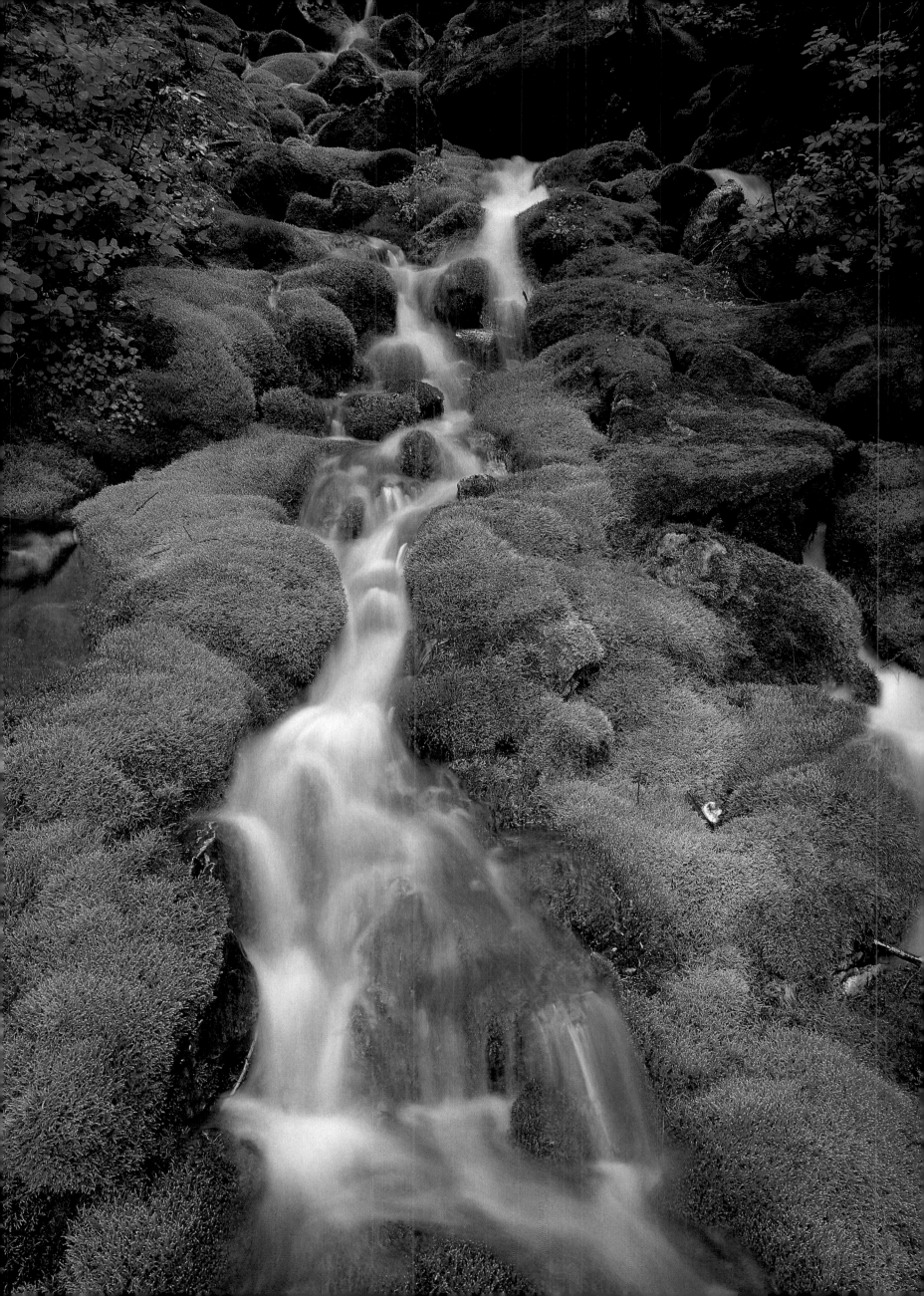

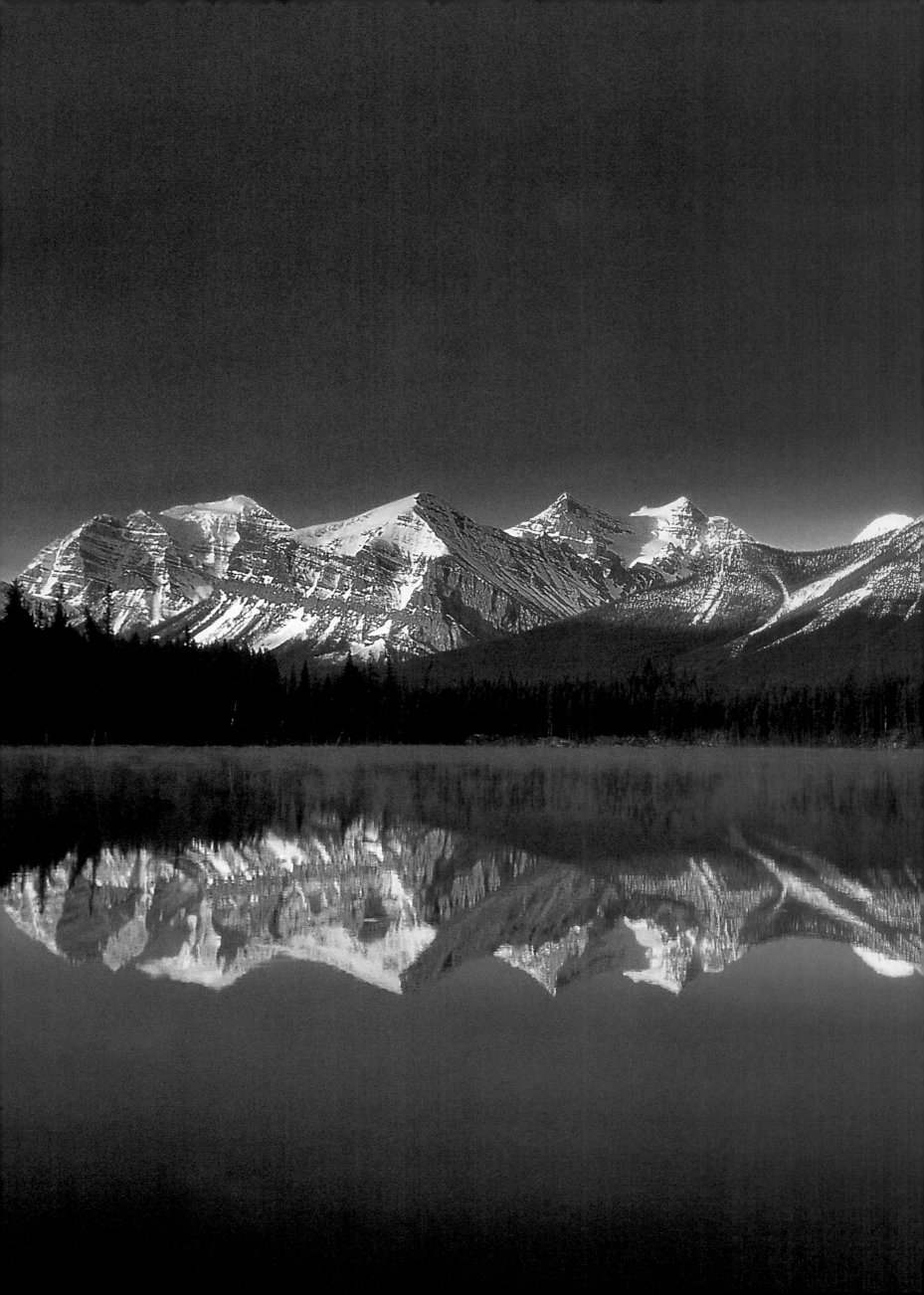

SUMMER
IN THE ROCKIES

SUMMER IN THE ROCKIES

IS MUCH LIKE THE FIRST,

SUMMER

Summer in the Rockies is much like the first, passionate stage of a love affair: always over too quickly but intensely beautiful while it lasts. One of the glories of the Rockies, alpine wildflowers come into their full splendor in midsummer. In some places, such as the San Juan Mountains, the spectacle draws people from around the world.

A walk on a mountain trail can take you from sun-drenched valleys into aspen groves where leaves filter the light to a dappled green glow. Climbing further, there are cooling breezes and the shade of pines. The elk and deer are at higher elevations now, and bighorn sheep graze in the meadows, rams apart from the ewes and their lambs. The predators have also moved higher, following the herds and their vulnerable young. Summer's exuberance reaches above the timberline to even the most severe alpine tundra, where snow covers the ground for half the year. Plants here must grow, bloom and reproduce quickly because of the extremely short growing season, and their urgency translates into a brief riot of color.

Summer's warmer temperatures breed spectacular storms, which can be frightening due to intense lightning and high winds. Day-to-day changes in the Rockies' summer weather can be dramatic. One hiker making his way through the Canadian Rockies in August enjoyed a lovely, sunny, 77°F (25°C) day. The following day he had

PASSIONATE STAGE OF A LOVE AFFAIR

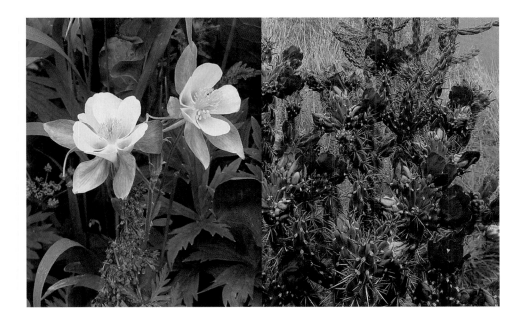

to shiver his way through 6 inches (15 centimeters) of snow in a cutting wind at 26°F (-3°C). In these northern mountains, significant snowfalls can happen around the middle of July and the first week of August.

Berries and bears come together on mountain slopes in summer. As they single-mindedly concentrate on fattening up for the winter, black bears and grizzlies work their way through various berry crops. In Jasper National Park in the Canadian Rockies, red buffalo berries are popular with grizzlies: an adult bear may gobble up 200,000 of them in a day. The caloric quest will continue until the bears retire to their dens for the winter.

Other animals, too, stockpile summer's bounty against colder, leaner days ahead. Up in the rocks near the meadows, a piercing *eep* alerts a passing hiker that one of the world's smallest farmers is nearby. The pika—a furry-footed, fist-sized animal related to rabbits and hares—spends late summer and autumn harvesting, drying and storing away grasses. Thanks to their hay piles, pikas do not have to hibernate to survive the long siege of winter.

Summer is a time of vigorous growth and activity for the plants and animals of these mountains. For people, this season of the Rockies brings a gift of wild, vivid beauty that is unique on our planet.

previous pages: **Banff National Park, Alberta**

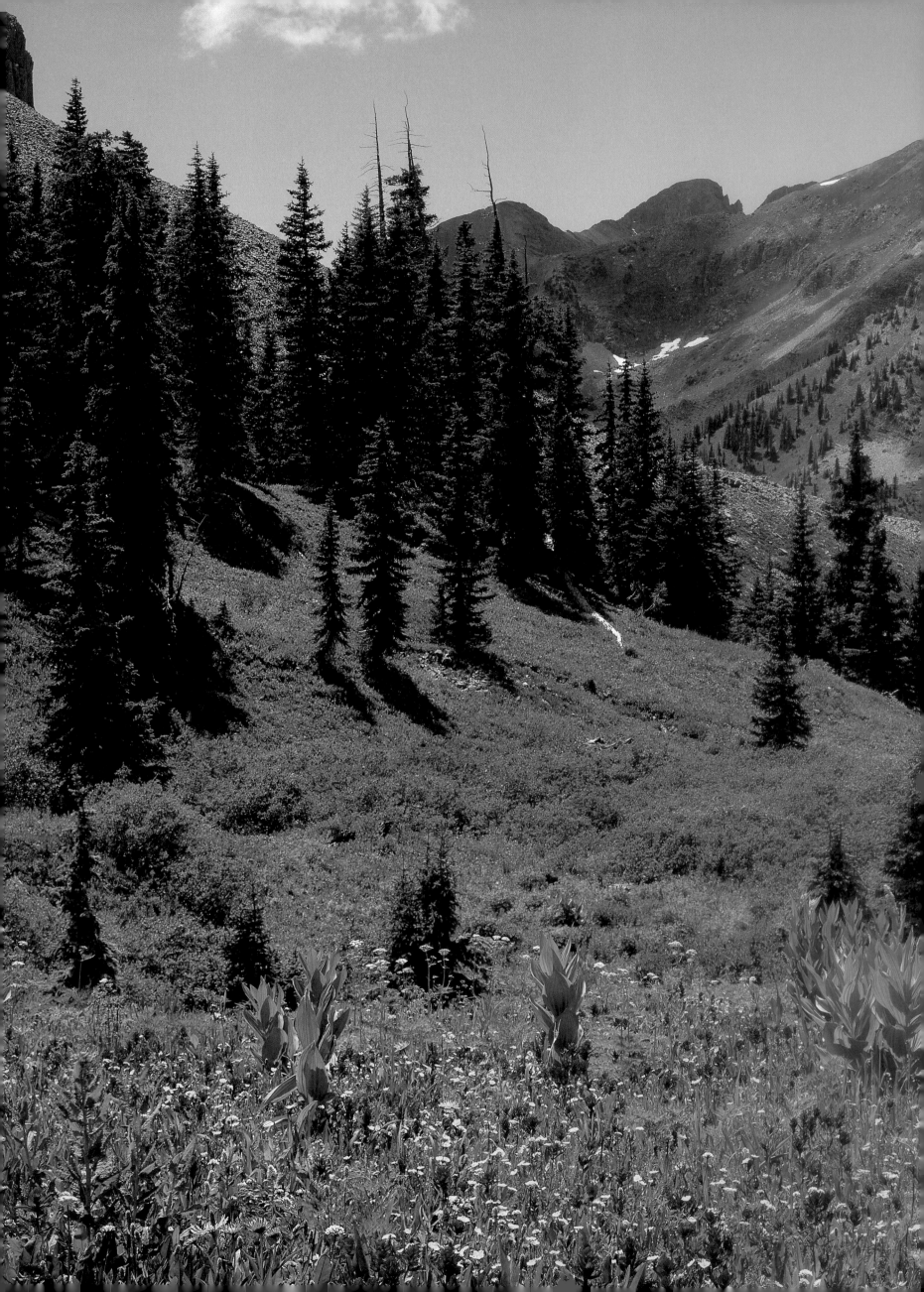

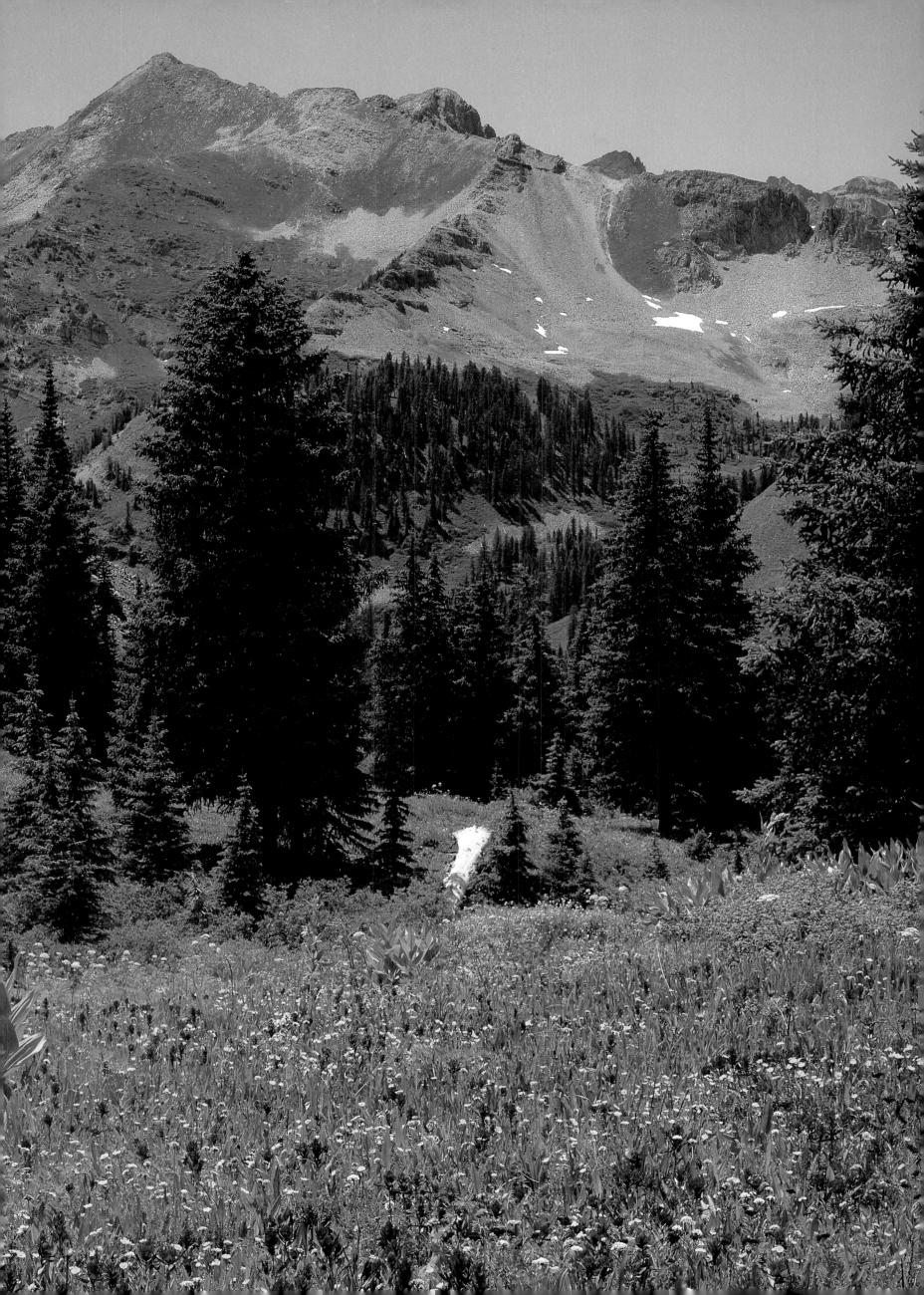

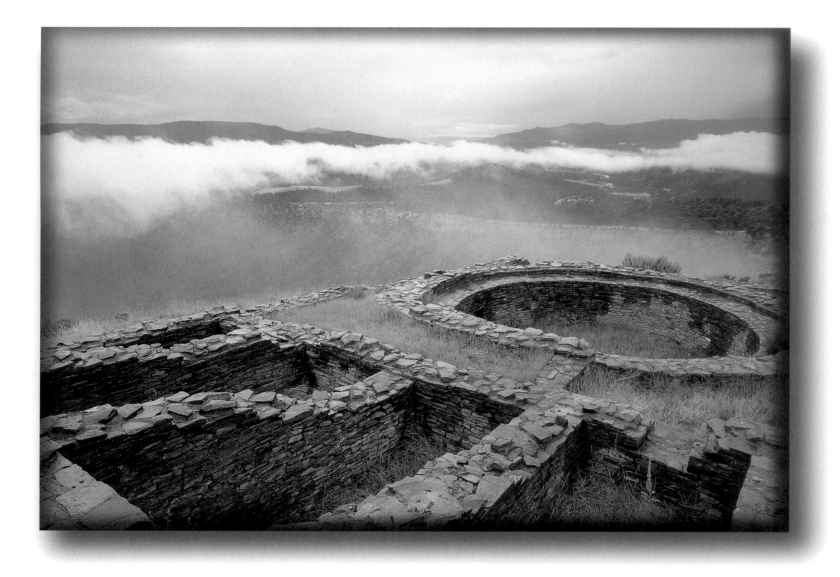

Chimney Rock Ruins, Colorado

The Chacoan people who built their pueblo high atop Chimney Rock must have had strong reasons for choosing that spectacular location. They hauled tons of dirt and rock up to the small, waterless site, while good farmland and water lay a thousand feet (305 meters) below in the valley.

right: **Banff National Park, Alberta**

Fireweed is one of the first plants to re-colonize land that has been burned or disturbed. By stabilizing the soil and helping to prevent erosion, it serves as a bandage for the scar until a more permanent cover of vegetation can take hold.

previous pages: **Cumberland Basin, Colorado**

True summer arrives late to the high pastures but atones for its tardiness with a lavish gift of flowers.

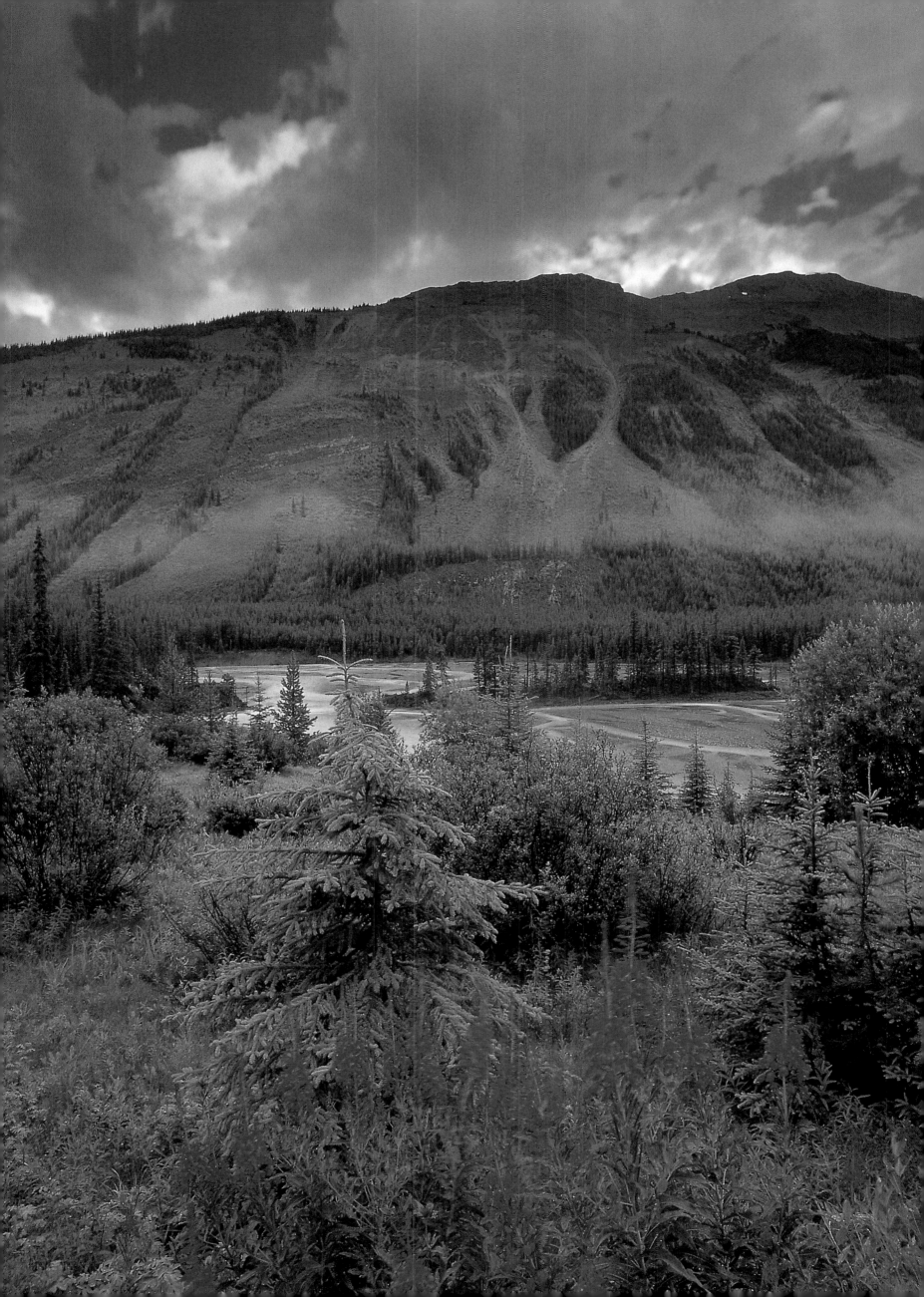

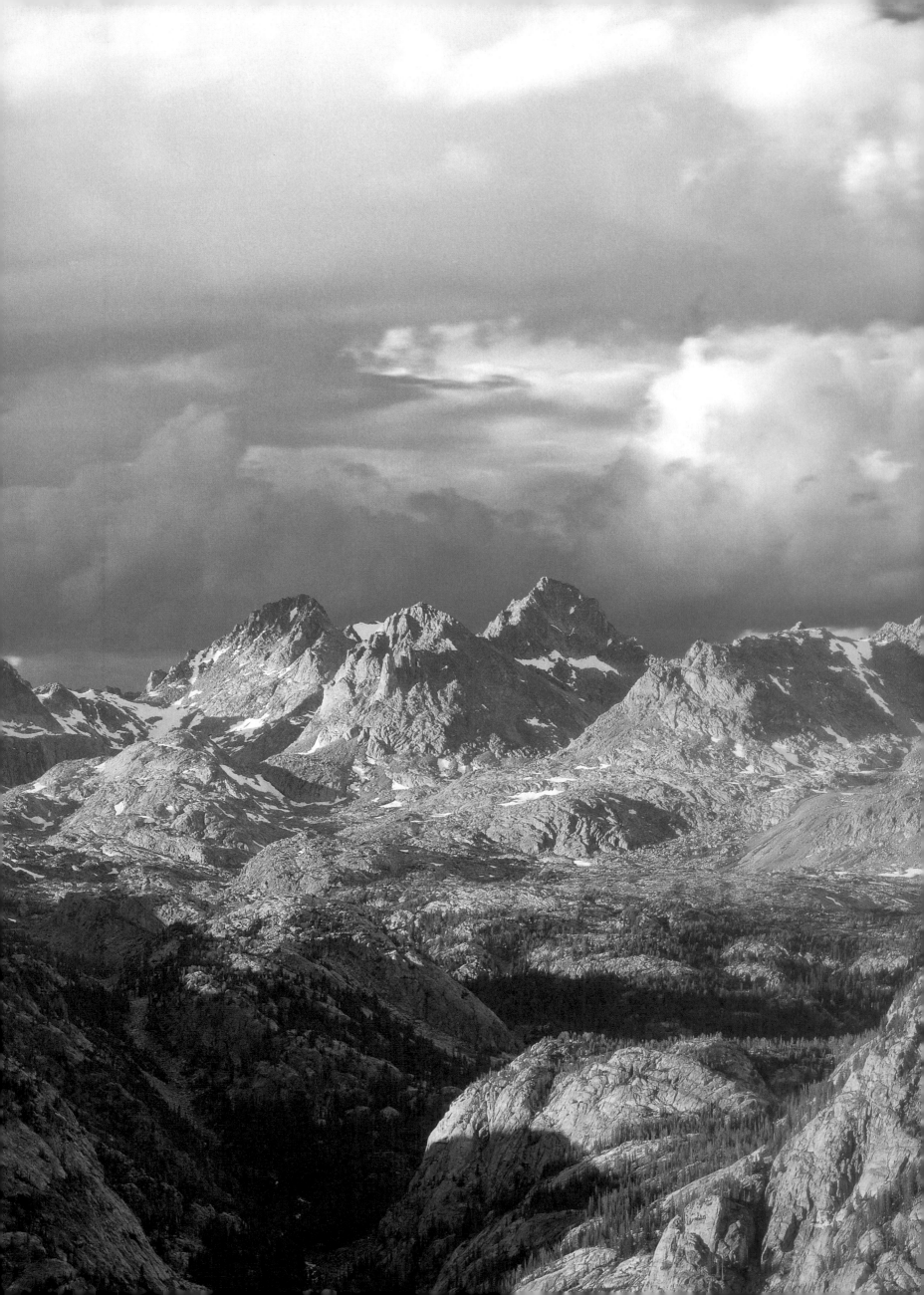

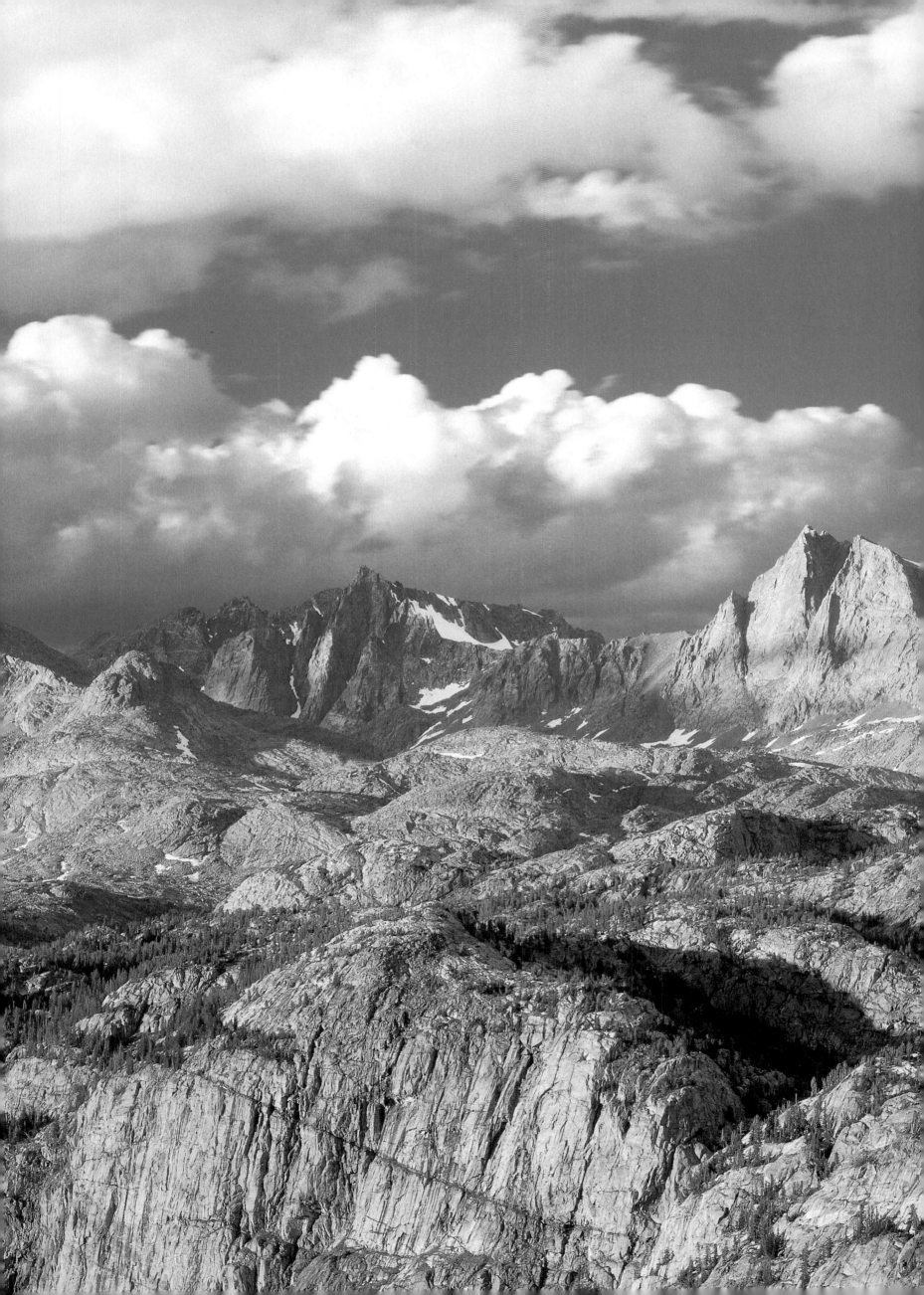

Jasper National Park, Alberta
Observing the landscape today, it is
difficult to imagine that glaciers half
a mile (0.8 kilometer) thick once filled
the broad Athabasca Valley.

previous pages: **Wind River Range,
Wyoming** Wind and water wage a
ceaseless war against the rock bones
of the mountains. The particles they
carry scour exposed surfaces. Water
collects in even the tiniest depressions
and creates ever-enlarging cracks by
expanding when it freezes.

overleaf: **Kananaskis Country, Alberta**
While roads and trails will take you
into some of the Rocky Mountains,
much of their expanse remains
inaccessible. The rugged terrain
guards the last intact parts of a
once much-greater wilderness.

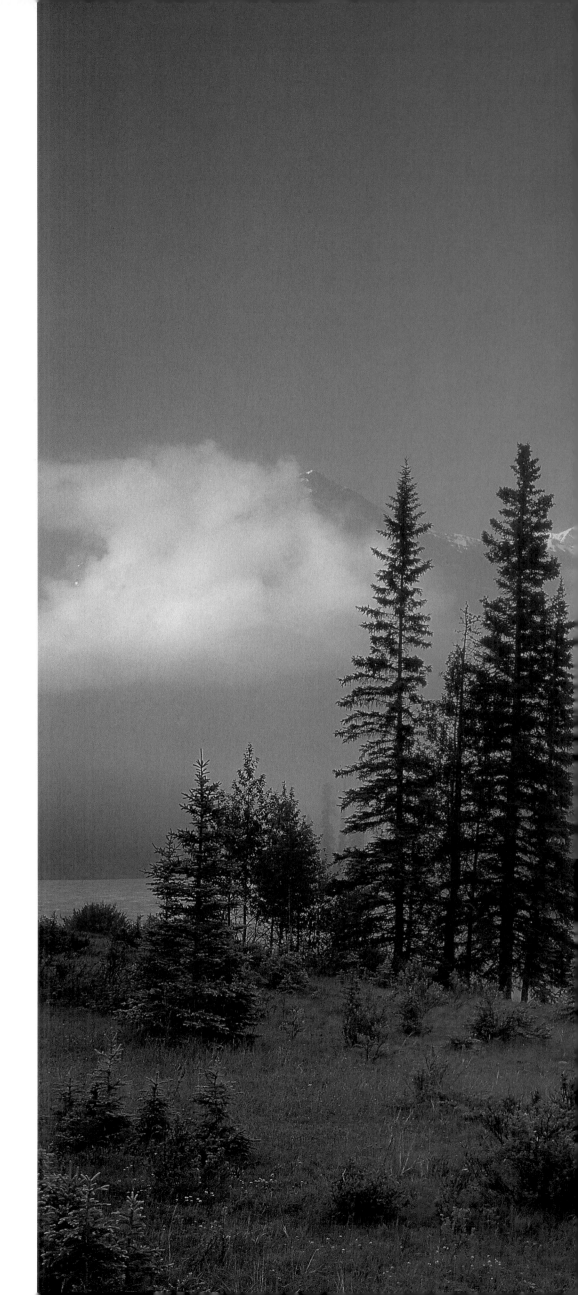

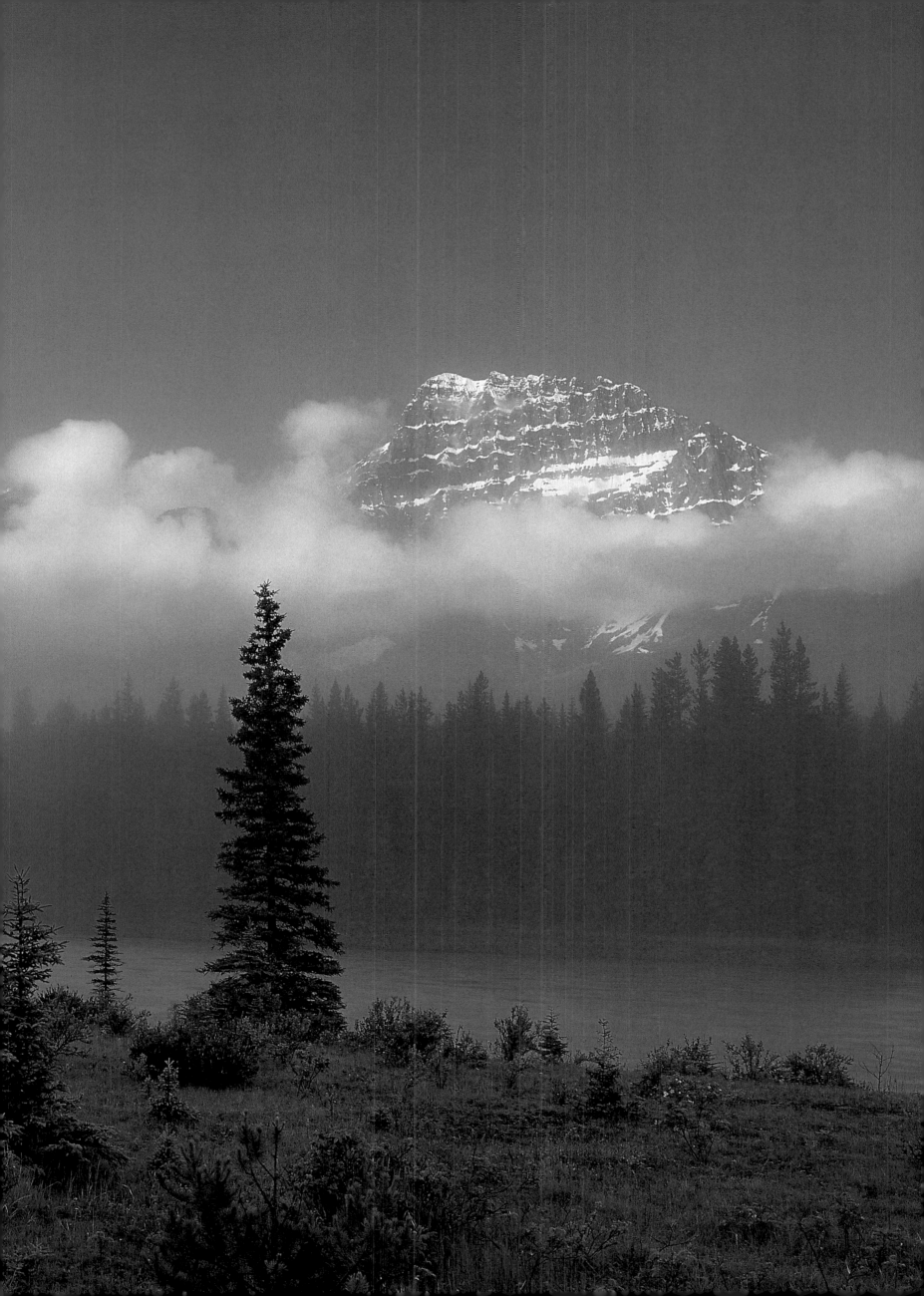

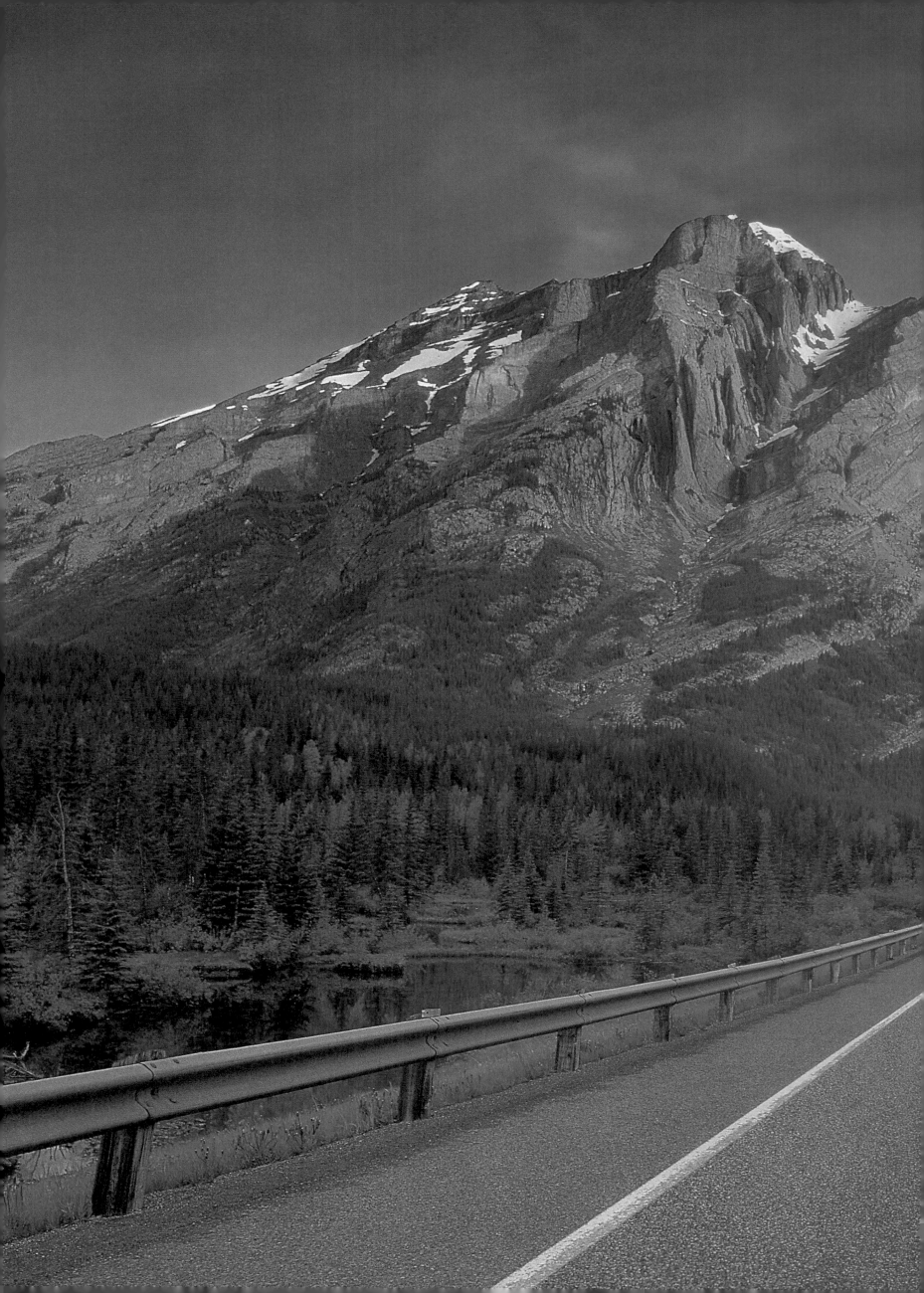

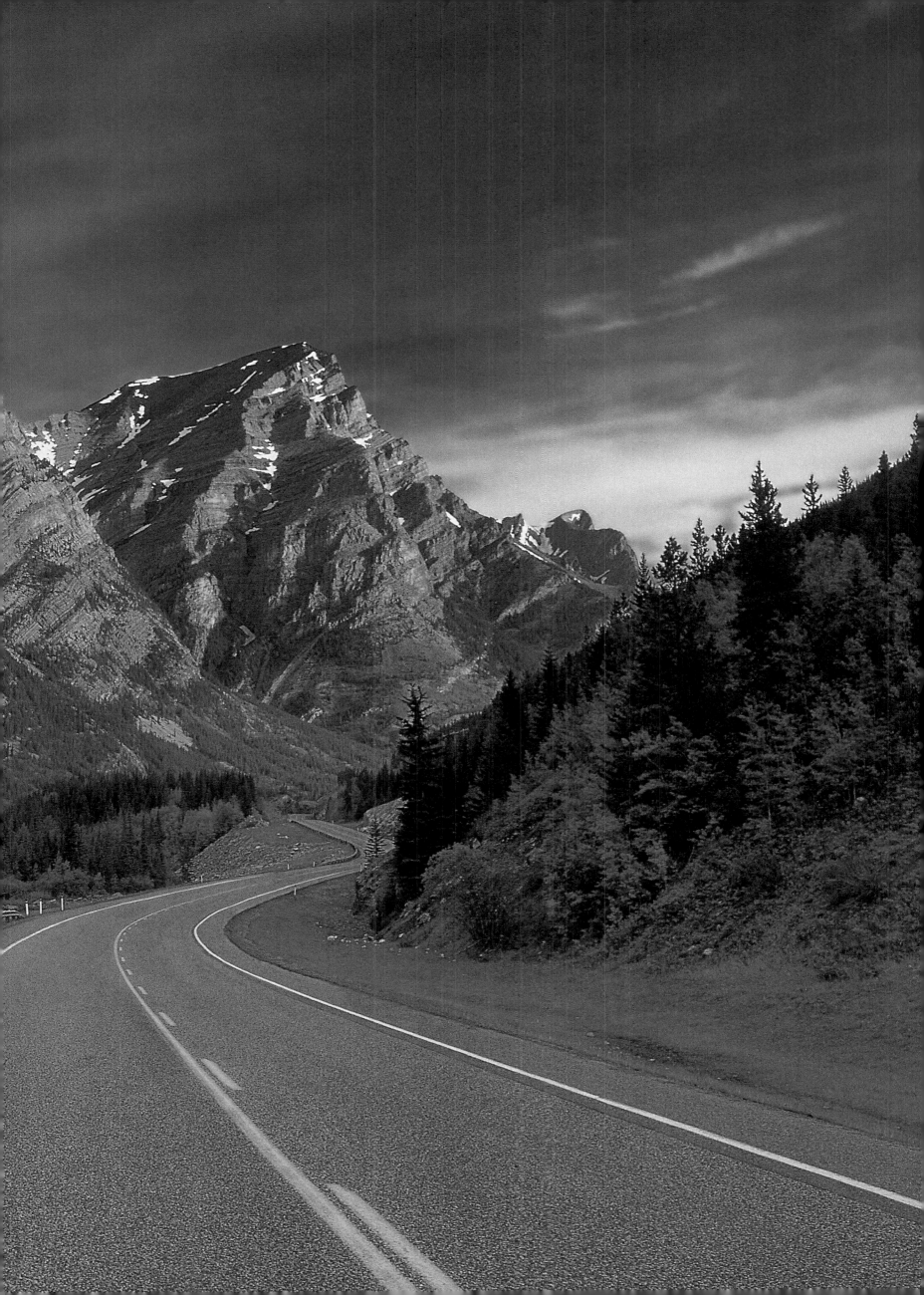

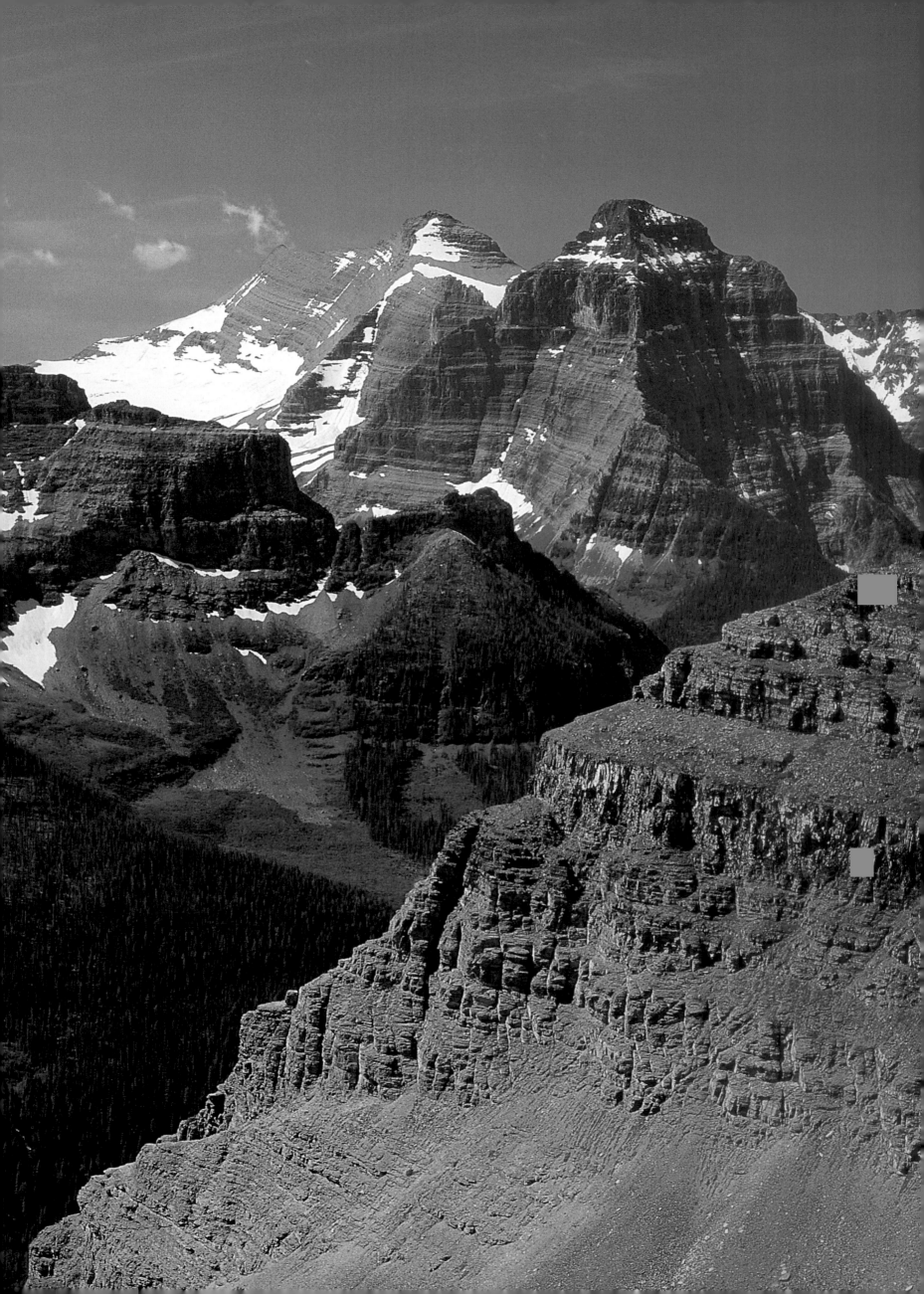

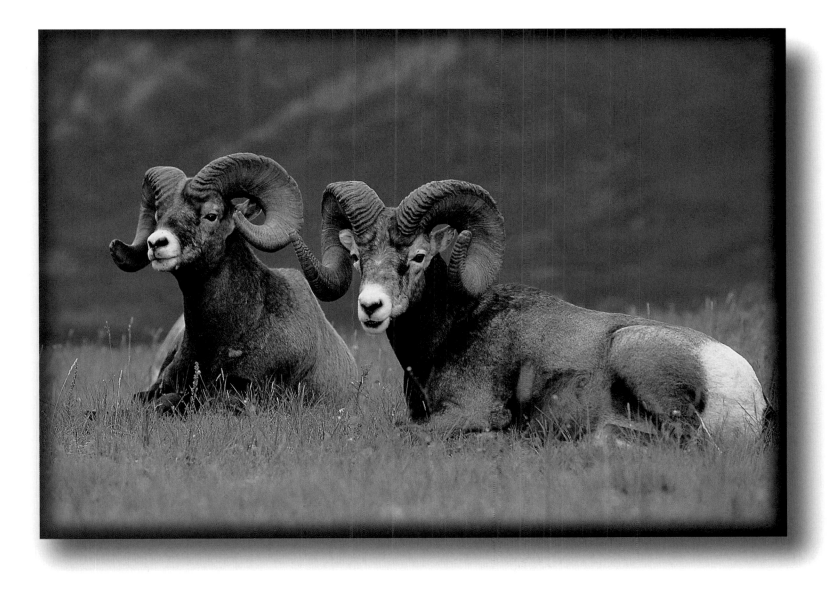

Bighorn Sheep

Having eaten earlier in the morning, two rams rest and chew their cuds.
They will probably graze twice more—around noon and in the evening—
then retire to a favorite sleeping place for the night.

left: **View into Glacier National Park, Montana,**
from Akamina-Kishinena Provincial Park, British Columbia

Boundaries drawn by humans seem especially superficial in the rugged terrain of
the Rockies. A person can stand in one nation and gaze across at a peak that lies in
another park, another country. However, the lines on the map mean that preserving
this wilderness will require the cooperation of a bewildering multitude of private
and public organizations.

overleaf: **Twin Peaks Wilderness, Utah**

Entire meadows of alpine sunflowers turn their faces eastward to receive the rays of
the rising sun. They do not follow the sun but keep this orientation throughout the day,
providing a rough but handy compass for the hiker.

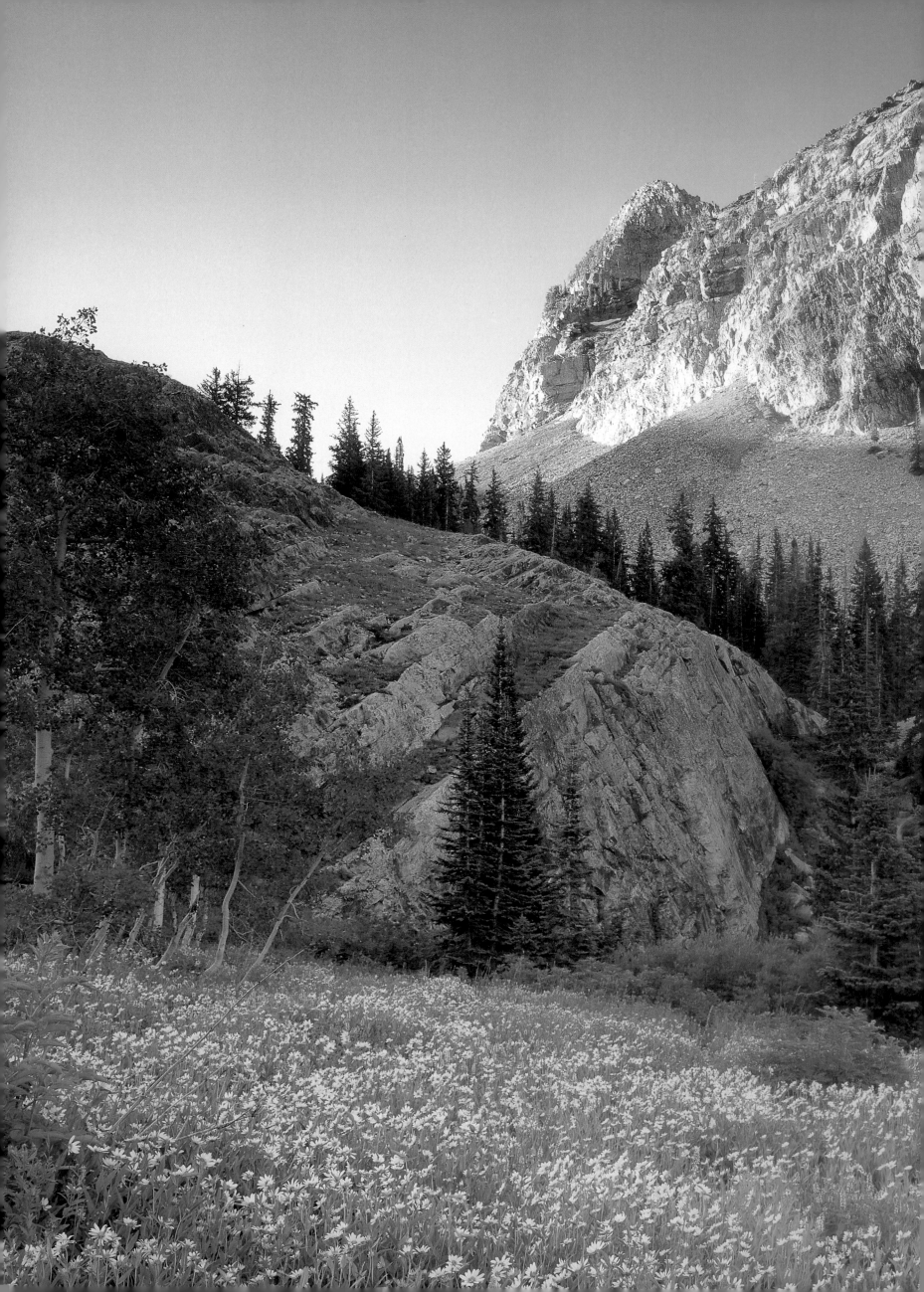

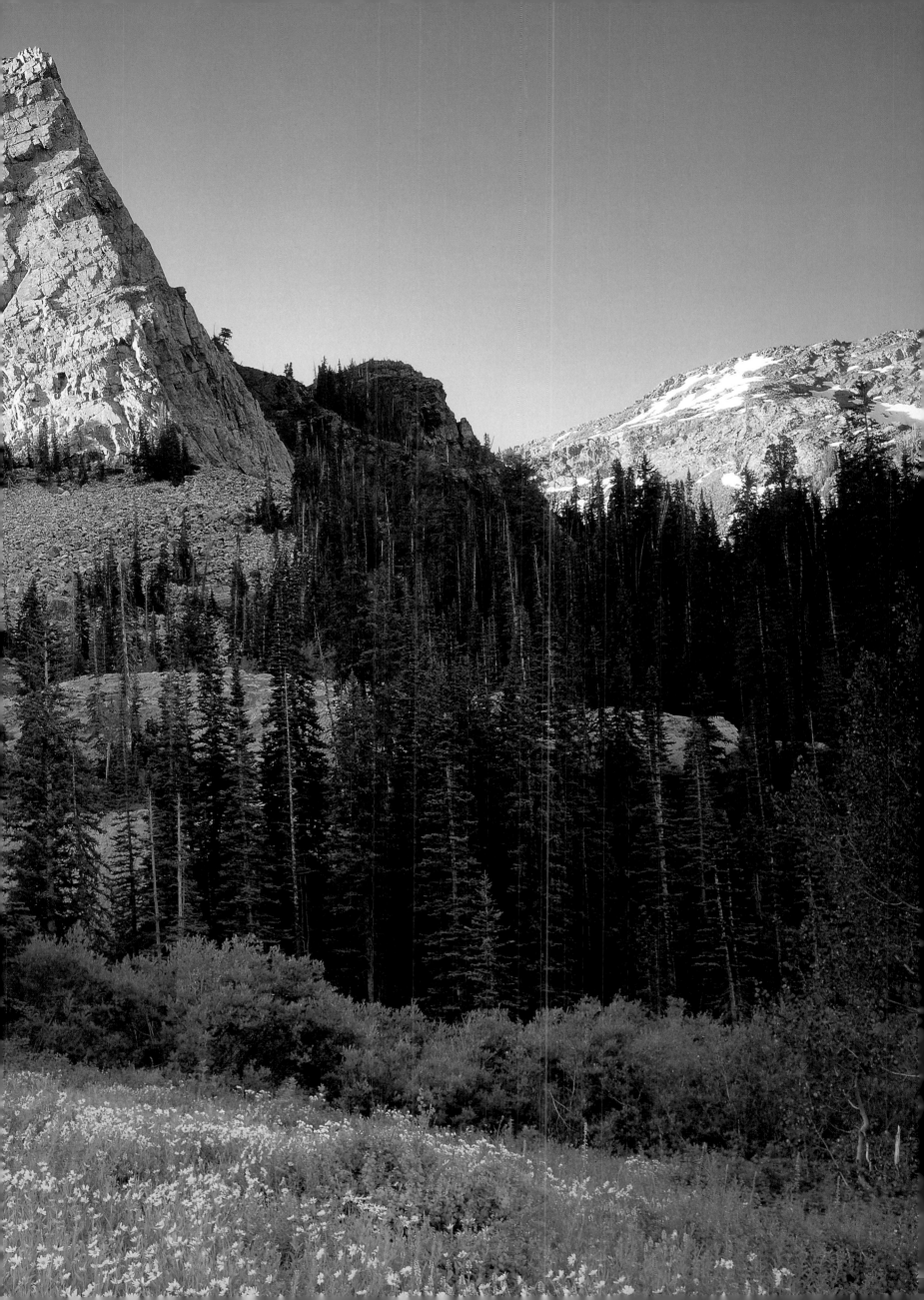

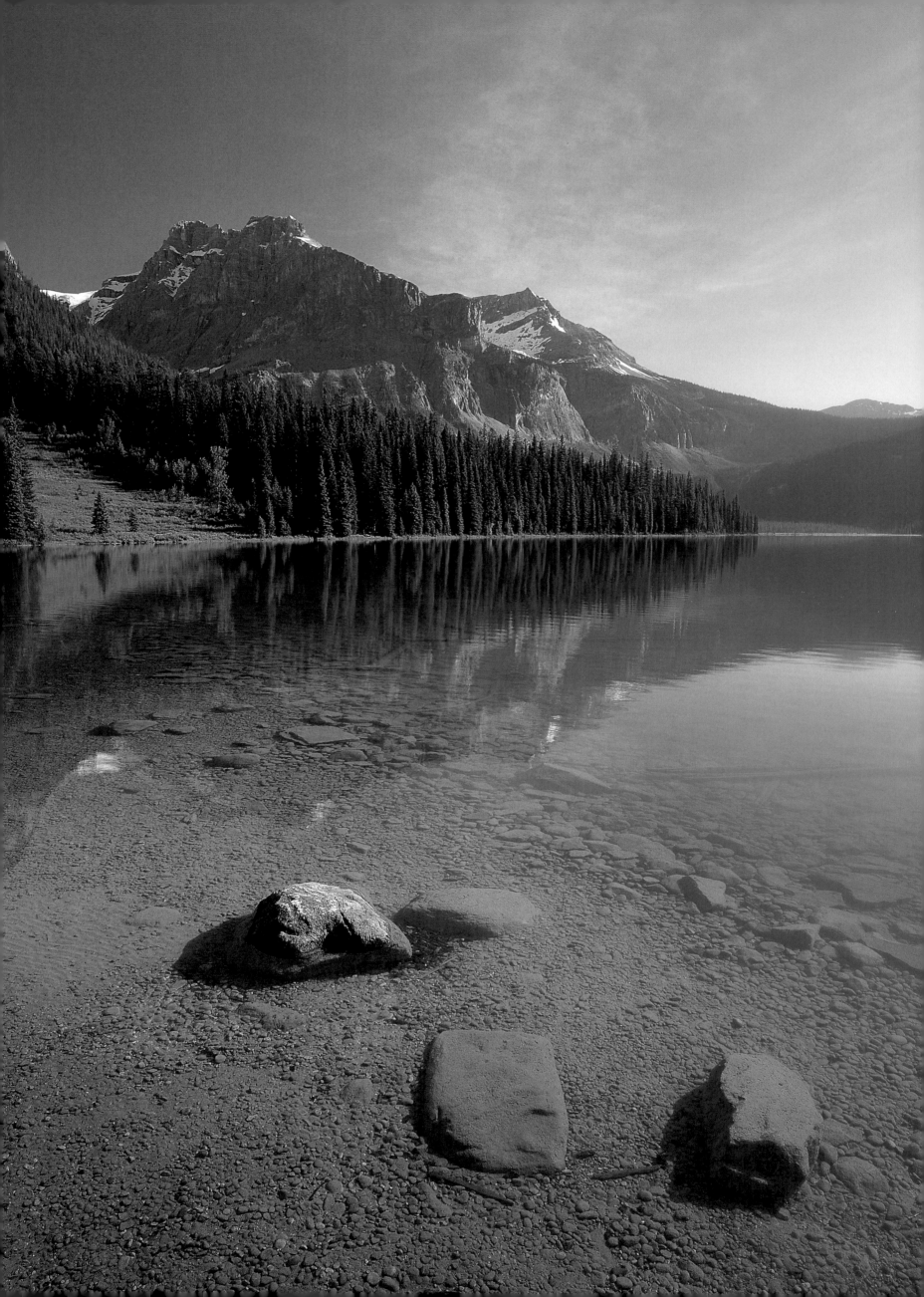

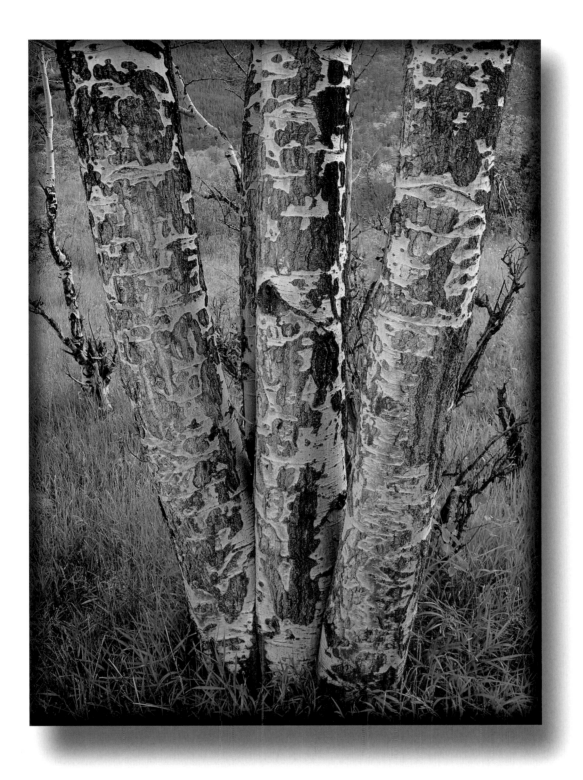

Rocky Mountain National Park, Colorado

The scars on an aspen's trunk reflect factors that have affected its life: summer rains bringing water needed for growth, winter's branch-breaking snows, and the autumn ritual of deer polishing velvet from new antlers.

left: Yoho National Park, British Columbia

The Emerald Fan, a vast alluvial deposit formed of material carried down from the mountains, is slowly filling Emerald Lake. The lake was once twice as large as it is now.

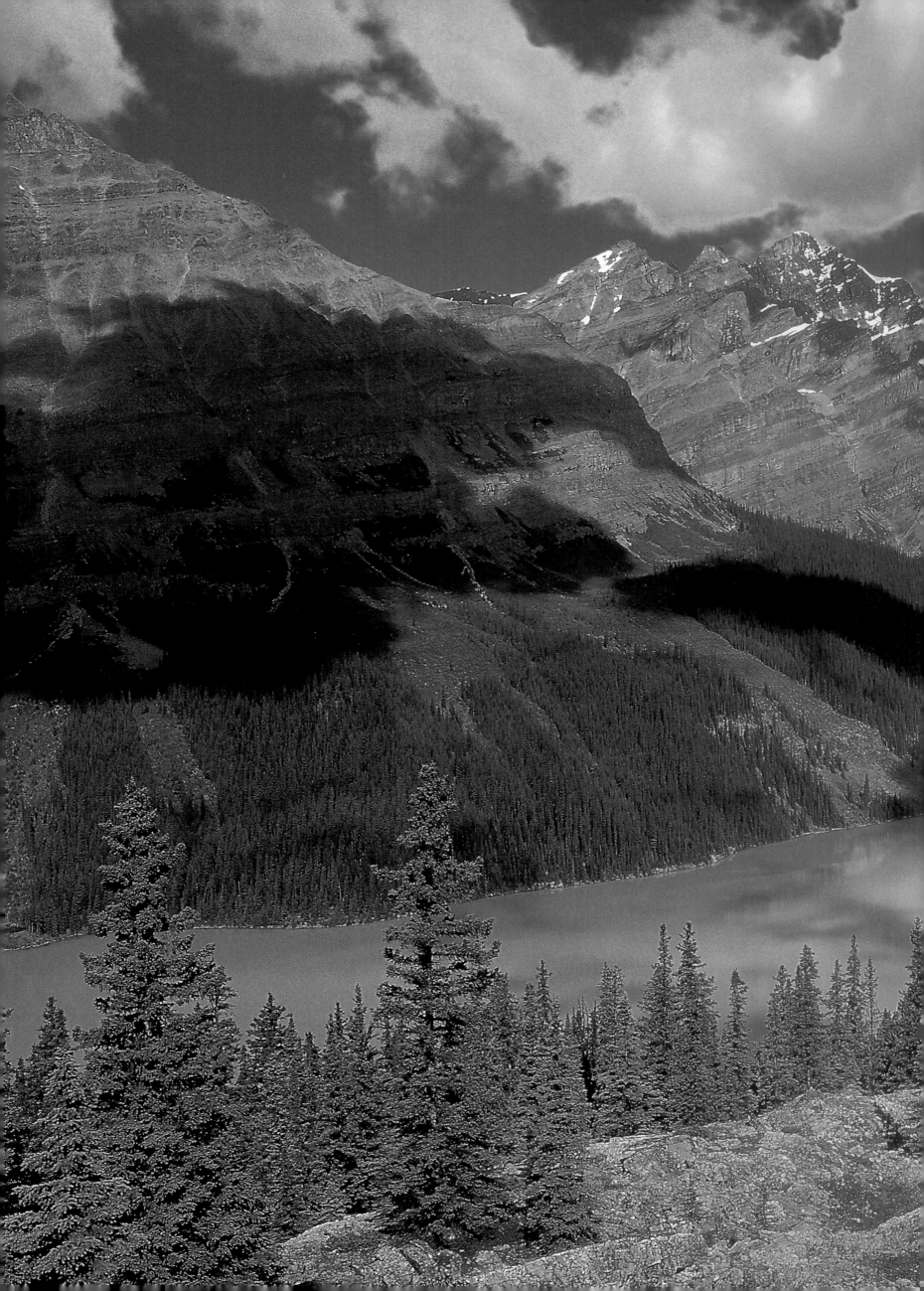

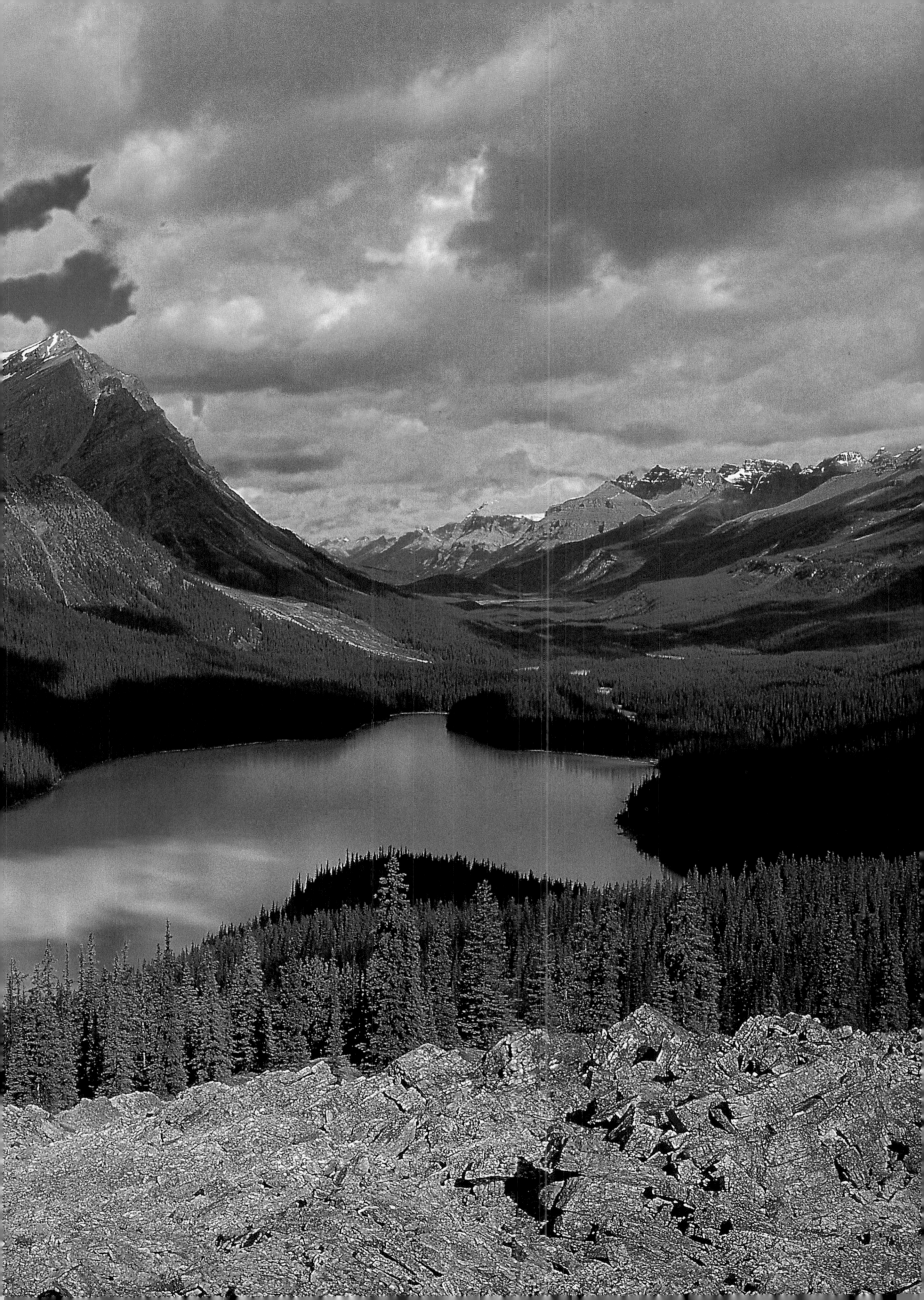

Abajo Mountains, Utah

The brilliant splash of color Indian paintbrush makes on the landscape comes not from its small, rather unremarkable flowers, but from the bracts enfolding them and from the plant's upper leaves.

right: **Willmore Wilderness Park, Alberta**

The wild beauty of this park can be explored only on foot or on horseback. Although it is nearly as large as Jasper National Park, Willmore remains unmarred by roads or human dwellings.

previous pages: **Banff National Park, Alberta**

The amazing color of Peyto Lake and many other mountain lakes is a legacy of the glaciers. Extremely fine particles of glacial sediment suspended in the water reflect the green and blue portions of the light spectrum.

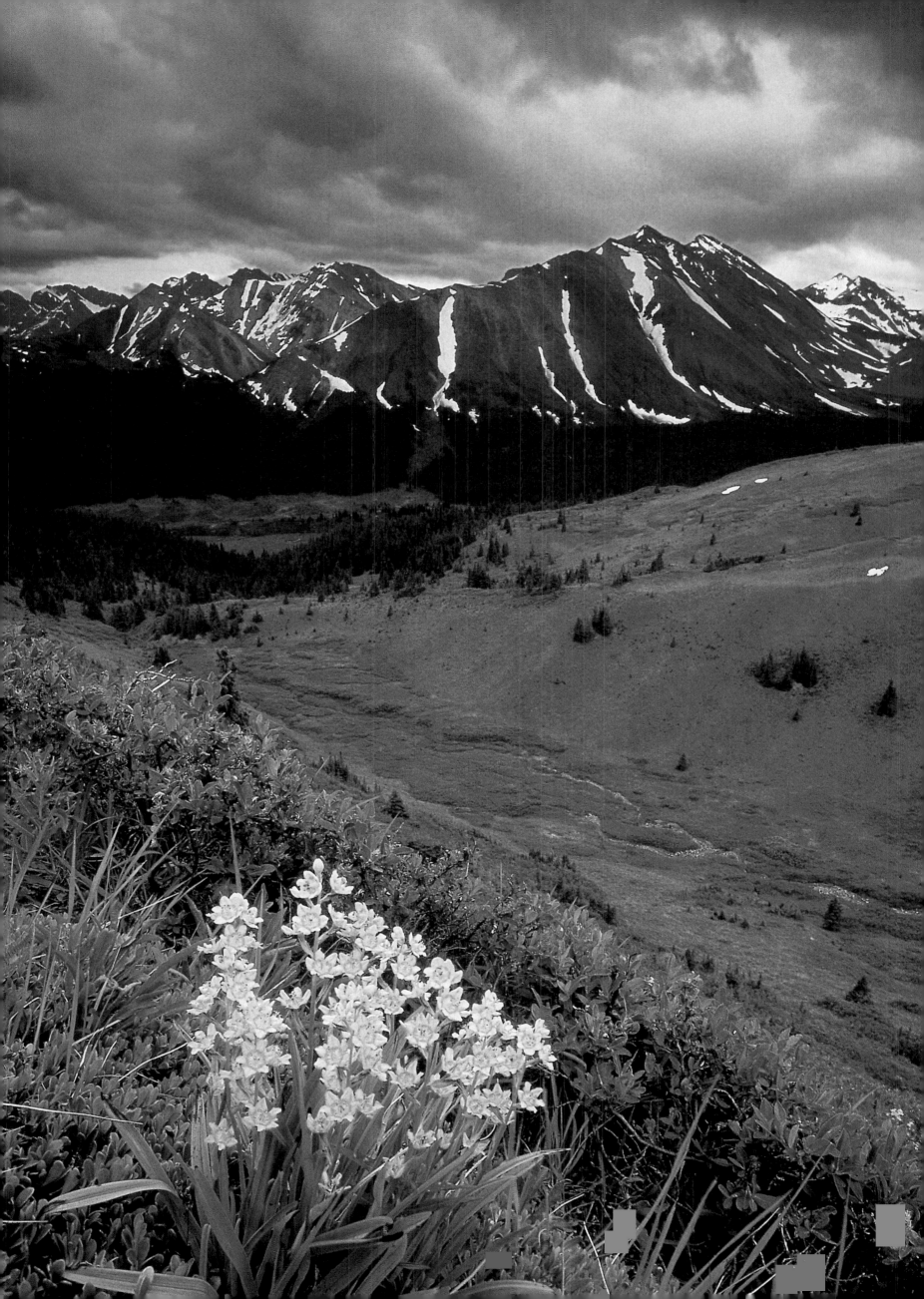

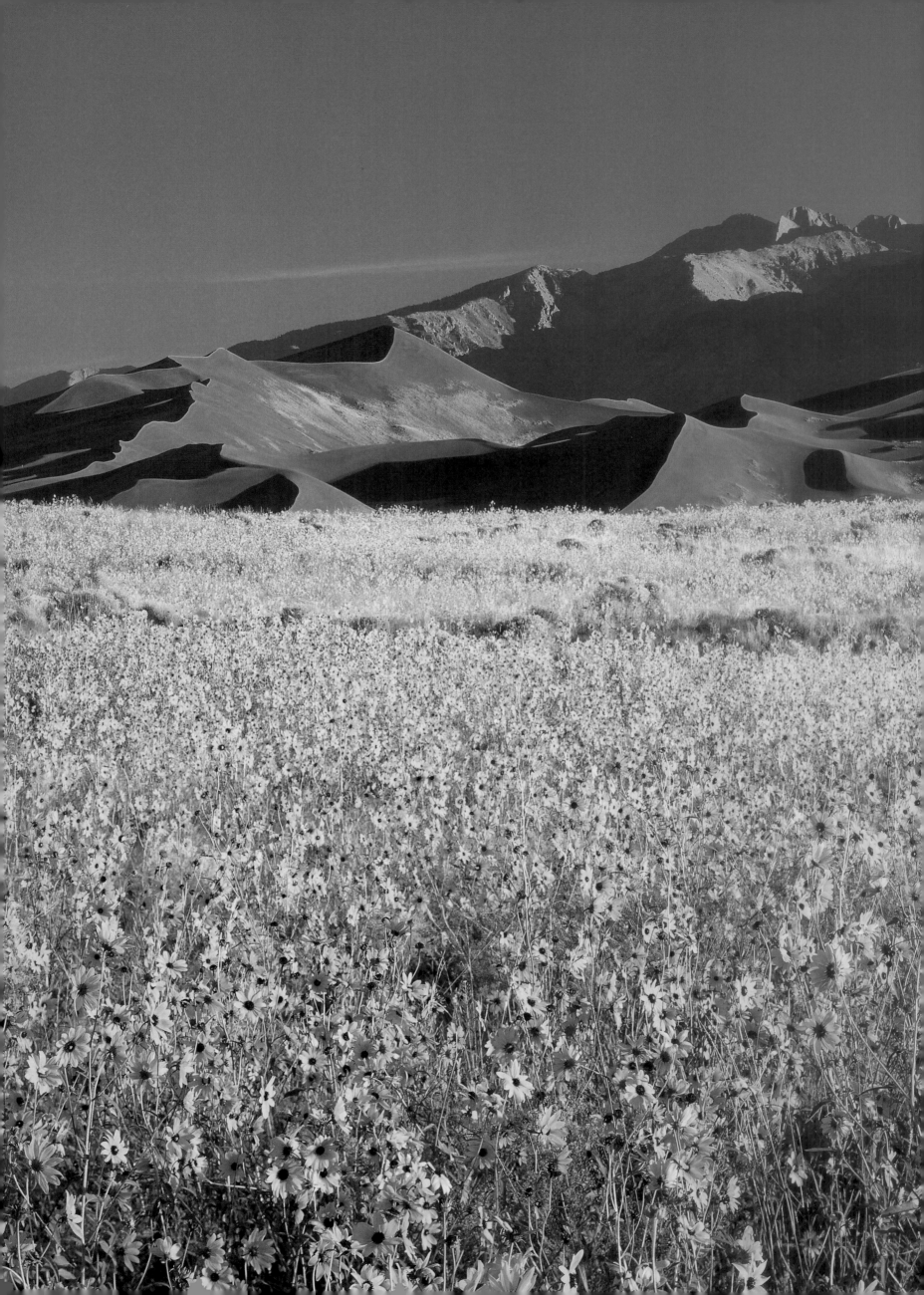

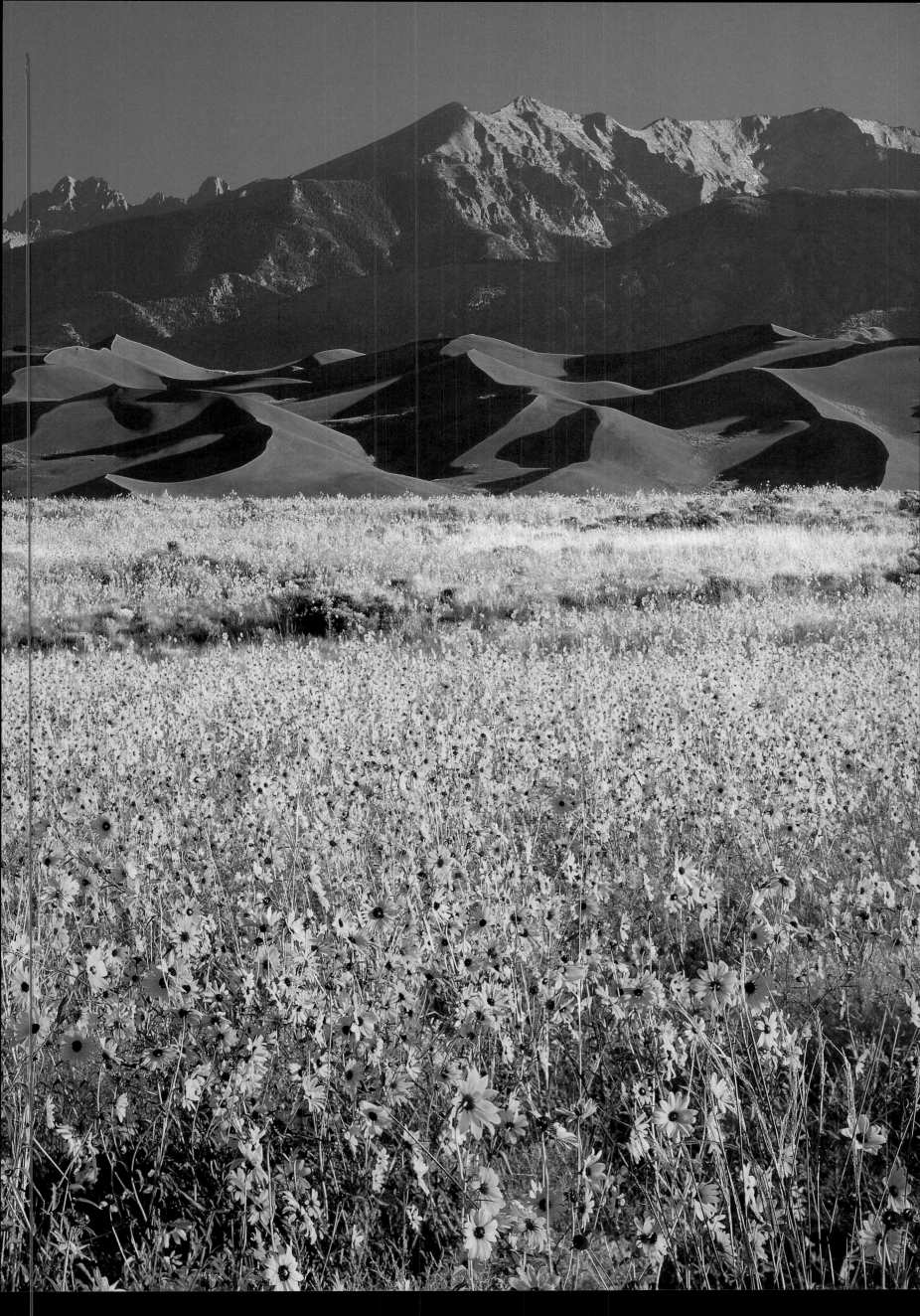

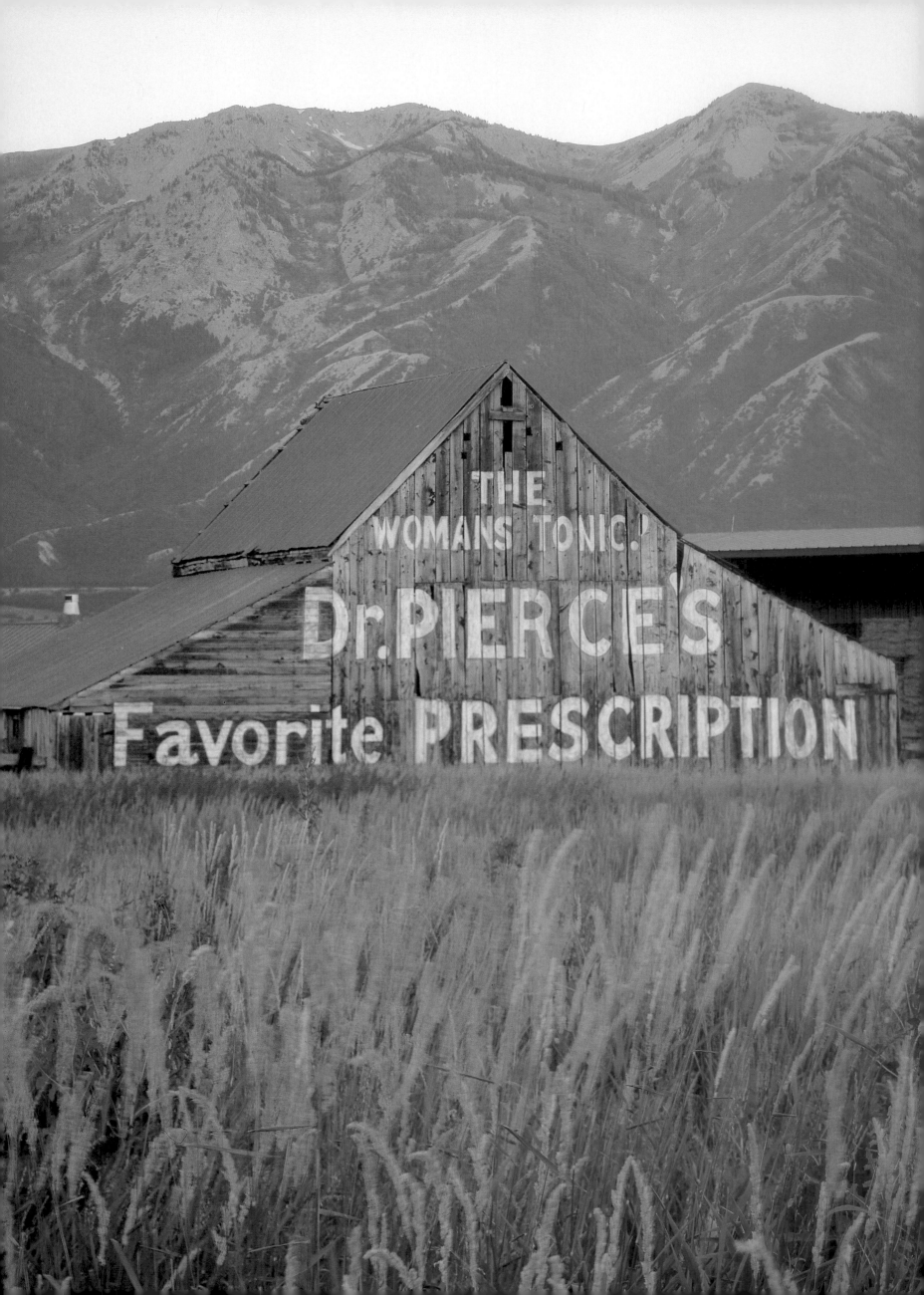

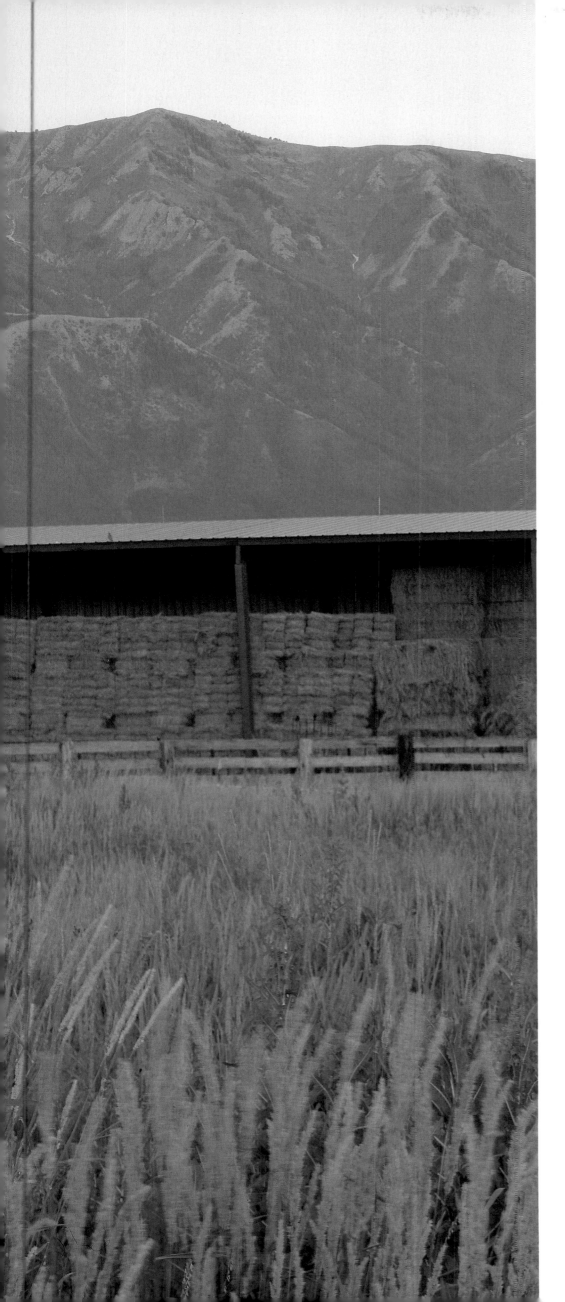

Near Logan, Utah This old barn with its prominent advertising has an appropriate backdrop: the Wellsville Mountains.

previous pages: **Great Sand Dunes National Monument, Colorado** About 35 square miles (91 square kilometers) of dunes, some rising more than 700 feet (213 meters) above the valley floor, lie in strange juxtaposition next to the edge of the Rocky Mountains. The sand from which the dunes are formed was deposited by the Rio Grande River and its tributaries. The appearance of the dunes is ever-changing, dependent on the whims of the wind.

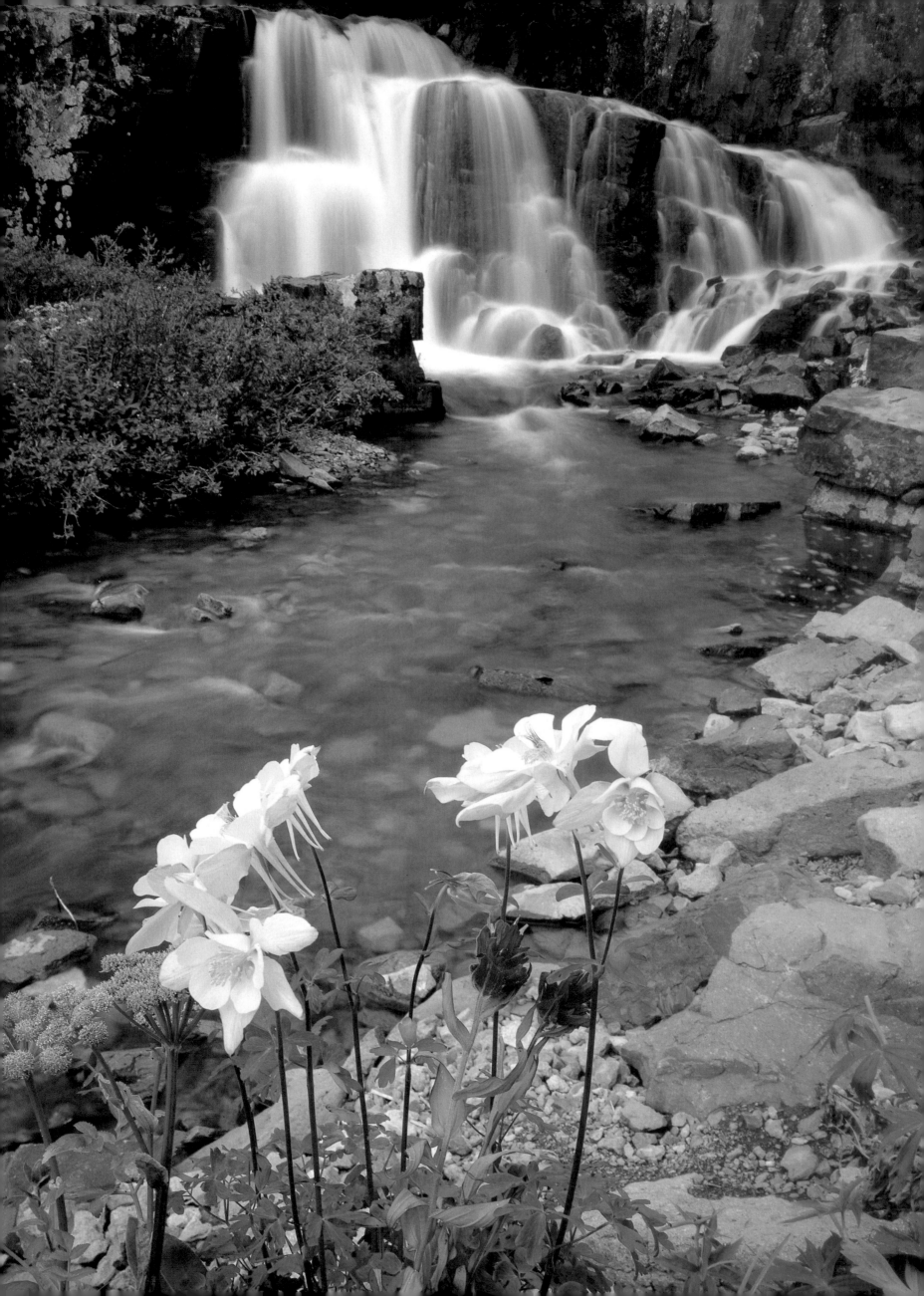

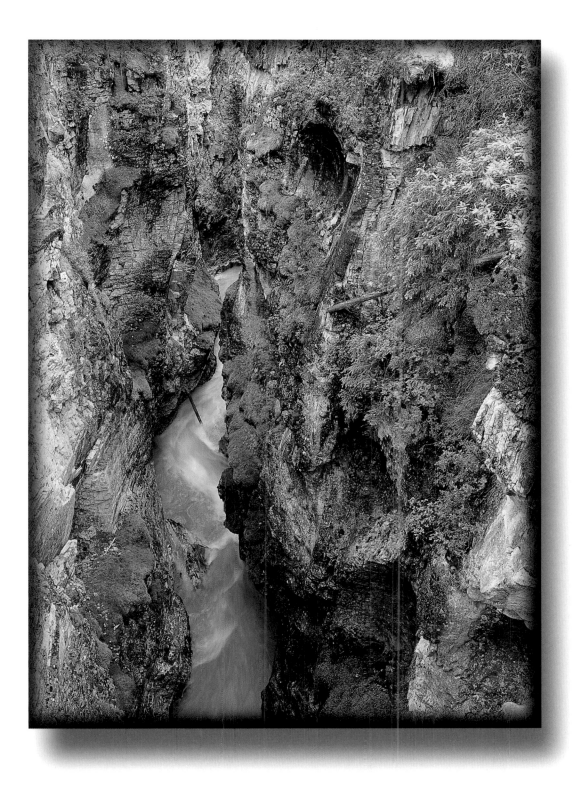

Kootenay National Park, British Columbia

The steep, moss-encrusted walls of Marble Canyon mark the approximate boundary between the area's main eastern and western mountain ranges. Tokumm Creek, which carved the canyon, runs along a fault line that lies between the two sets of mountains.

left: **Uncompahgre National Forest, Colorado**

Early on an August morning, one can sit beside a mountain stream and hear little but the rush of water and perhaps a few bird calls. Here, in Yankee Boy Basin, one might also be able to detect the roar of engines: it is part of a popular travel route for adventurers in four-wheel-drive vehicles.

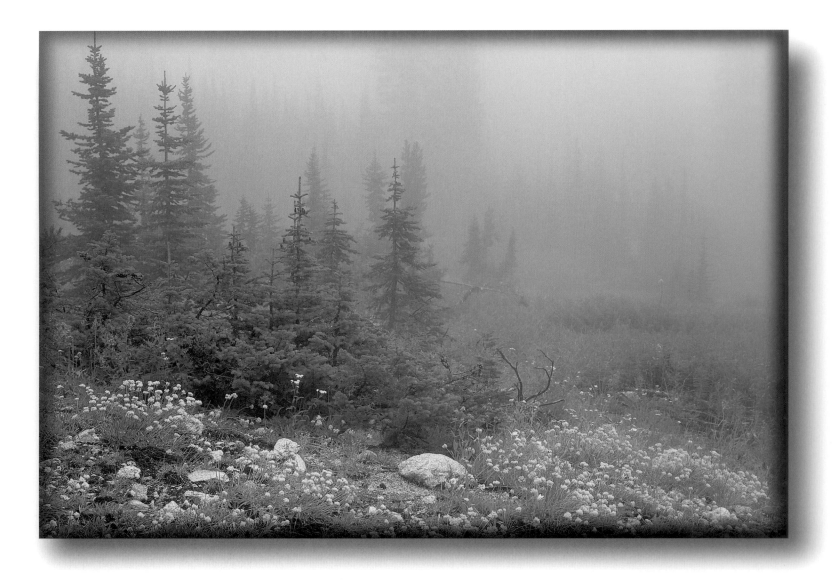

Sawtooth Wilderness, Idaho
Buckwheat and Indian paintbrush glow despite the gray blanket of morning fog.
West of the Continental Divide, some parts of the Rockies experience weather that
is an extension of the damp Pacific Northwest climate.

right: **Yoho National Park, British Columbia**
Depending on where in the mountains you happen to be, the sun may set rather quickly
or it may linger. Here evening's rich colors flow out onto the quiet waters of a reflecting
pool on the Kicking Horse River.

previous pages: **Maroon Bells/Snowmass Wilderness, Colorado**
July in the Rocky Mountains does not always look much like summer. Some high passes
only now become navigable as the snow continues to linger.

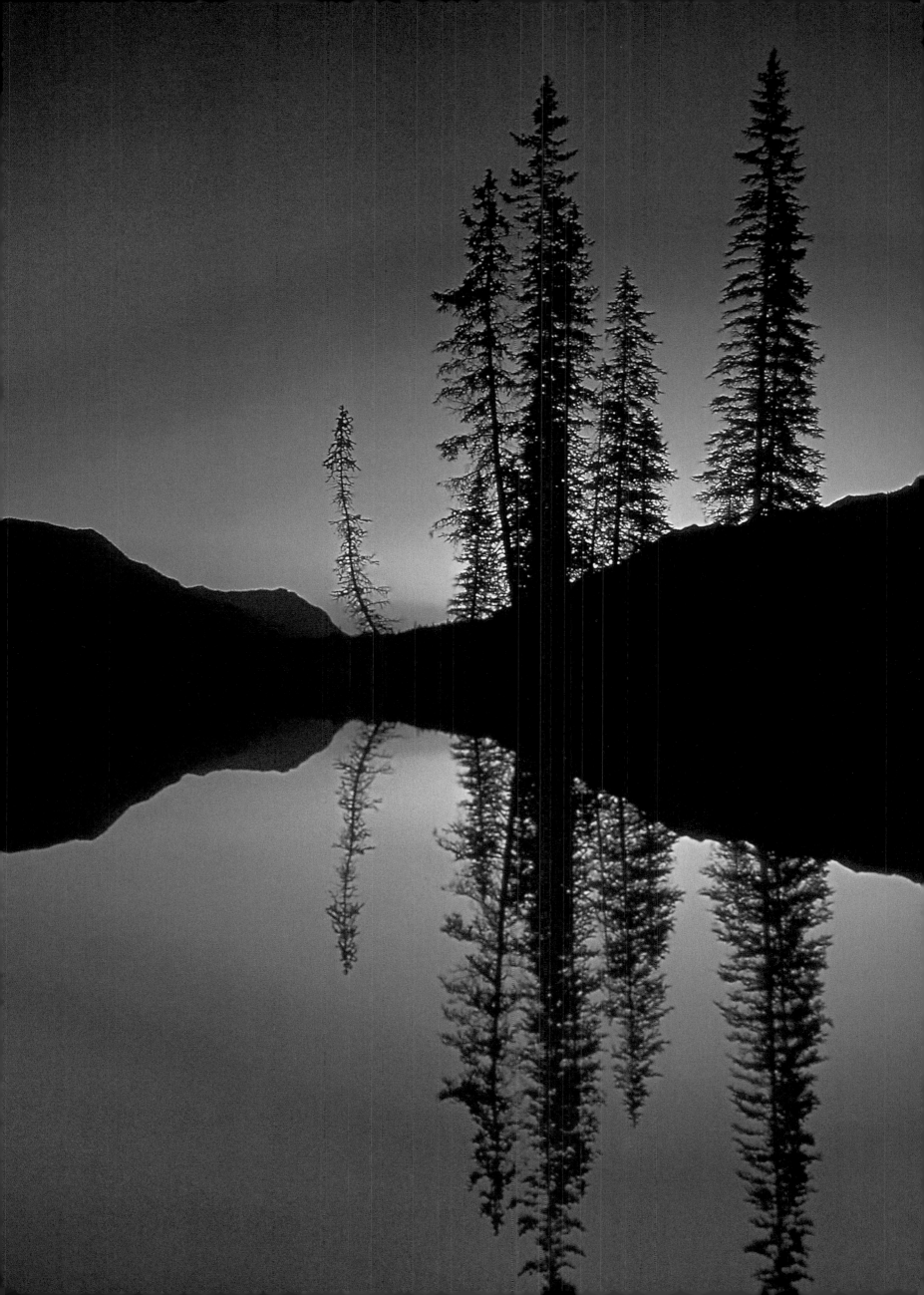

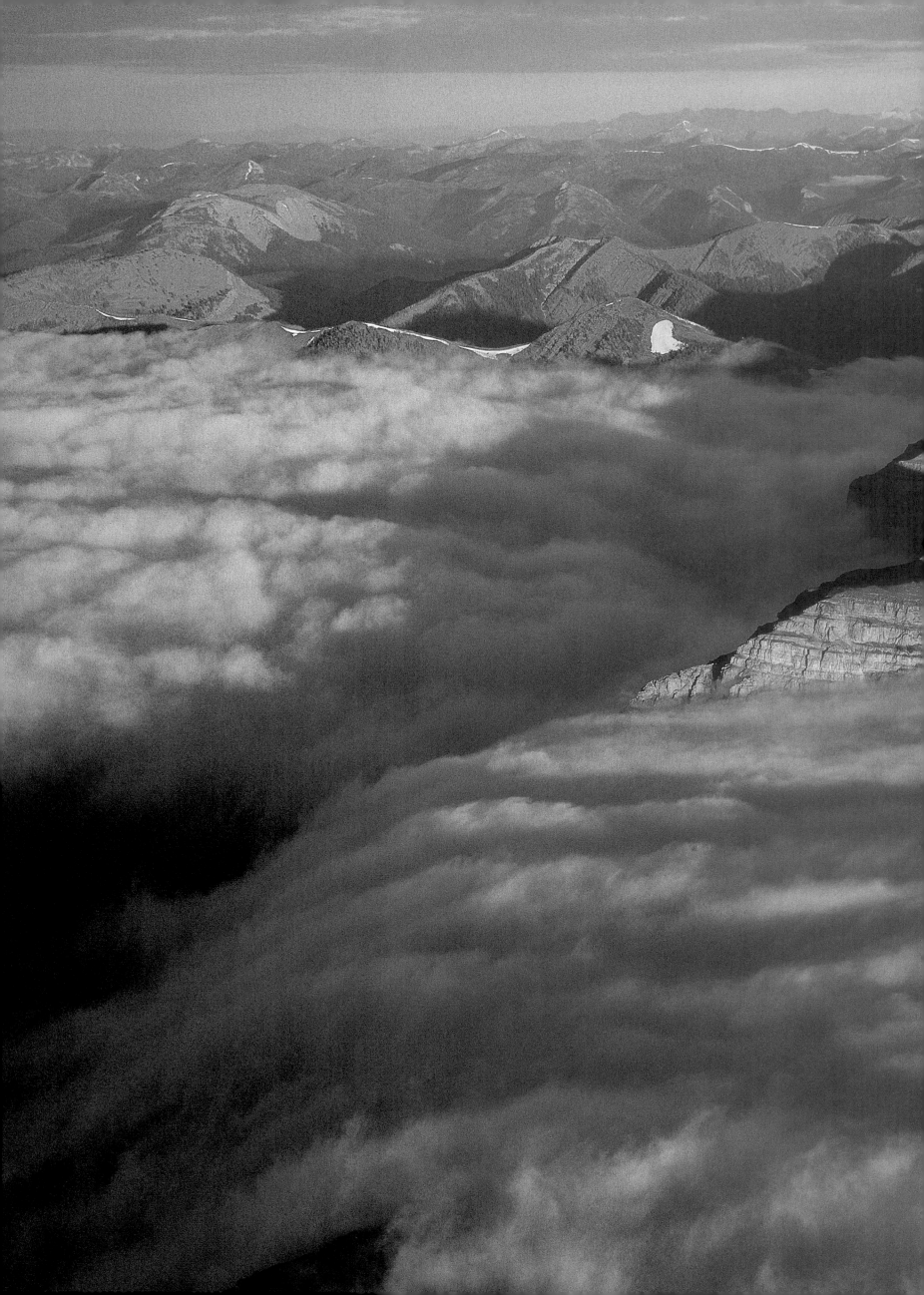

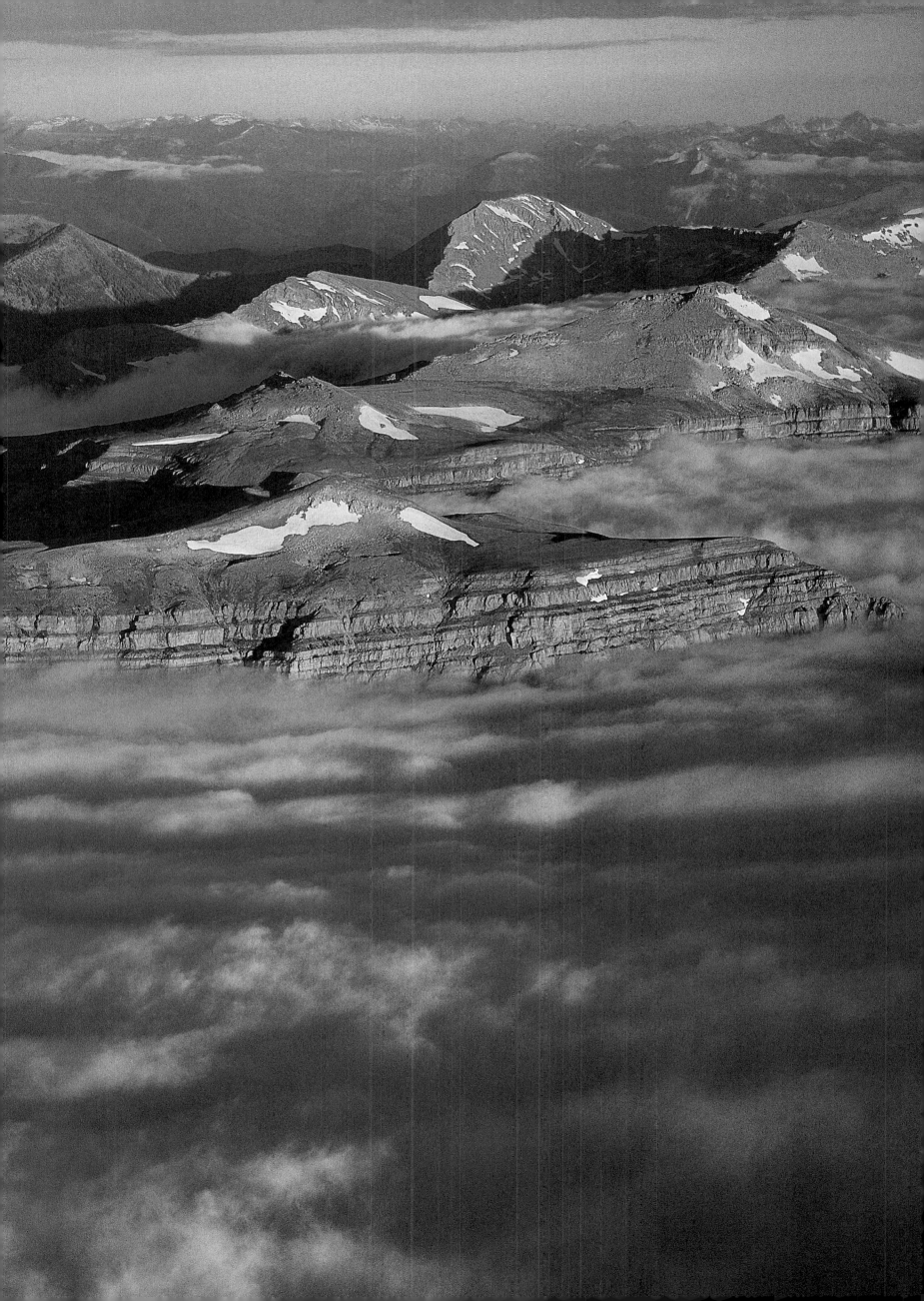

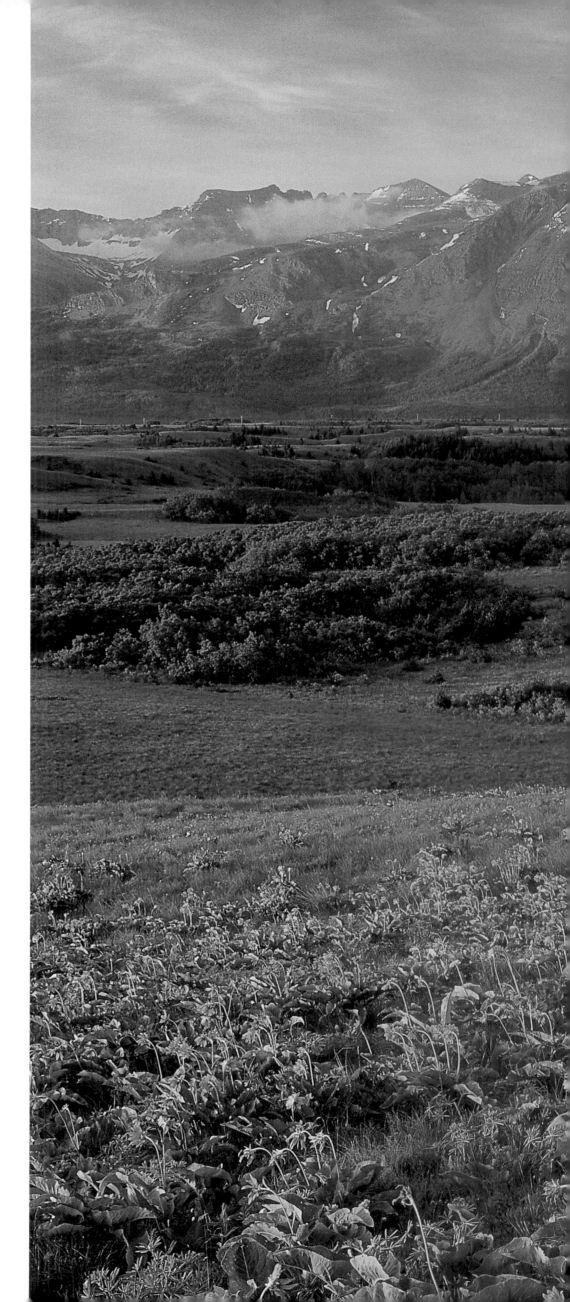

Waterton Lakes National Park, Alberta Vimy Peak stands in the distance behind a meadow of balsamroot. Native peoples ate the roots, seeds and tender shoots of balsamroot, either raw or cooked. The plant is also an important food for grazing animals, including elk, deer and bighorn sheep.

previous pages: **Bob Marshall Wilderness, Montana** Emerging from the mist as though in the process of being formed, these peaks actually began their rise about 70 million years ago.

90

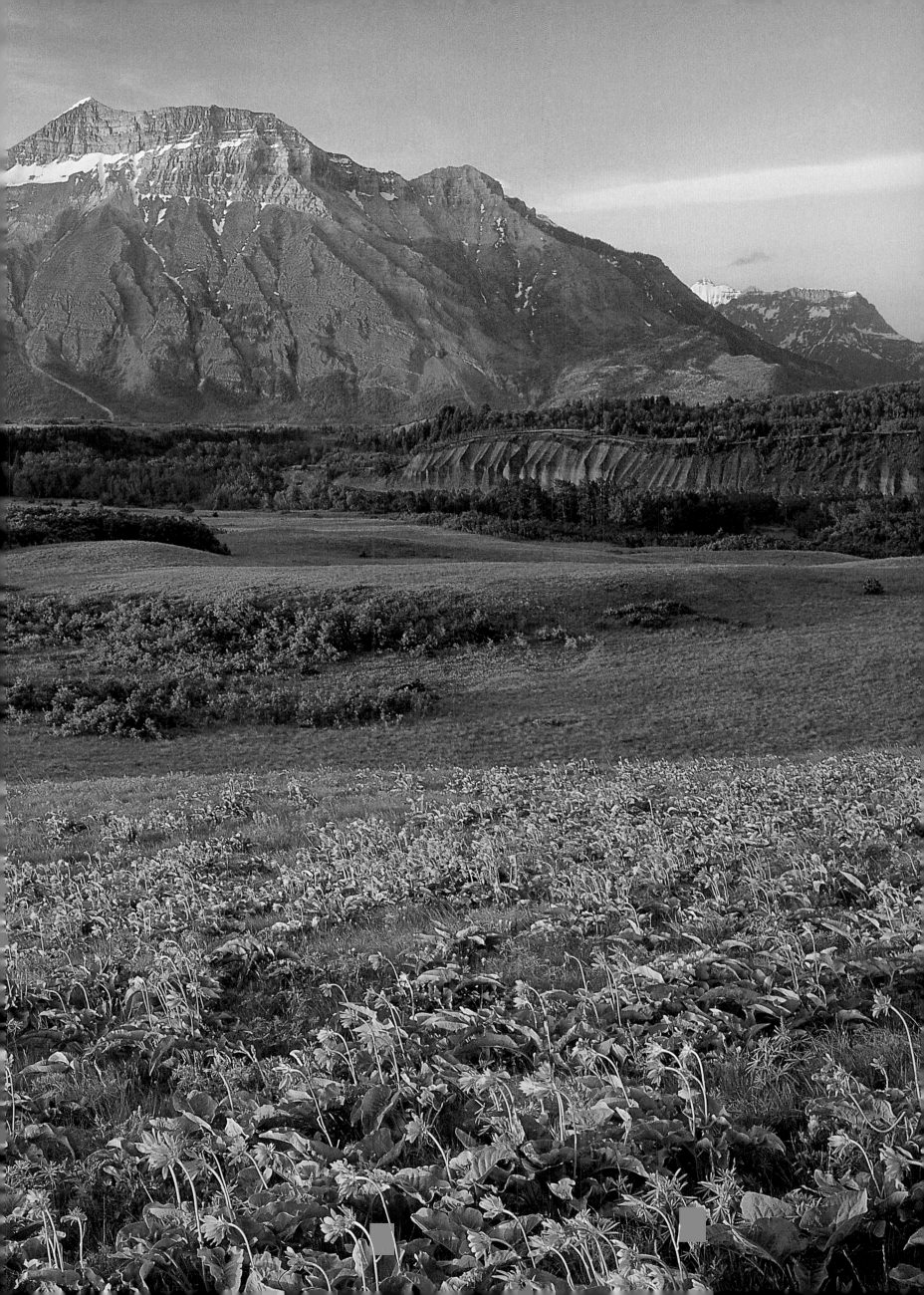

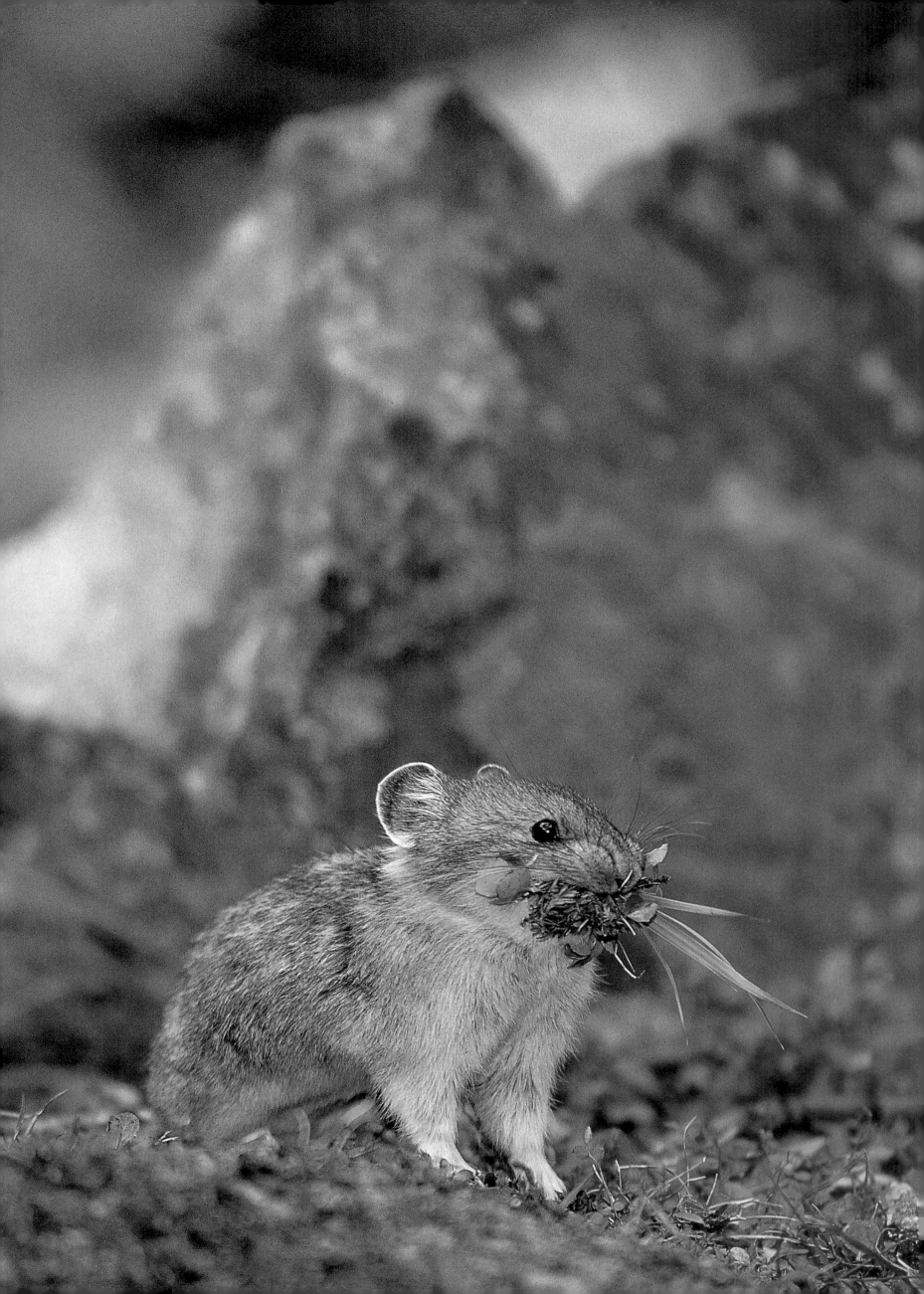

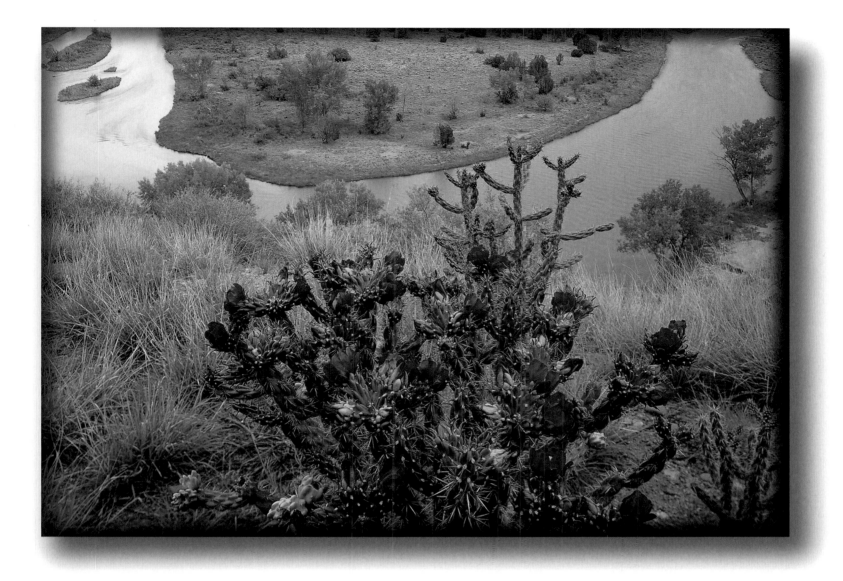

Chama River, New Mexico

The blooms of this cholla cactus would have made a fitting subject for artist
Georgia O'Keefe, who lived at nearby Abiquiu. Cacti and mountains may seem
a strange combination but several species grow in the Rockies, eking out a living
in the driest, rockiest ground.

left: **Pika**

In late summer and autumn, pikas gather vegetation to dry in the sun. Stored
away in the pika's den among the rocks, it will supply the industrious little
animal with enough food to make it through the winter without hibernating
to conserve energy.

overleaf: **Dinosaur National Monument, Colorado**

Steamboat Rock stands at the confluence of the Green and Yampa rivers. About
170 million years ago, this was a lushly vegetated floodplain where dinosaurs roamed.
Since 1909 the bones of more than twenty complete dinosaur skeletons, including
Apatosaurus, *Diplodocus*, and *Stegosaurus*, have been quarried from rocks nearby.

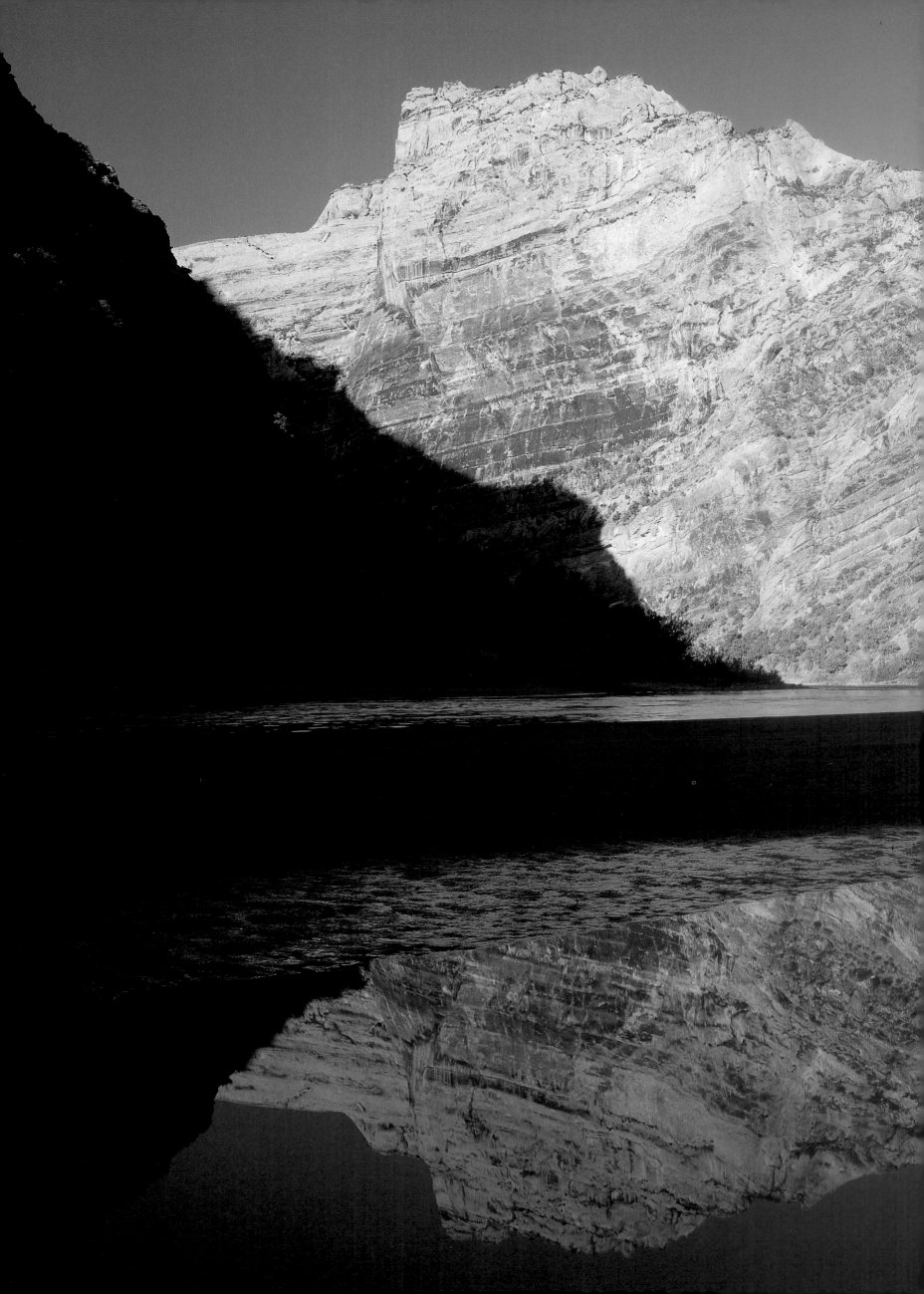

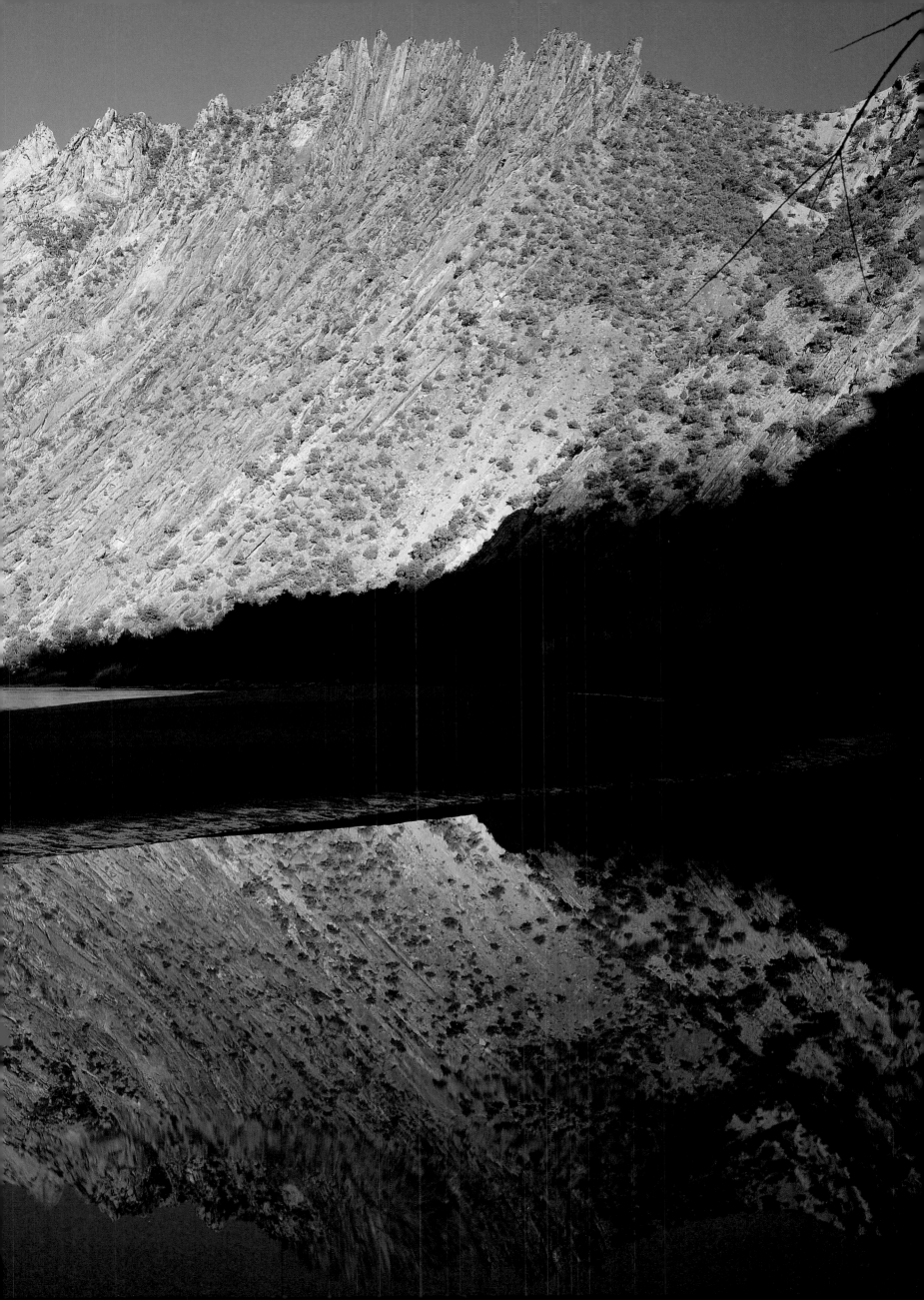

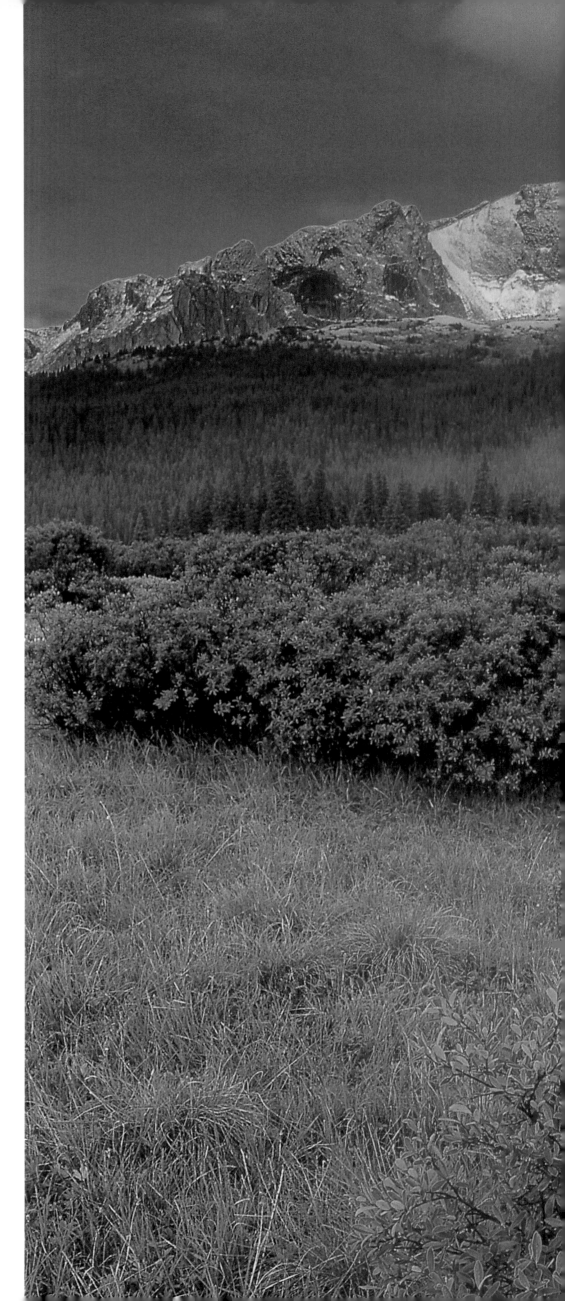

Willmore Wilderness Park, Alberta
Grass-carpeted valleys provide food for a variety of animals, large and small. Predators aware of this seek their sustenance here as well.

overleaf: **Yellowstone National Park, Wyoming** Hot springs below its surface and heated runoff from thermal features on its banks warm the waters of the Firehole River. When mountain man Jim Bridger told of a river running so fast it got hot on the bottom, he may have been basing his tall tale on the Firehole.

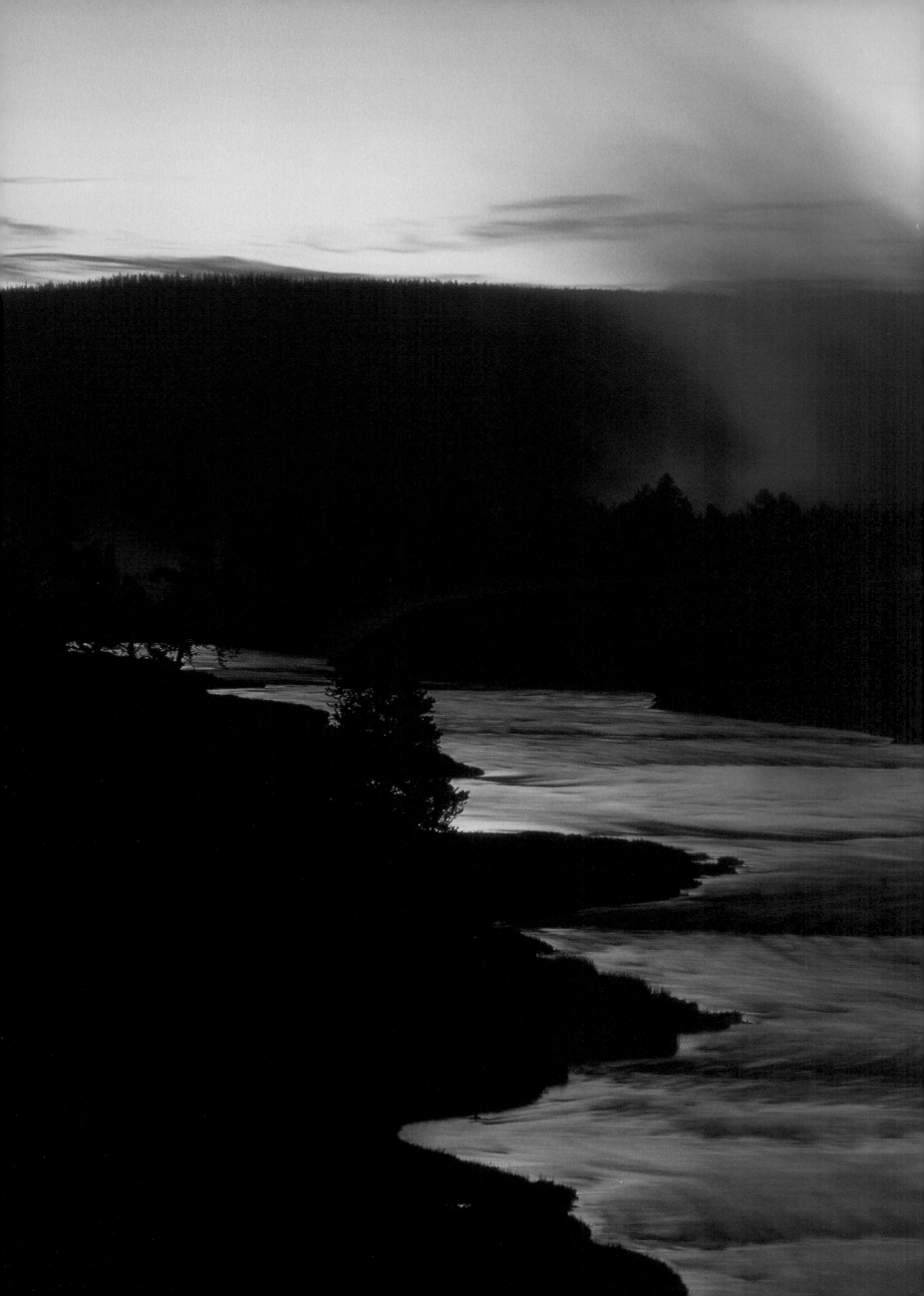

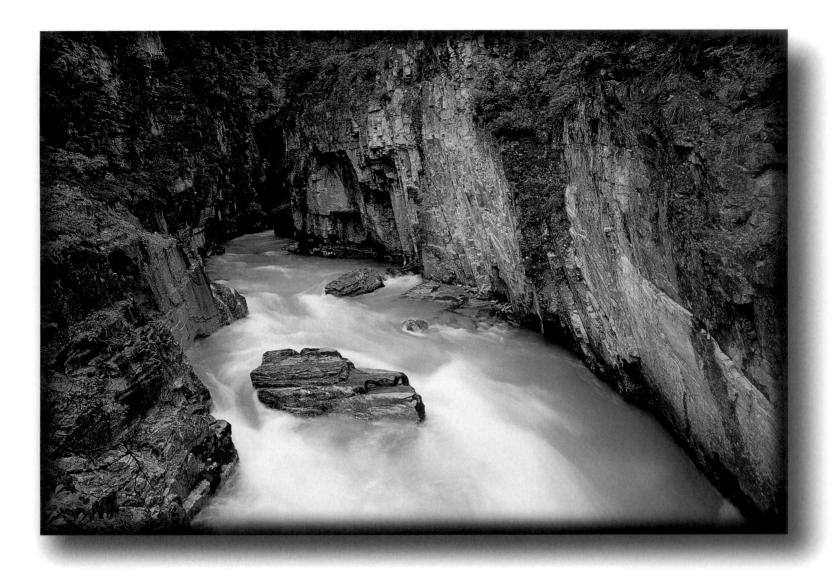

Kootenay National Park, British Columbia
Dependent on runoff from higher elevations, mountain streams wax and wane.
By late summer, many rushing torrents such as this will be reduced to mere trickles.
Some will disappear altogether.

right: **Mount Sneffels Wilderness, Colorado**
The luxuriant midsummer displays of wildflowers in this part of the Rockies have
been described as some of the most spectacular on Earth.

overleaf: **Glacier National Park, Montana**
When dawn comes to the mountains, the sun's rays may drape the peaks
in alpenglow—a warm, magical light unlike any other.

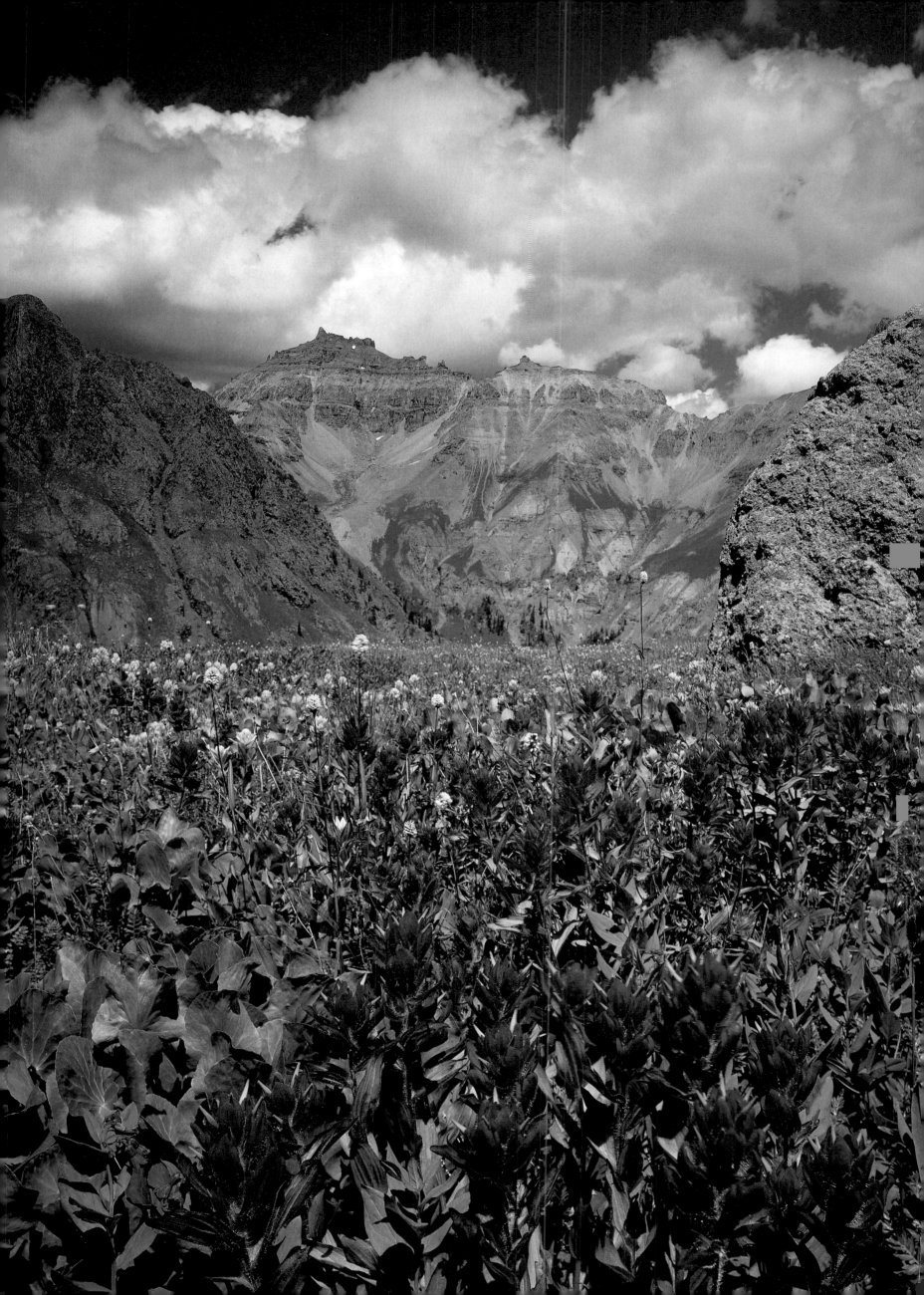

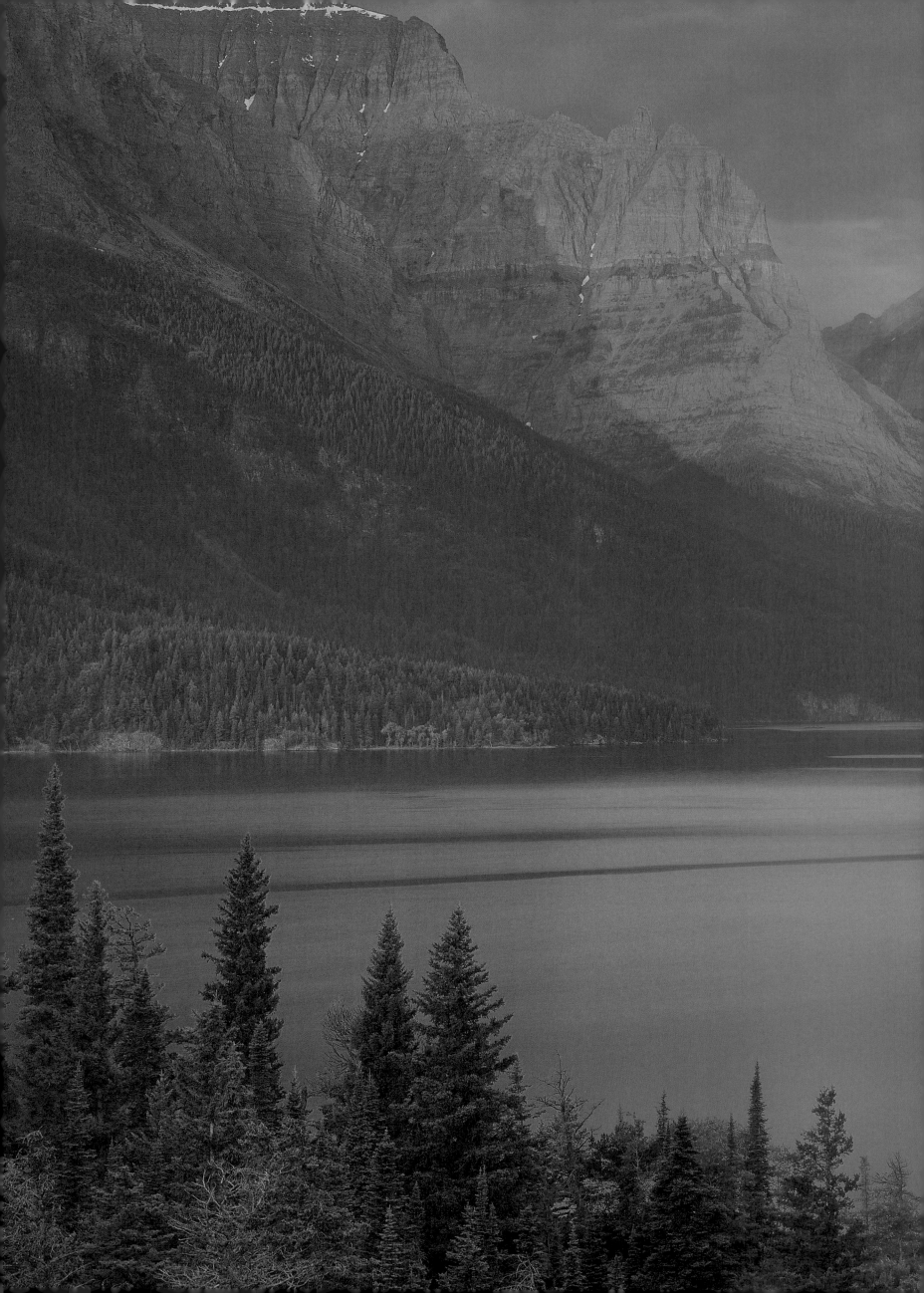

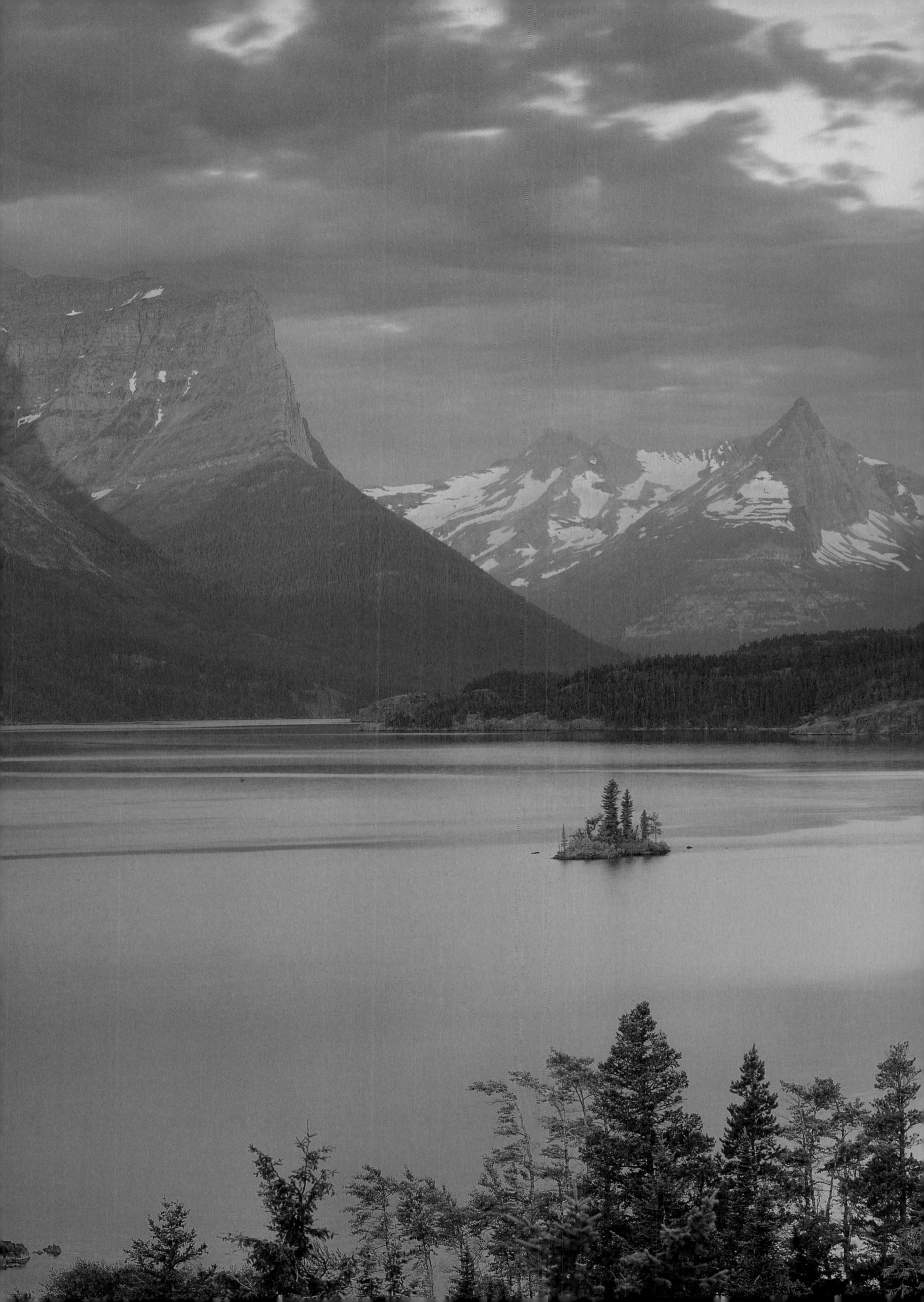

Waterton Lakes National Park, Alberta When conditions are right, alpine vegetation can magically transform what, only a few months ago, appeared to be a barren valley into a lush emerald oasis.

overleaf: **Ghost Ranch, New Mexico** The towering spire of Chimney Rock keeps watch over a land filled with weird and wonderful treasures. In the 1940s, paleontologists working not far away uncovered hundreds of skeletons of an early carnivorous dinosaur, *Coelophysis*.

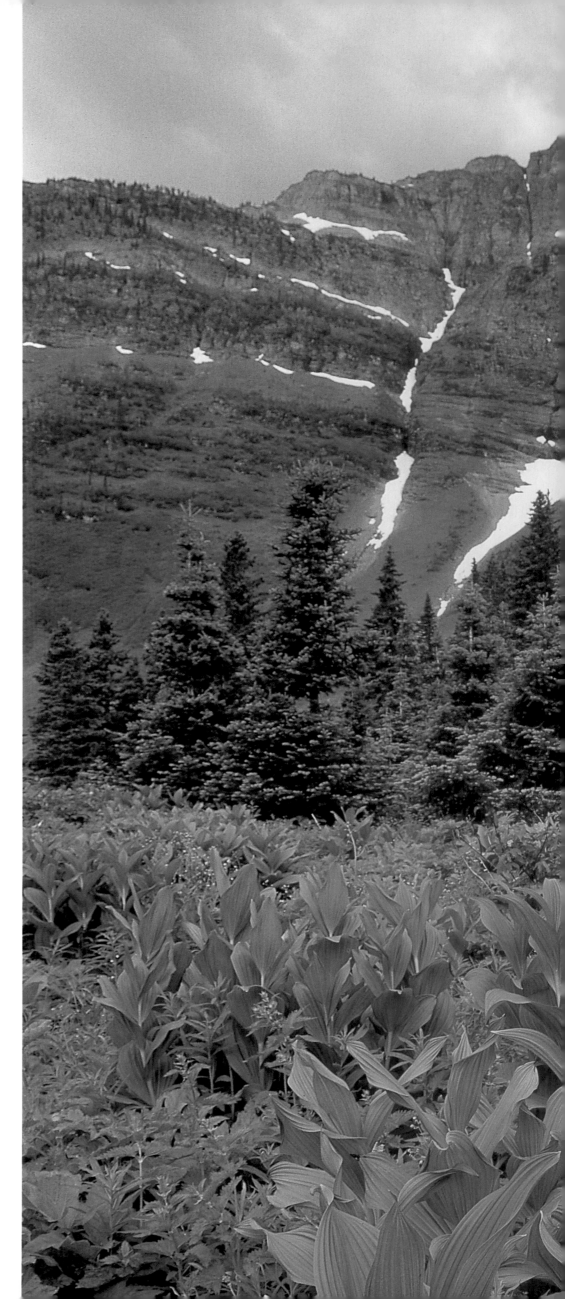

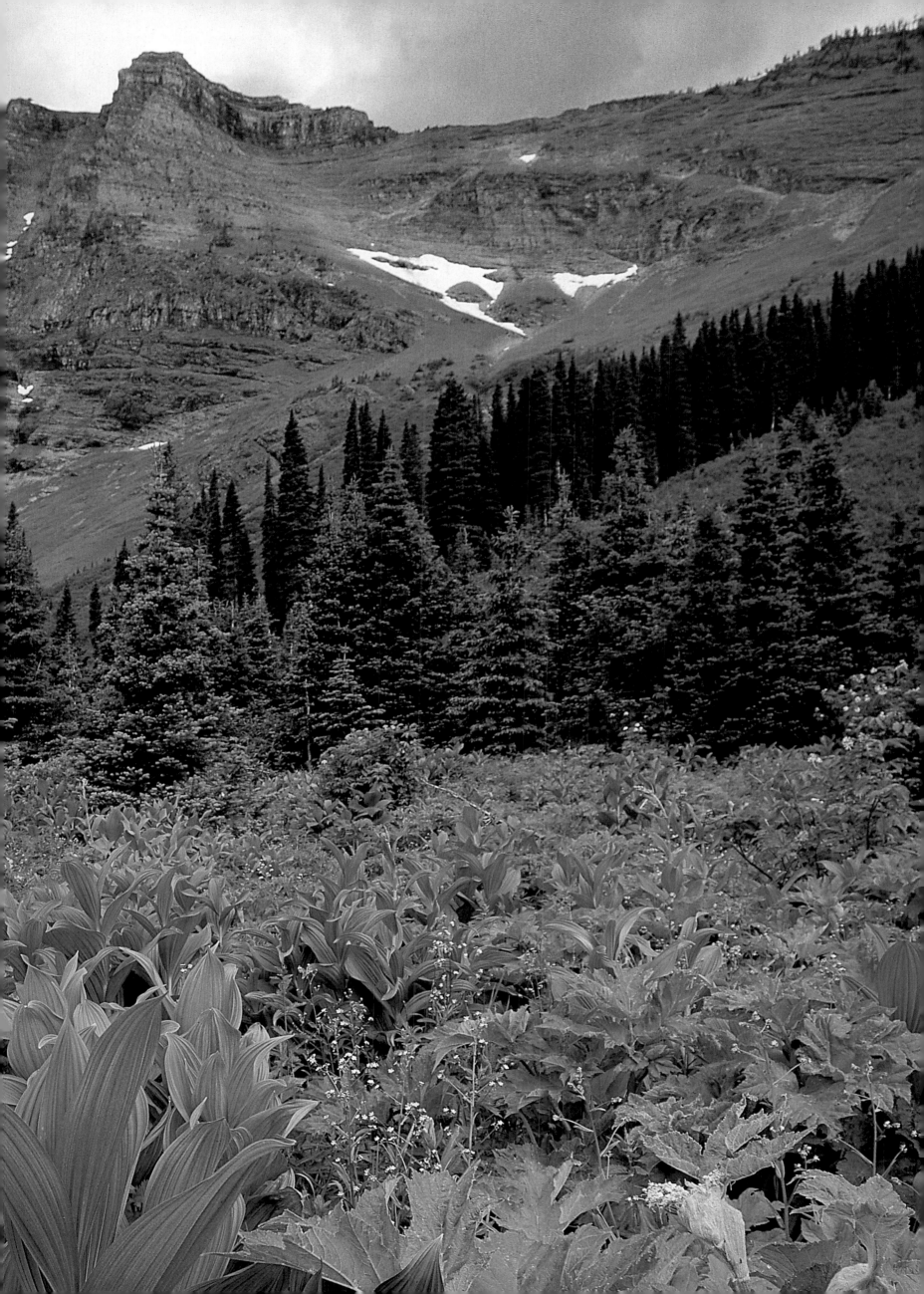

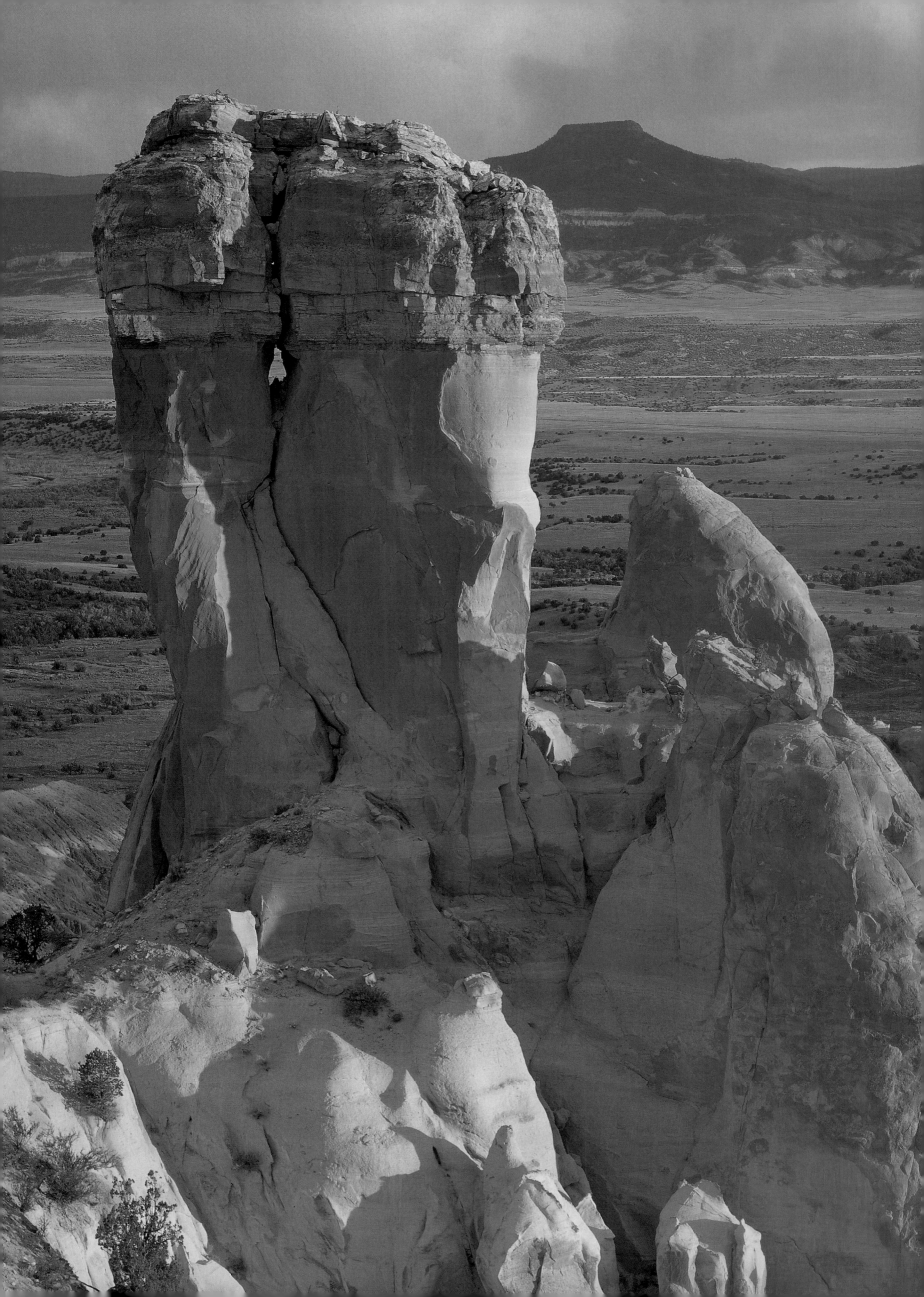

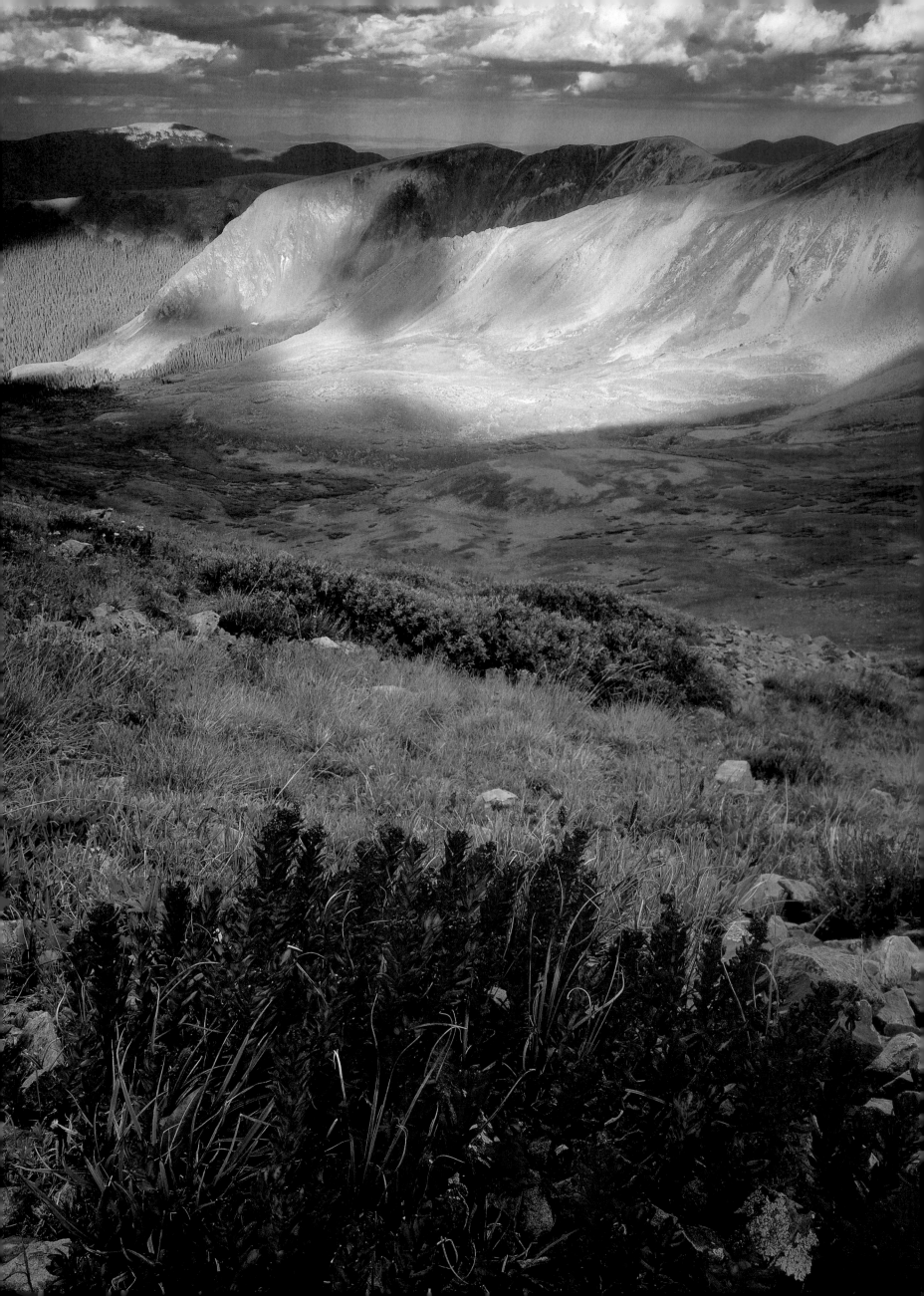

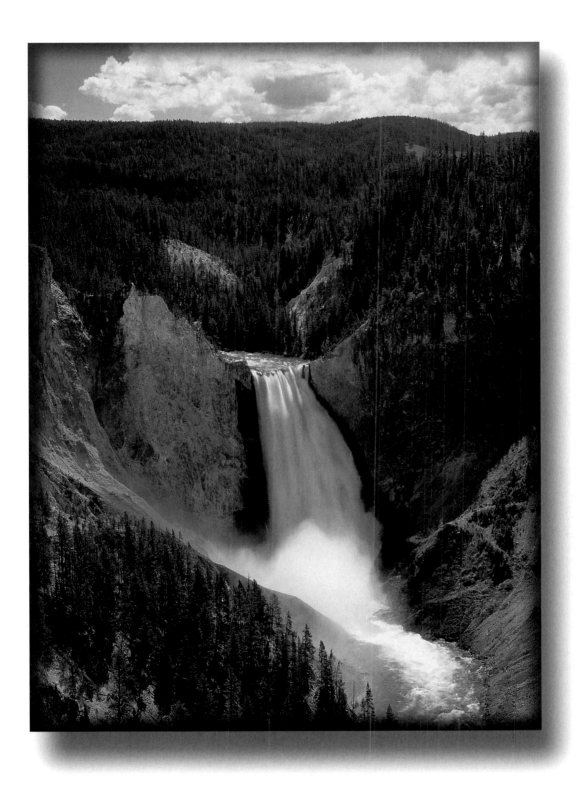

Yellowstone River, Yellowstone National Park, Wyoming

Both river and park take their name from the color of the cliffs revealed in
this deep, water-carved canyon. The 308-foot (94-meter) falls exist because the
rock above the falls resists the erosion of the churning water better than the rock
below the falls, which has been weakened by thermal activity.

left: **Wheeler Peak Wilderness, New Mexico**

The rose crown, a member of the sedum family, is closely related to many hardy
succulent plants valued by gardeners for their toughness. Alpine plants must
overcome a variety of obstacles, including limited moisture, gusting winds, and
a growing season that may be as short as ten weeks.

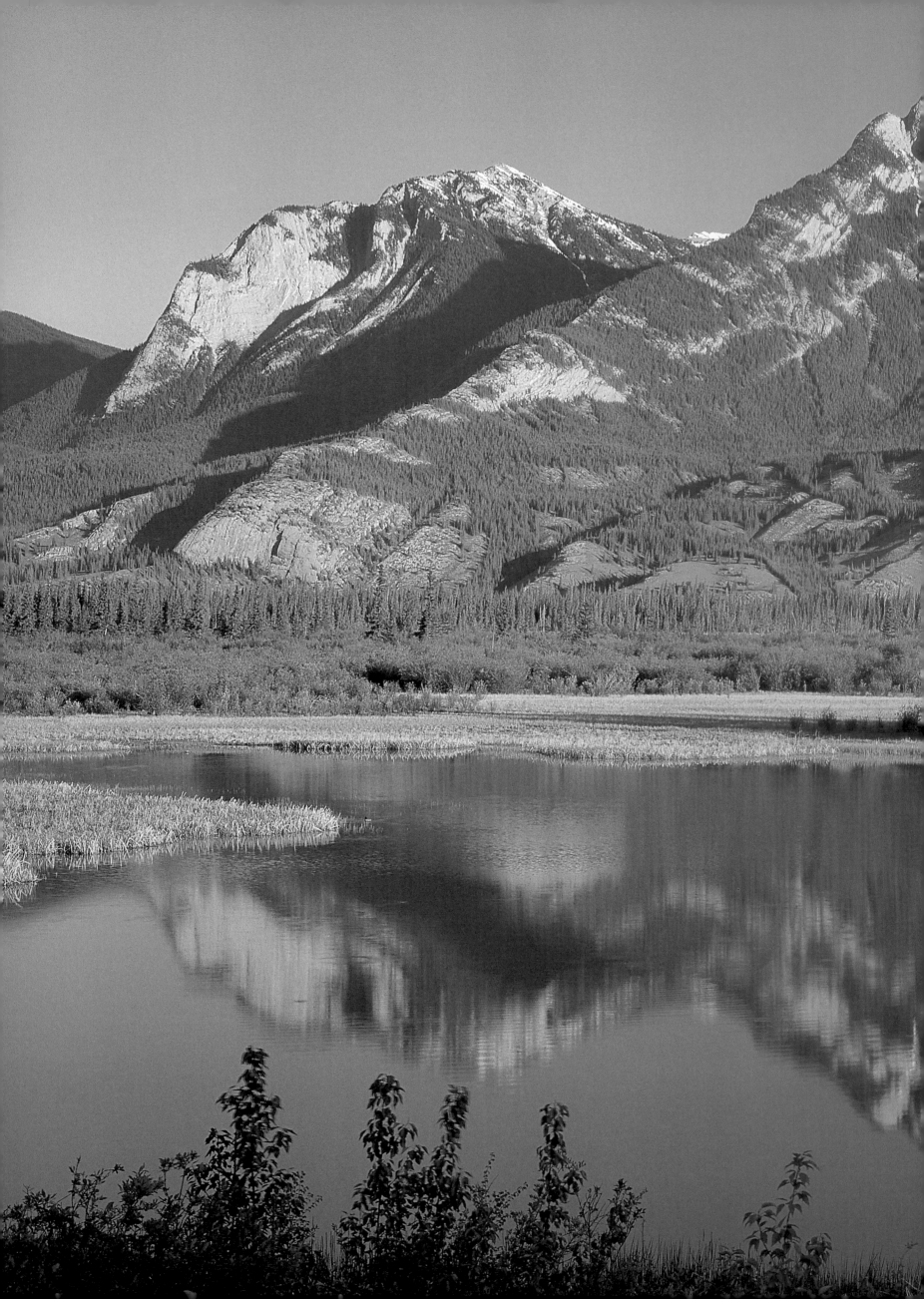

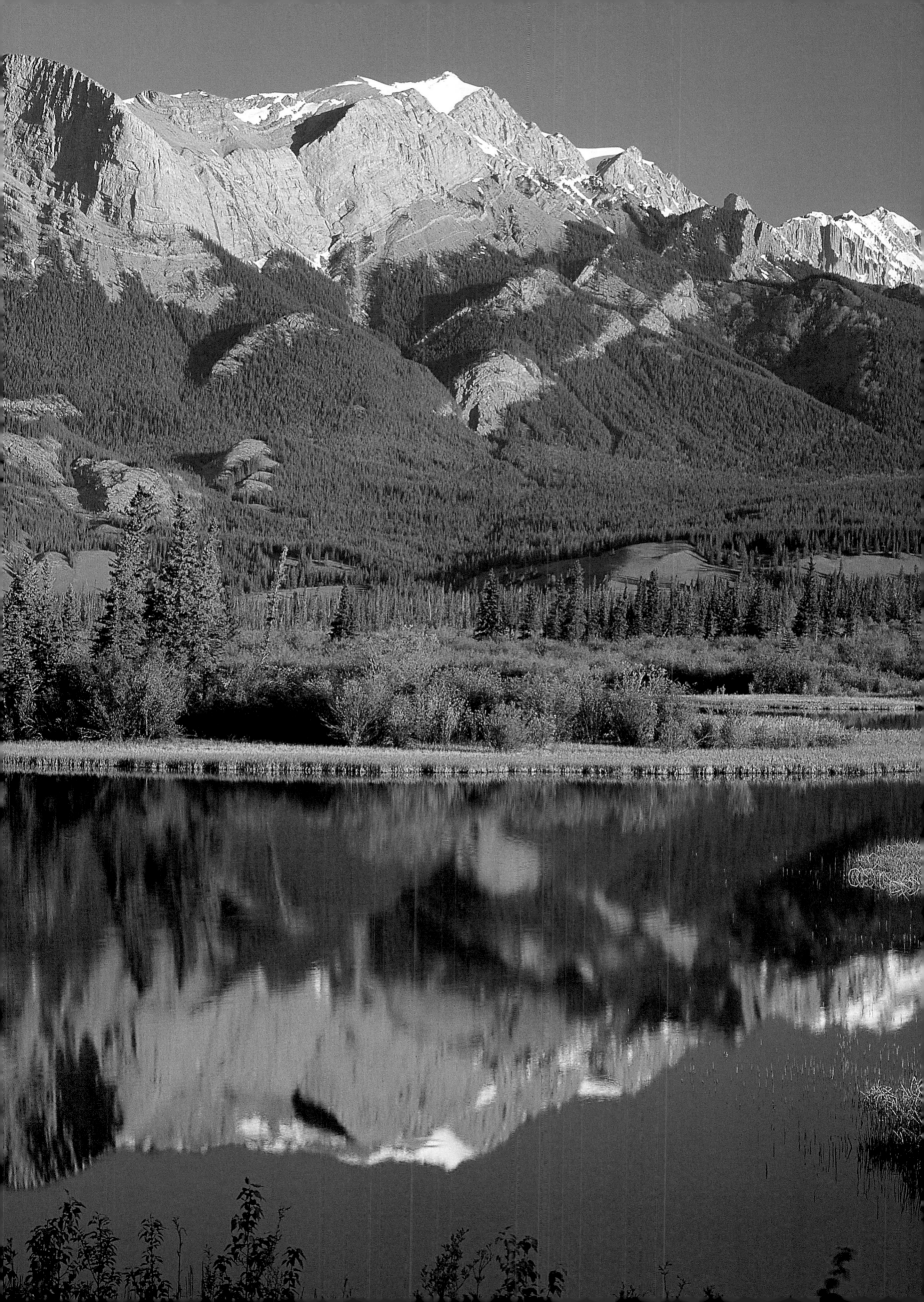

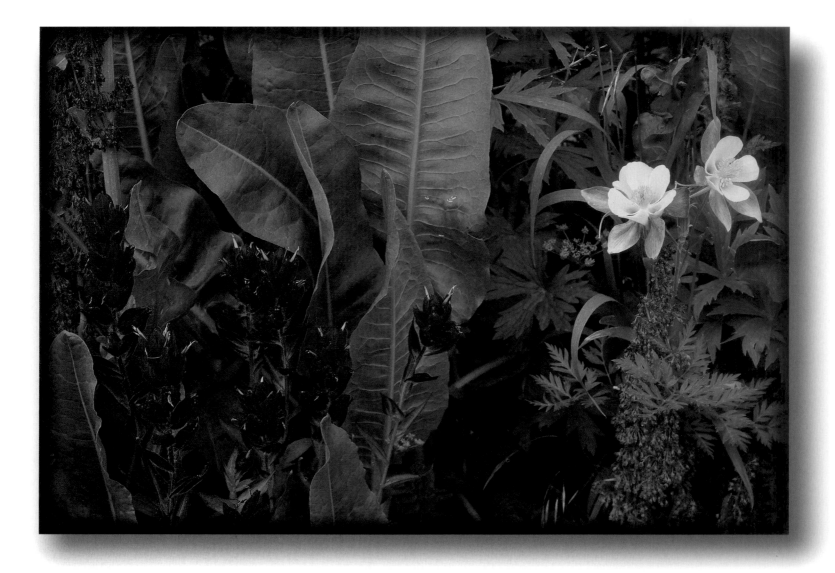

Sneffels Range, Colorado

Mount Sneffels, from which this range takes its name, was itself named for the volcano
that formed the starting point of Jules Verne's *Journey to the Center of the Earth*.
That barren peak held nothing to compare with the Sneffels' abundant summer
greenery, enhanced here by columbine and Indian paintbrush.

right: San Juan Mountains, Colorado

Zigzagging its way through a meadow of dandelions, a log fence mimics the line of
peaks behind it. Many foothill and low mountain meadows are used as pastureland
for domestic livestock.

previous pages: Jasper National Park, Alberta

Jasper is the largest national park in the Rocky Mountains: 4,200 square miles
(10,900 square kilometers). Less than 8 percent of that area lies in valley bottoms.
Mountain slopes, high meadows, peaks and glaciers fill the rest of the landscape and
give Jasper its remarkable beauty.

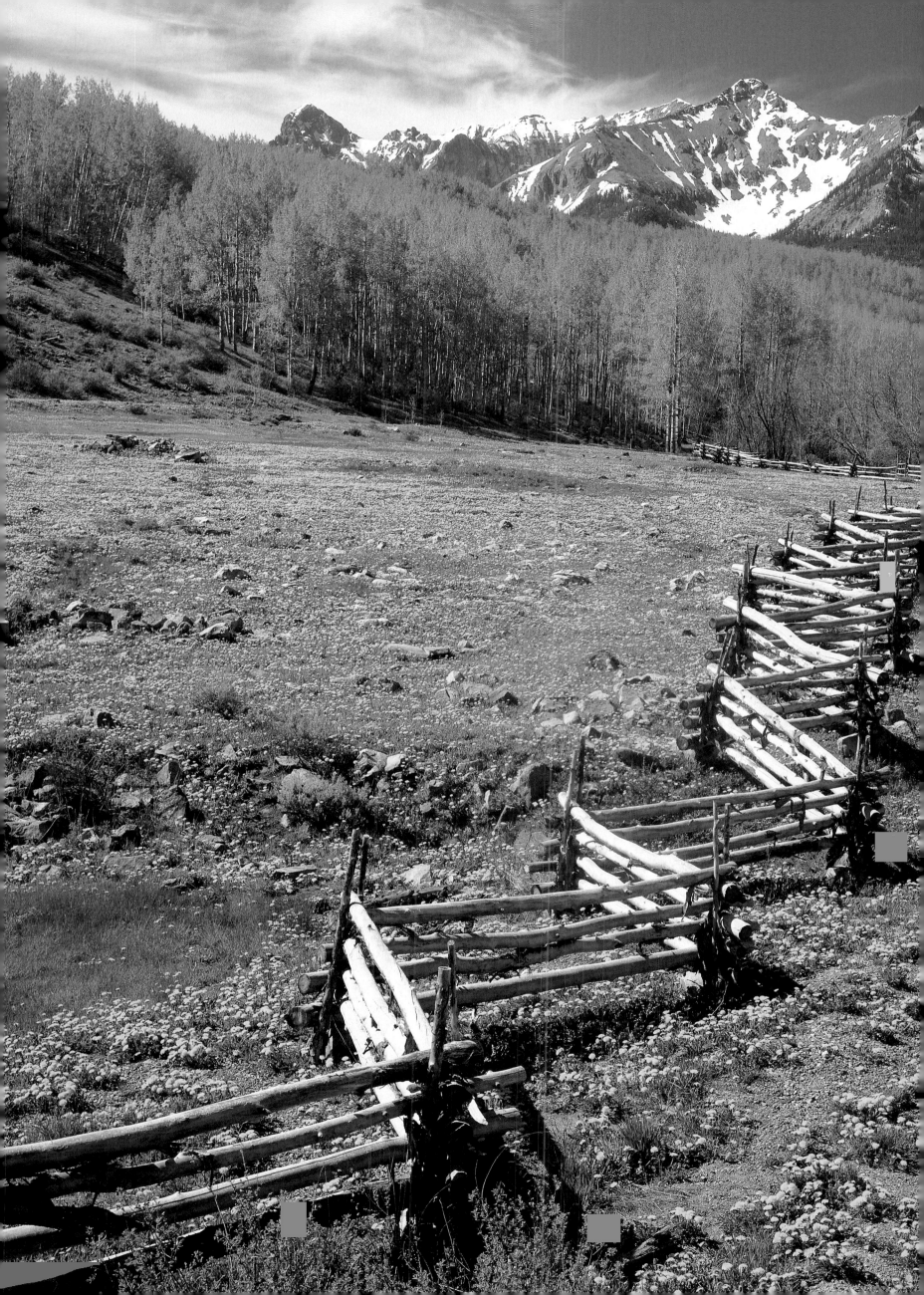

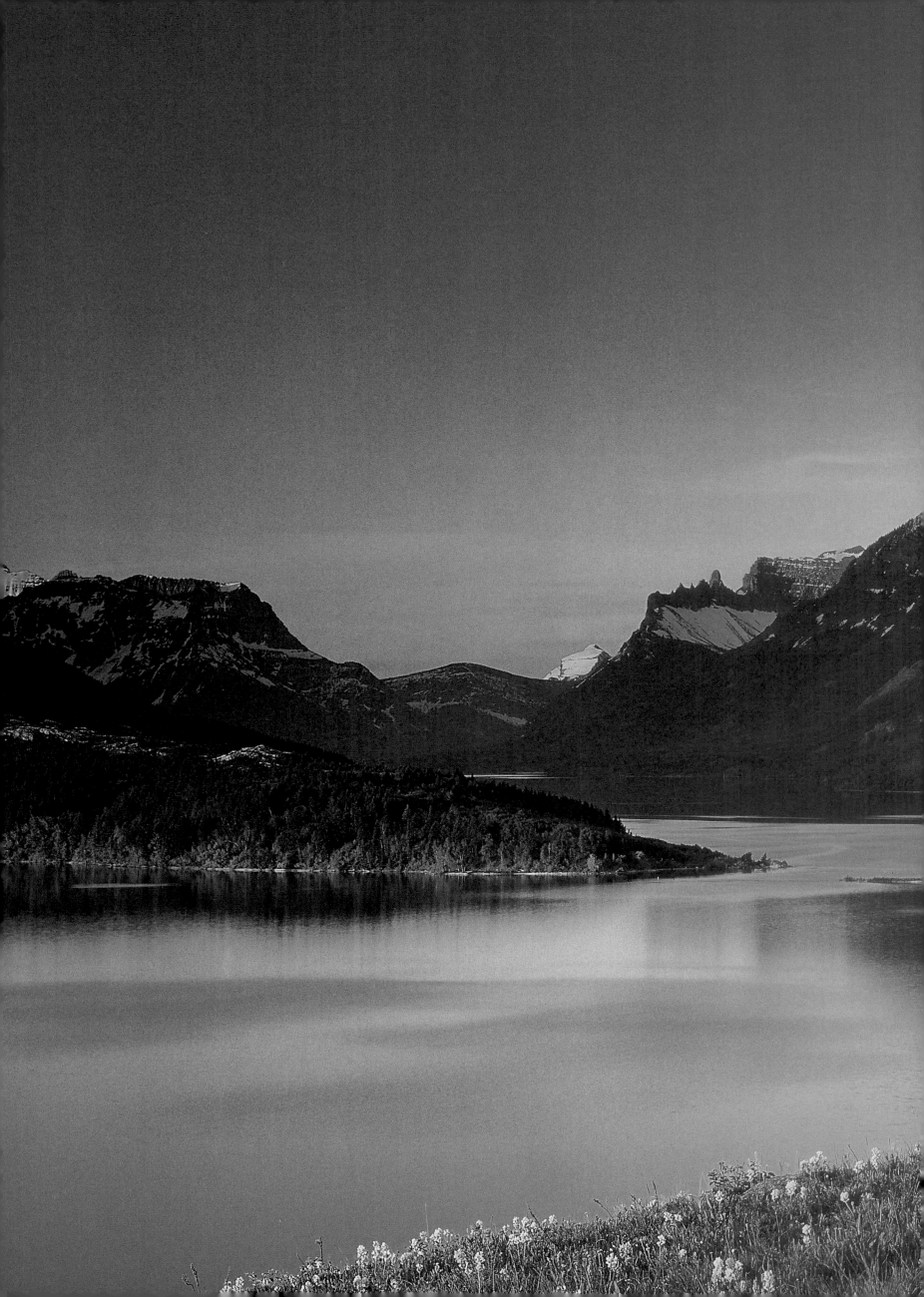

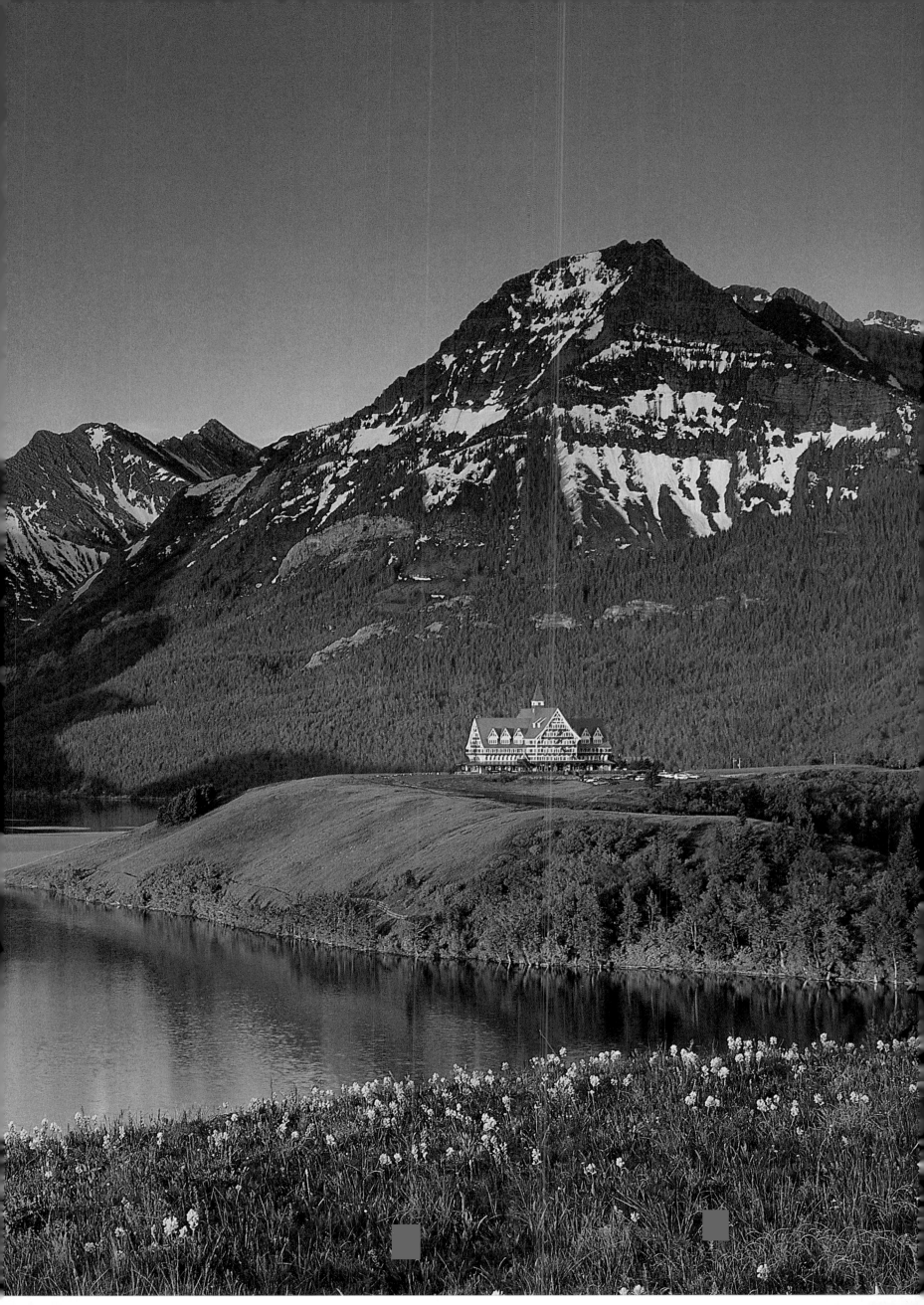

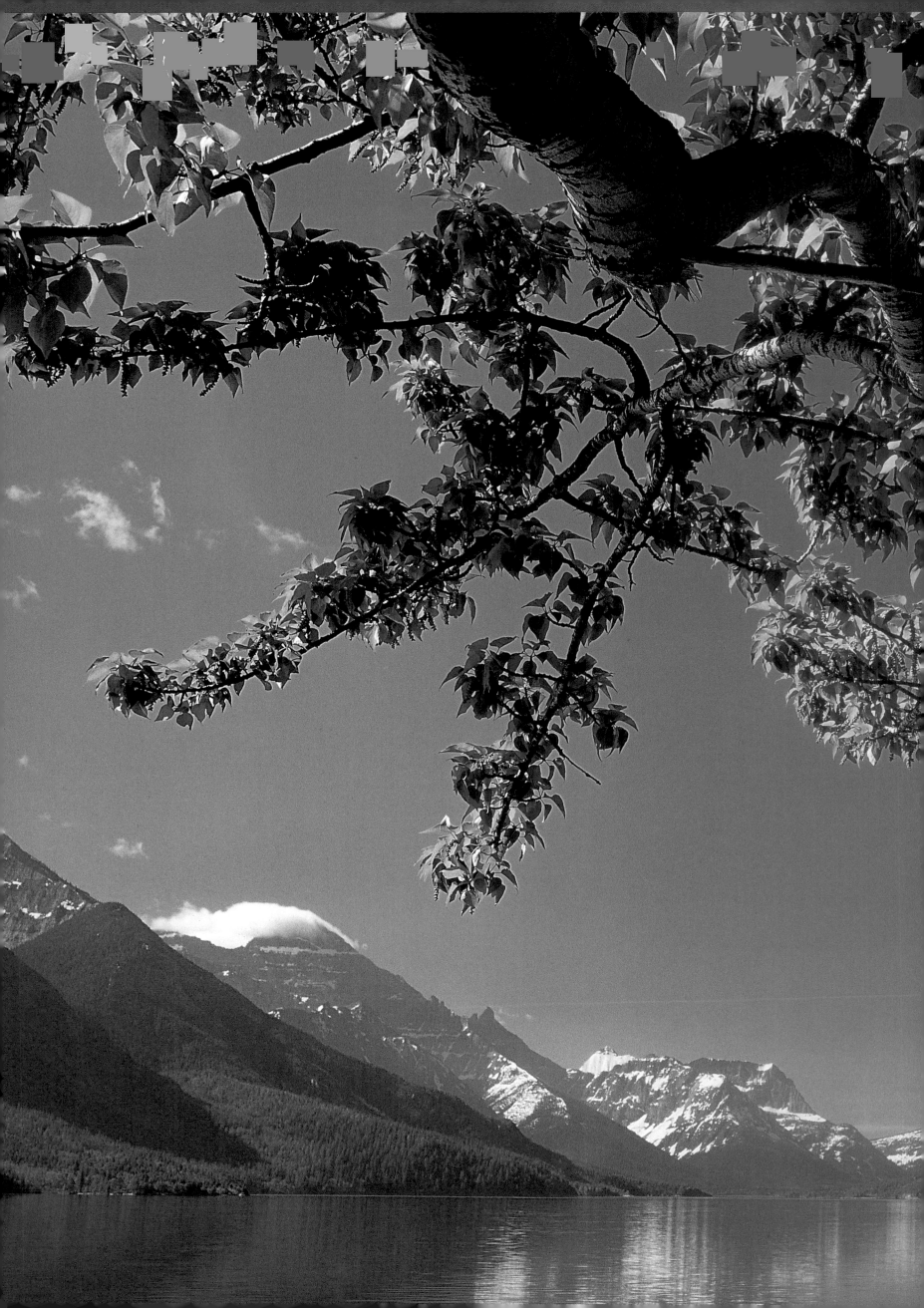

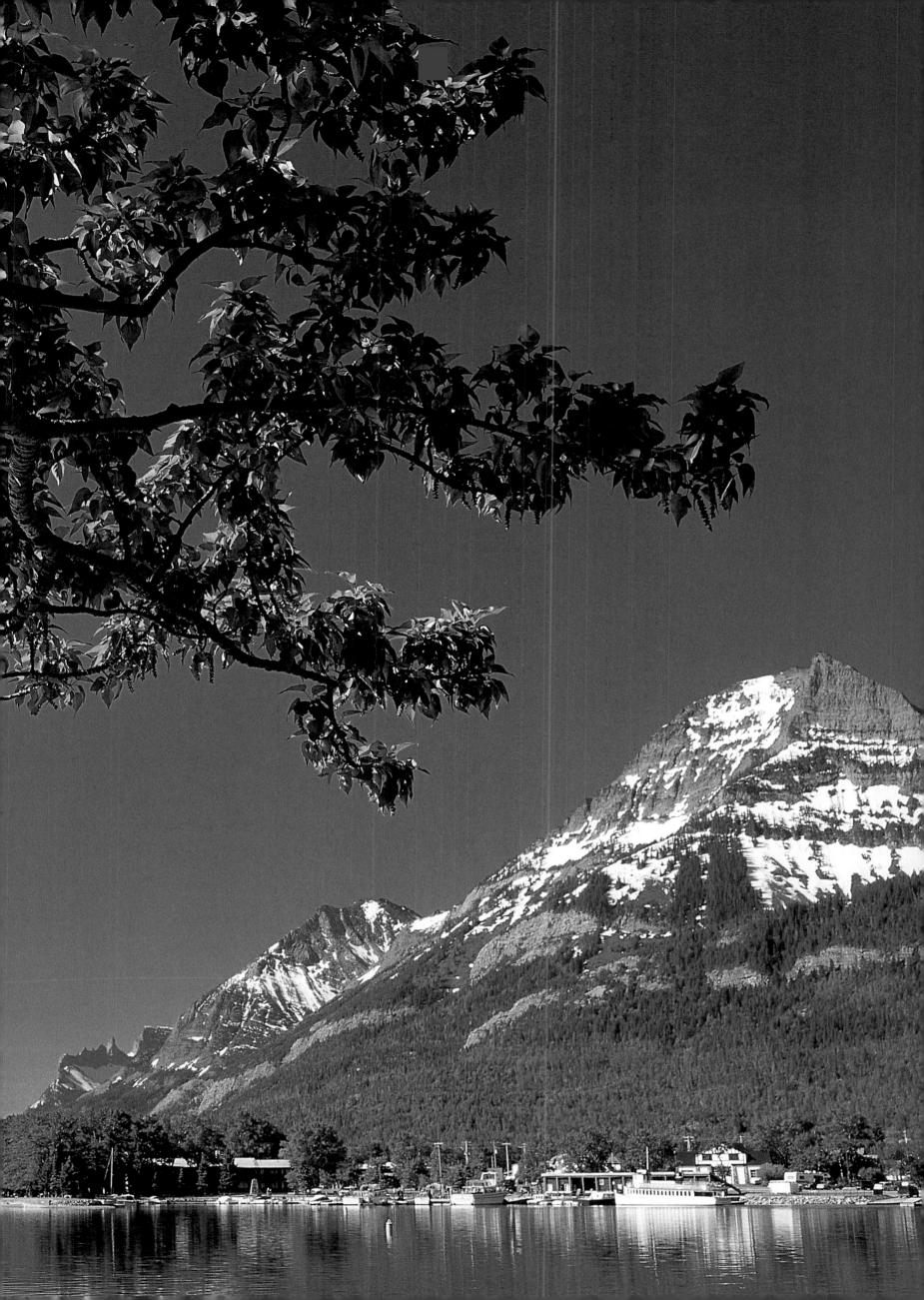

Yoho National Park, British Columbia *Yoho*, a Cree word expressing wonder and awe, is a fitting name for this park. Much of its dramatic beauty is due to glacial erosion, which carved out the valleys and created a landscape filled with sheer rock walls and waterfalls.

previous pages: **Waterton Lakes National Park, Alberta** Canada made Waterton its fourth national park in 1895. Fifteen years later, Glacier received the same status in the United States. Later, recognizing that the two parks are really a single geographical, geological and ecological unit, the U.S. Congress and the Canadian Parliament officially named the area the Waterton-Glacier International Peace Park.

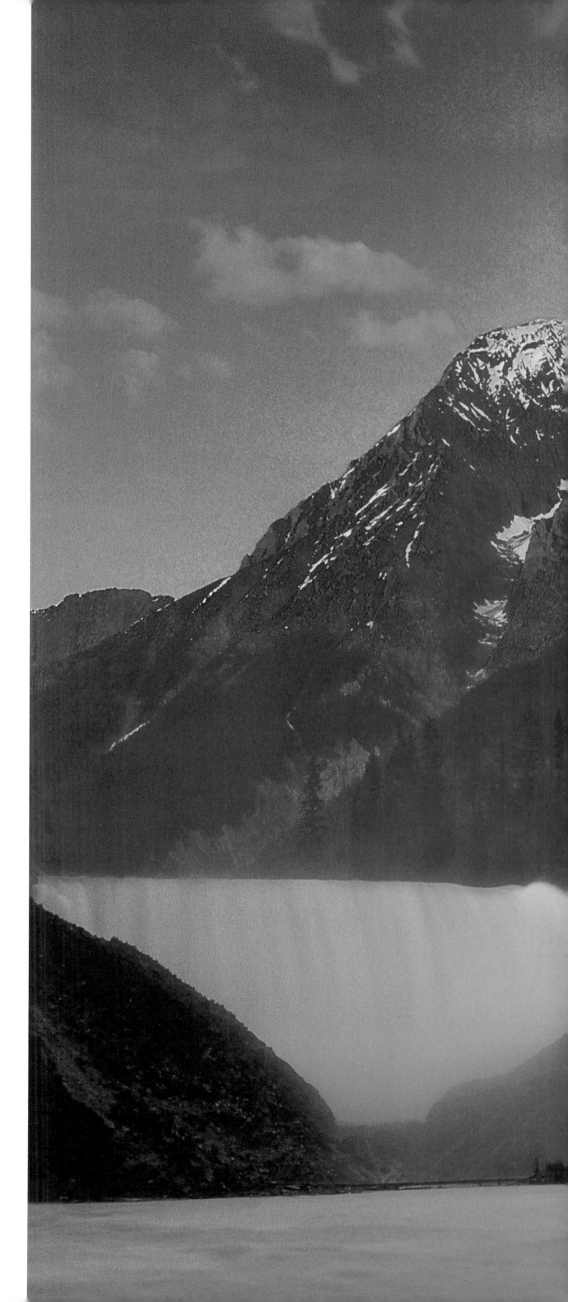

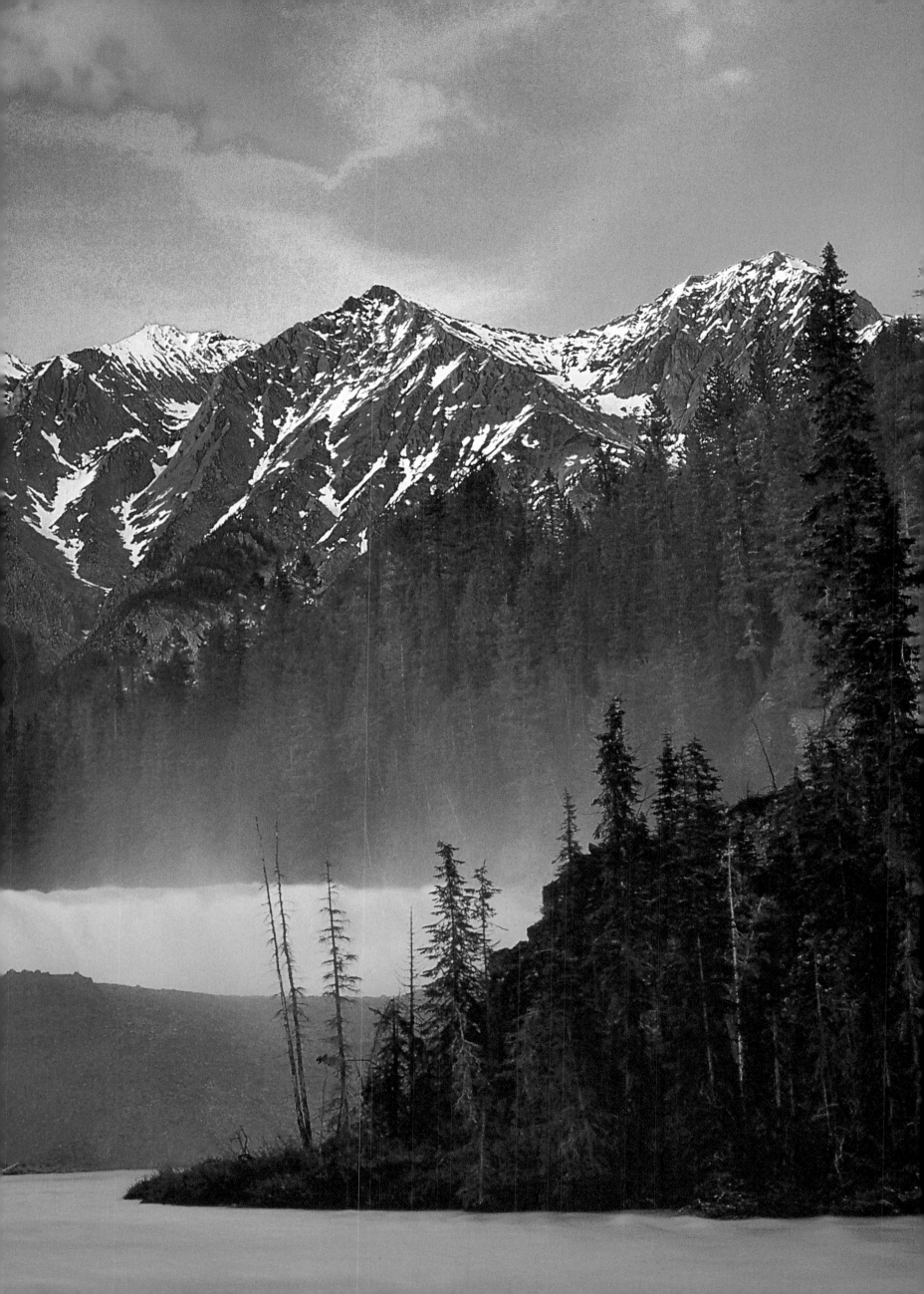

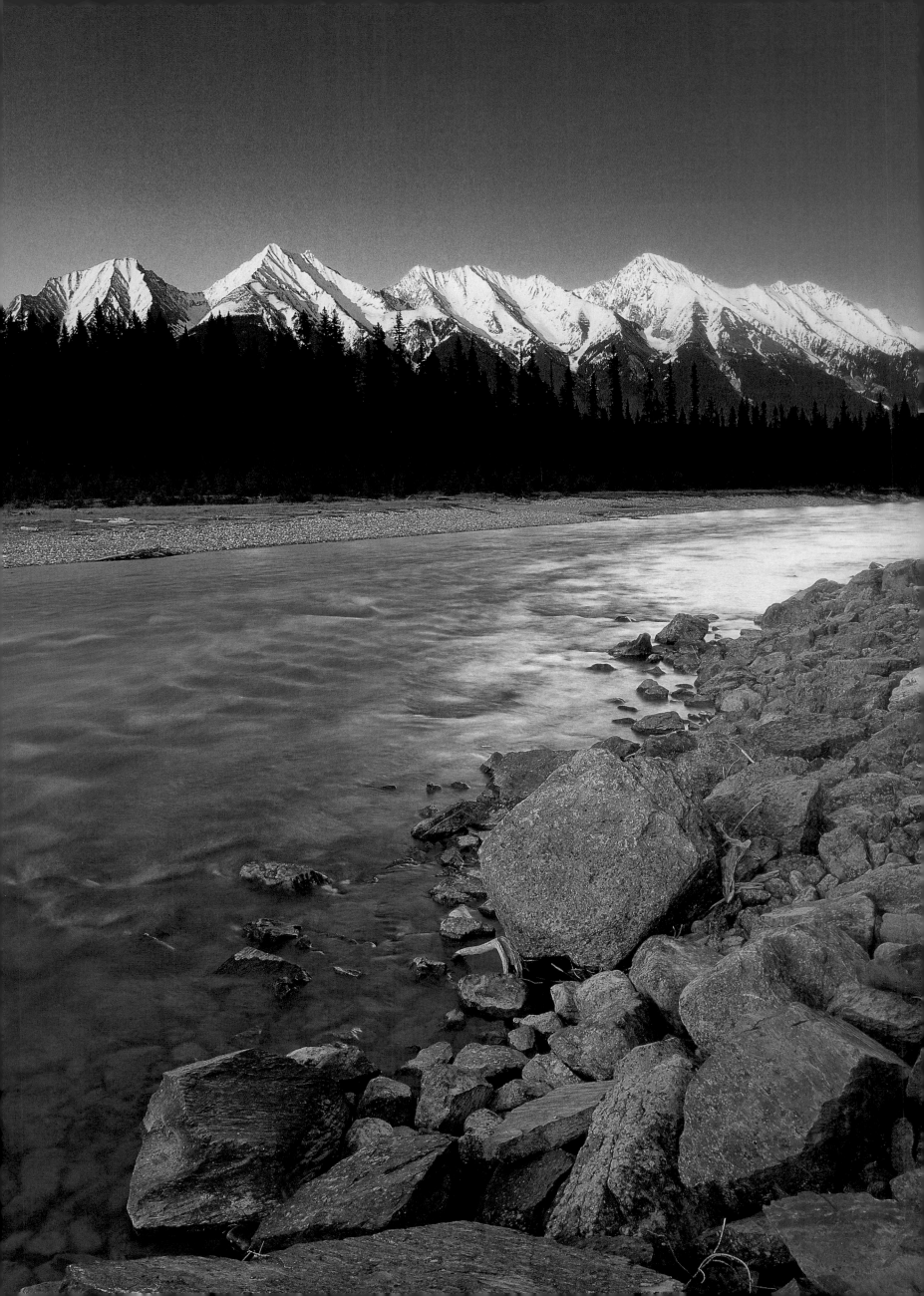

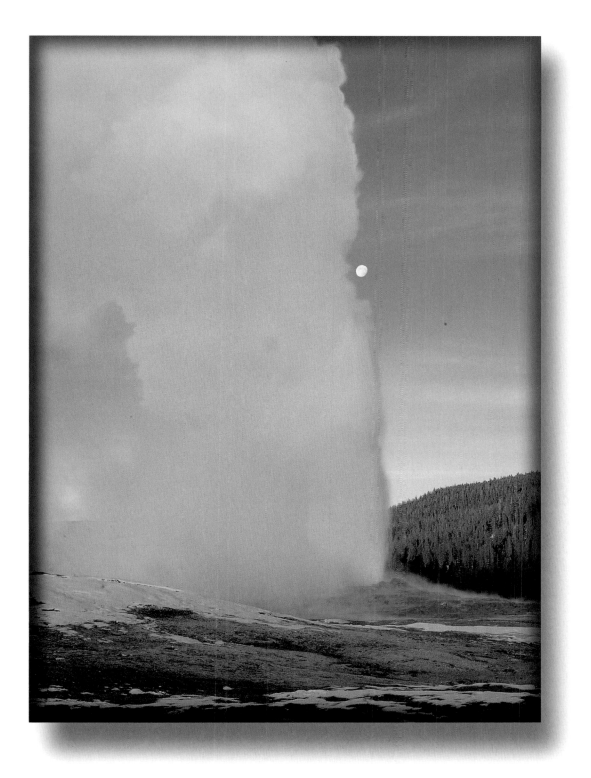

Yellowstone National Park, Wyoming

Although it is not the most regular, highest or biggest geyser in Yellowstone,
Old Faithful is undoubtedly the most famous. Unlike most of the park's
geysers, Old Faithful has shown remarkably little variation in its eruptive behavior
since it was first seen by white explorers in 1870.

left: Kootenay National Park, British Columbia

A broad river valley and snow-covered peaks illustrate only two of Kootenay's
many landscapes and ecosystems. It has the distinction of being the only national
park in Canada to contain both cacti and glaciers.

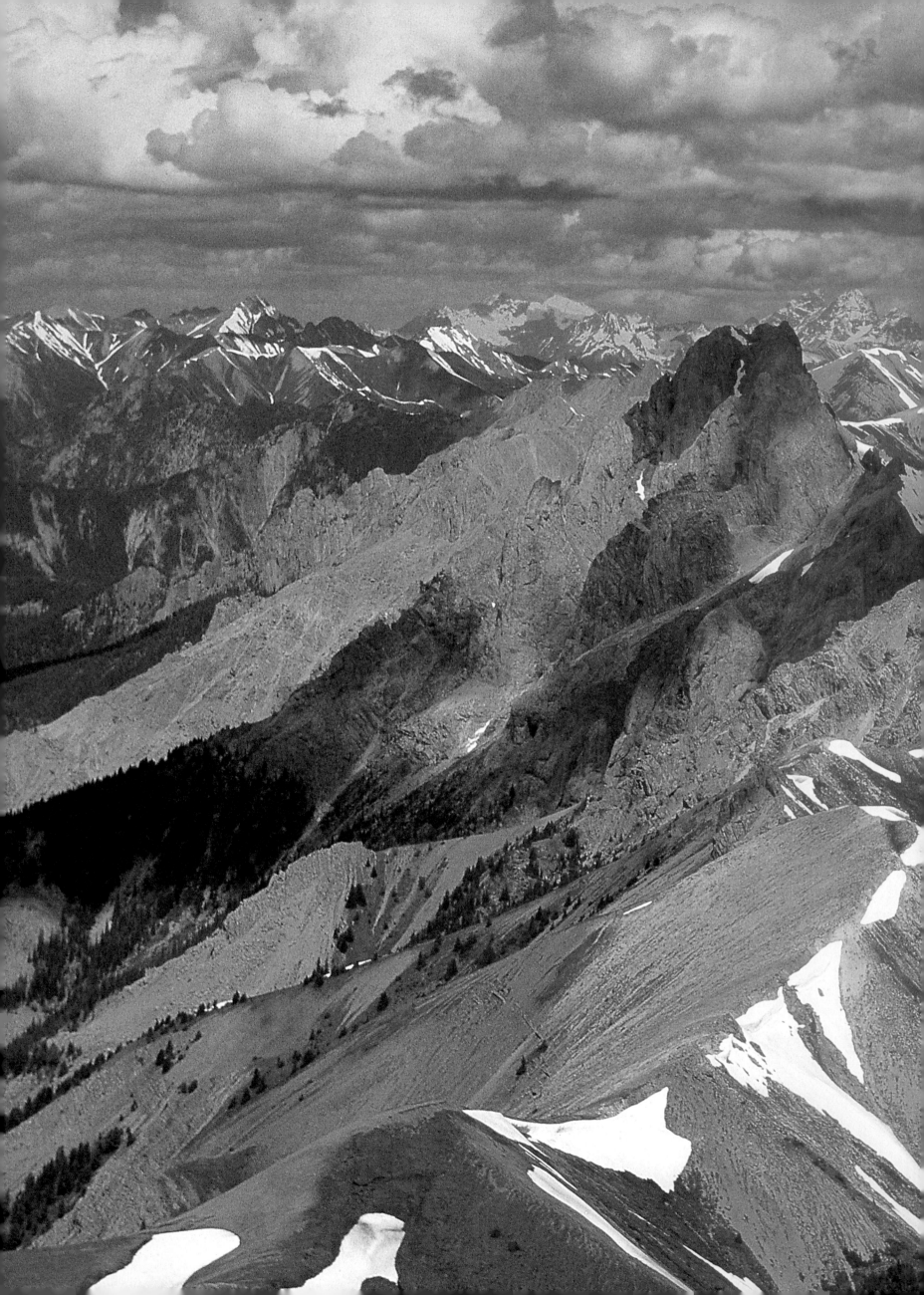

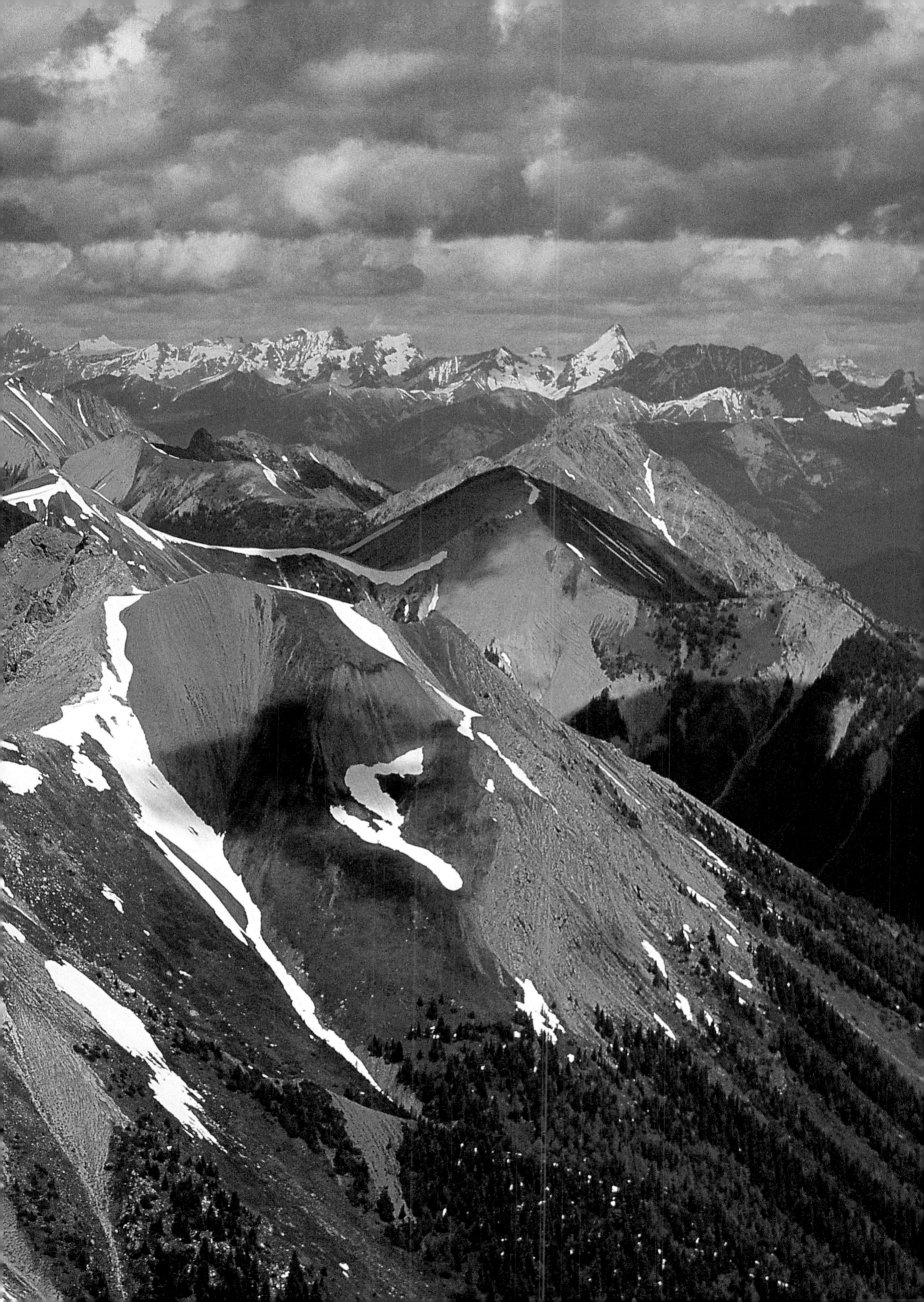

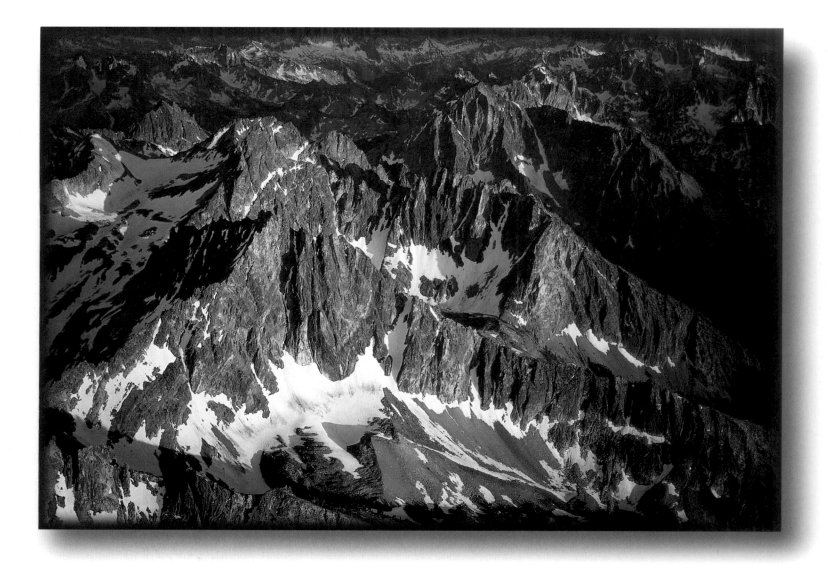

Sawtooth Wilderness, Idaho

From this vantage point, it is easy to understand why the Rockies have been called
the spine of North America: "the place where the bone shows through."

right: **Yoho National Park, British Columbia**

The Kicking Horse River, known as *Wapta* to the area's native people, got its current
name in 1858. James Hector, leading an expedition up an unknown river valley, was
kicked in the chest by his horse. Hector recovered from his injuries but the party
memorialized his accident when they named the river and nearby pass.

previous pages: **Kootenay National Park, British Columbia**

Kootenay National Park, Yoho, Banff, Jasper, and three adjoining provincial parks have
been declared a UNESCO World Heritage Site—a designation that places the area on
par with the Pyramids, the Acropolis, and the Great Barrier Reef.

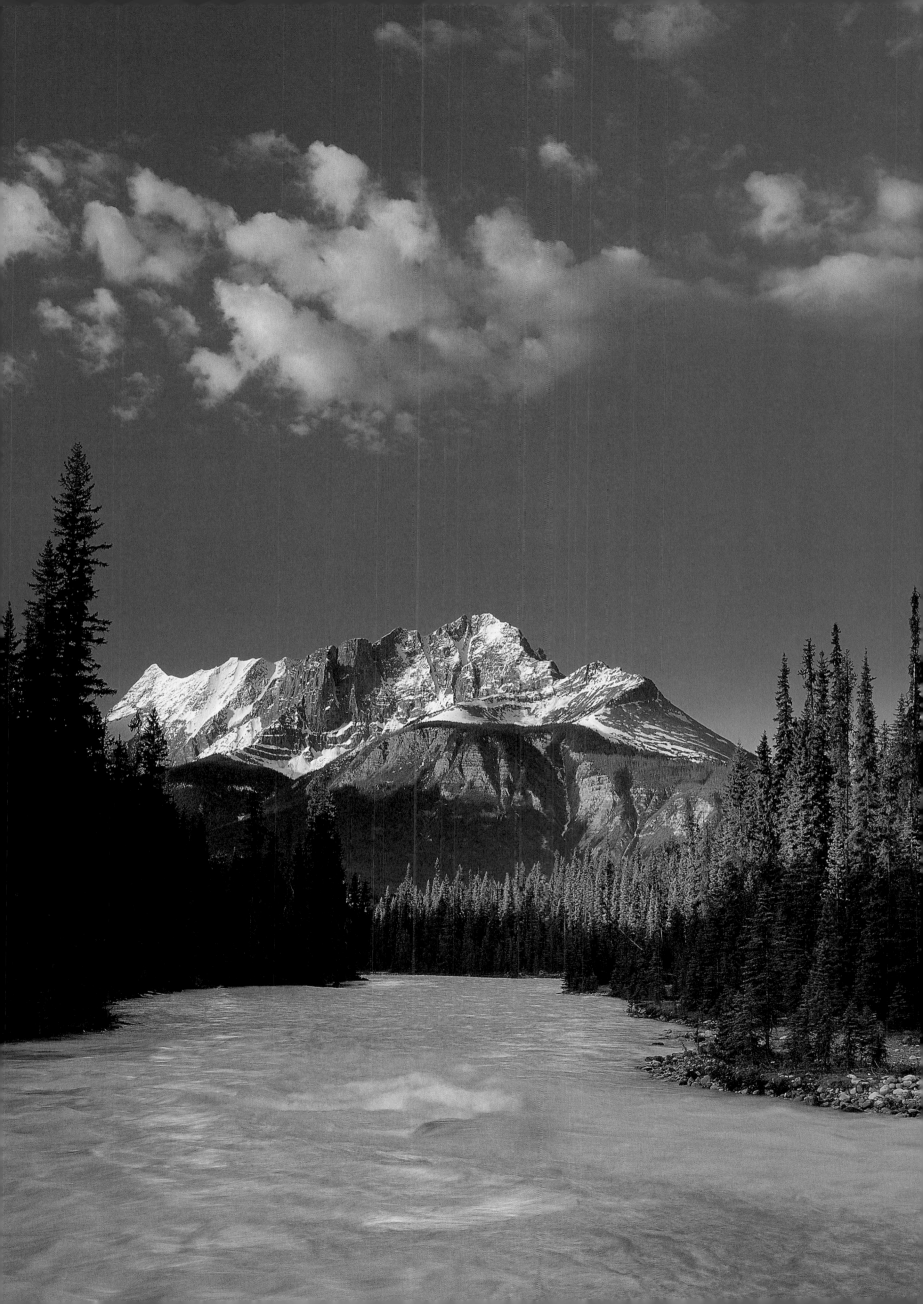

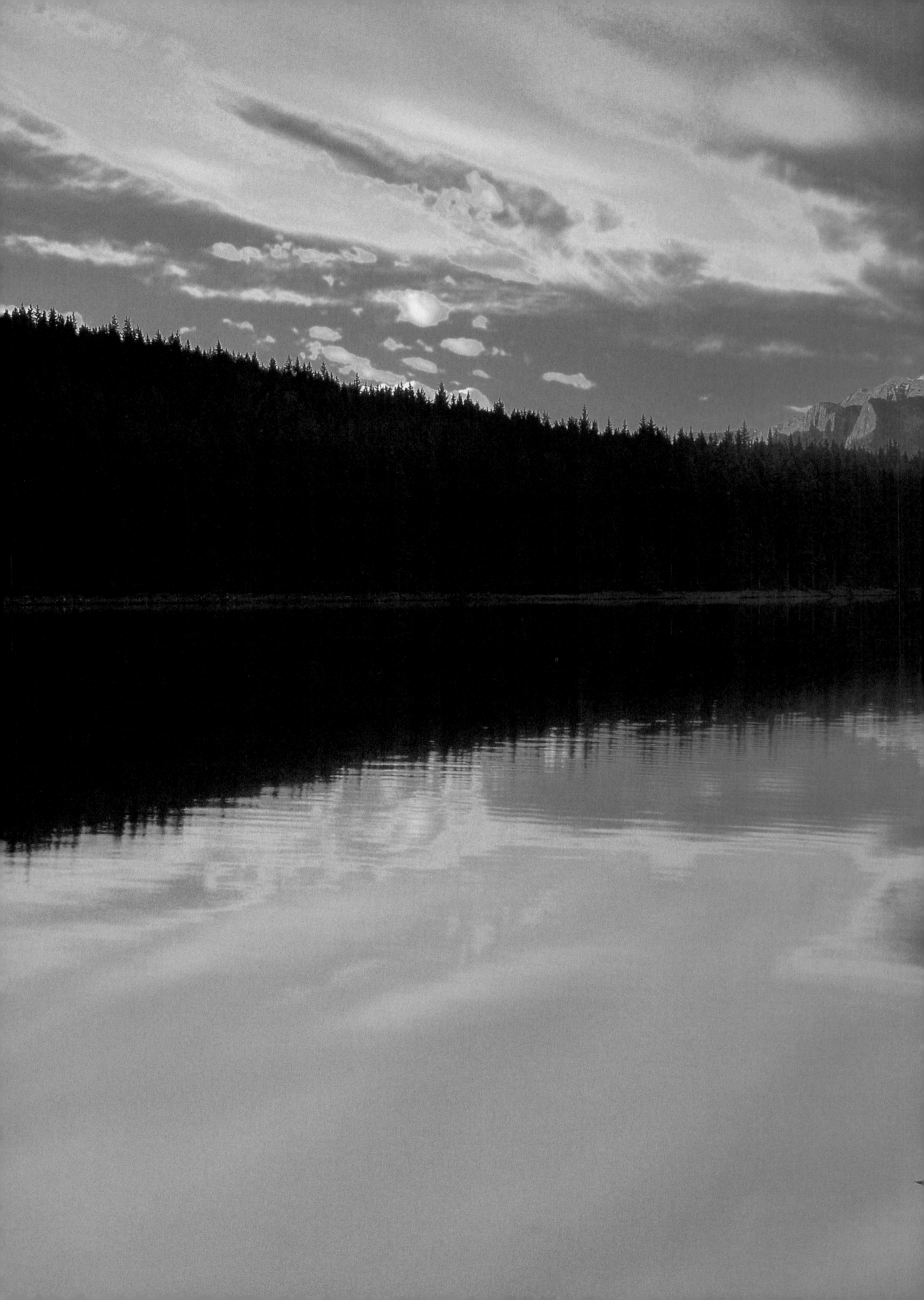

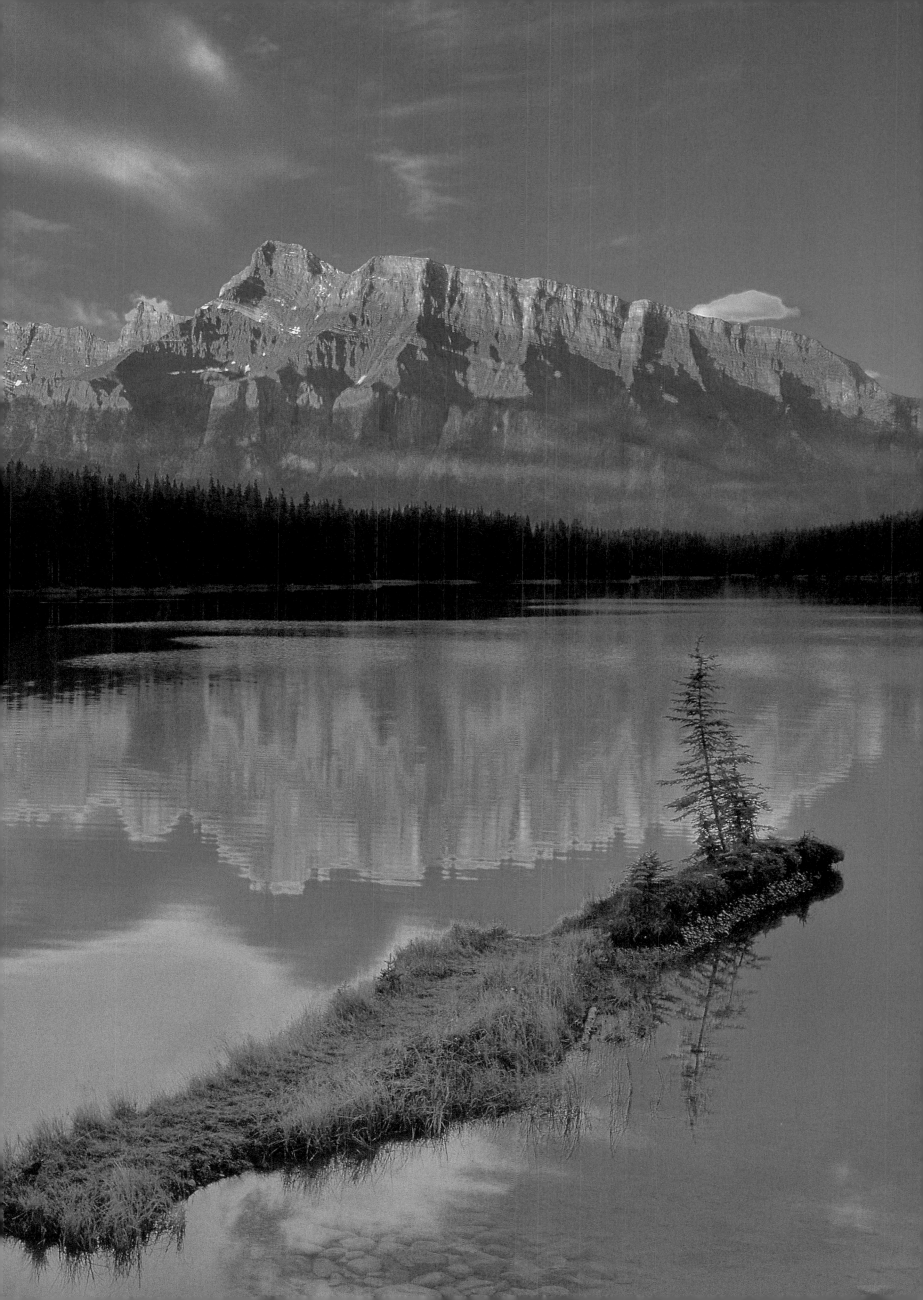

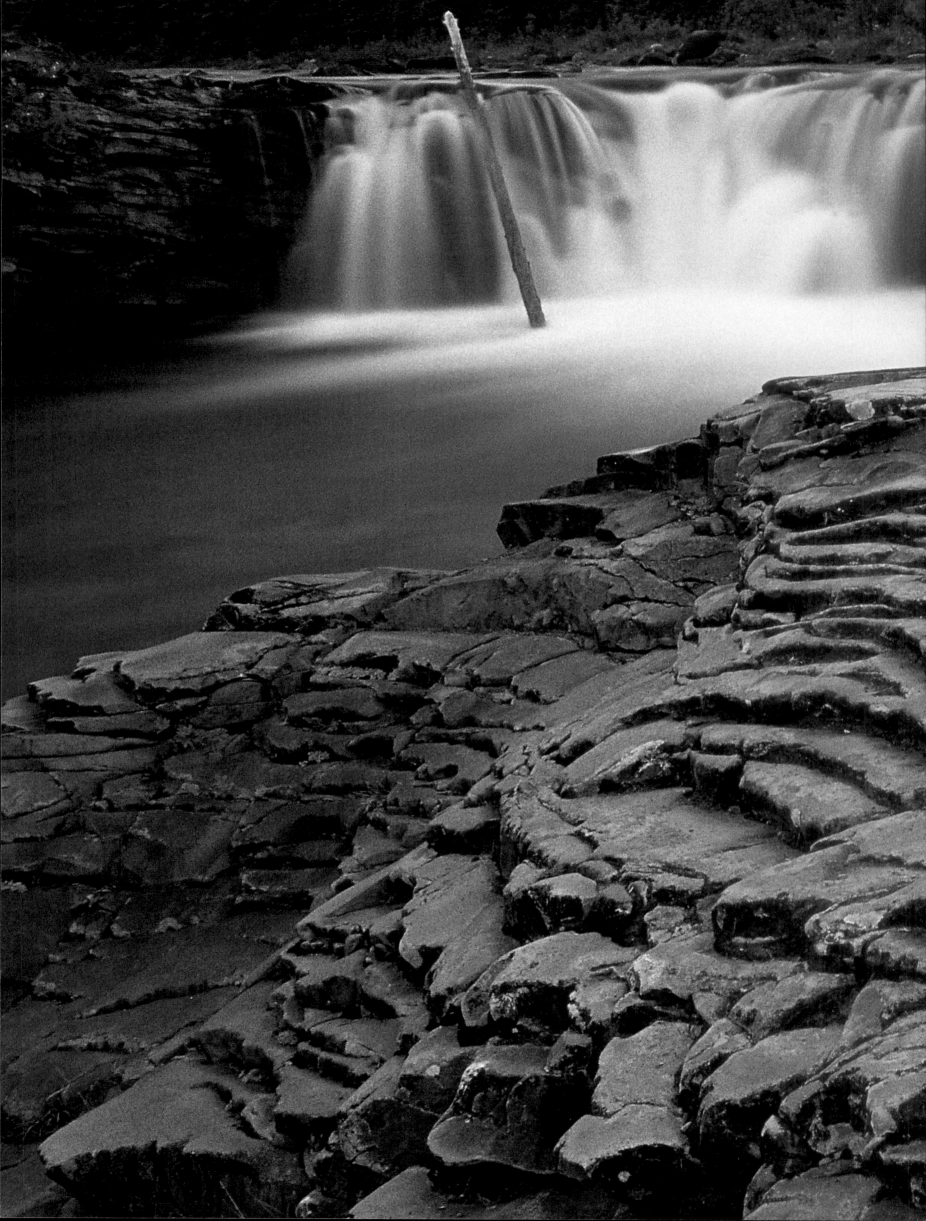

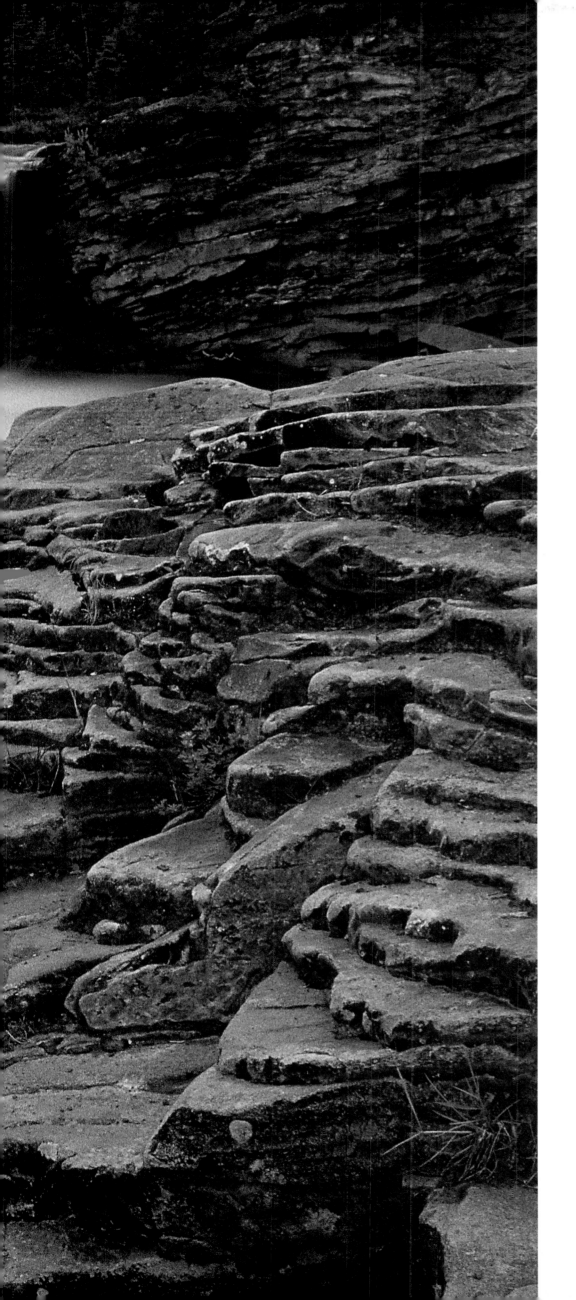

Sheep River Wildlife Sanctuary, Alberta Pounding through its valley, the Sheep River has eaten away at the hard layers of rock that restrain it. In keeping with the name, bighorns are often seen grazing on nearby slopes or scrambling up the rocks.

previous pages: **Banff National Park, Alberta** A gloriously glowing Mount Rundle spills its reflection into Two Jack Lake. Distinguished Canadian watercolor painter, Walter Phillips, said of Rundle, "I never tire of painting it, for it is never the same."

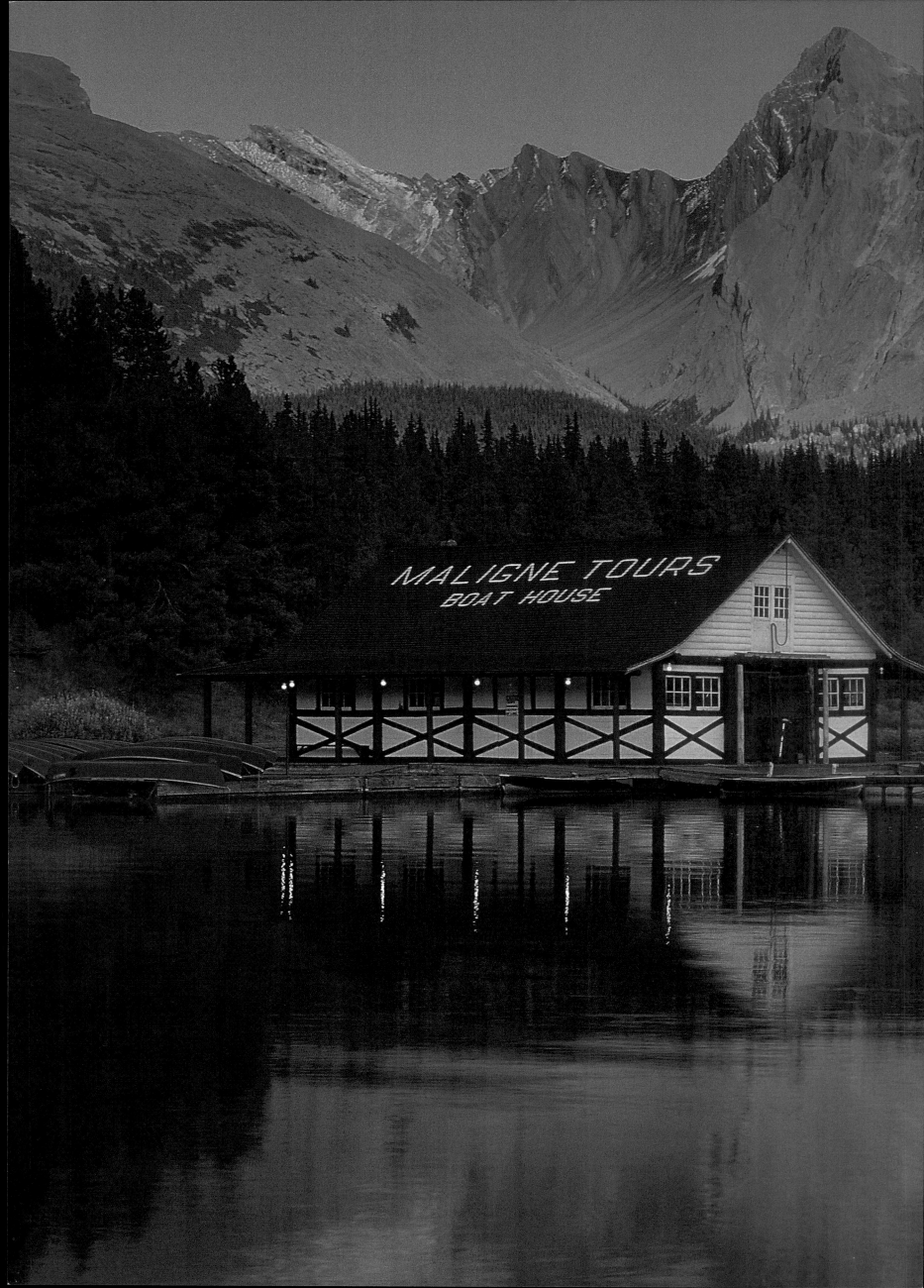

AUTUMN
IN THE ROCKIES

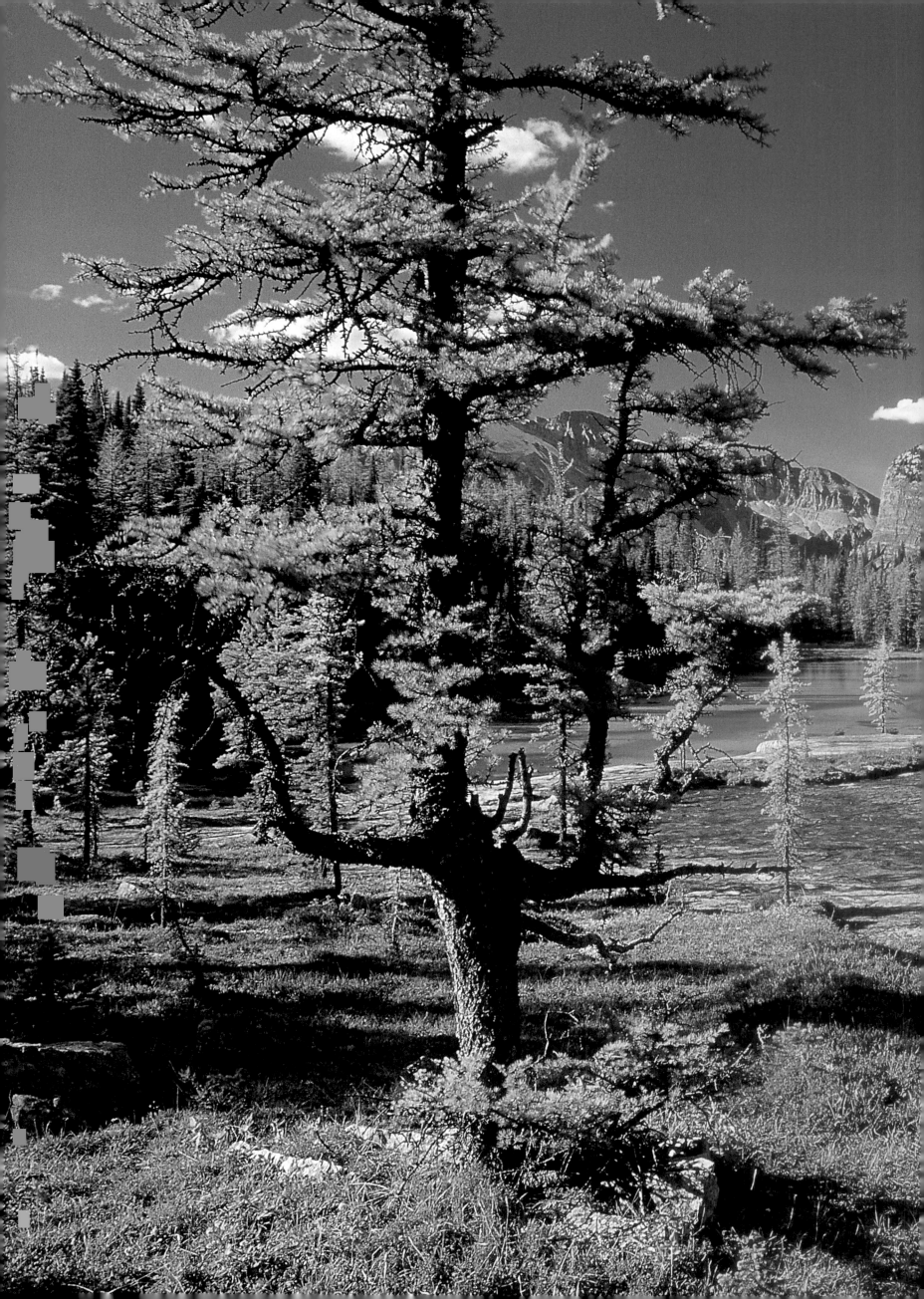

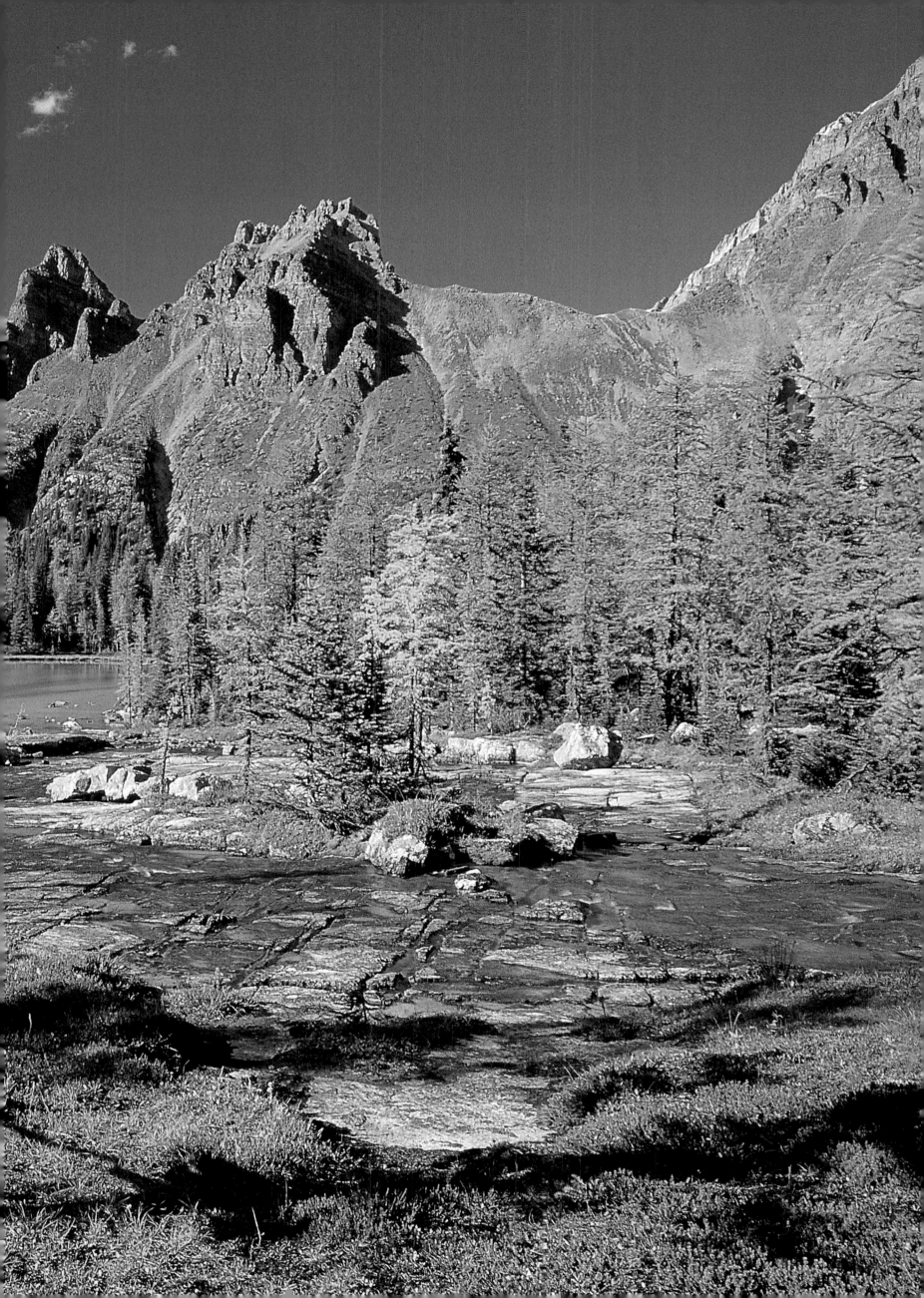

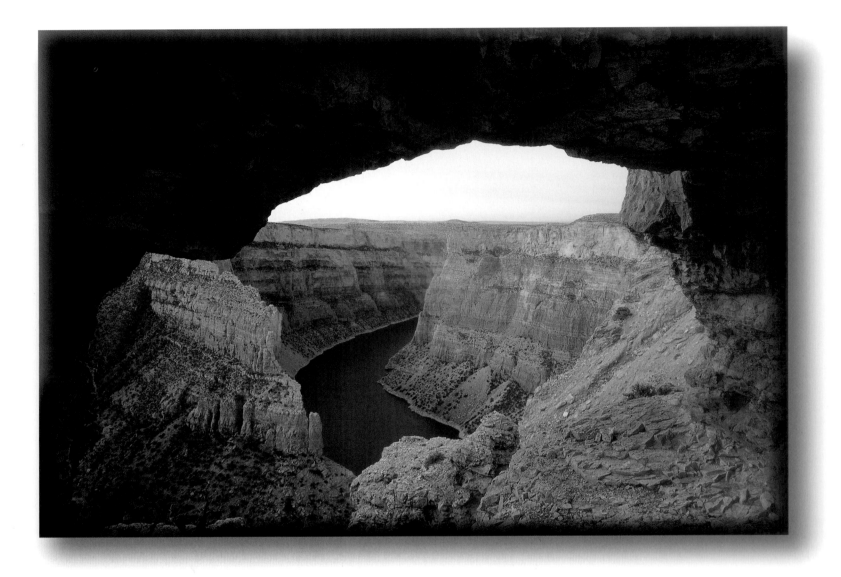

Bighorn Canyon National Recreation Area, Montana
Unheralded by dramatic changes in vegetation, autumn creeps up on this
canyon landscape.

right: **Mount Timpanogos Wilderness, Utah**
Bigleaf maples stream down the slope in a wide band of scarlet, echoing the path
of the falling water behind them. The bigleaf, a close relative of the sugar maple,
can be found from Alaska to Mexico.

previous pages: **Yoho National Park, British Columbia**
Splashes of yellow give the first hint of autumn's arrival at the Opabin Cascades.
In the background lie the Wiwaxy Peaks, which take their name from a Stoney
word meaning "windy."

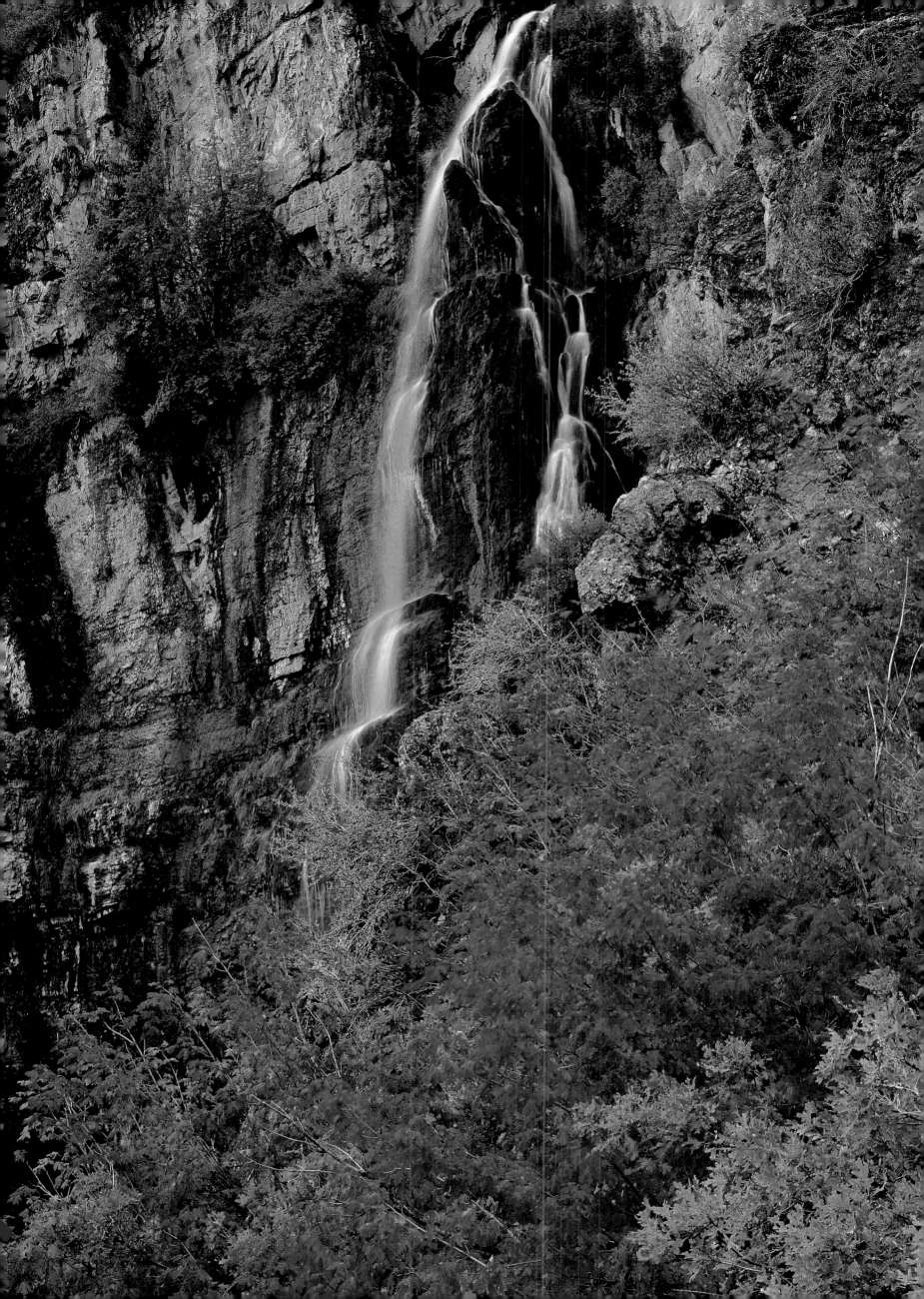

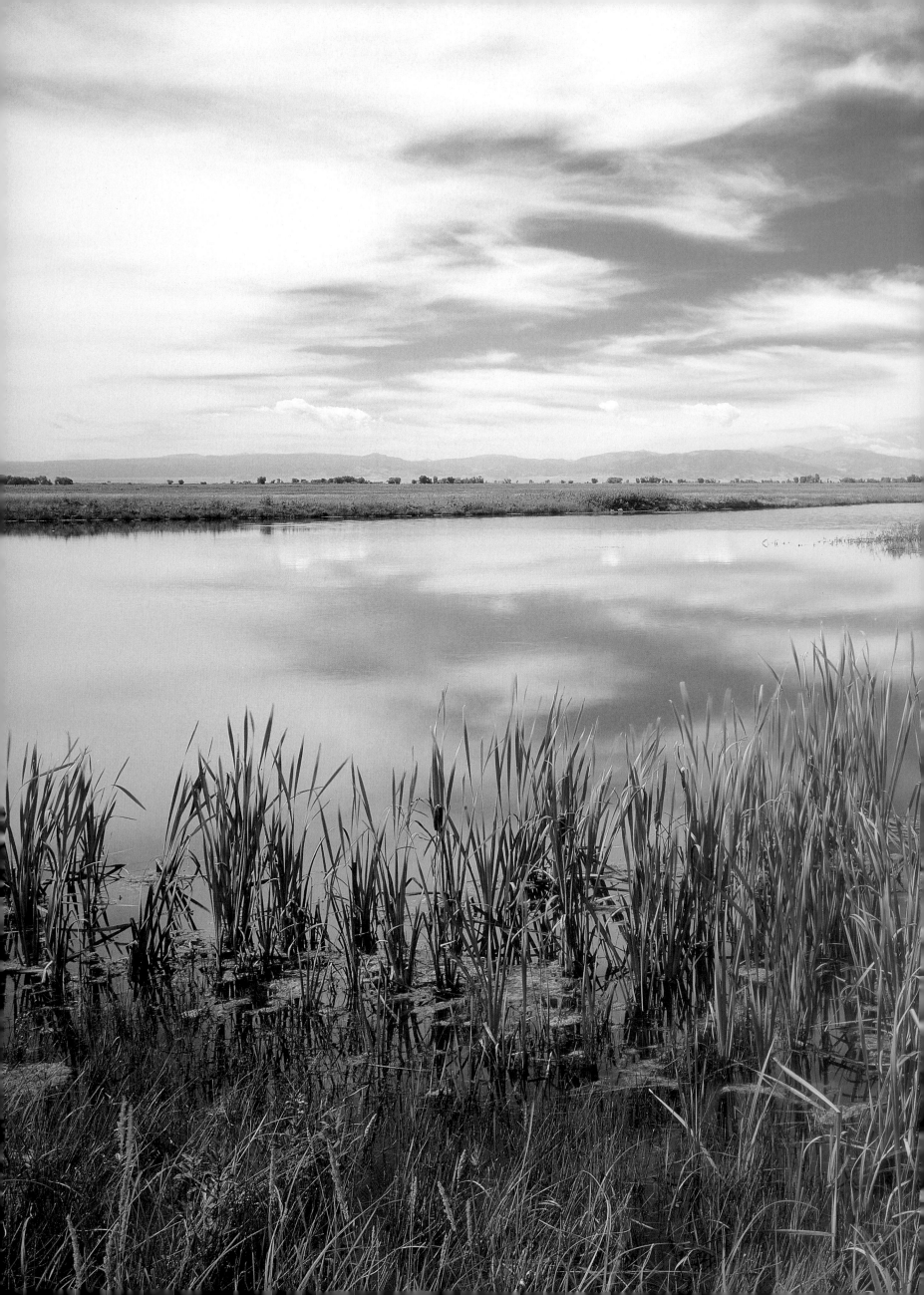

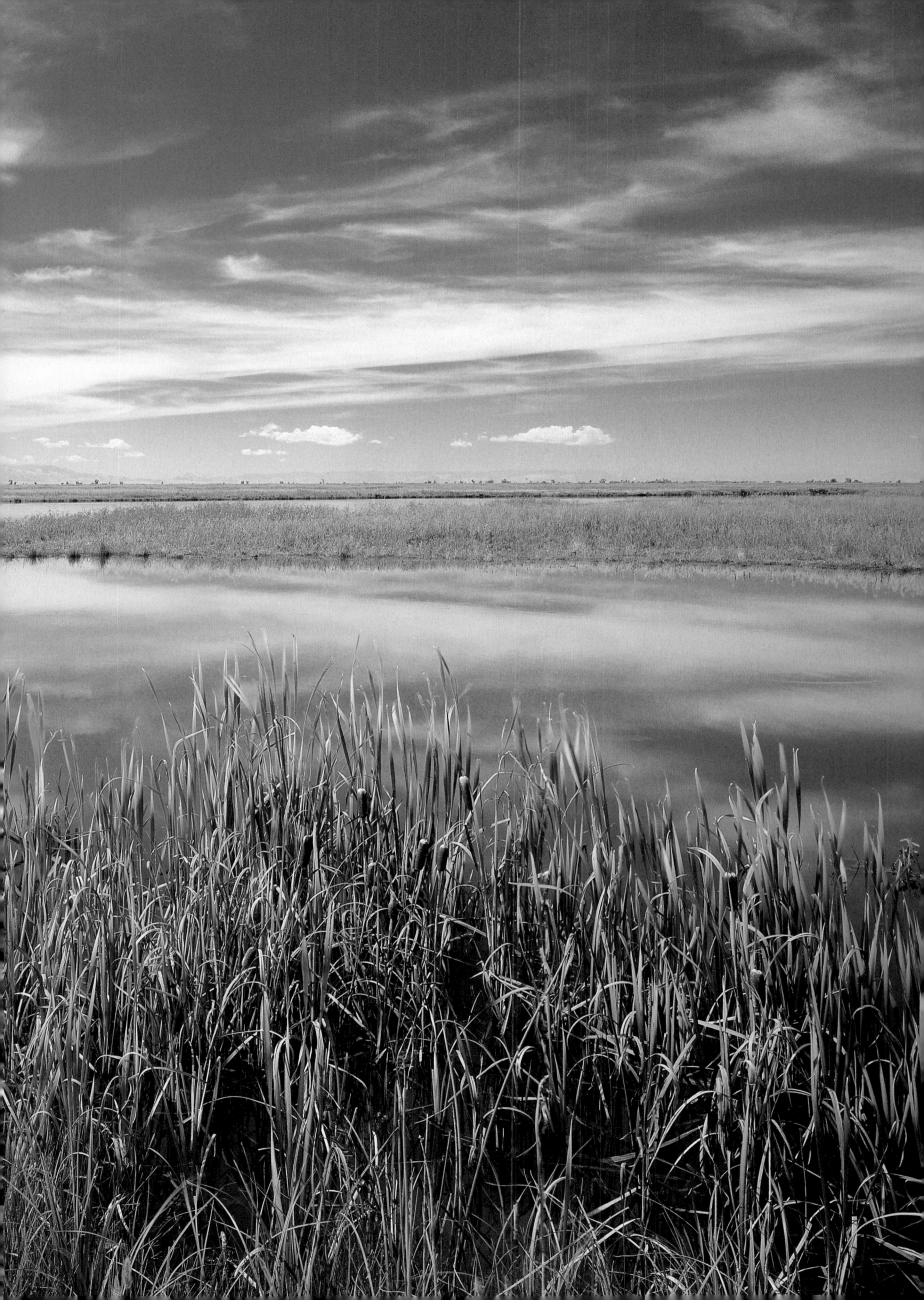

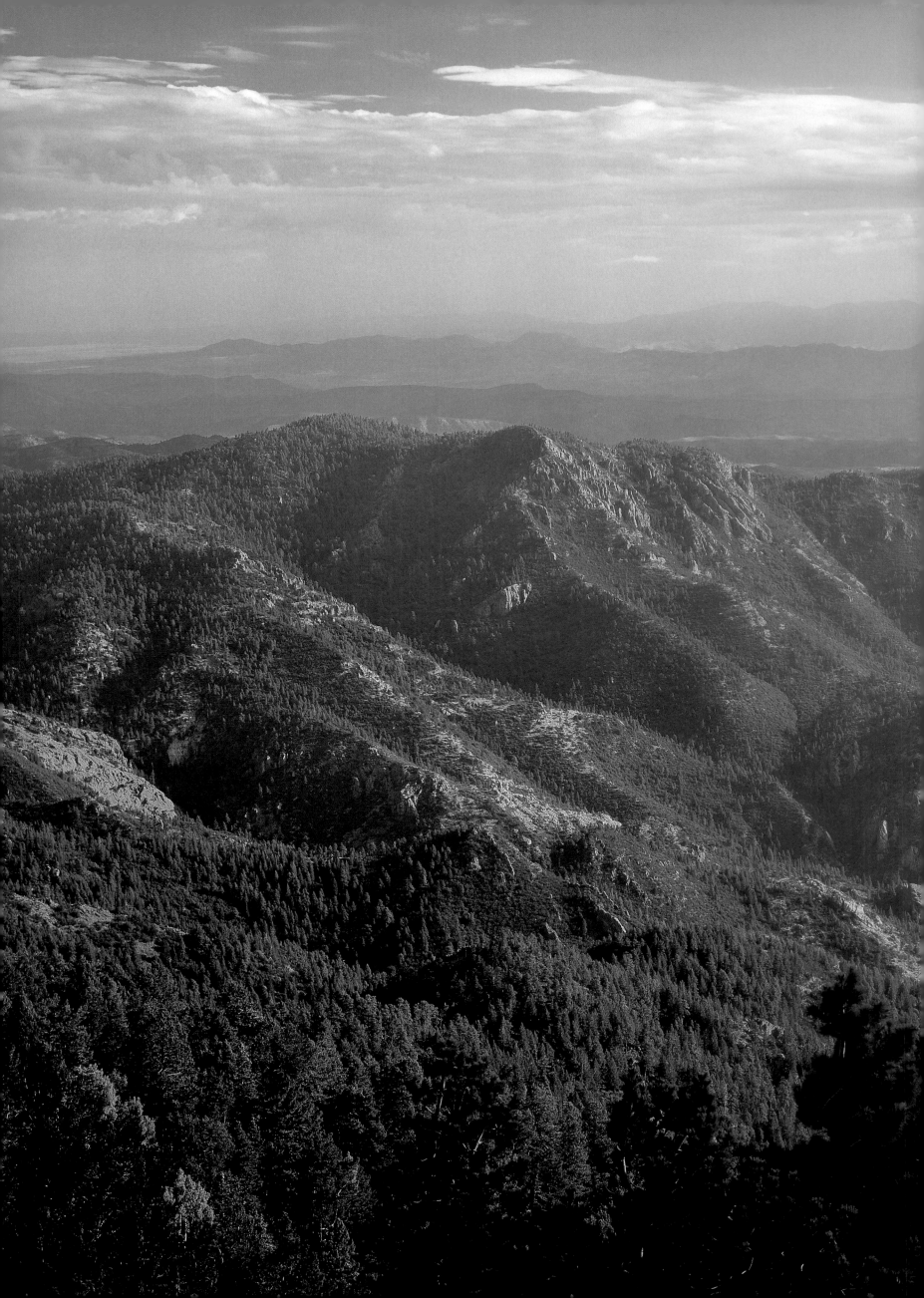

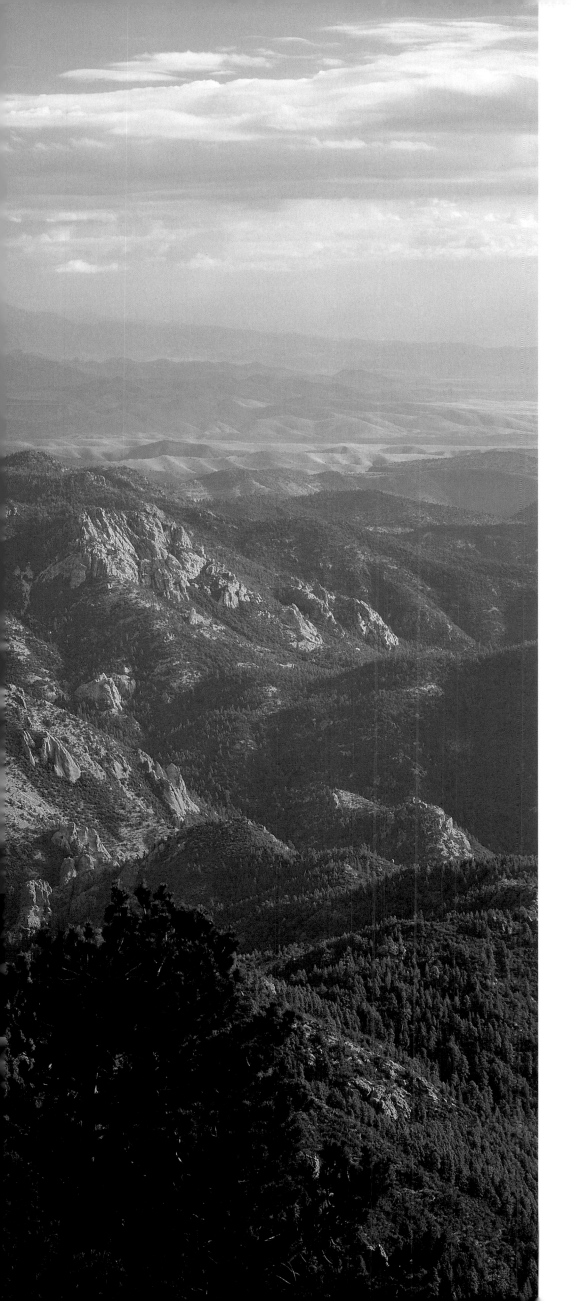

View of Aldo Leopold Wilderness from Gila National Forest, New Mexico
Aldo Leopold, an eloquent spokesman for wilderness protection, wrote "Wilderness is a resource which can shrink but not grow. . . . The creation of new wilderness in the full sense of the word is impossible. We must preserve our wild lands now."

previous pages: **Alamosa National Wildlife Refuge, Colorado**
These marshes along the Rio Grande provide habitat for great numbers of ducks, geese and shorebirds. Each spring and autumn, thousands of sandhill cranes migrate through the area, and sometimes a few rare whooping cranes accompany them.

overleaf: **Jasper National Park, Alberta**
As autumn progresses, flecks of gold seem to be carried from the marsh grasses to the surrounding hillsides. The speed at which the trees change color is highly dependent on the weather. In some cases, it happens virtually overnight.

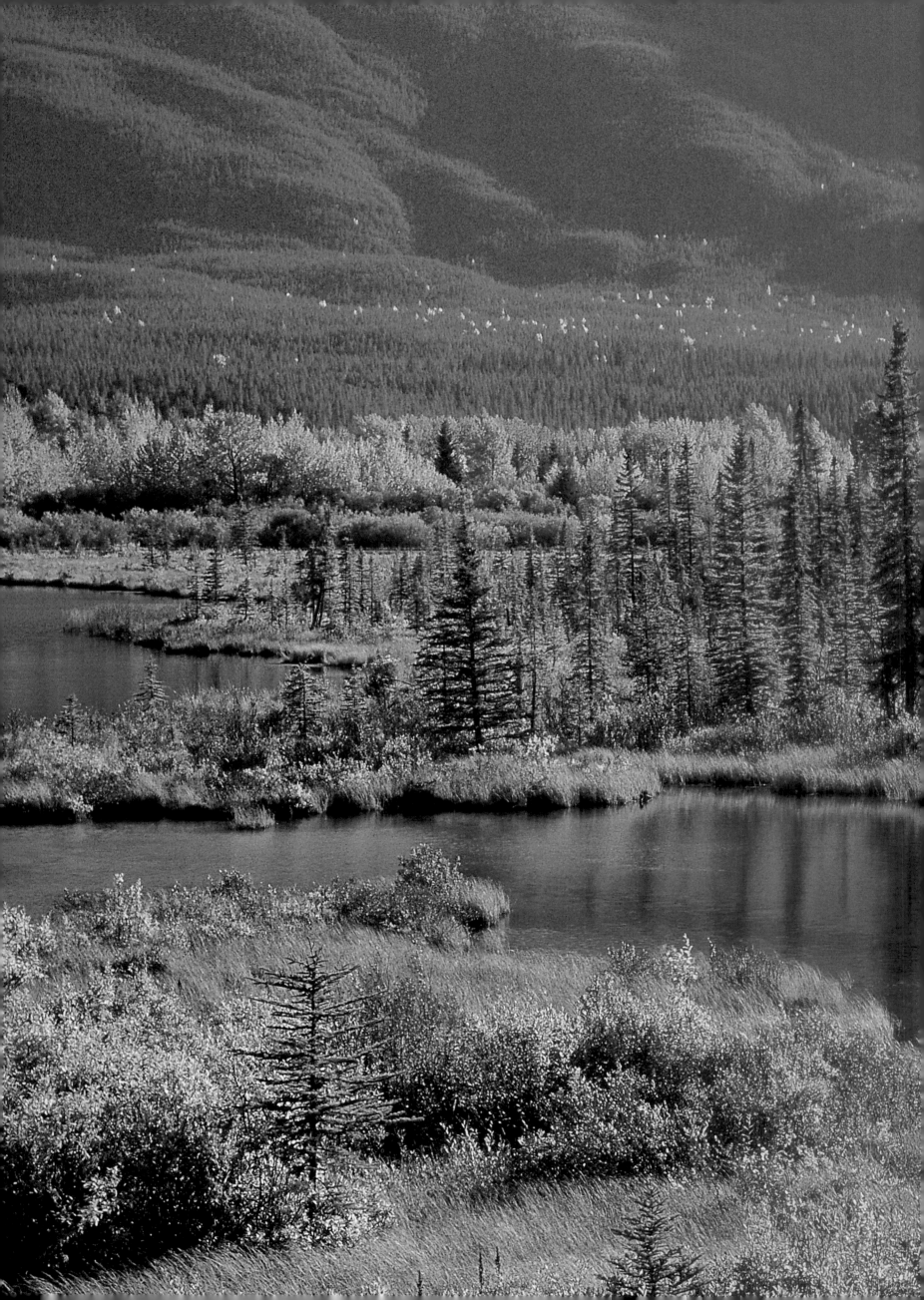

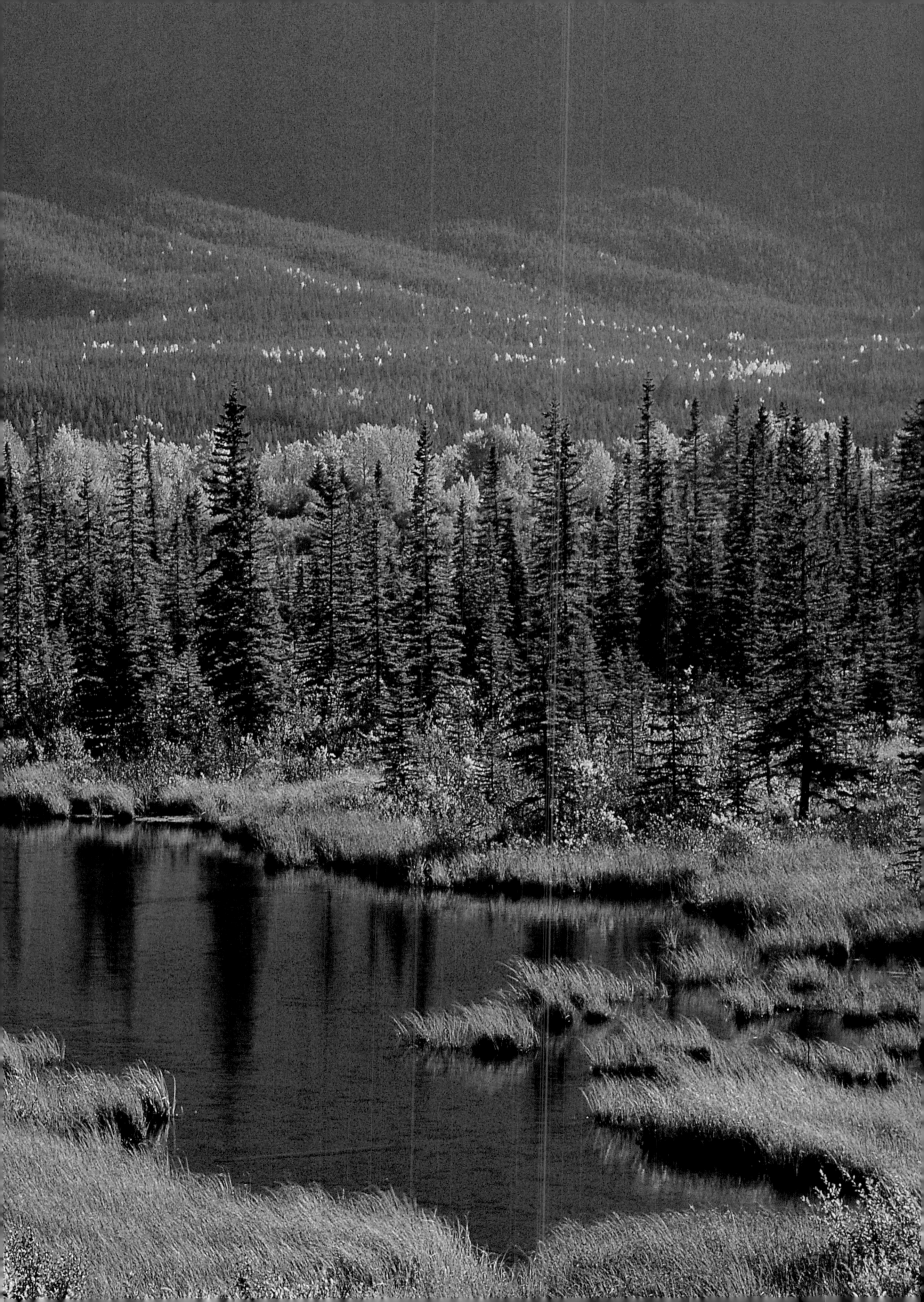

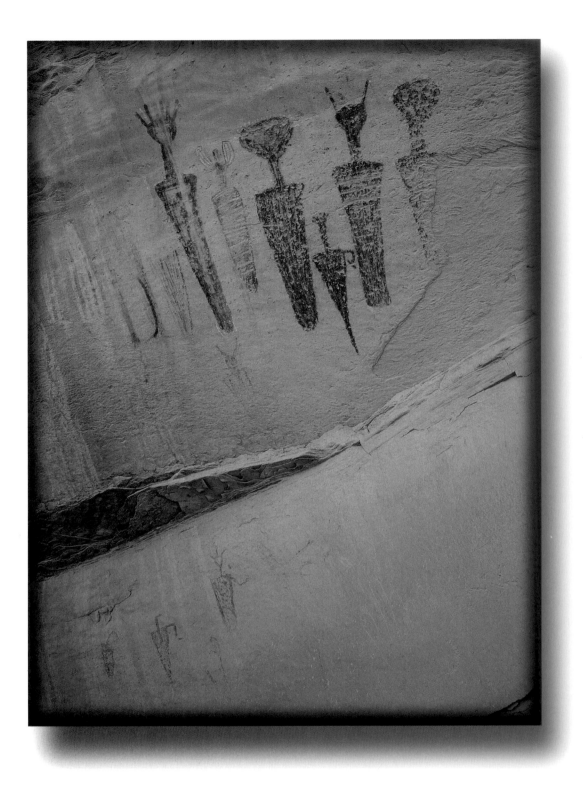

Book Cliffs, Colorado

These enigmatic "Carrot Men" pictographs are from the White River area of Colorado. Archaeological evidence indicates that humans continuously occupied the area south of the White River from 2700 B.C. until about 750 years ago.

right: **Mount Timpanogos Wilderness, Utah**

Sunrise on a crisp October morning reveals a blanket of fog near the base of the Timpanogos Range. This part of the Wasatch Mountains holds a buried treasure: on the slope of Mount Timpanogos, groundwater has dissolved the 330-million-year-old limestone and formed caves filled with delicate ornamentation, including strange curlicues called helictites.

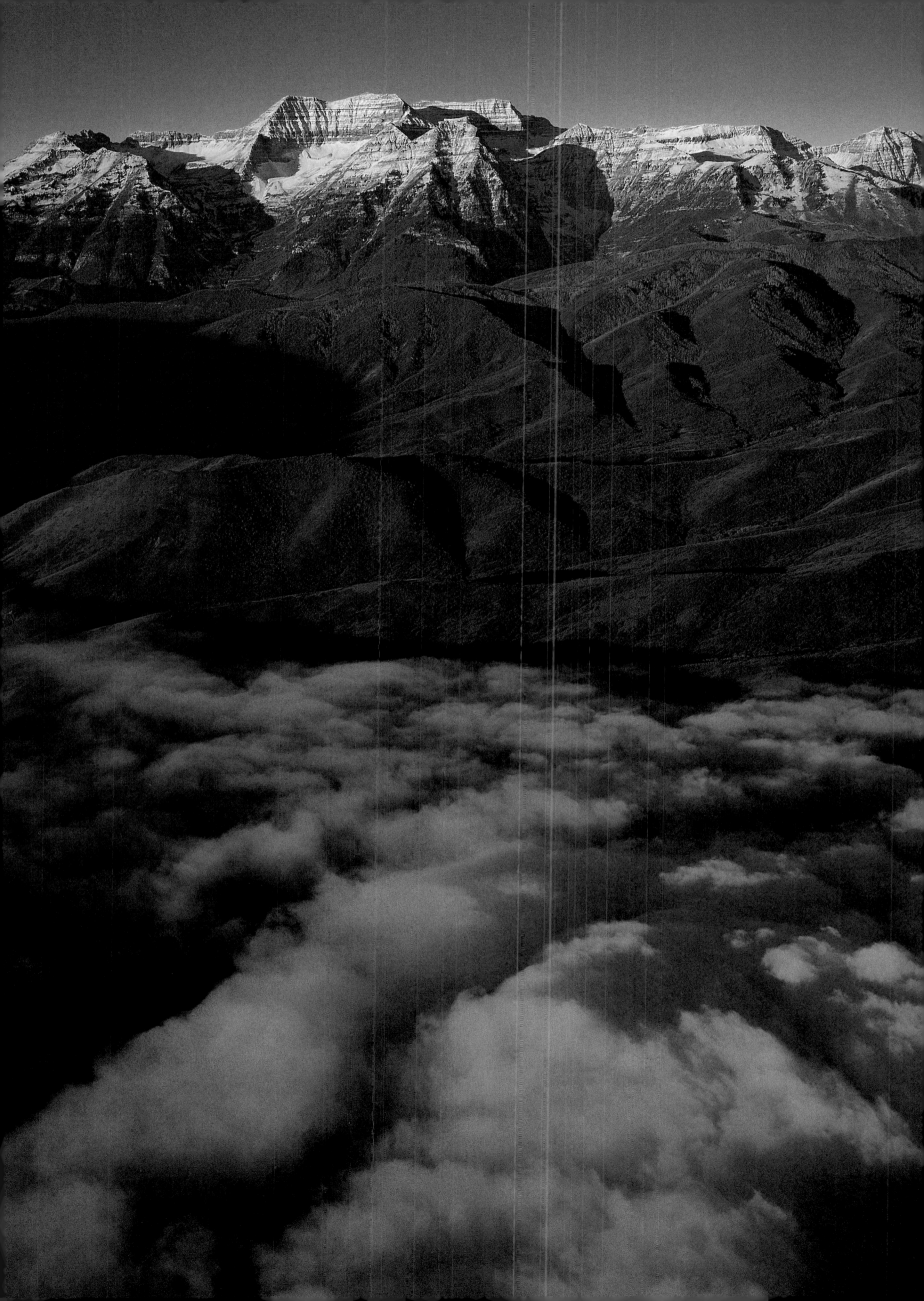

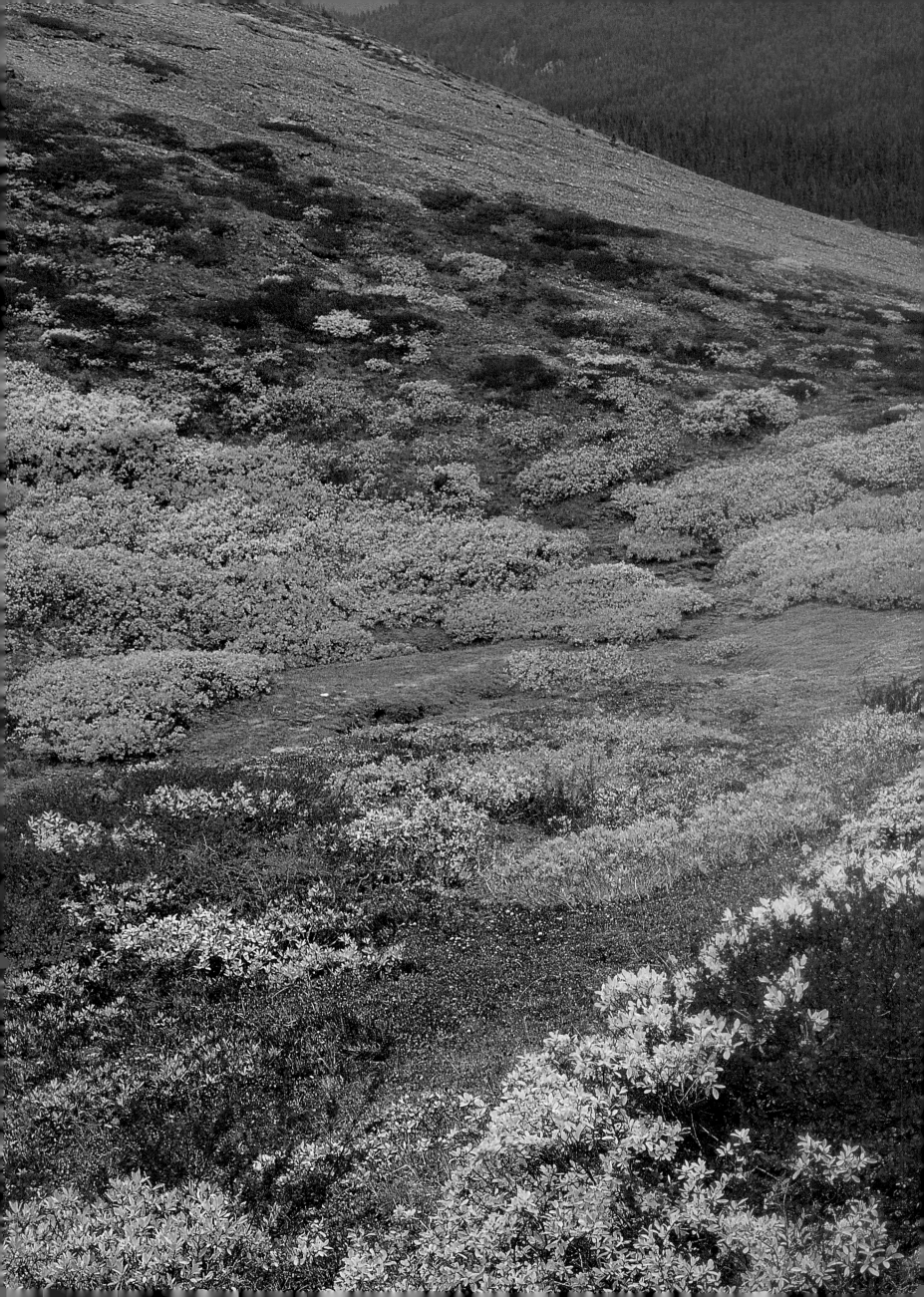

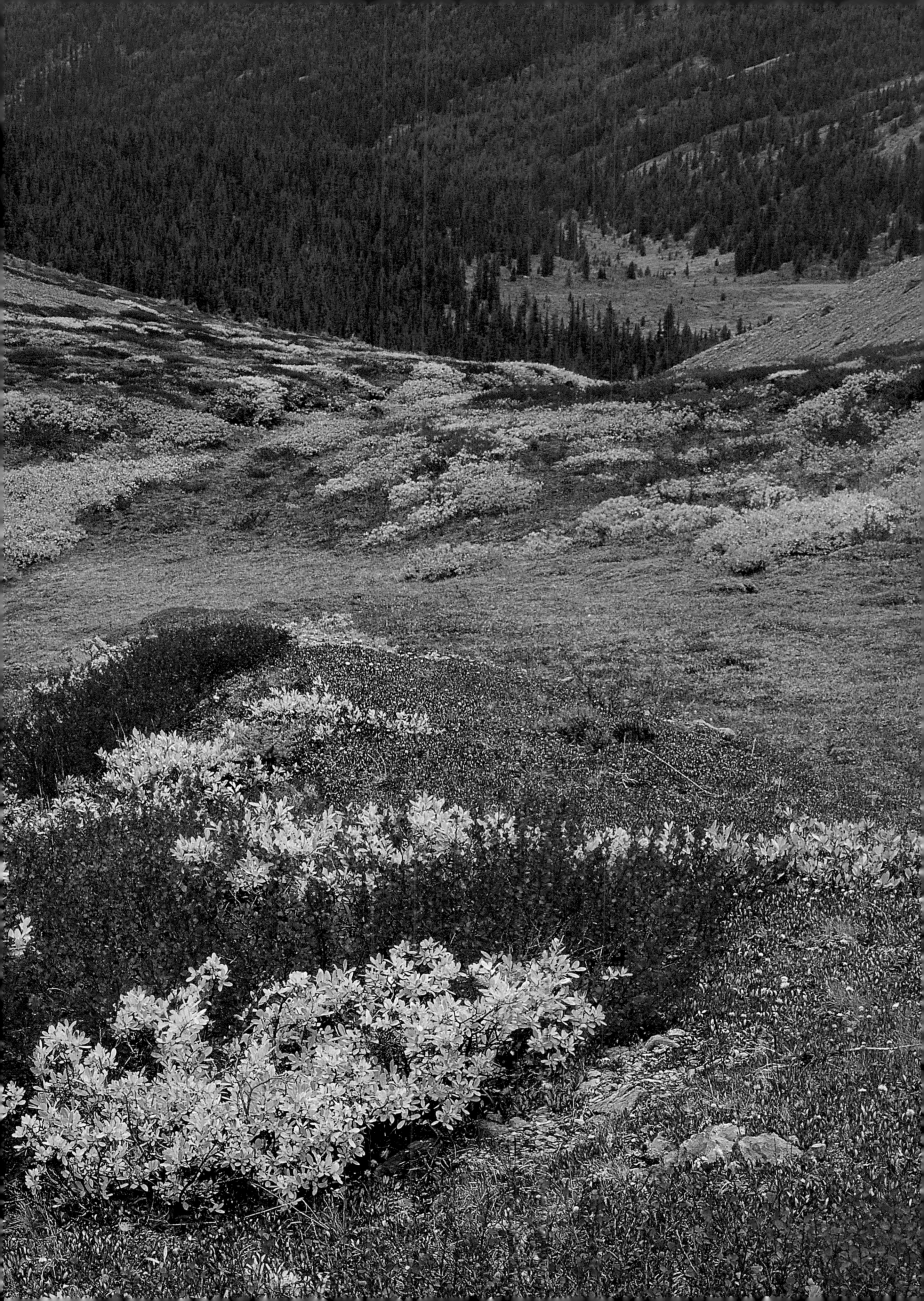

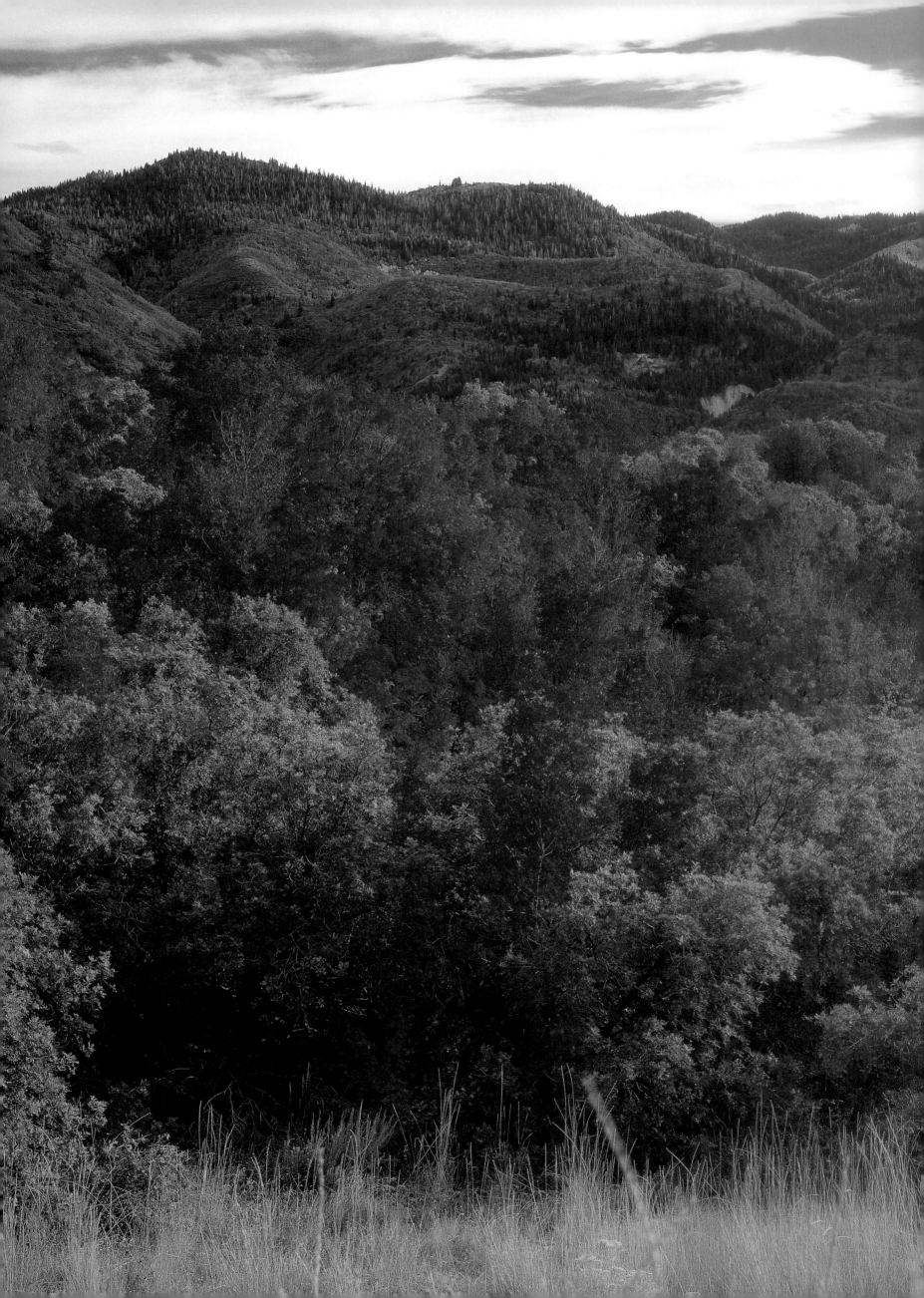

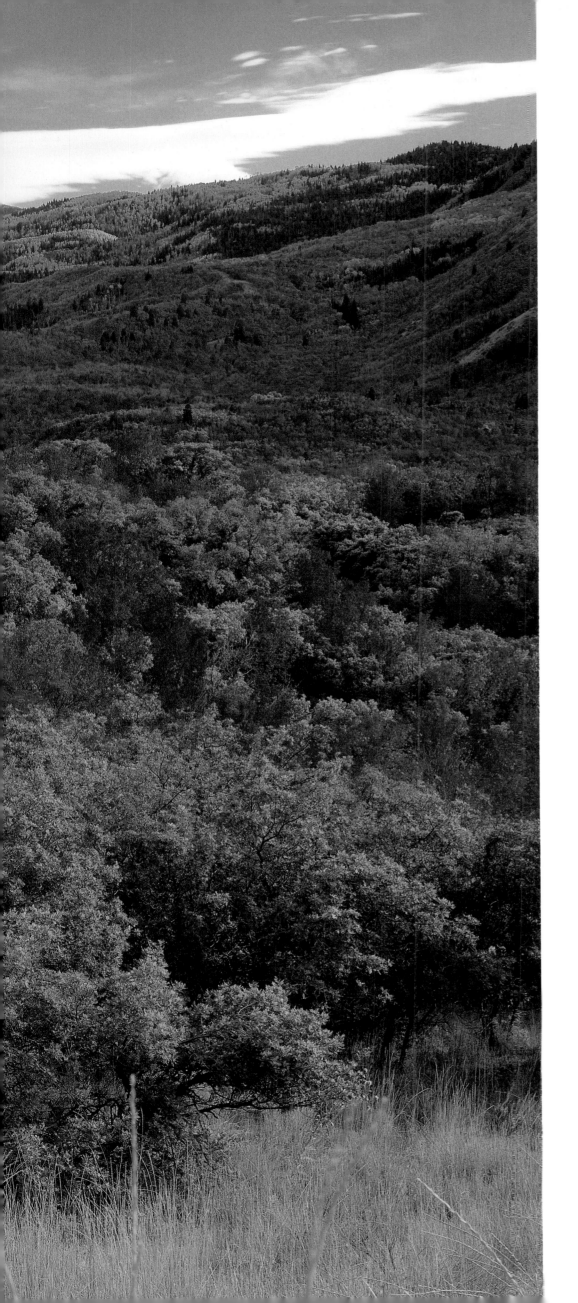

Uinta National Forest, Utah
Trees such as these maples actually contain red and yellow pigments in their leaves throughout the growing season, but the green of chlorophyll overpowers them. The colors we associate with autumn only become visible when the tree stops producing chlorophyll in preparation for winter dormancy.

previous pages: **Jasper National Park, Alberta** Wilcox Pass, named for Walter Wilcox, who crossed the pass in 1896, is an excellent example of alpine tundra. Here, above the timberline, ground-hugging plants persevere despite the harsh climate and brief growing season.

overleaf: **Uinta National Forest, Utah**
The U.S. Forest Service realizes what a draw the beautiful fall colors of the mountains can be: the website for this forest displays a "Fall Colors Map" that indicates where maple and oak brush such as this can be found.

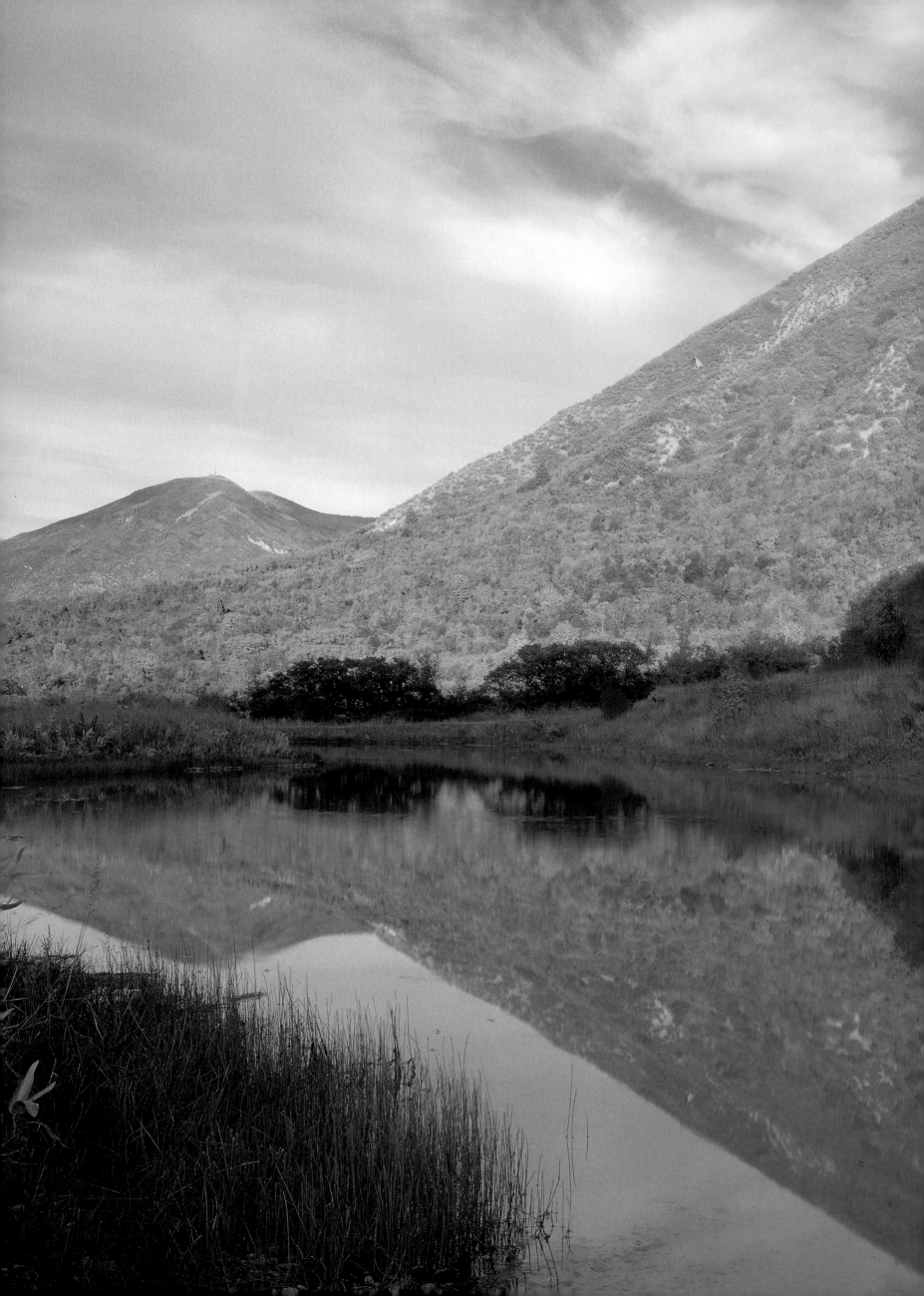

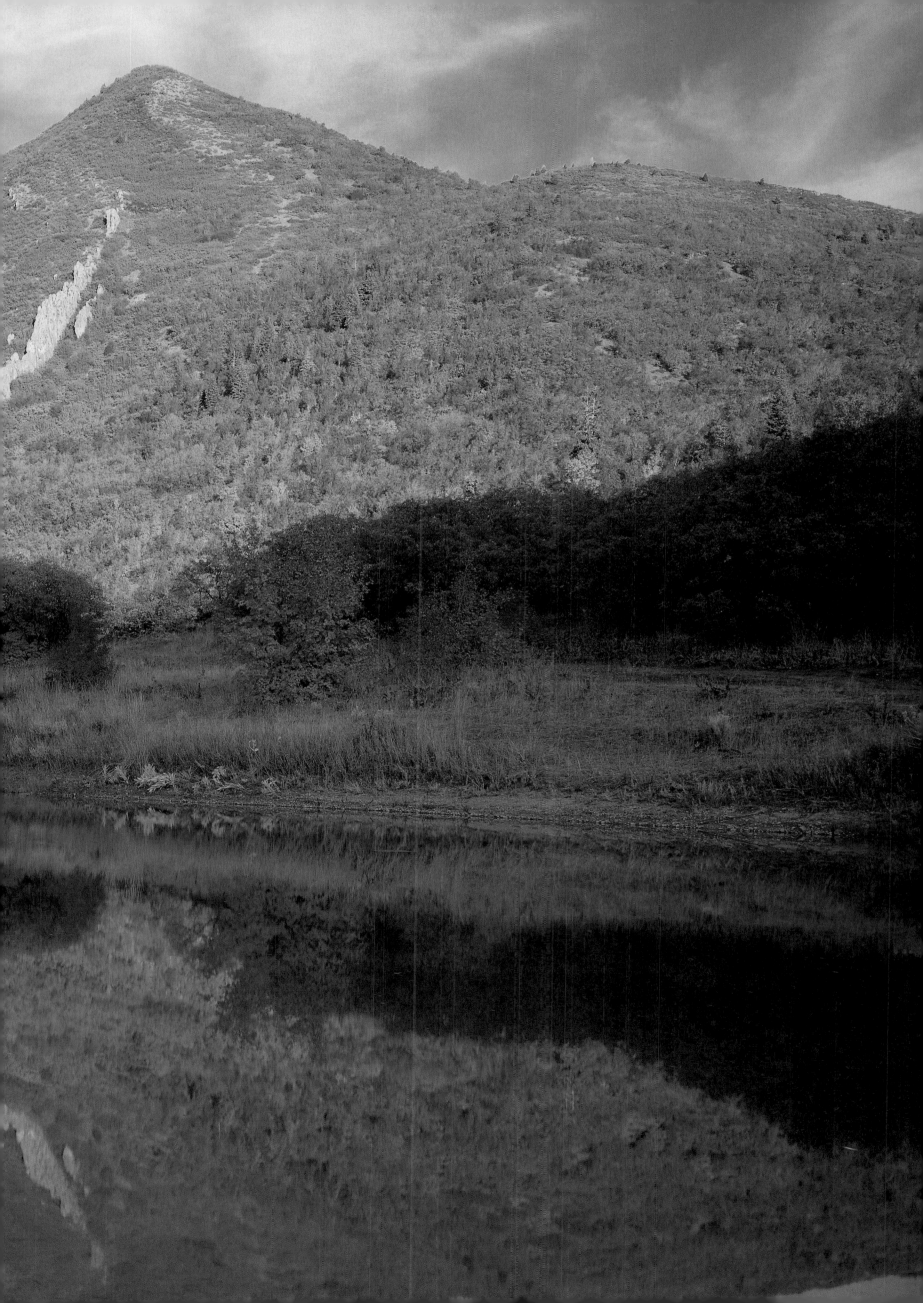

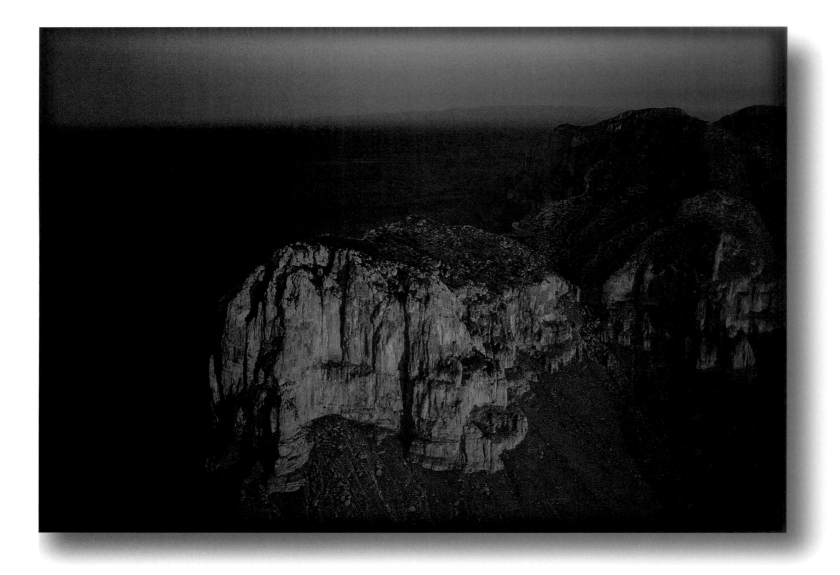

El Capitan, Guadalupe Mountains National Park, Texas

After the summer solstice, days grow shorter and sunrise arrives later each day.
The change in day length triggers other events; for instance, for some animals, such as
bears and ground squirrels, it is a signal to begin hibernation. Hibernating animals begin
their winter sleep at different times, depending on their species and location.

right: **Mount Robson Provincial Park, British Columbia**

At 12,972 feet (3,954 meters), Mount Robson is the Canadian Rockies' tallest peak—
tall enough to create its own weather. When moist air is forced to climb over this
mountain, water droplets condense to form clouds that trail downwind from the peak.

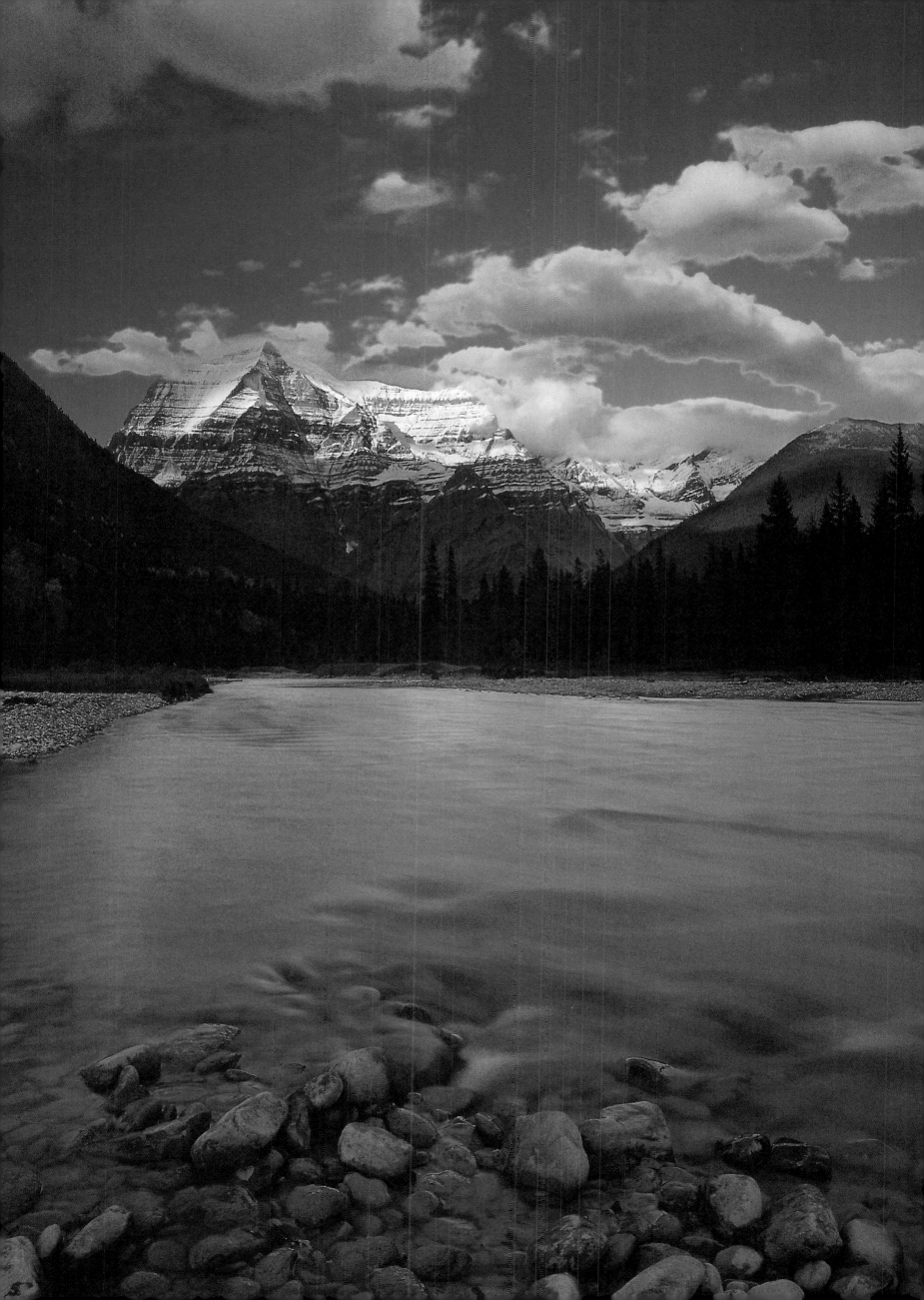

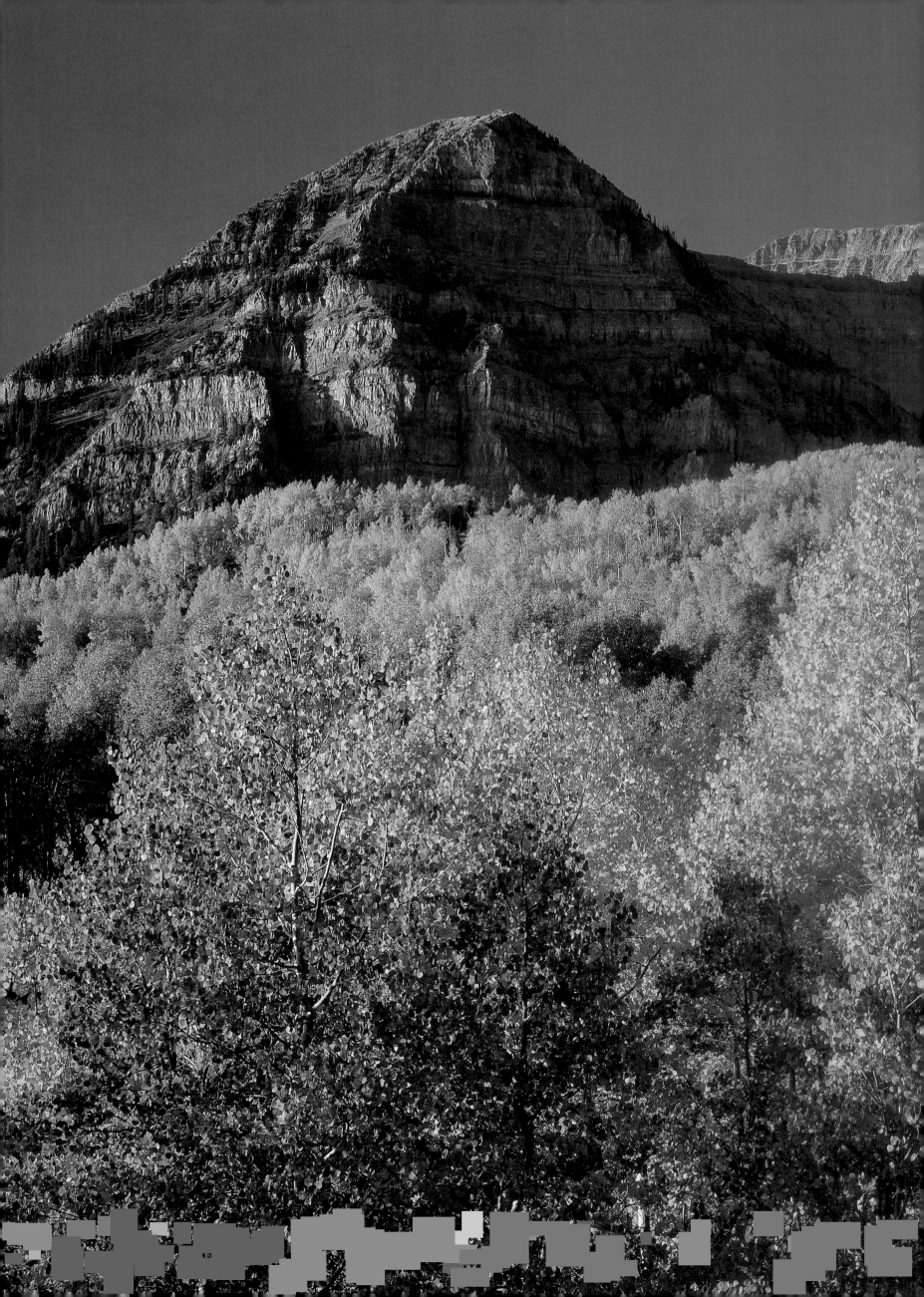

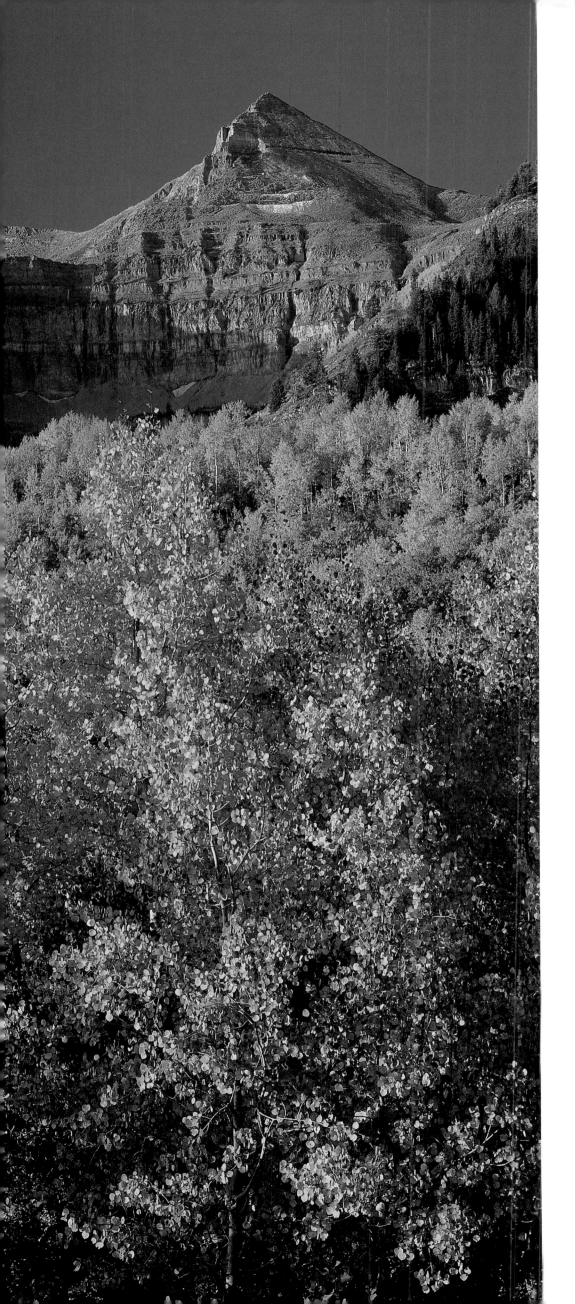

Mount Timpanogos Wilderness, Utah Aspens magically transform the slopes in front of Mount Timpanogos into a golden sea. Although their leaf color can range from deep crimson to bright yellow, yellow is the most common.

previous pages: **Jasper National Park, Alberta** Autumn colors serve to emphasize the timberline. Although a few hardy stragglers penetrate the tundra, this is where it becomes too cold, dry and windy for most trees to survive.

overleaf: **Yoho National Park, British Columbia** Larches signal autumn's arrival at Opabin Pass. Behind them lies Hungabee Mountain, whose name was given by the Stoney people and means "chieftain."

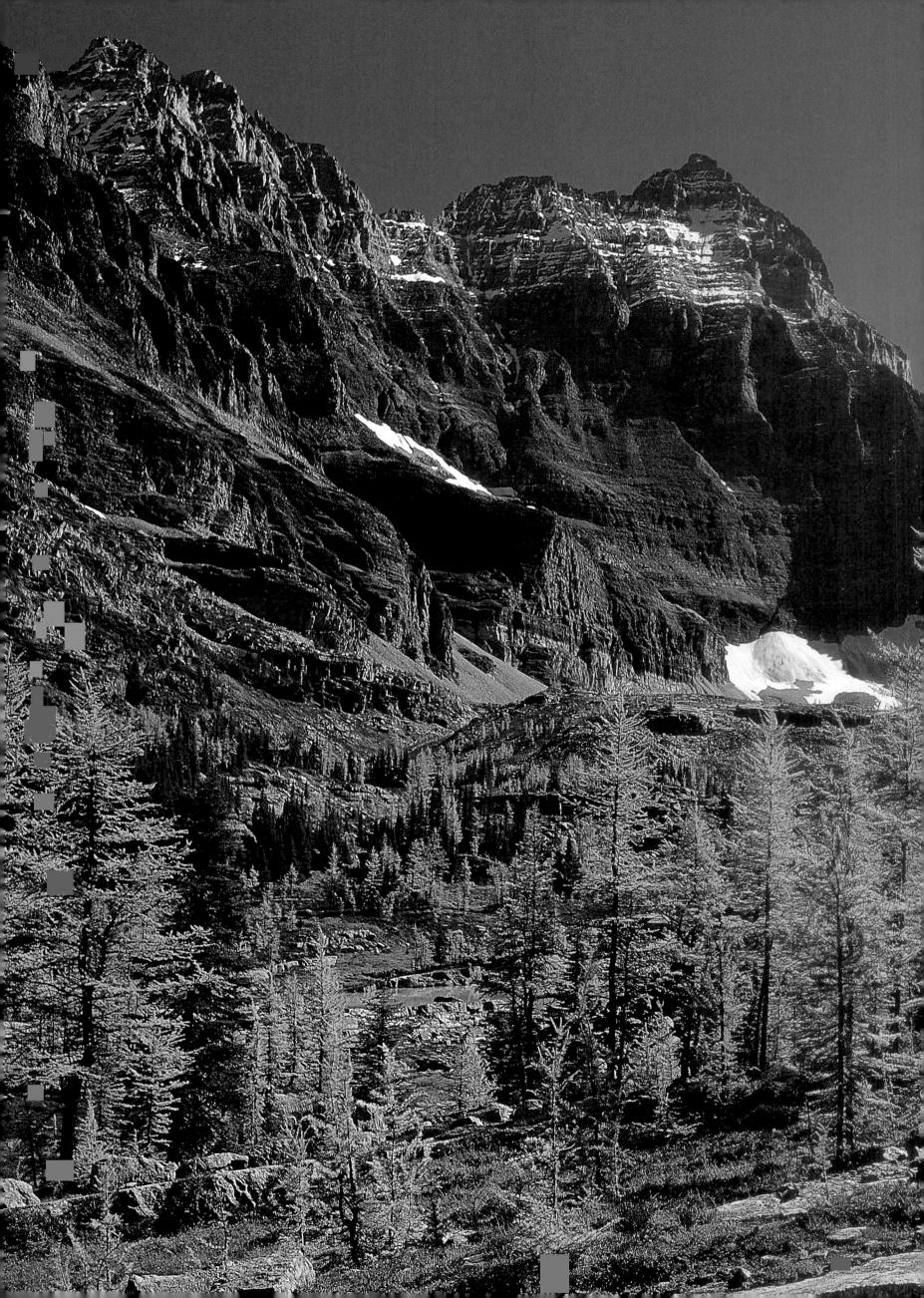

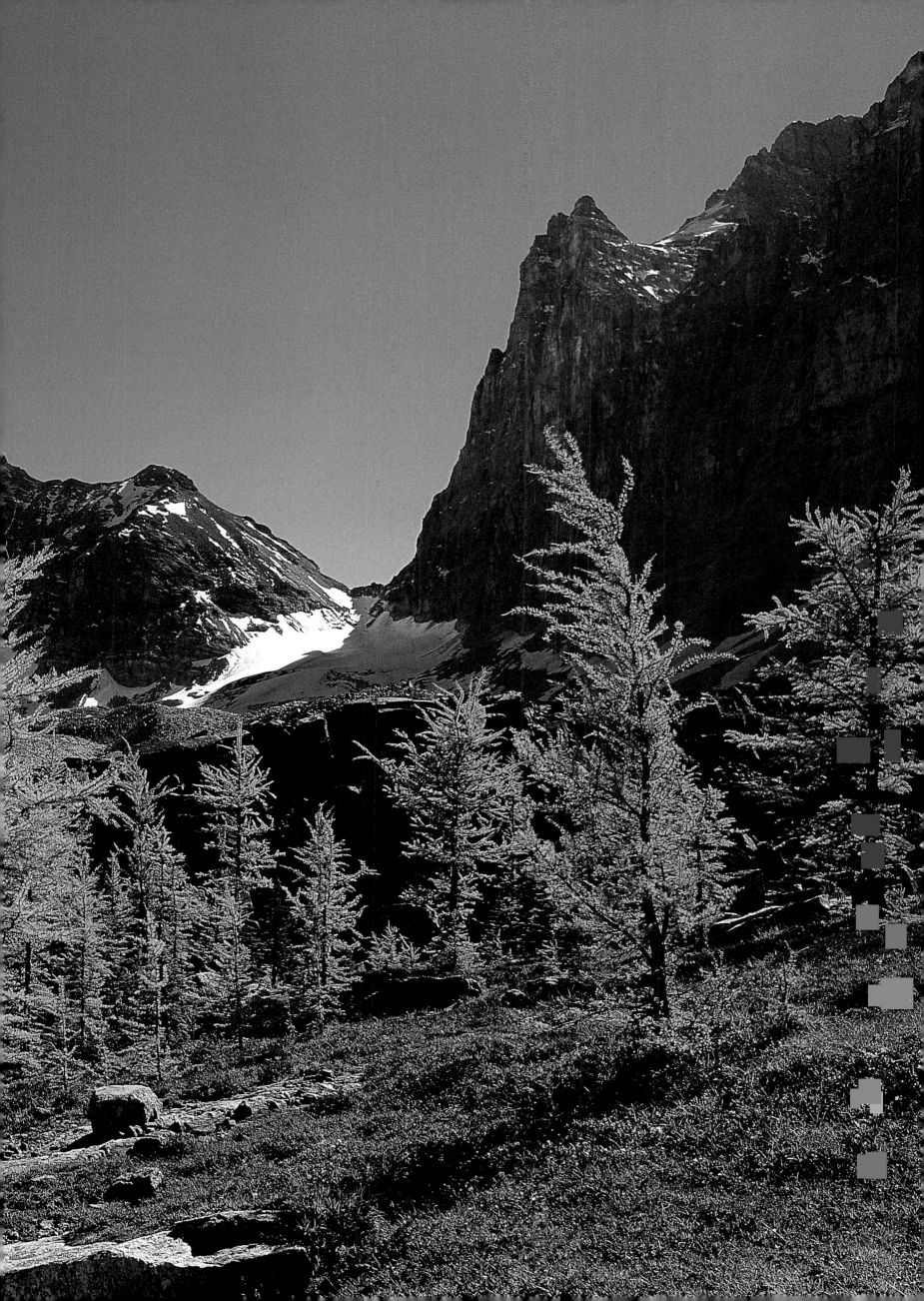

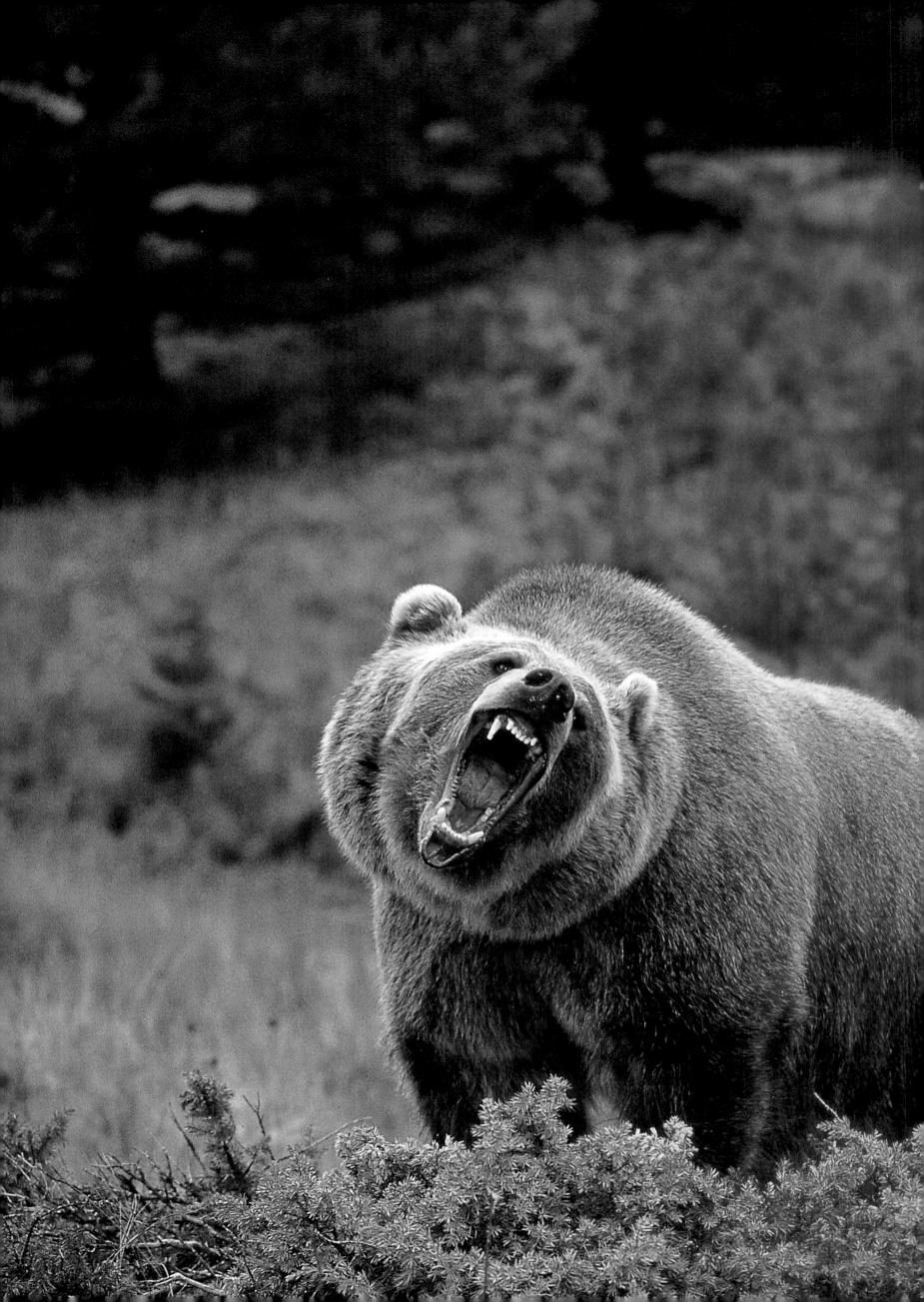

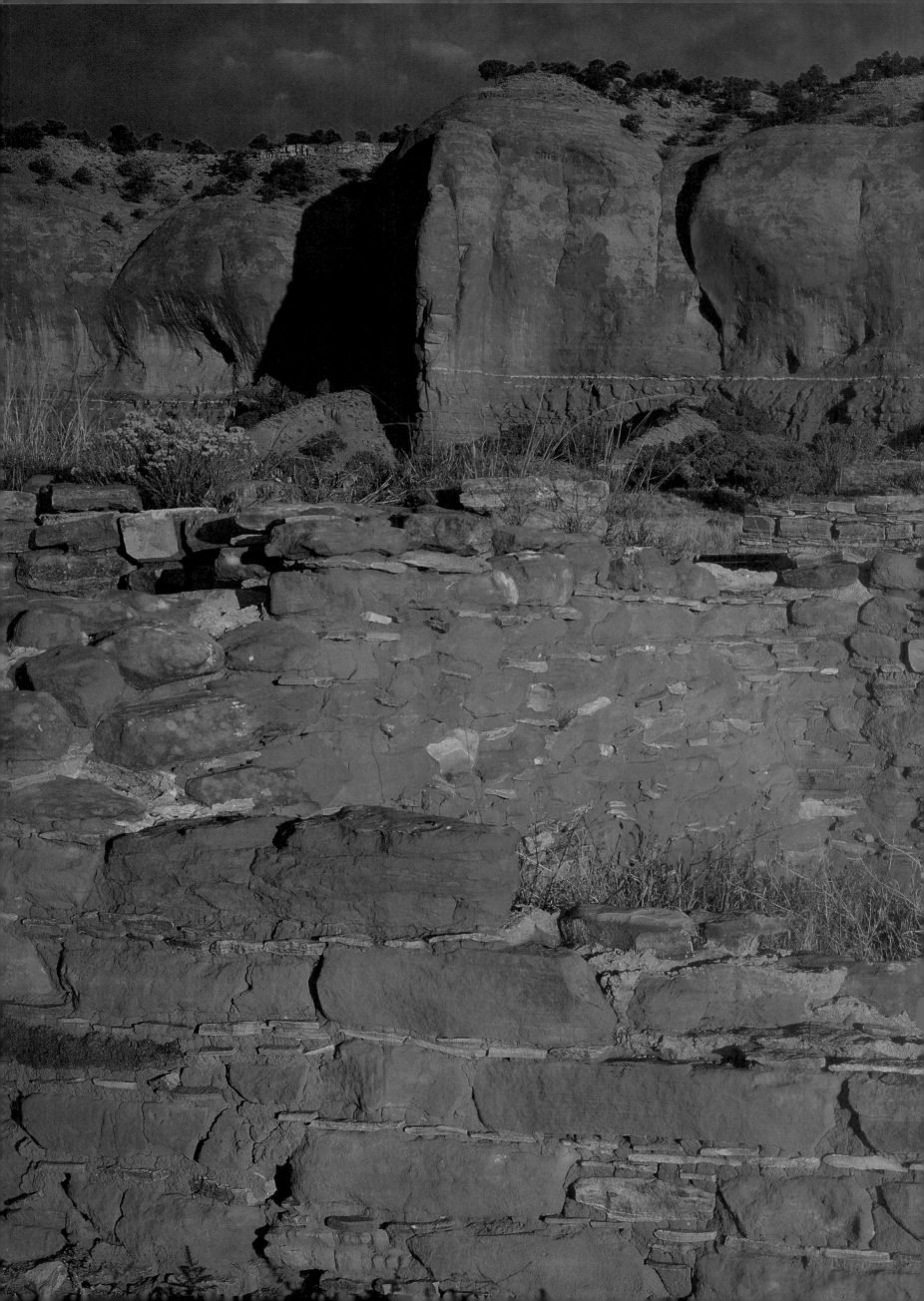

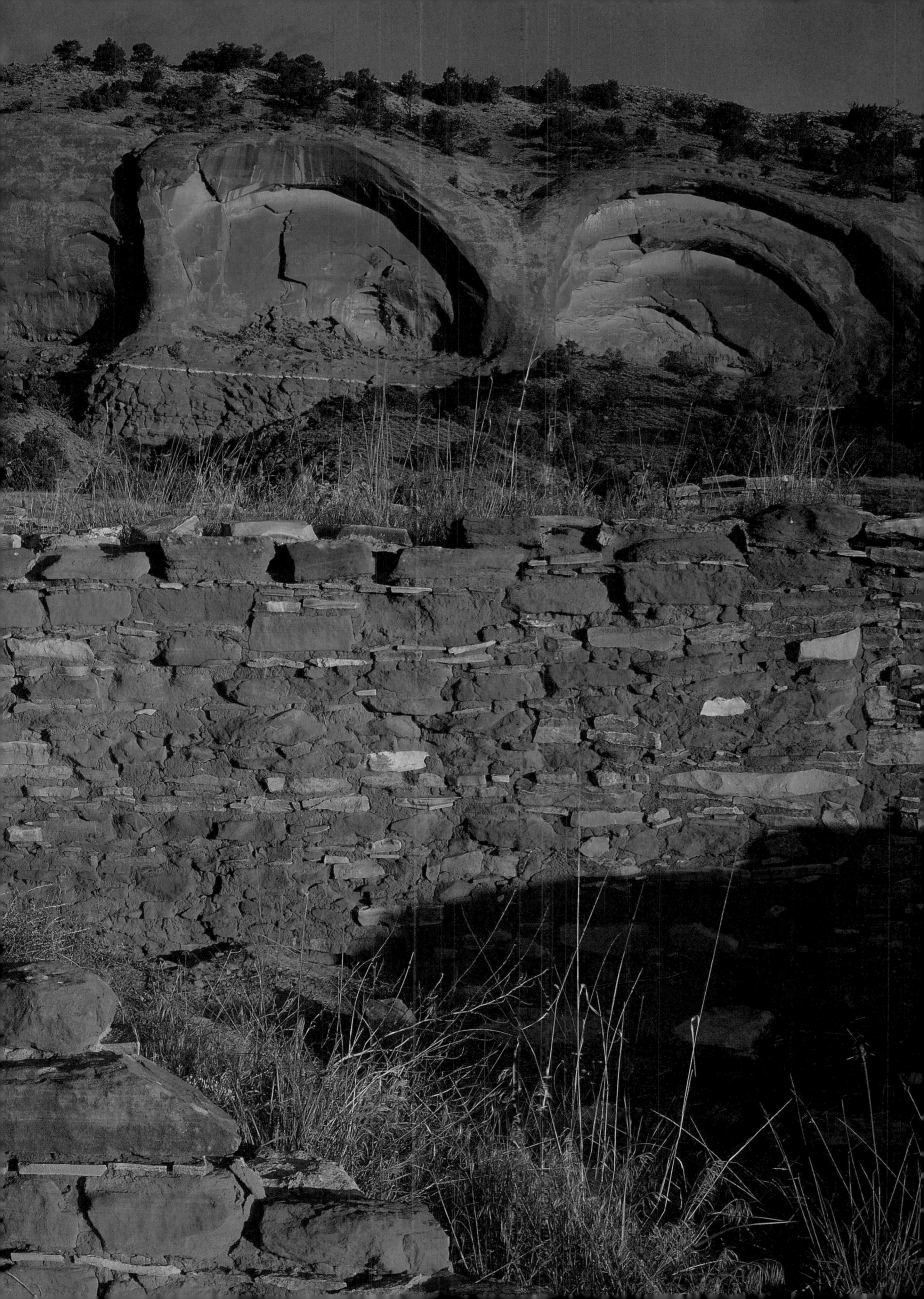

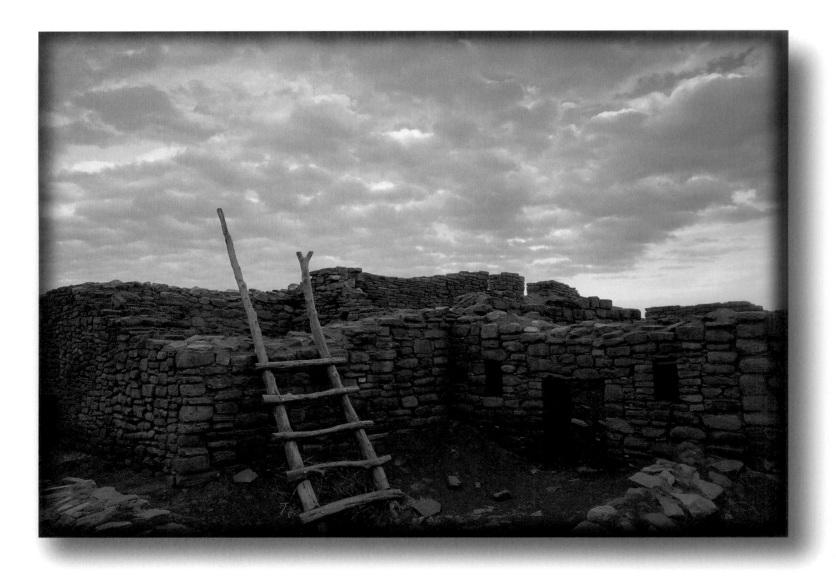

Lowry Pueblo Ruins, Colorado

Only a tiny portion of the ruins at Lowry Pueblo have been excavated: this dwelling and a great kiva. The pueblo, built almost a thousand years ago, at one time covered more than a square mile (2.6 square kilometers) and may have held 1,500 to 1,800 people.

right: Devils Tower National Monument, Wyoming

The Kiowa people tell that long ago a giant bear pursued seven sisters. The girls sought refuge on a great tree stump and, after crying to the spirits for help, were transported to the sky where they became the stars we call the Pleiades. The bear's claw marks are still visible on the now-petrified stump.

overleaf: Sheep River Valley, Alberta

Aspen groves such as this serve as nurseries for other trees. They not only provide shelter but each autumn they drop a thick layer of leaves that decay to provide a rich growing medium for seedlings.

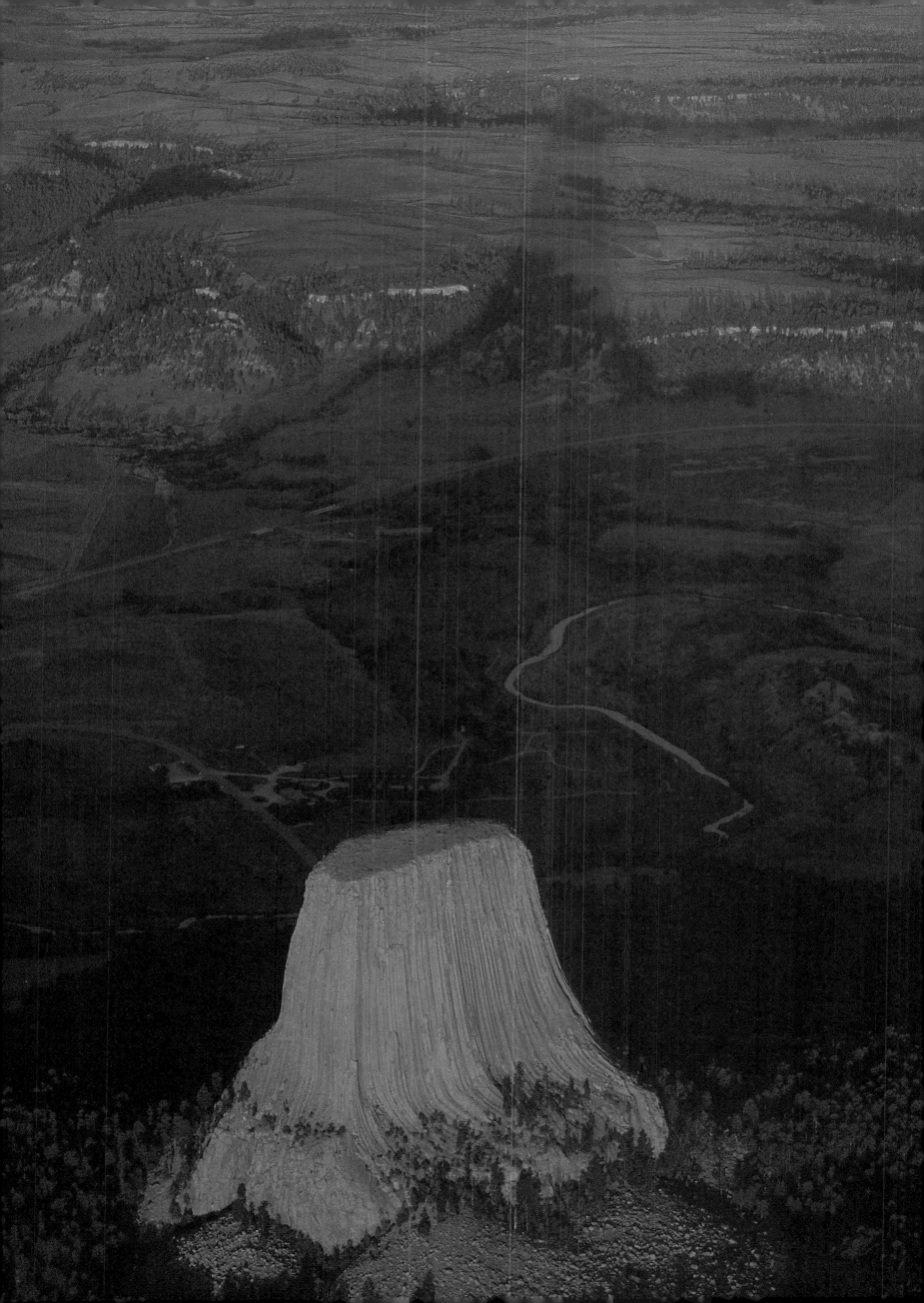

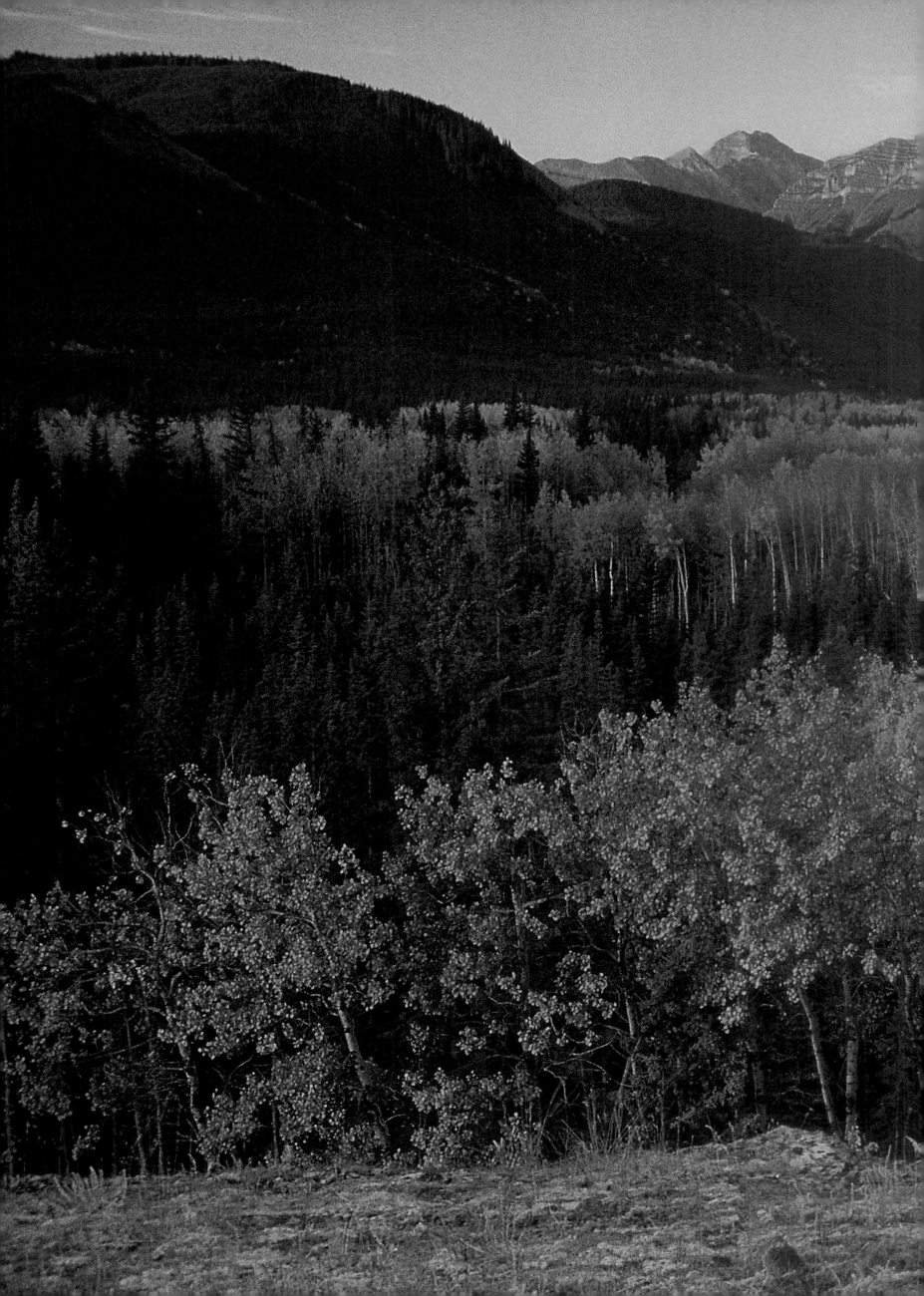

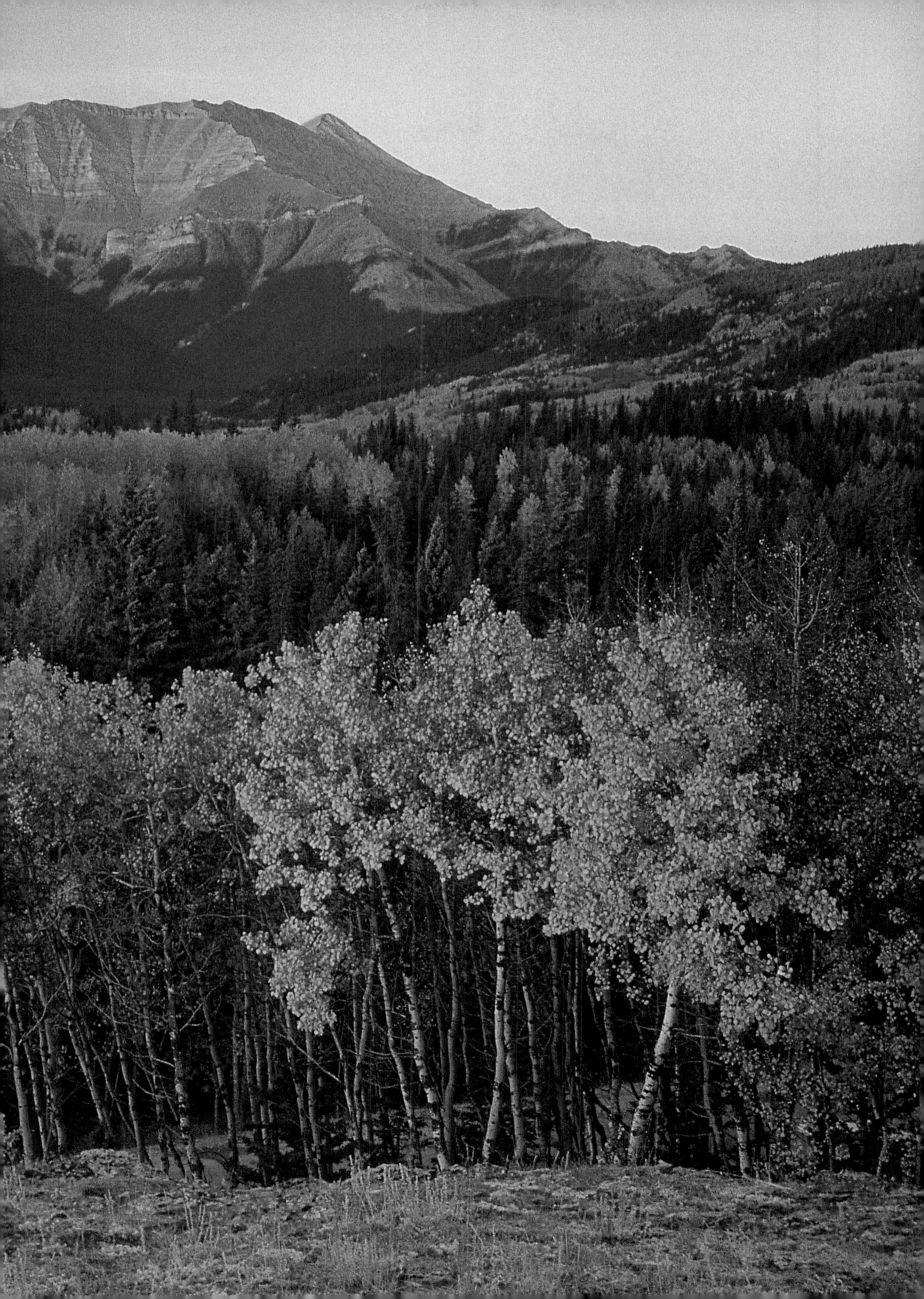

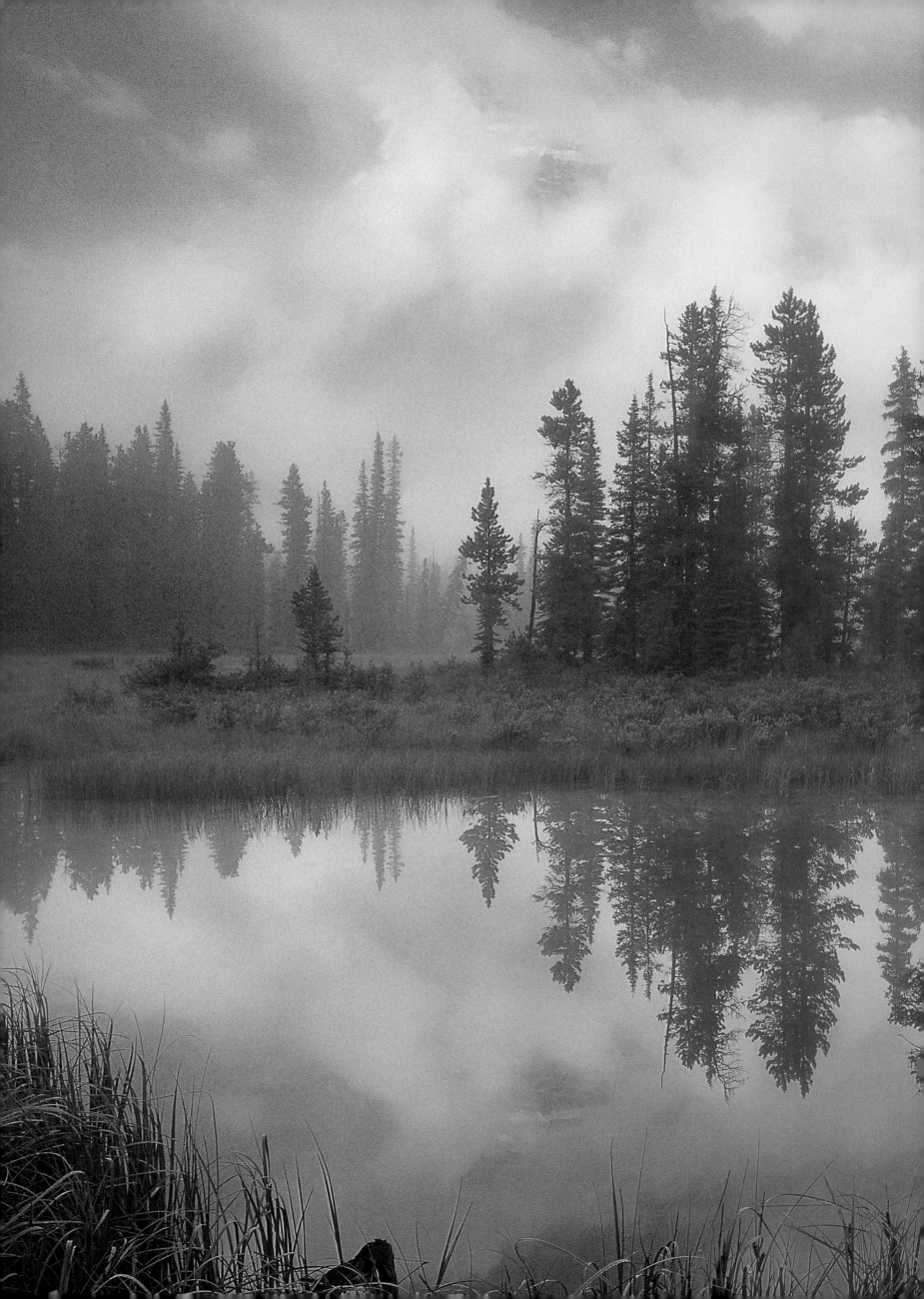

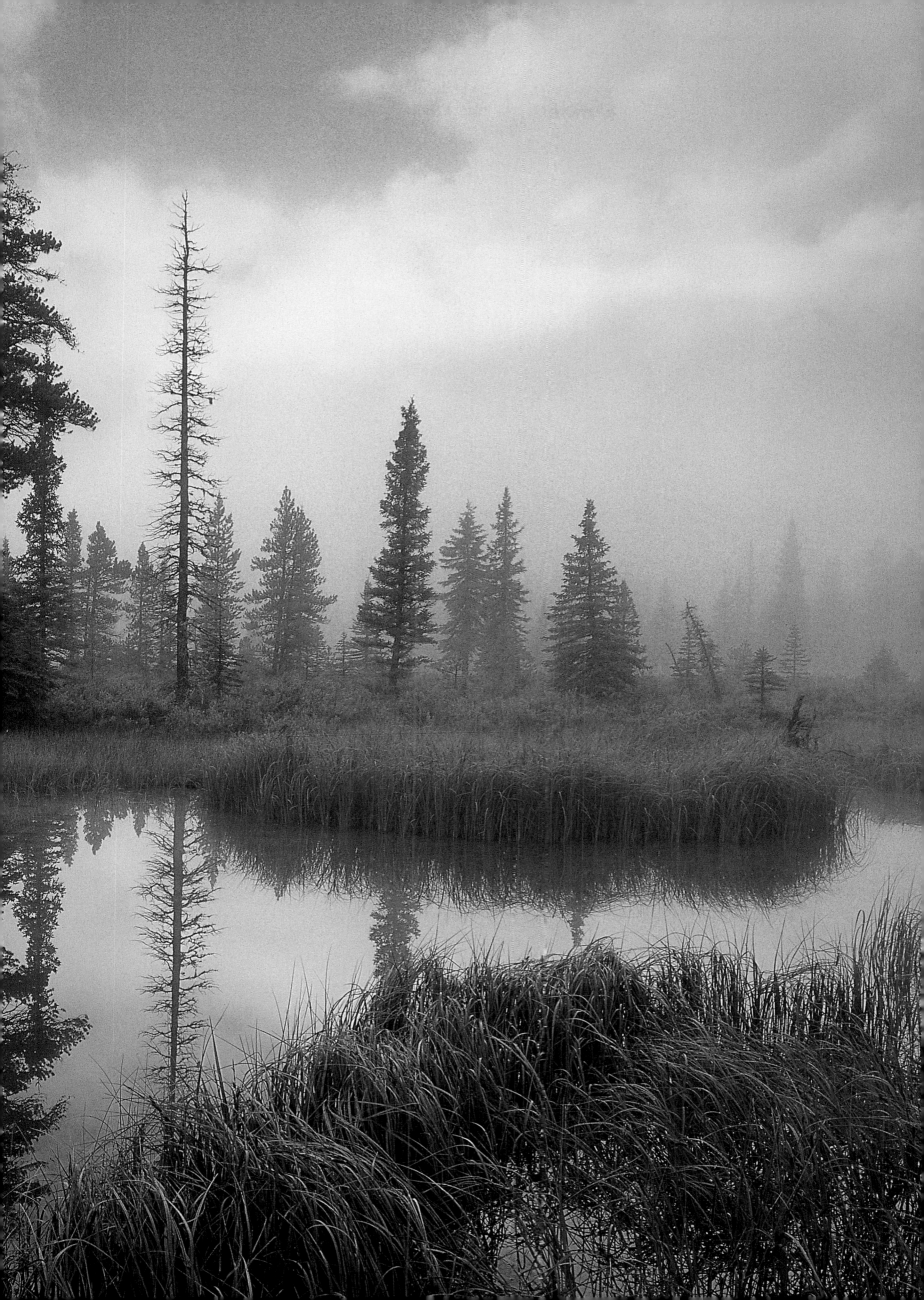

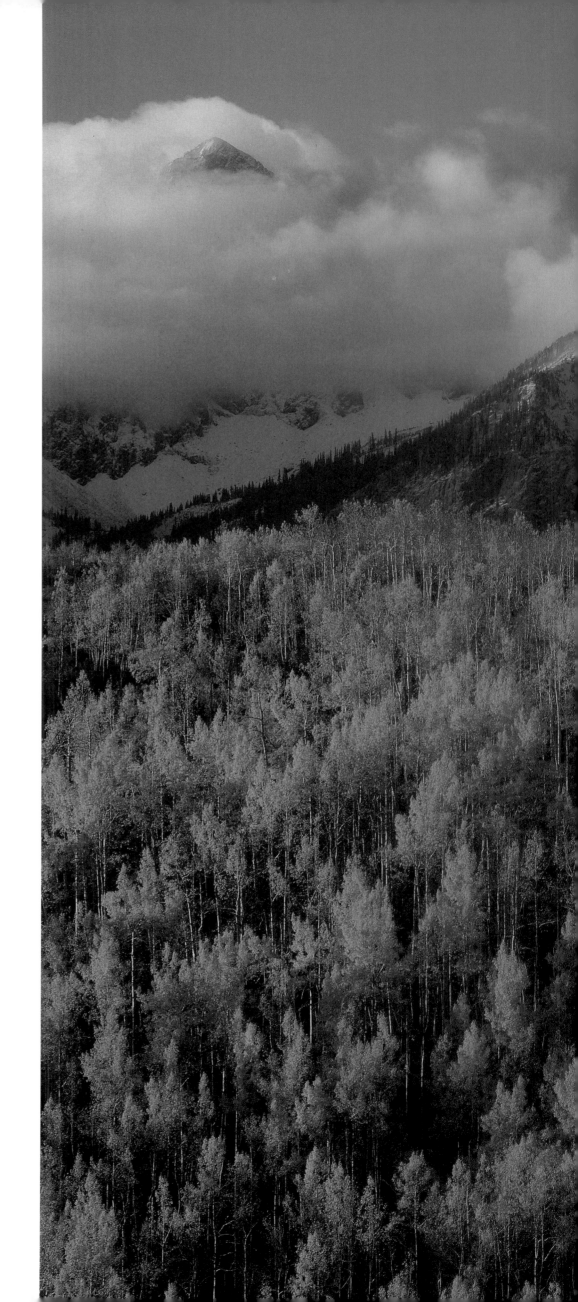

San Juan Mountains, Colorado
Larger than the state of Vermont, the San Juan Mountains and their offshoots sprawl over more than 10,000 square miles (25,900 square kilometers). They are the largest, and perhaps the most rugged, single range in the U. S. portion of the Rockies.

previous pages: **Banff National Park, Alberta** Mount Chephren was originally named Pyramid Mountain, but in 1918 the peak was renamed in order to avoid confusion with the Pyramid Mountain near Jasper. The new name kept a link with the original: Chephren built the second of Egypt's three Great Pyramids.

overleaf: **Waterton Lakes National Park, Alberta** In the foothills, the transition from summer to autumn is sometimes subtle. The changing colors of the trees are muted by the soft golden-browns of surrounding grassland.

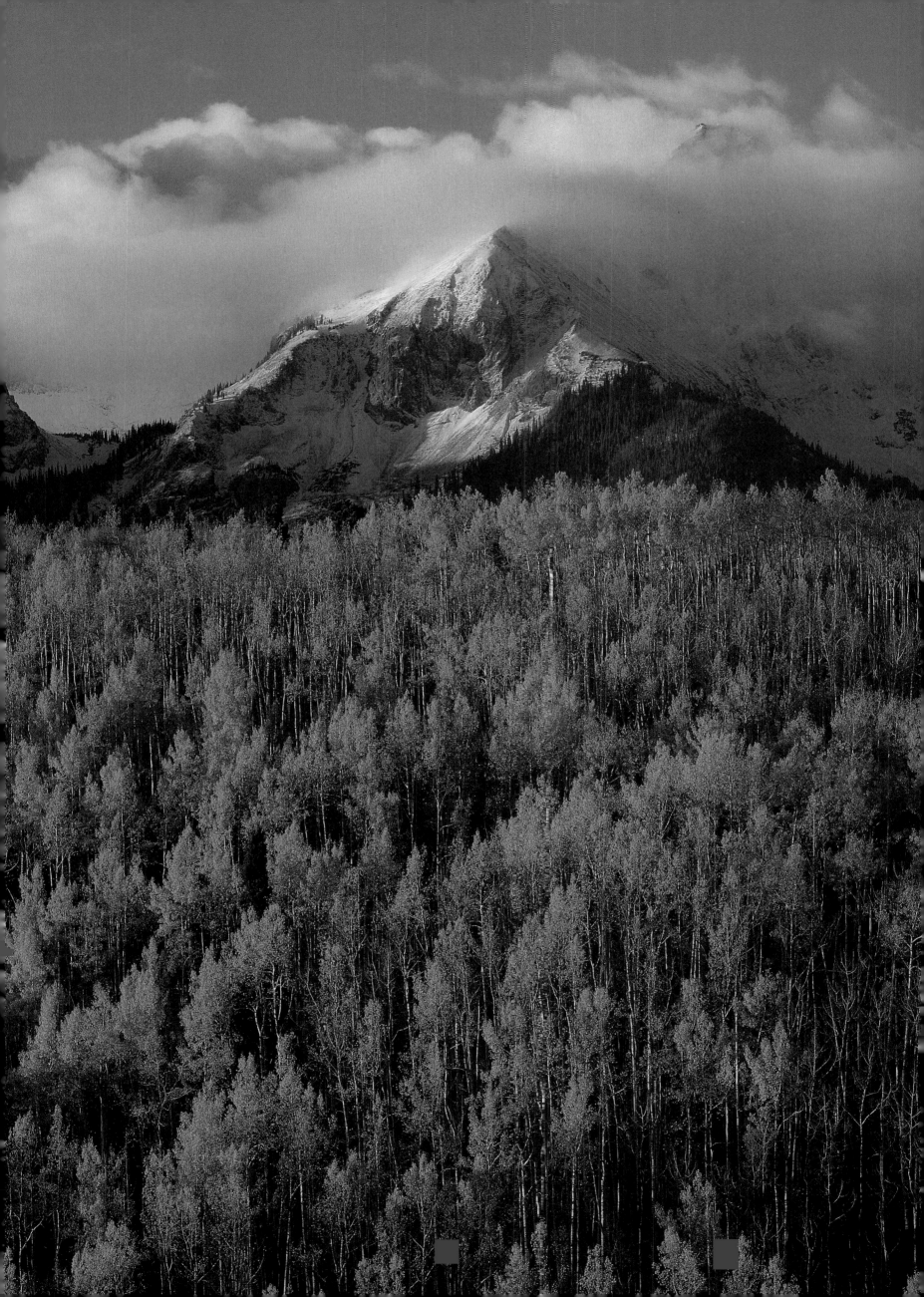

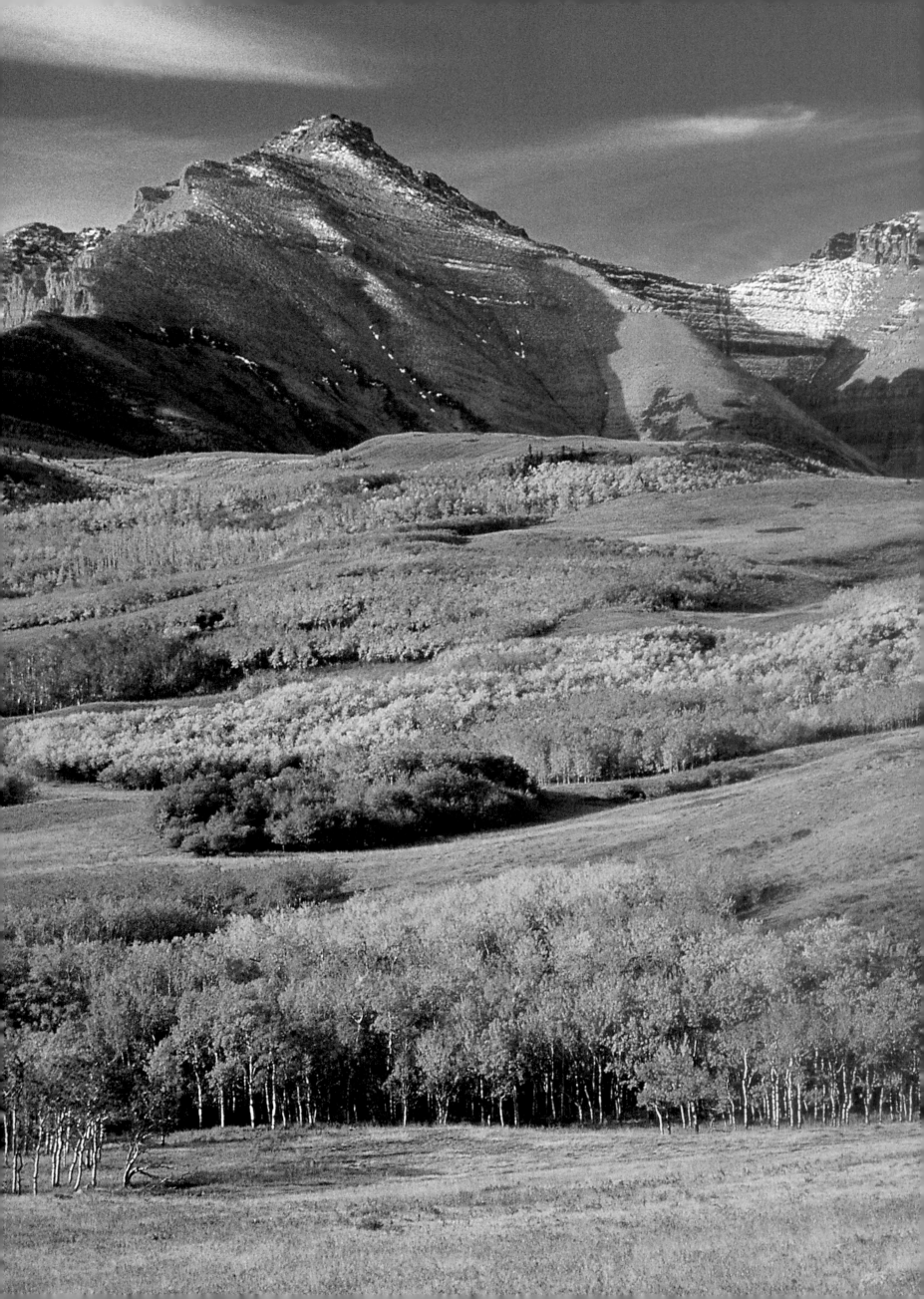

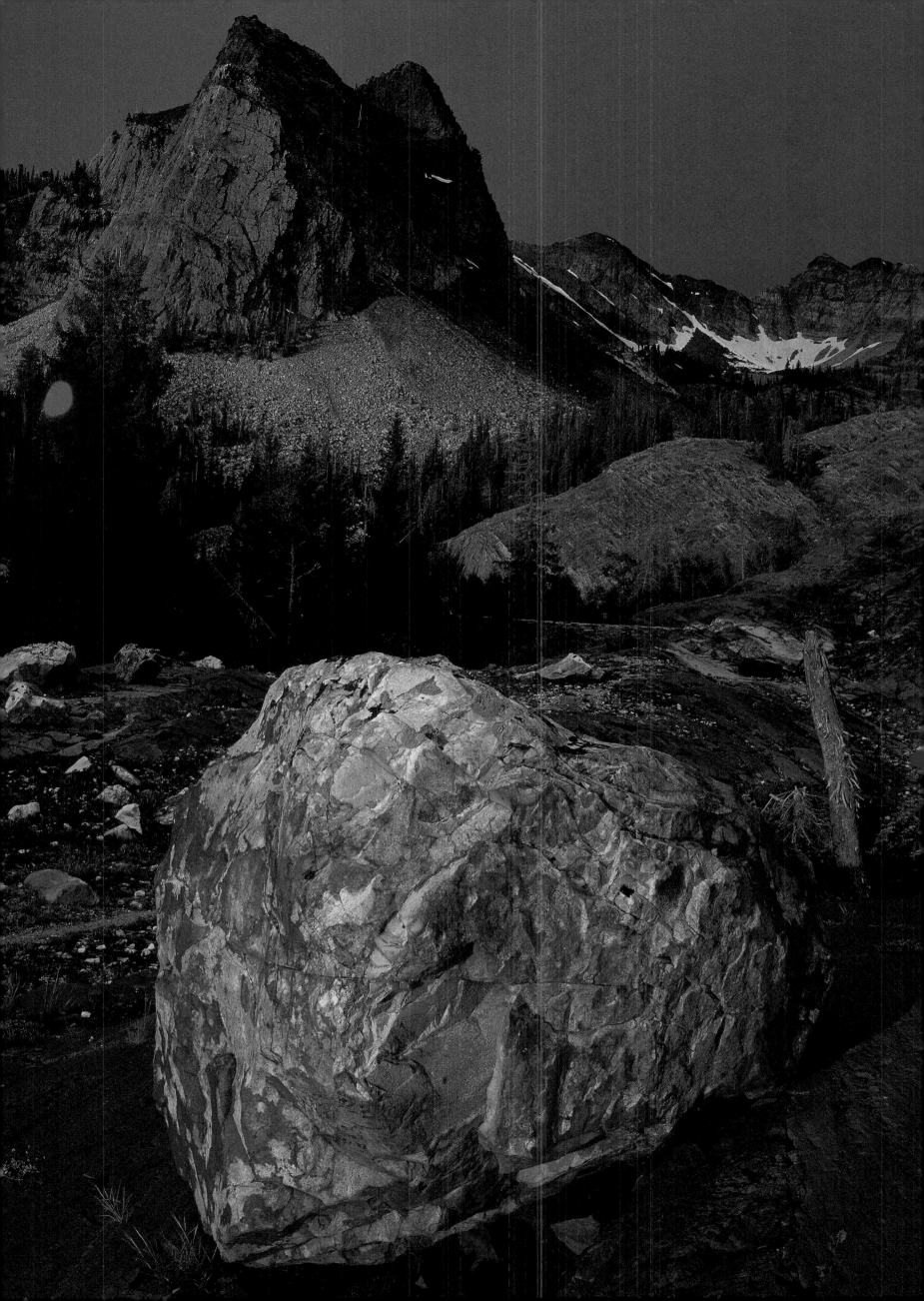

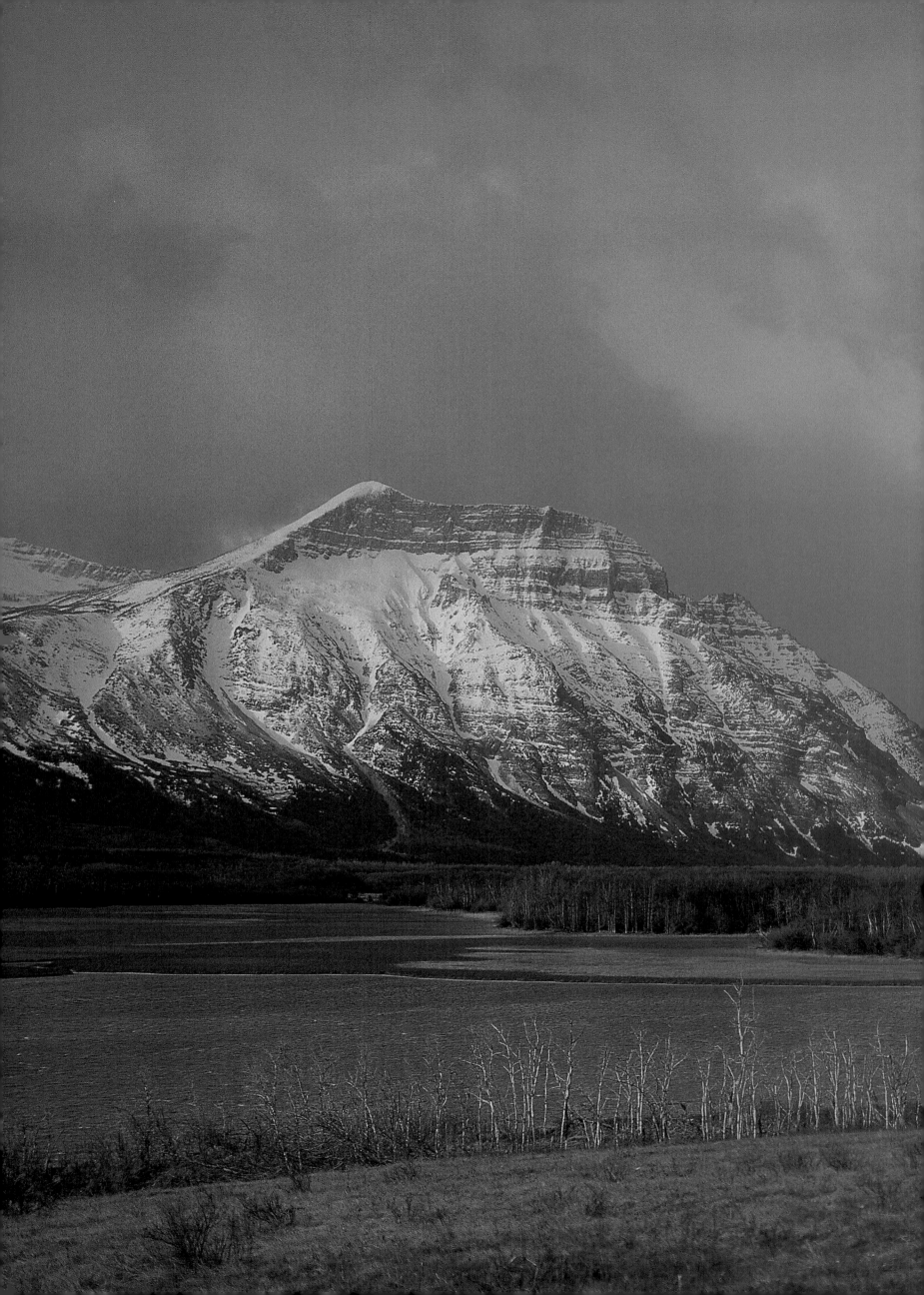

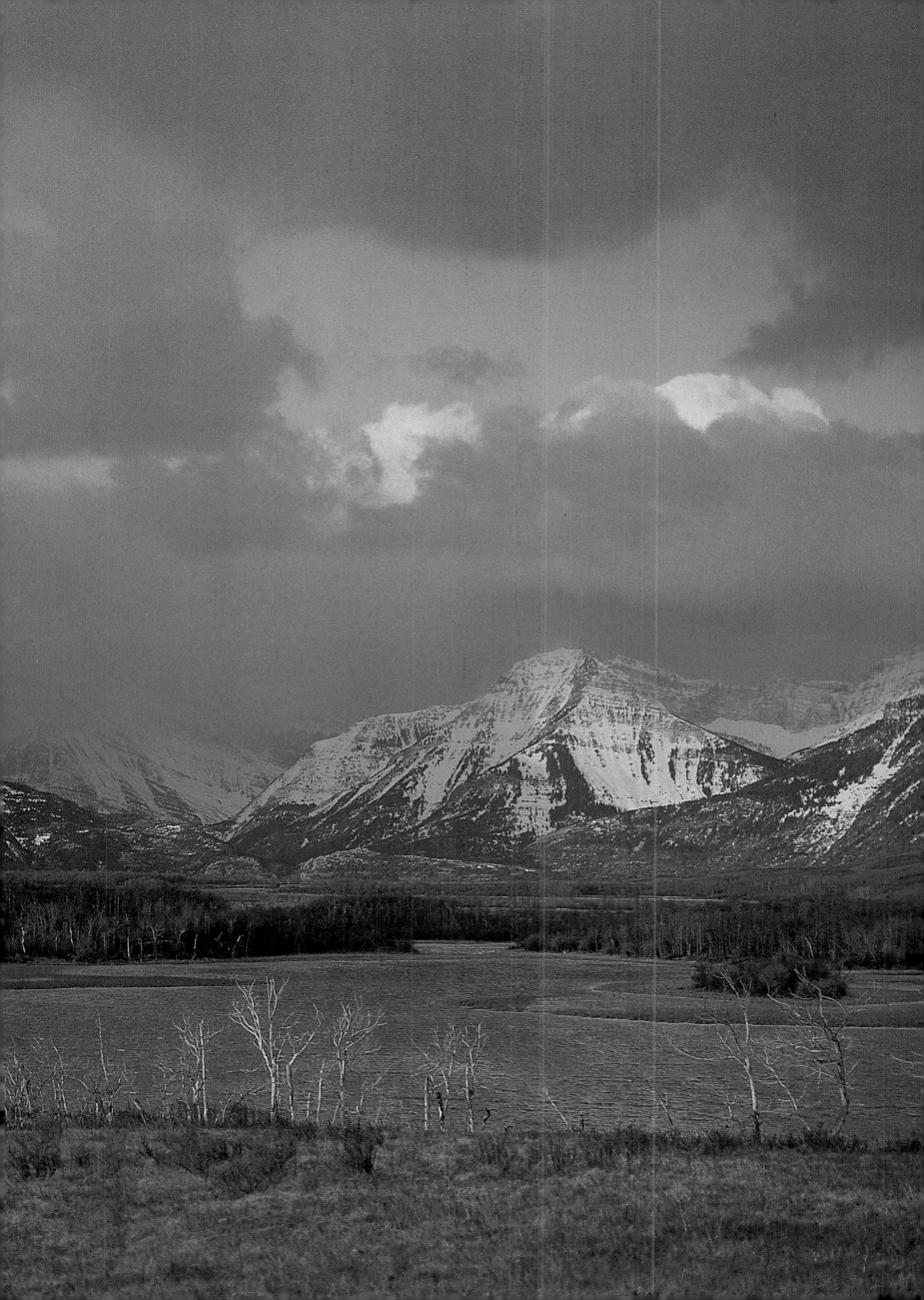

View towards Waterton Lakes National Park, Alberta Autumn is harvest time on the prairies. The mountains in Waterton and Glacier national parks rise so abruptly from the plains that farmers work their fields against a backdrop of snowy peaks.

previous pages: **Waterton Lakes National Park, Alberta** The snowline slowly creeping down from the peaks behind Maskinonge Lake is a visual reminder of winter's inexorable approach.

overleaf: **Wasatch/Cache National Forest, Utah** Autumn gives way to the first approach of winter in Lamb's Canyon. Stubborn, colorful holdouts, the aspen leaves, too, will eventually be hidden by a blanket of white.

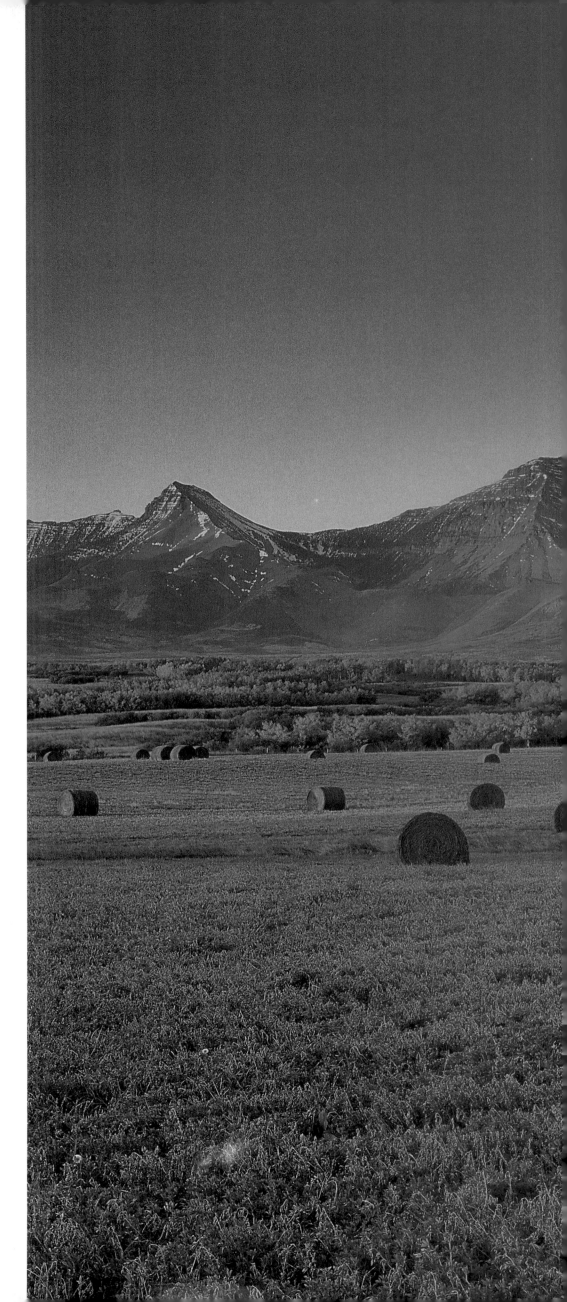

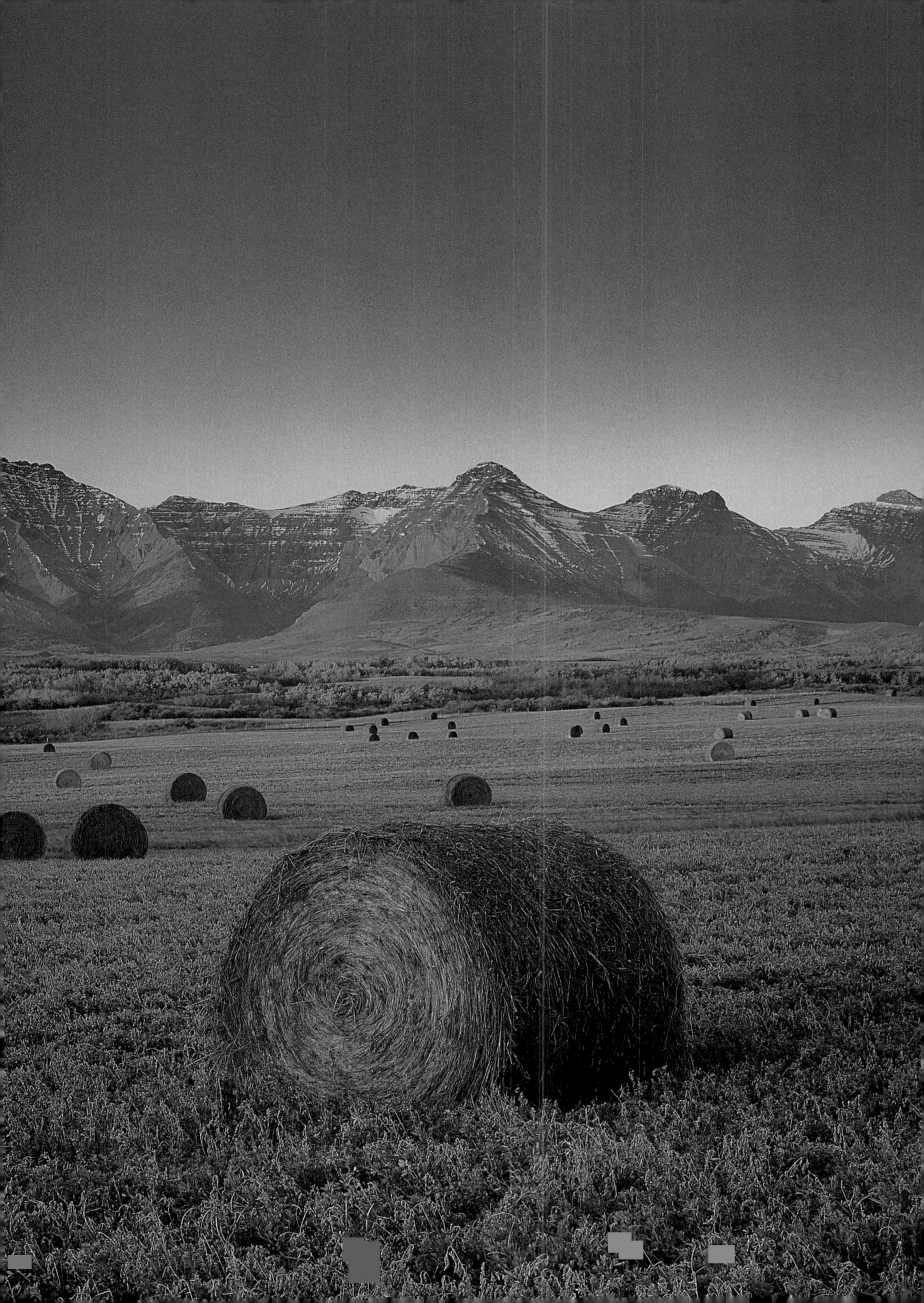

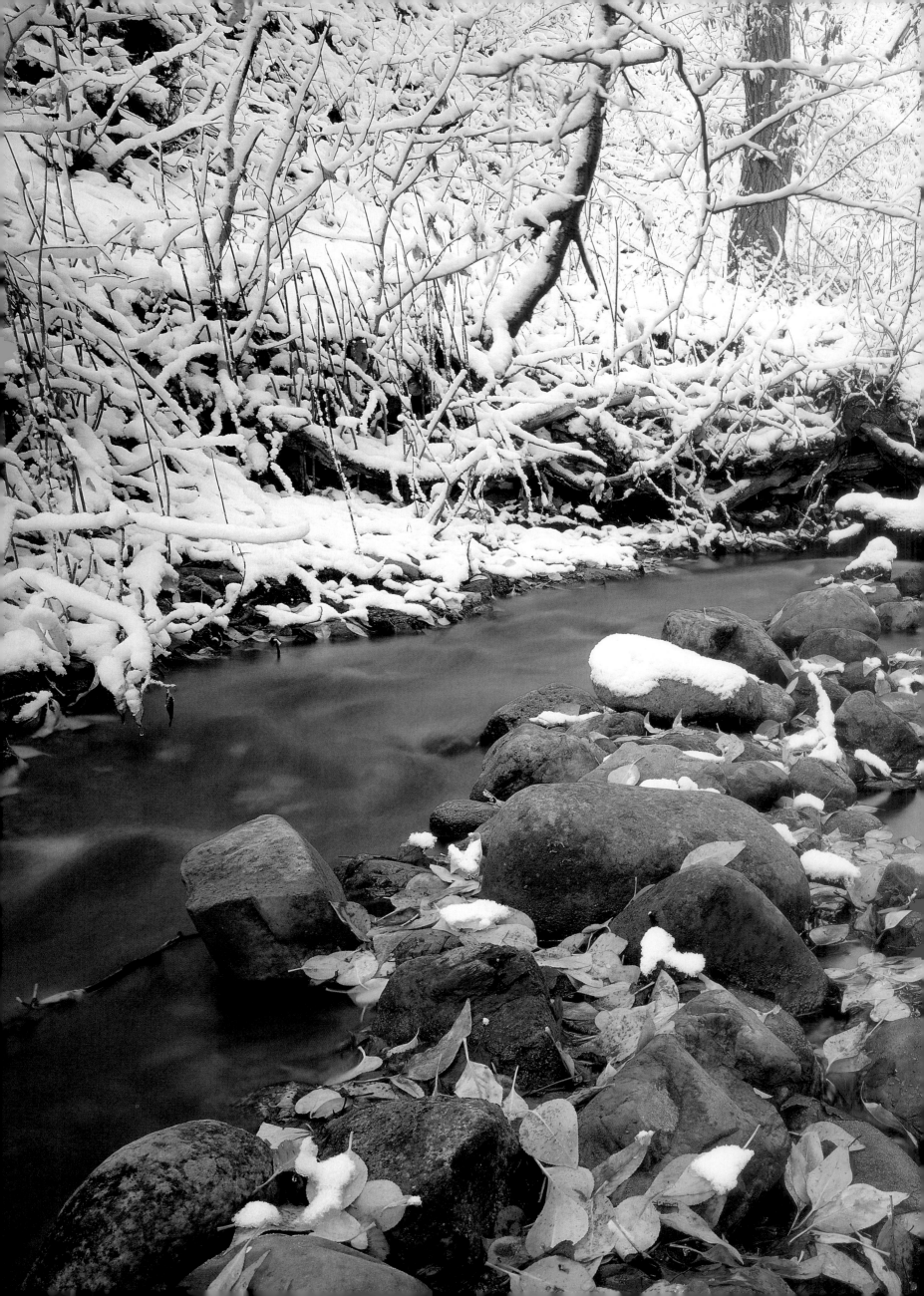

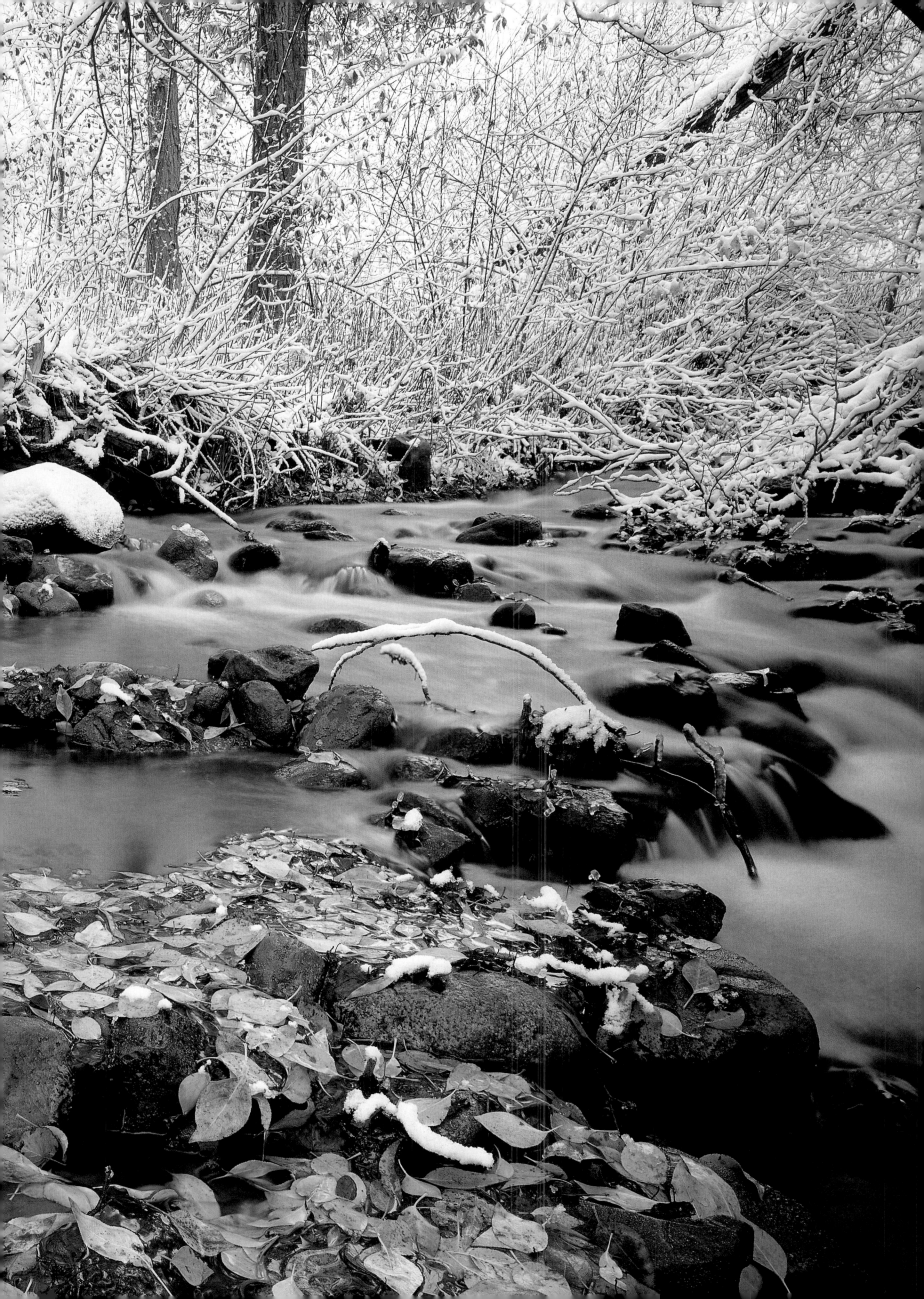

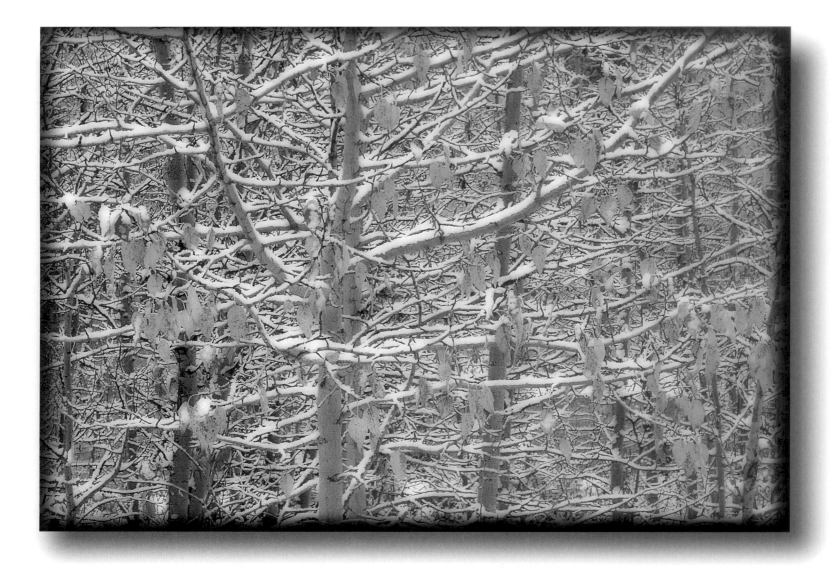

Kananaskis Country, Alberta
Tattered remnants of autumn's golden days, a few leaves cling to a snowy aspen tree.
Winter snows will transform this aspen forest into an artistic exercise in line and form.

right: **Jasper National Park, Alberta**
Crunching through frozen grass to stand beside Patricia Lake not far above
Jasper townsite, it is obvious that autumn is almost at an end. However, the sight of
Pyramid Mountain in the morning light is worth the chilly hike.

overleaf: **Jasper National Park, Alberta**
Moberly Flats, along with Adolphus Lake in the northwest of the park, are named for
Métis settler Adolphus Moberly, who lived in the Athabasca Valley. In 1908, Moberly
guided A. P. Coleman, a geology professor from Toronto, to Mount Robson.

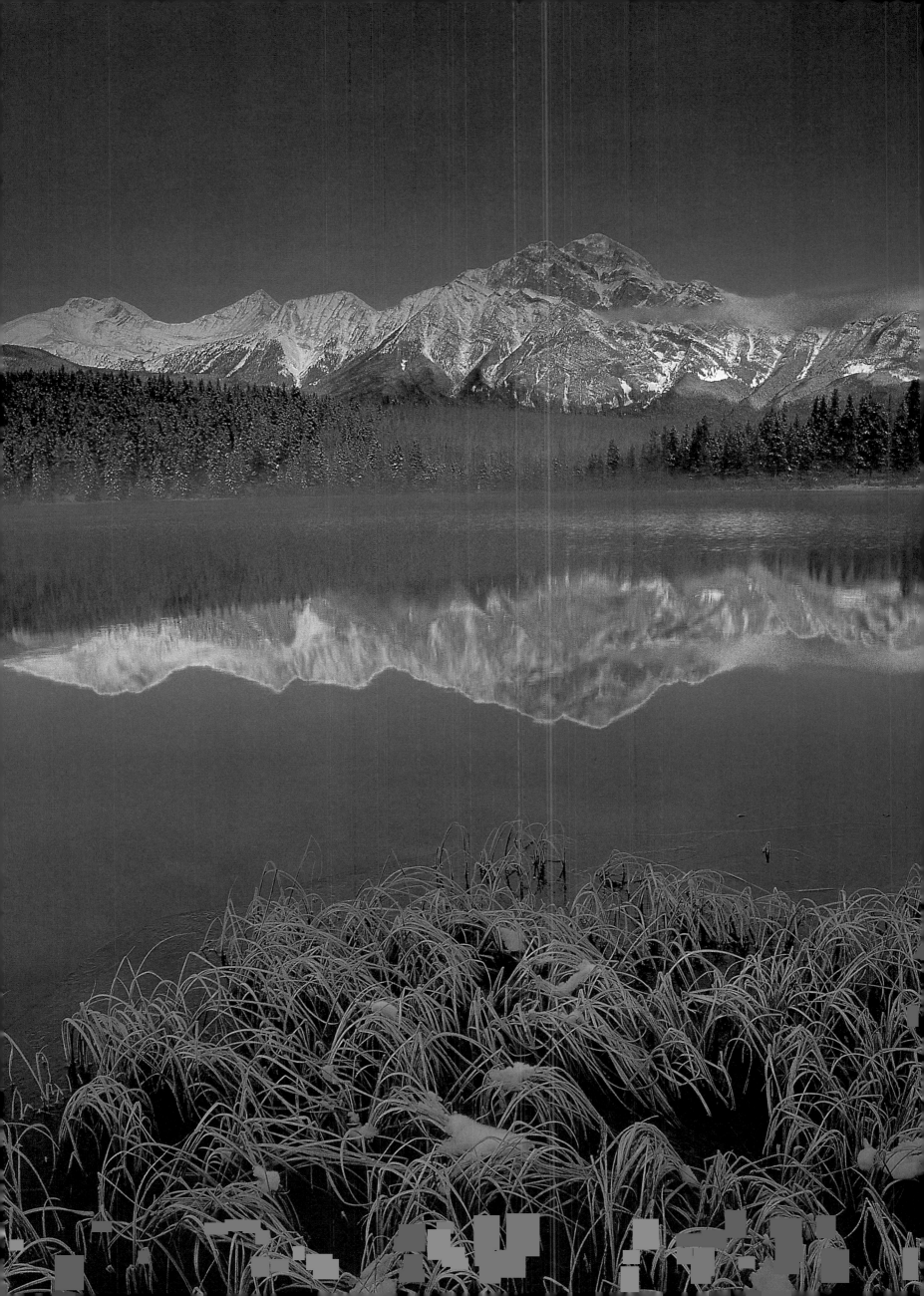

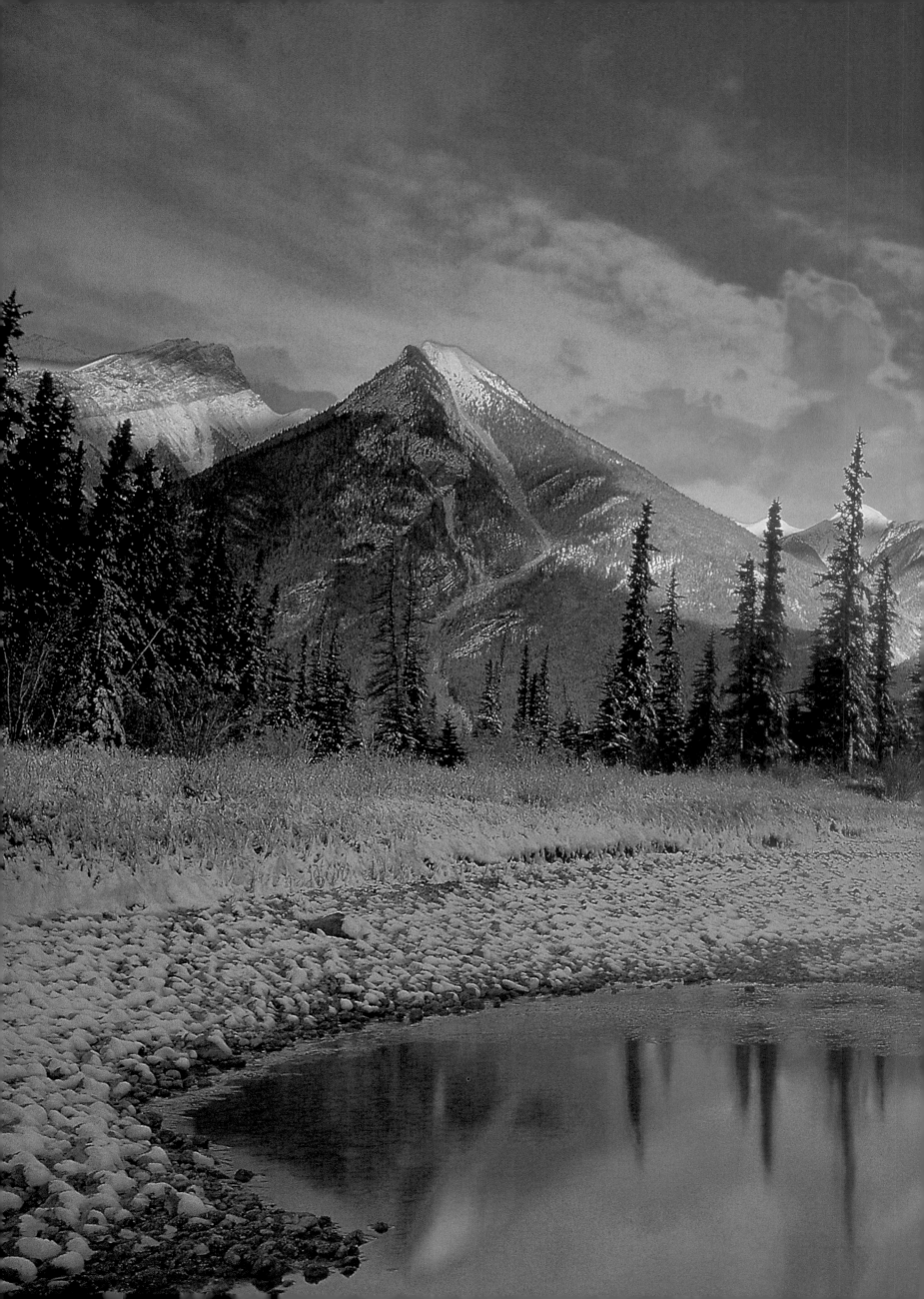

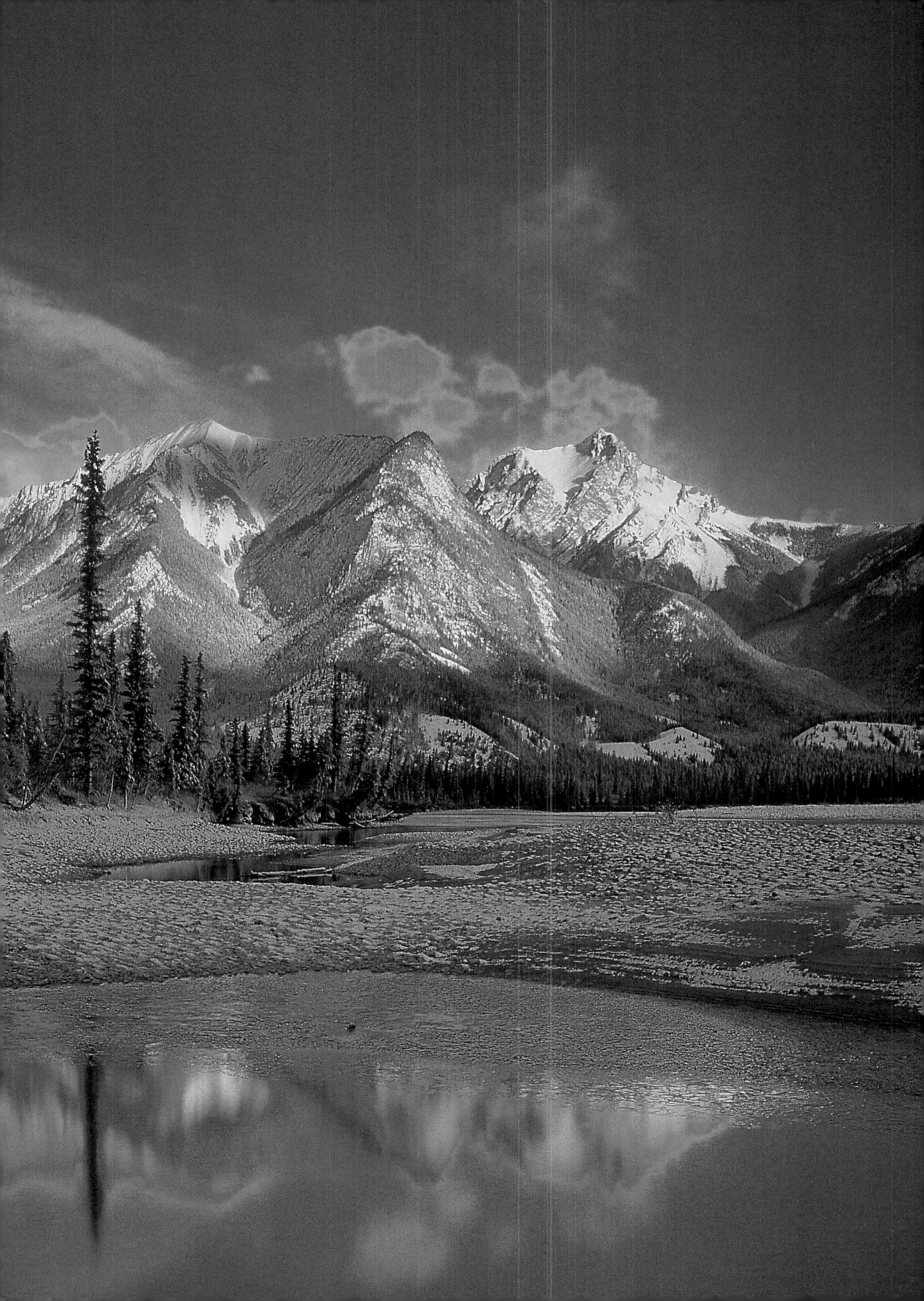

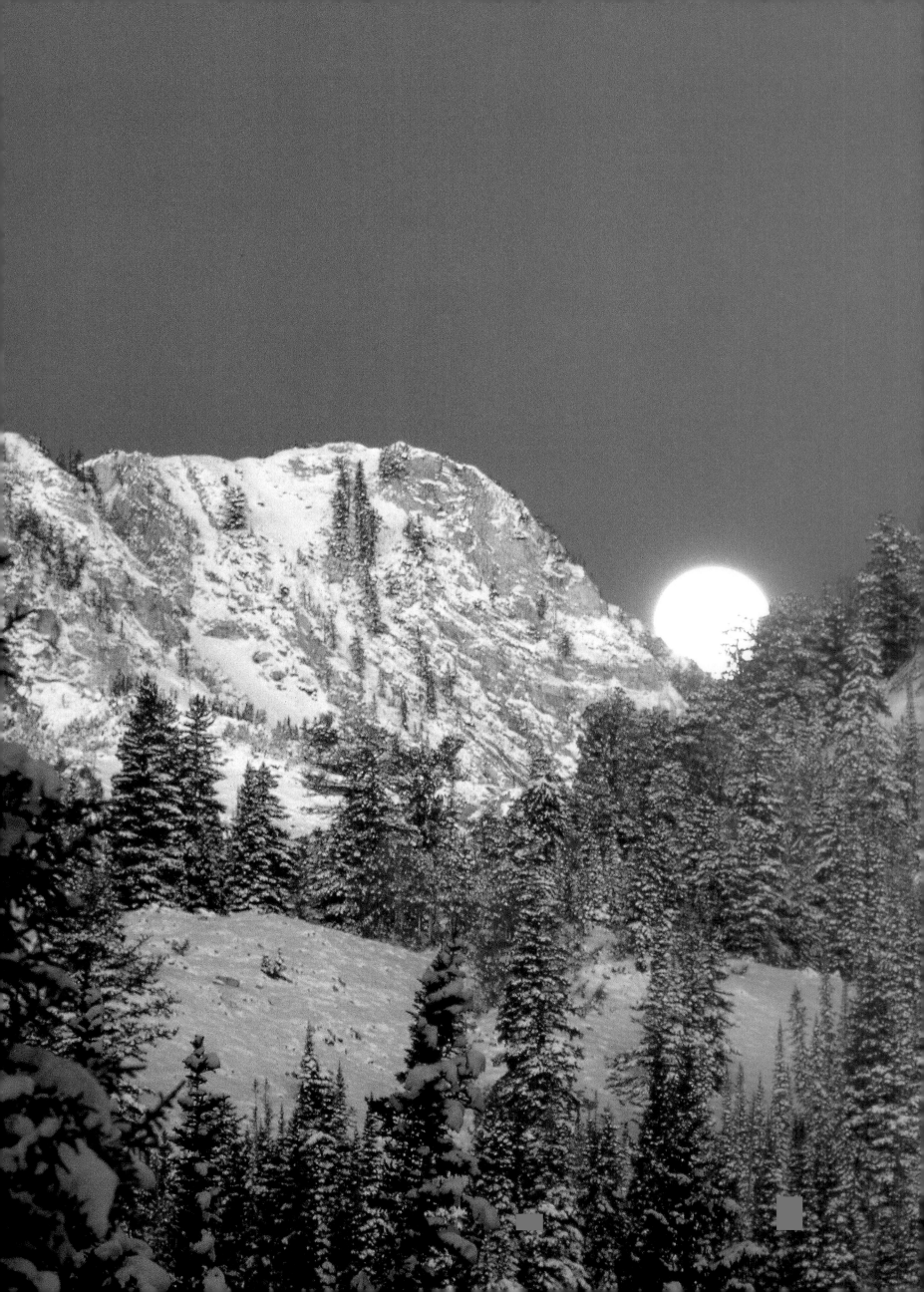

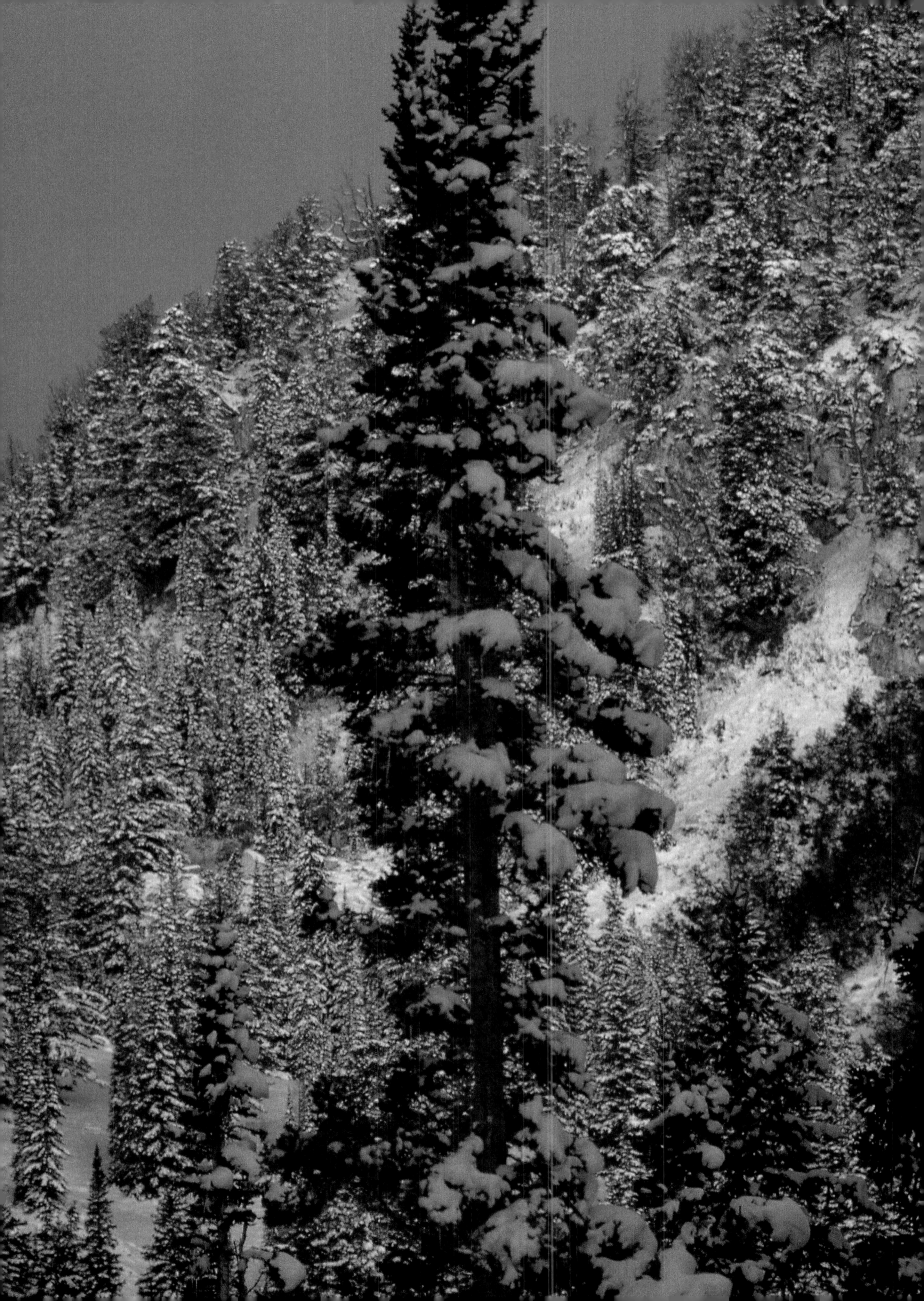

Wasatch/Cache National Forest, Utah The light dusting of snow on the trees and the open water are clear indications that true winter has yet to arrive at Silver Lake.

previous pages: **Wasatch/Cache National Forest, Utah** At Silver Lake in Big Cottonwood Canyon, the last light from a setting full moon shines on the remains of an autumn snowstorm. This wilderness scene is less than an hour's drive from Salt Lake City and its more than a million inhabitants.

overleaf: **Banff National Park, Alberta** Larch Valley takes its name from these golden trees, which are a species called Lyall's larch. The larches shed their needles each fall and grow new, bright green ones the following spring. Some of these trees may be more than 400 years old.

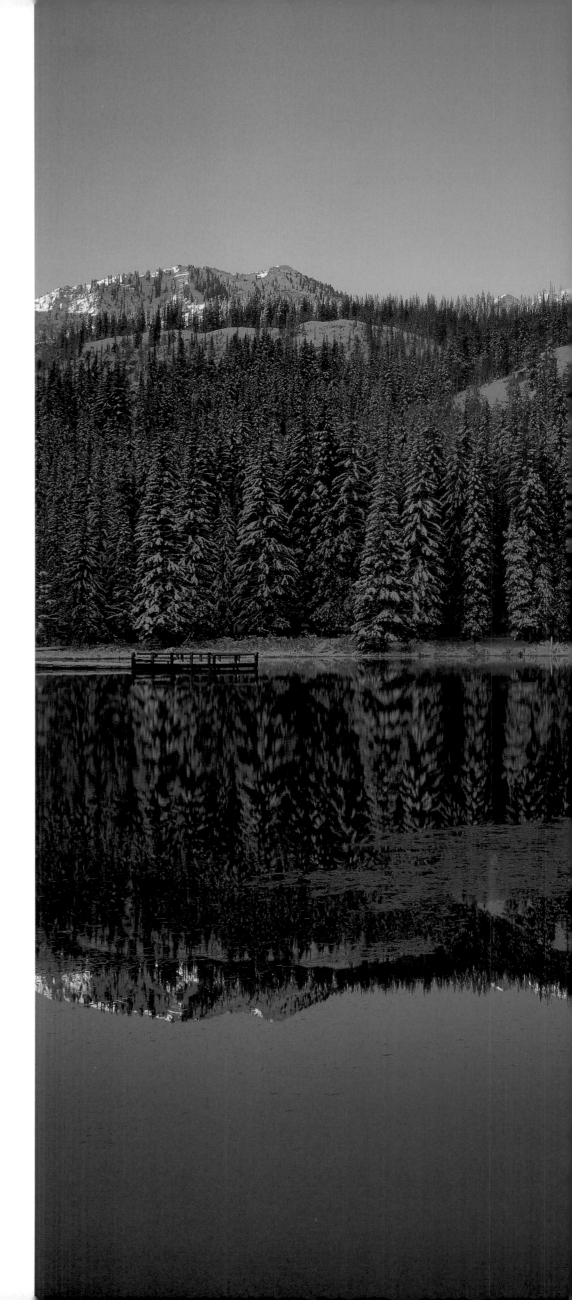

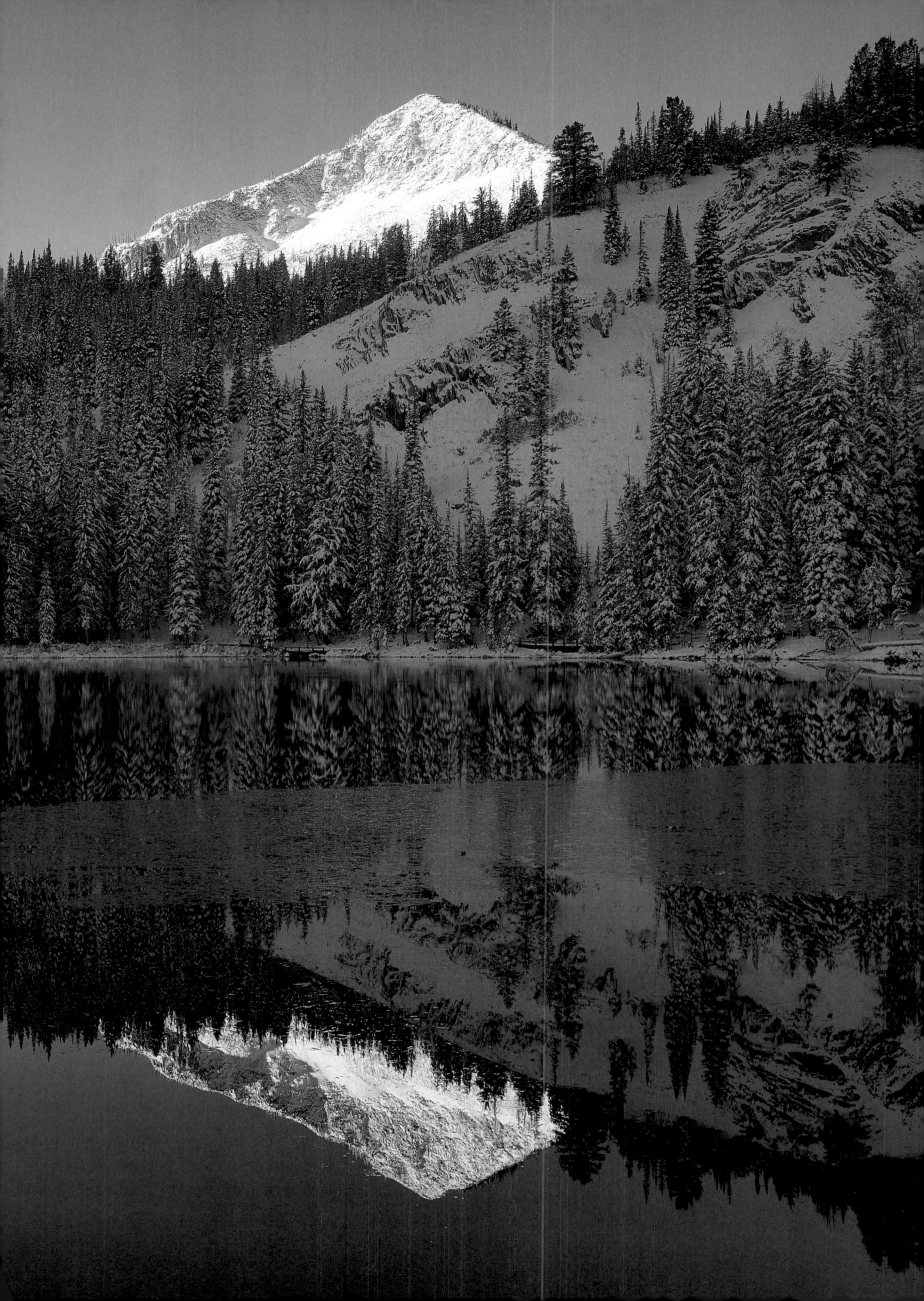

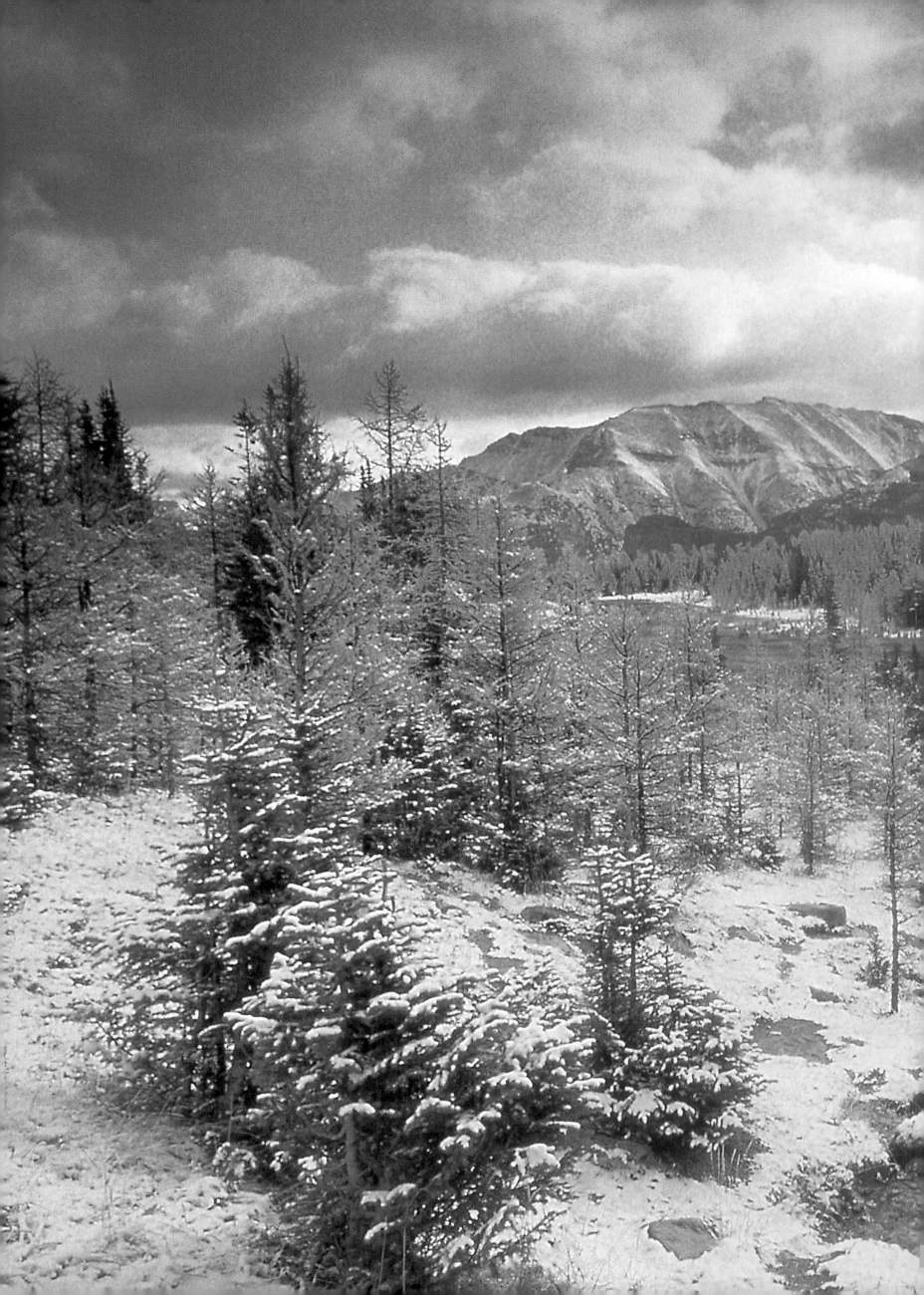

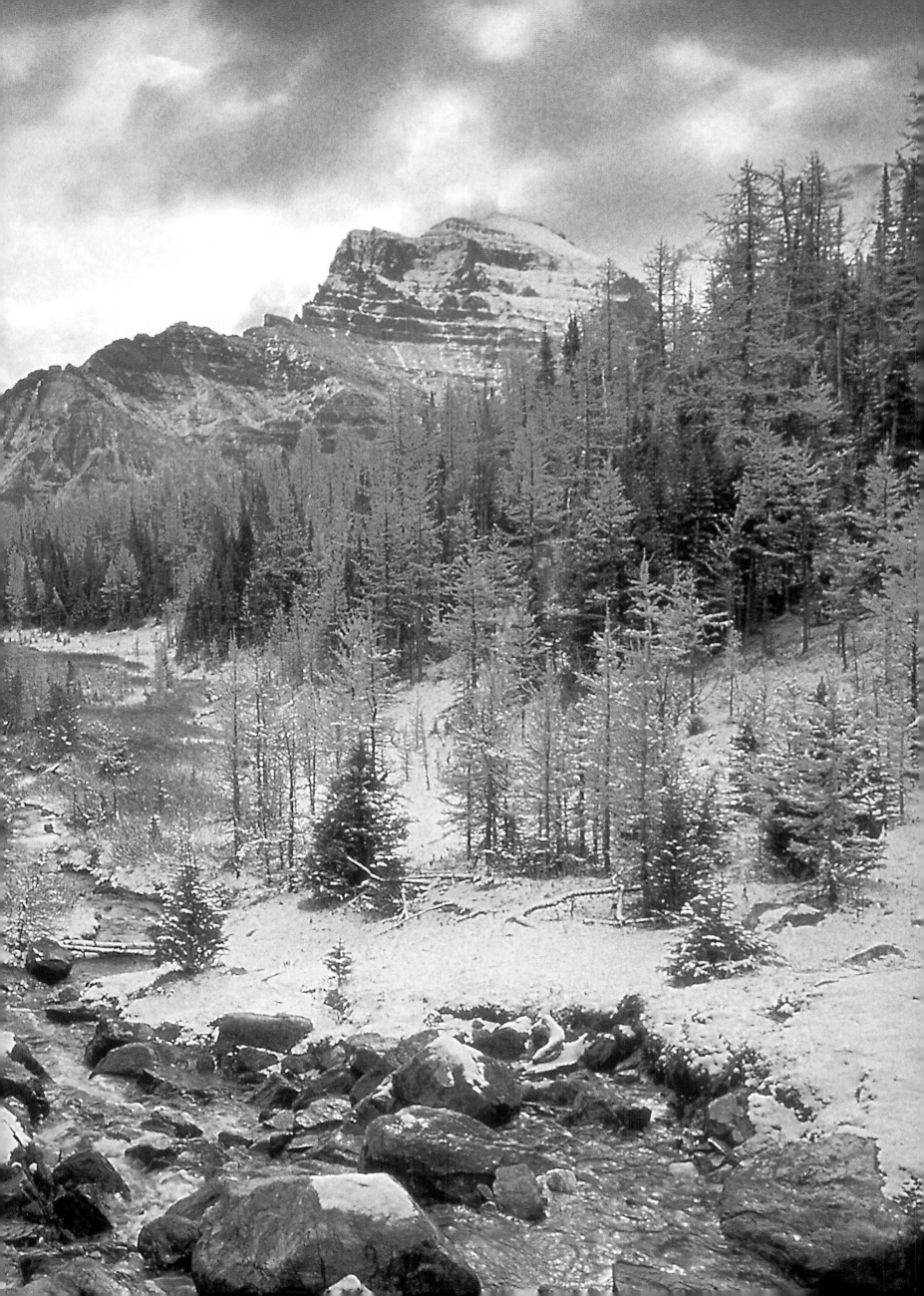

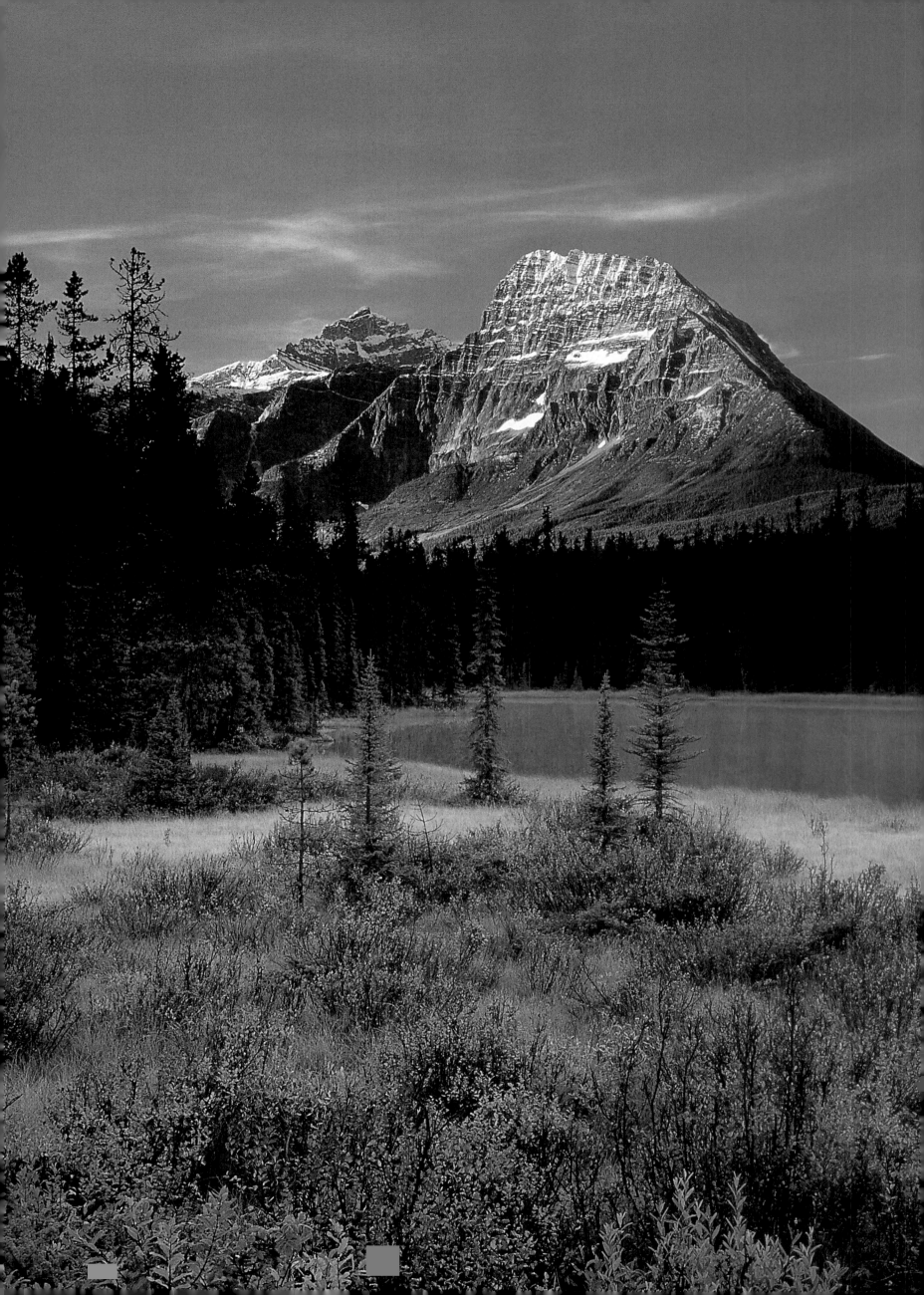

High Uintas Wilderness, Utah
An aerial view of an alpine lake reveals telltale signs that freeze-up is underway.
The surface ice may form and break many times.

left: **Jasper National Park, Alberta**
The 570-million-year-old rock of Mount Fryatt was eaten away on all sides by
glaciers until only a broad central peak remained.

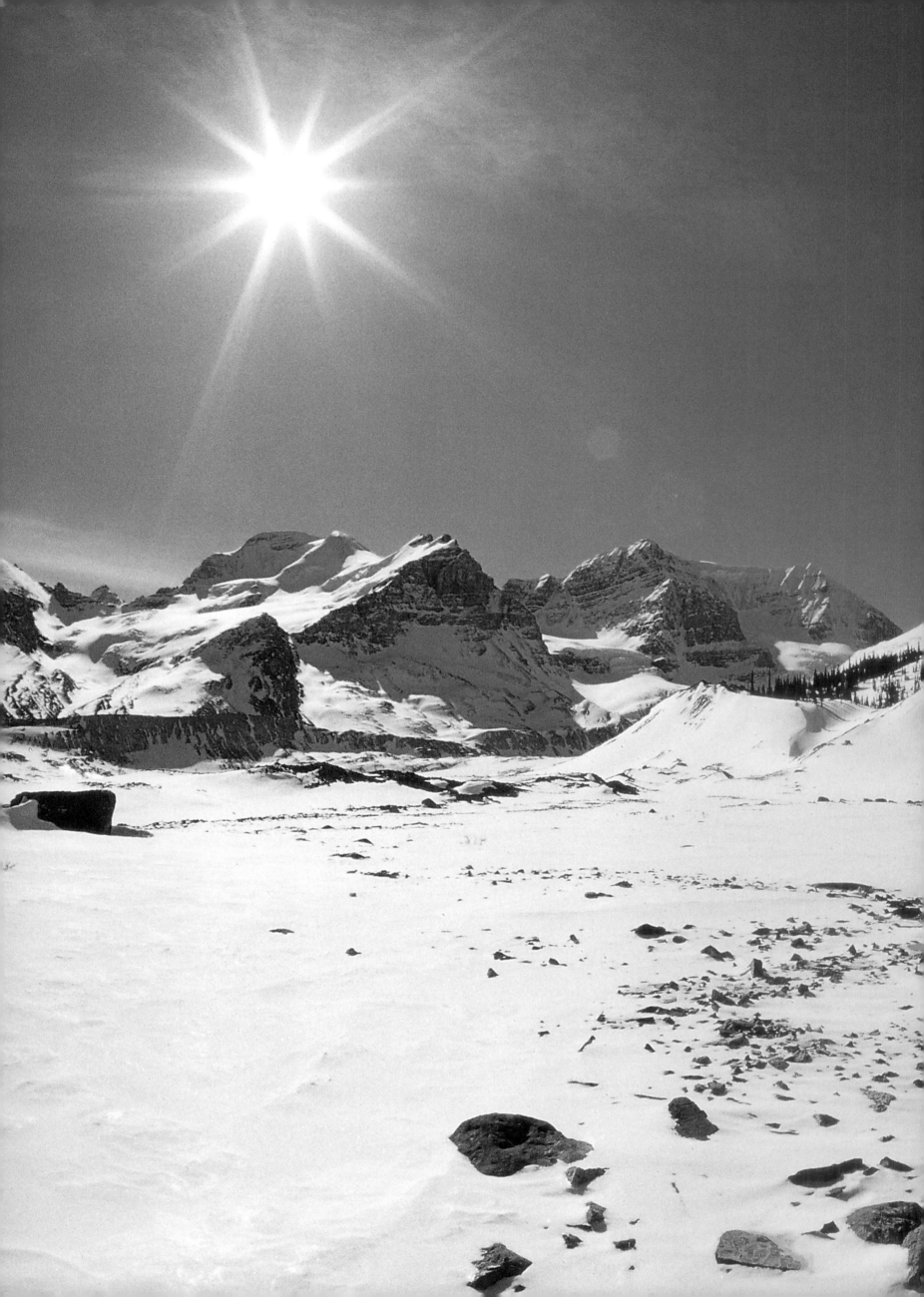

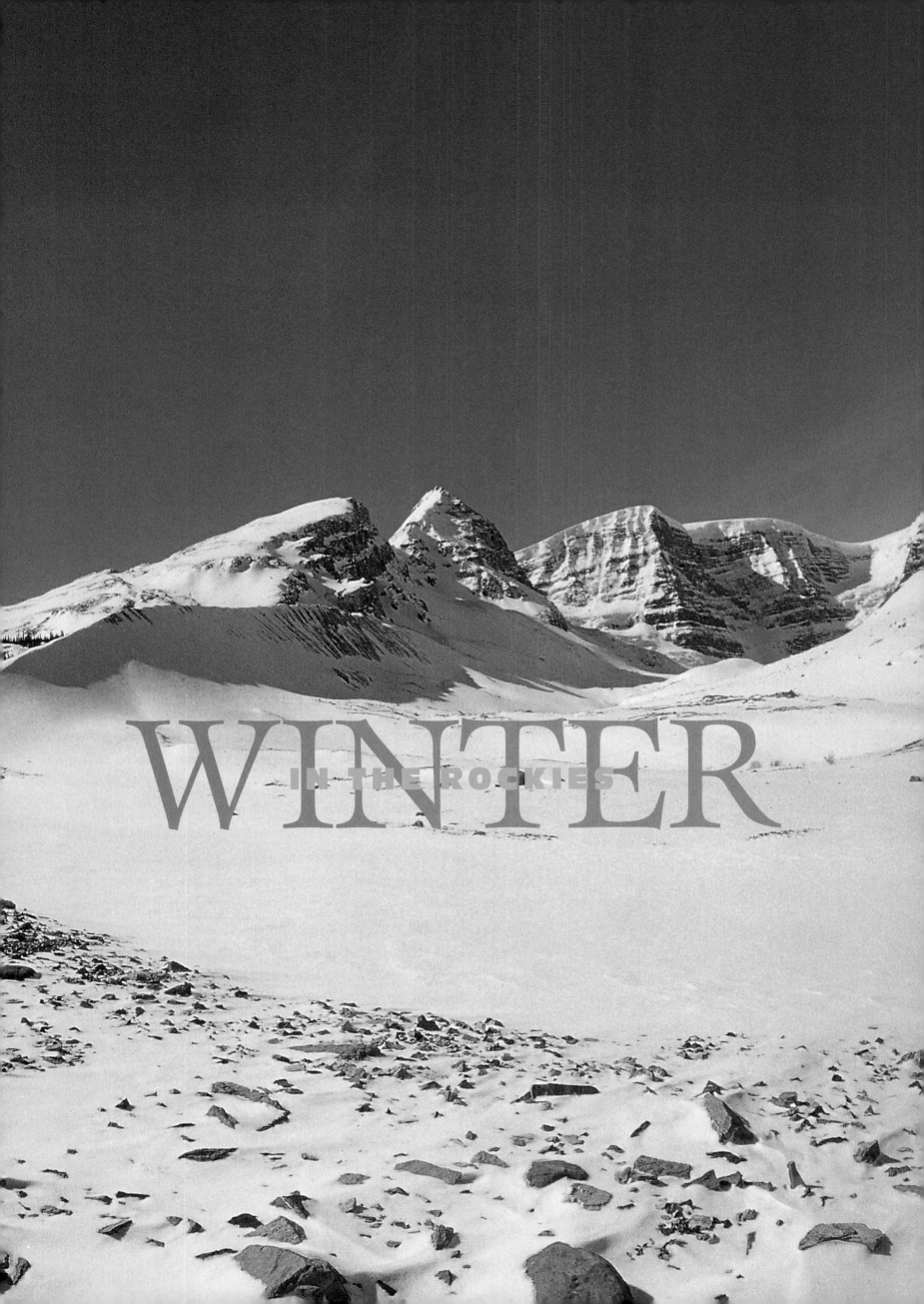

WINTER IN THE ROCKIES

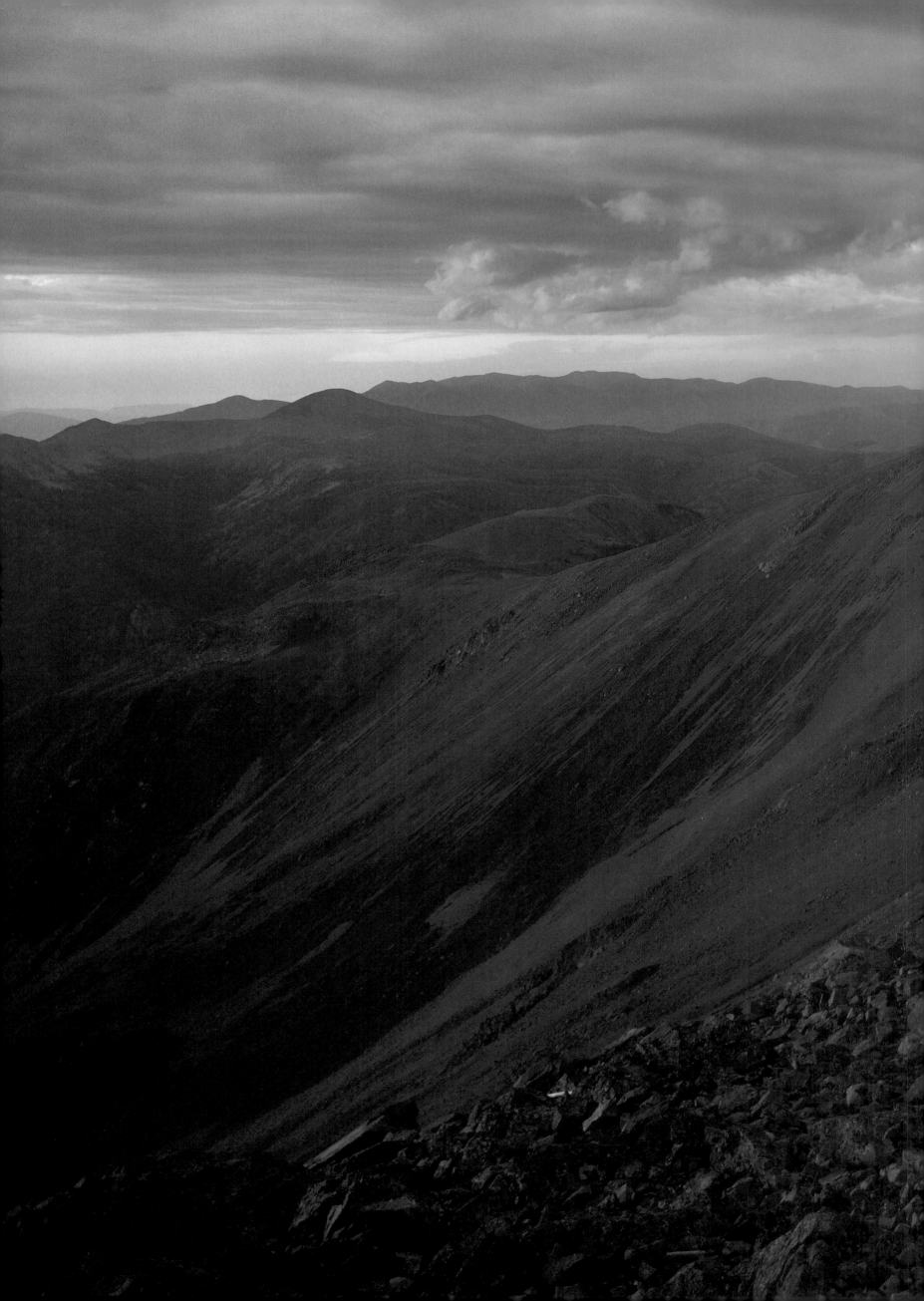

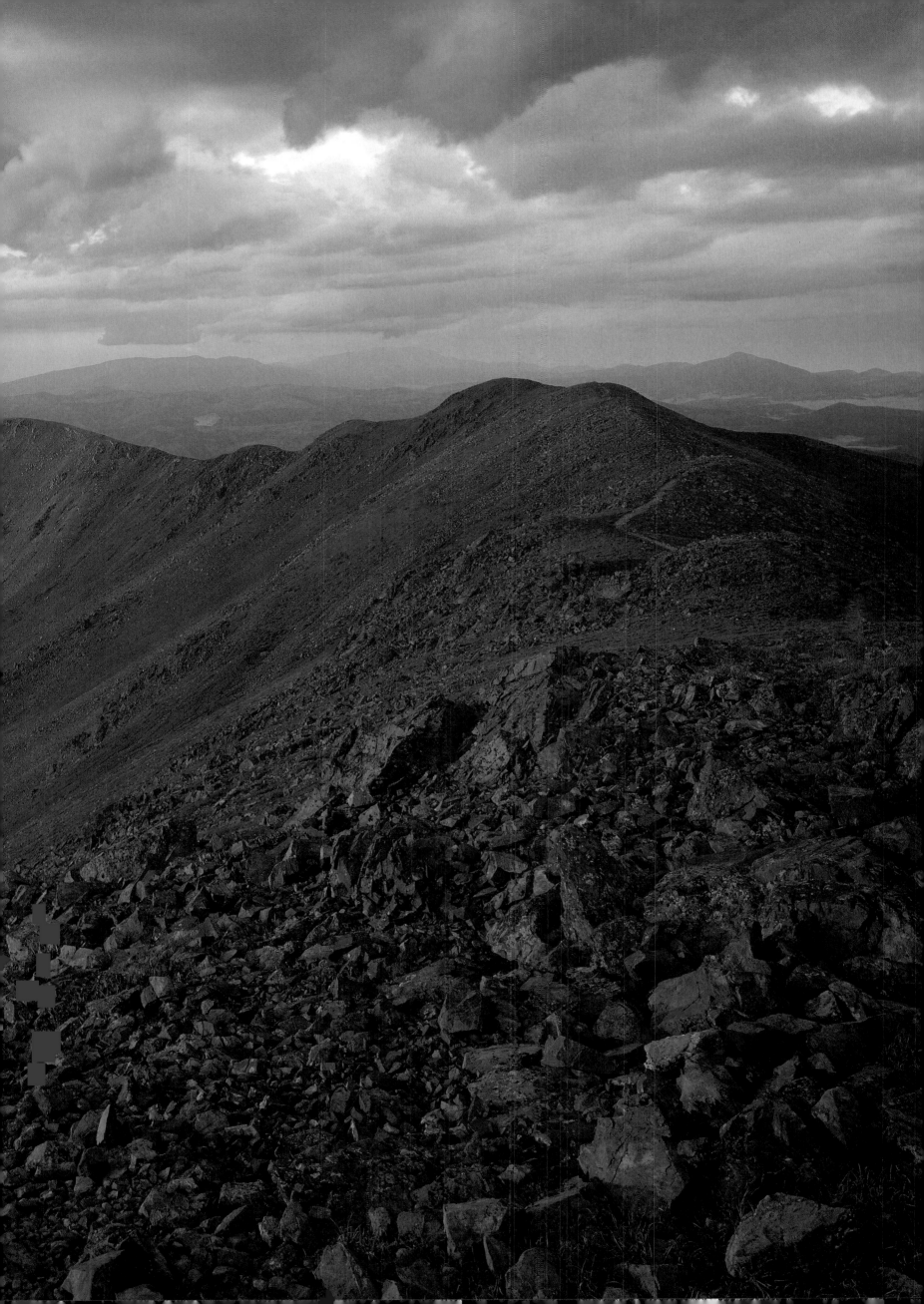

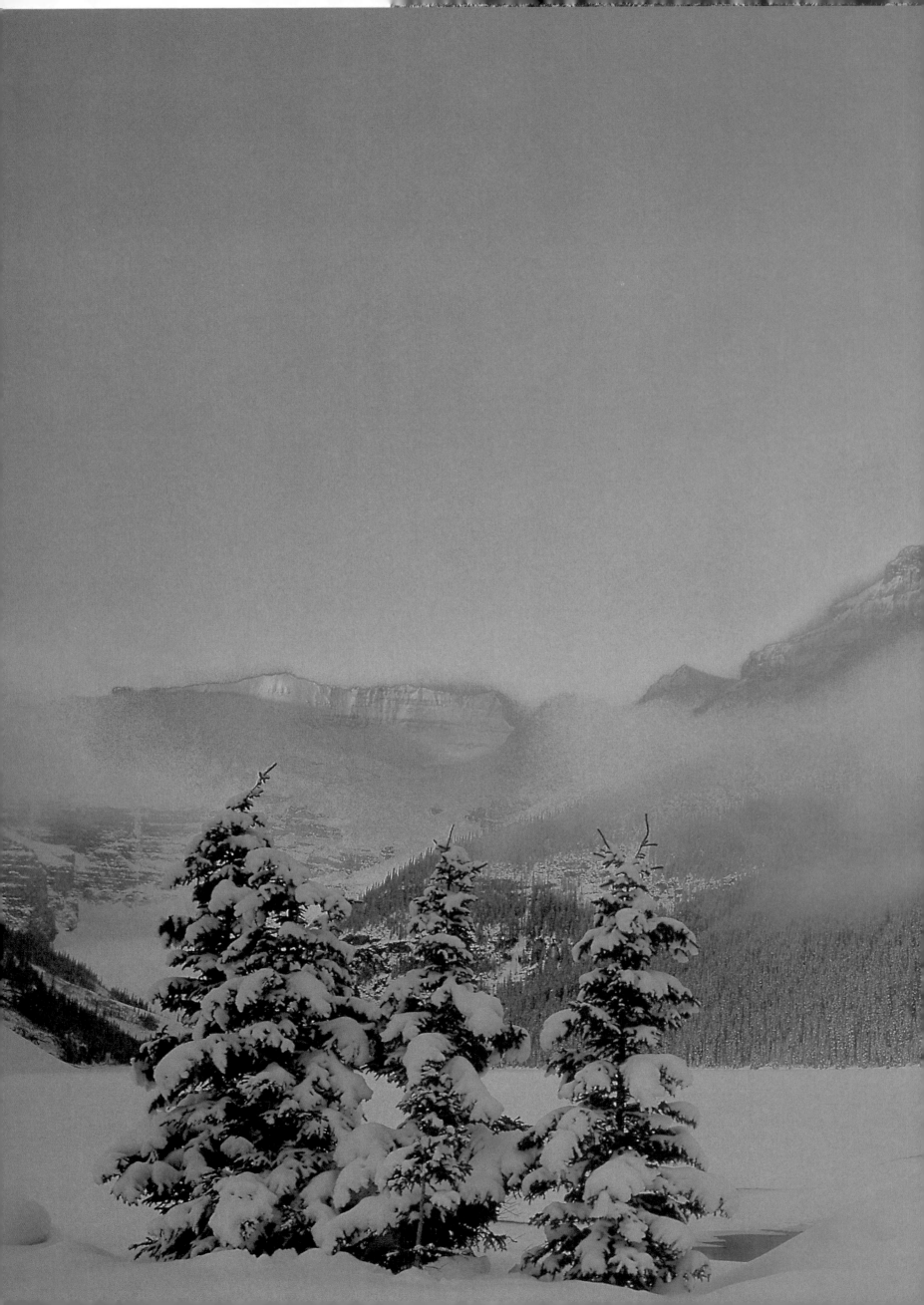

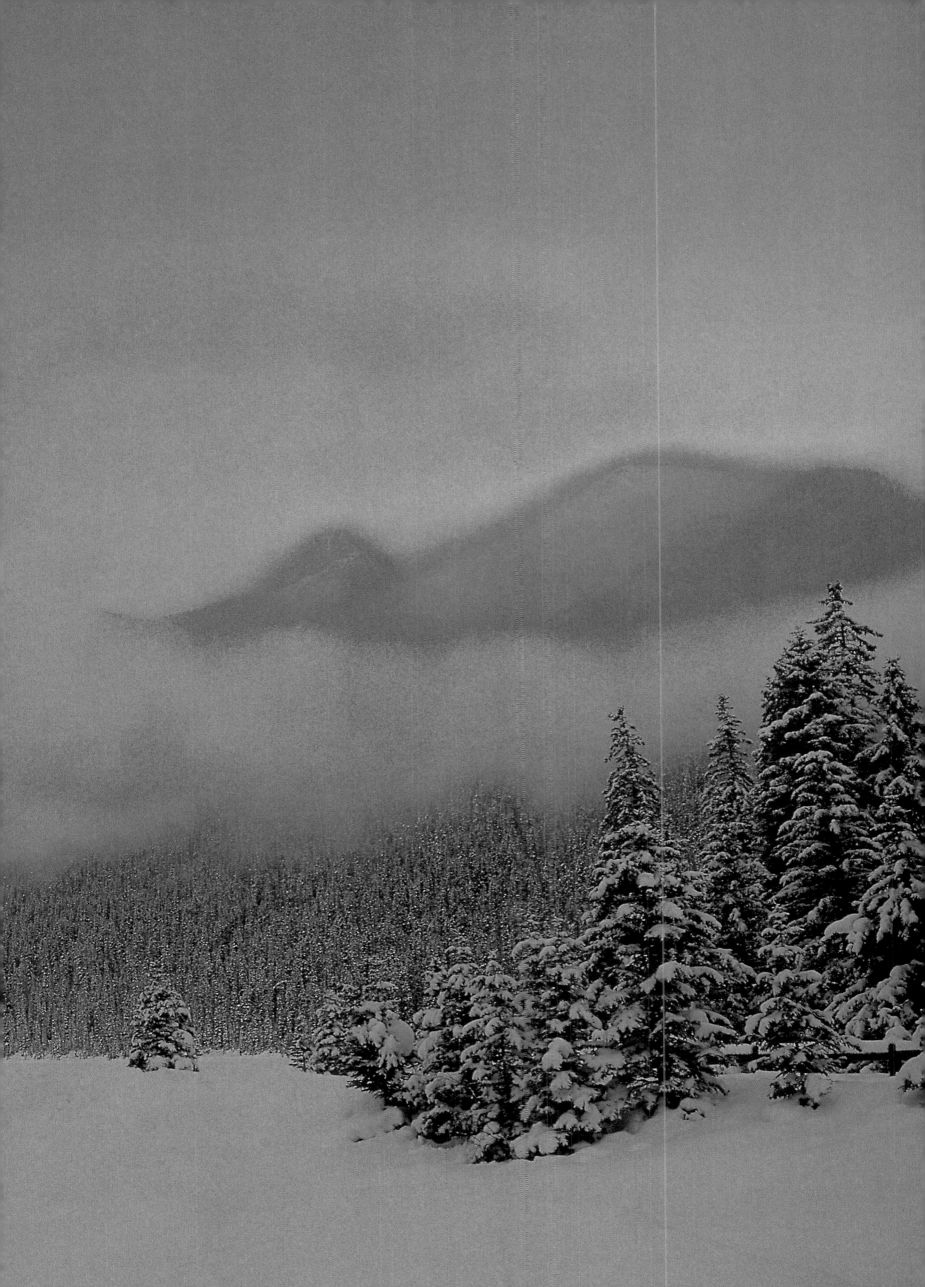

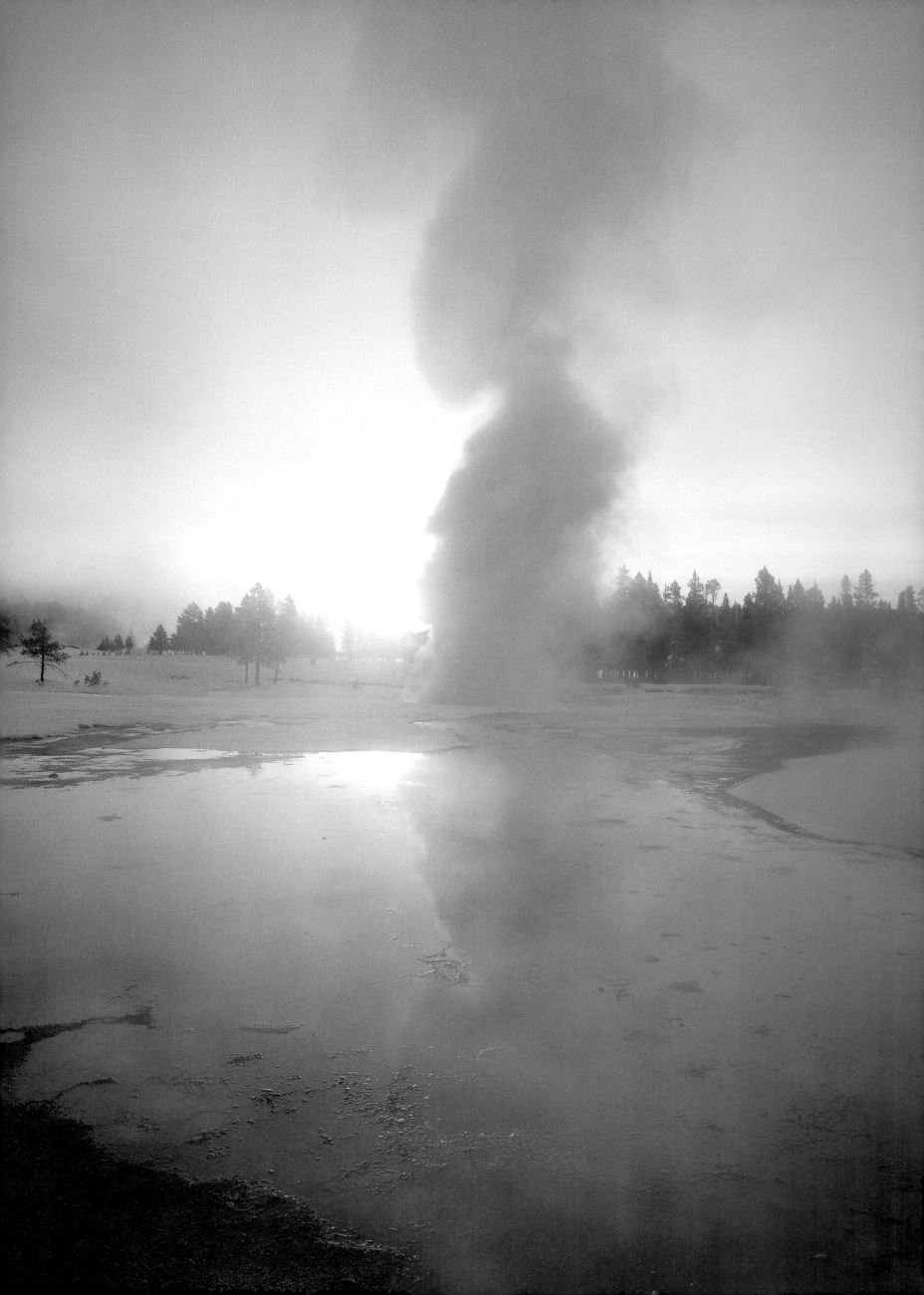

Manti-La Sal National Forest, Utah
The last rays of the evening sun touch trees cloaked in ice. Although beautiful,
ice such as this can cause a great deal of damage if it becomes too thick and heavy
for the trees to support.

left: **Yellowstone National Park, Wyoming**
Steam rising from the ground at dawn in a snowy landscape seems strange,
but during winter in Yellowstone, such sights are an everyday occurrence.
The heated waters of the park's many thermal features, such as this geyser,
create billowing clouds wherever they come in contact with the frigid air.

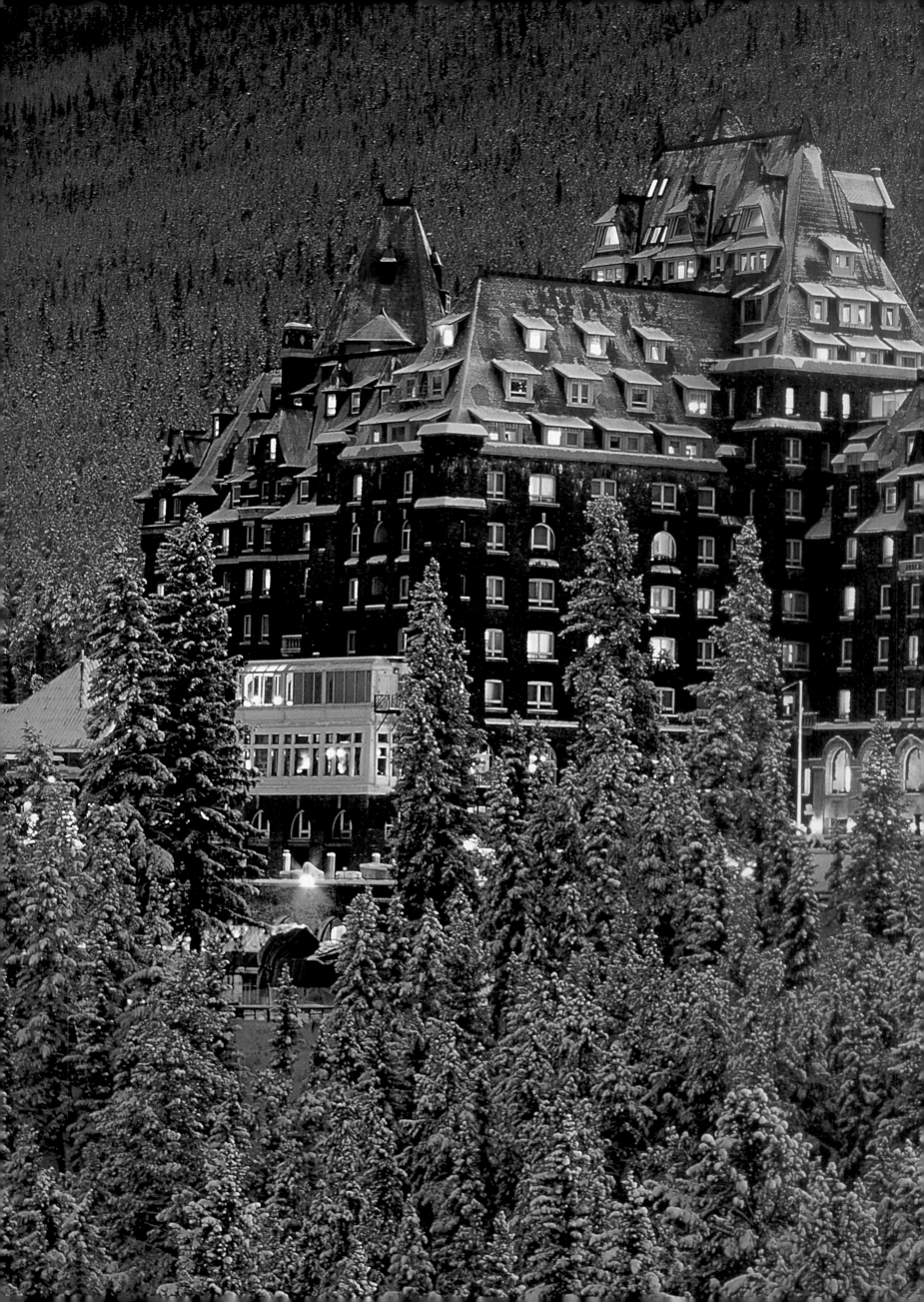

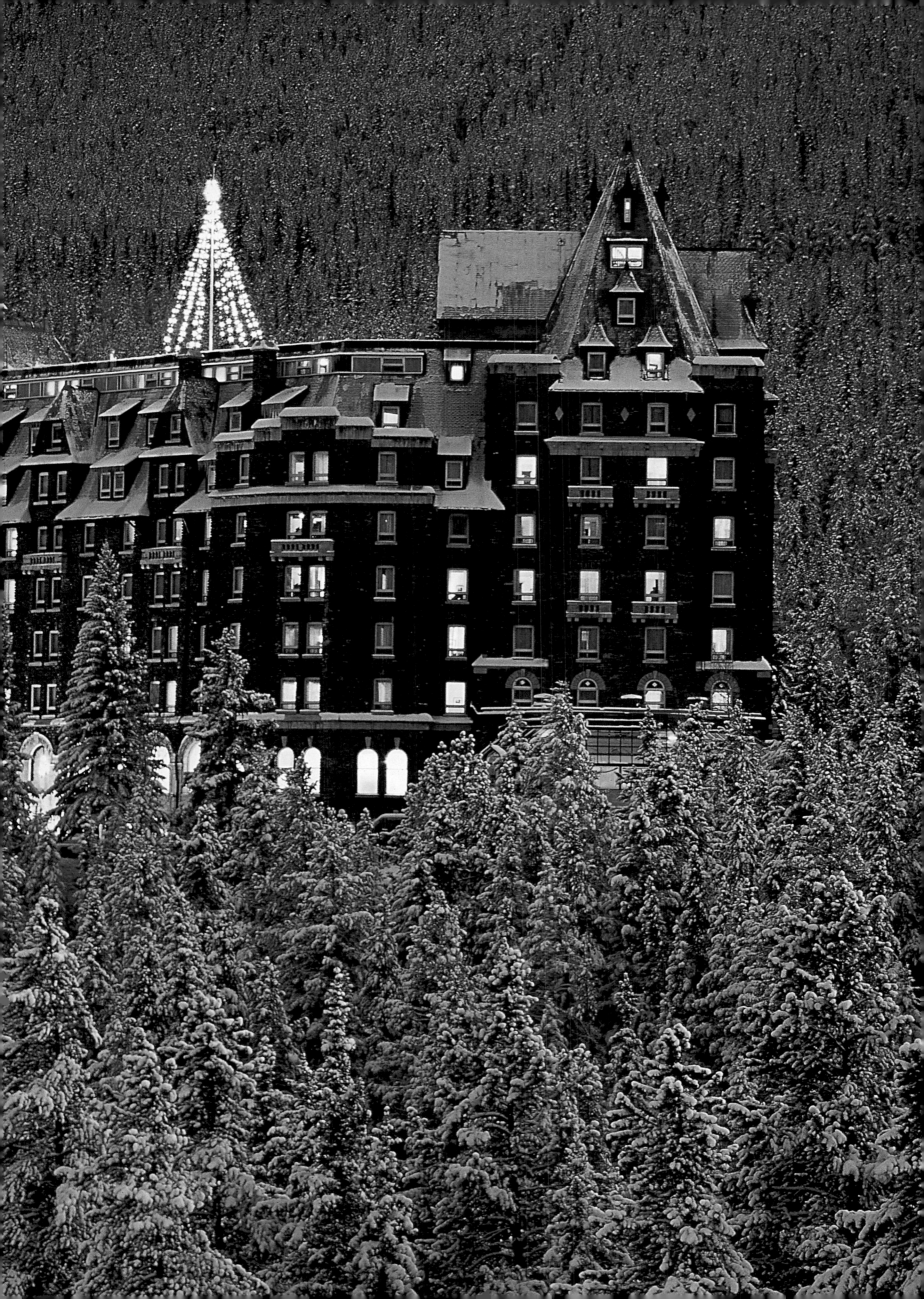

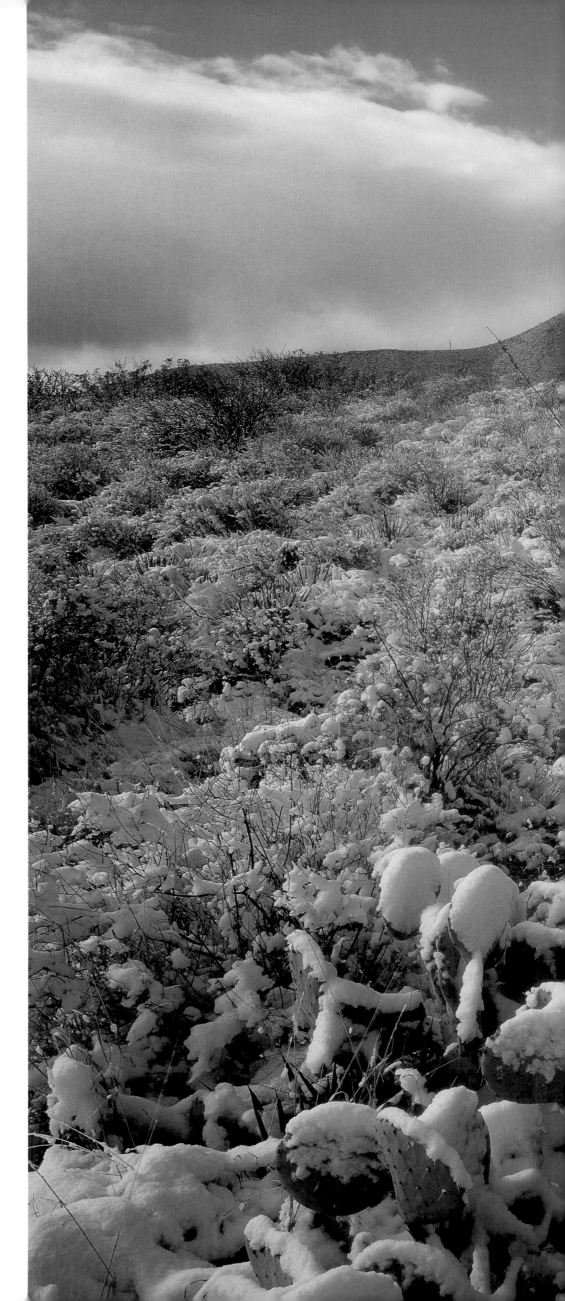

Big Bend National Park, Texas
Some outlying parts of the Rockies rarely see snow, even in the depths of winter. These cacti in the Chisos Mountains may not experience such an event again in their lifetime.

previous pages: **Banff National Park, Alberta** The venerable Banff Springs Hotel has been welcoming travelers since 1888. At that time, a room rented for a rather expensive $3.50 per night.

overleaf: **Jasper National Park, Alberta** The two mountains in this image, Morro Peak and Hawk Mountain, were both named by Morris P. Bridgland in 1916: one for the flight of a bird, the other for a flight of fancy. Bridgland saw a hawk circling near the peak of one while the other, it is believed, was named because its appearance reminded him of famous Morro Castle in Puerto Rico.

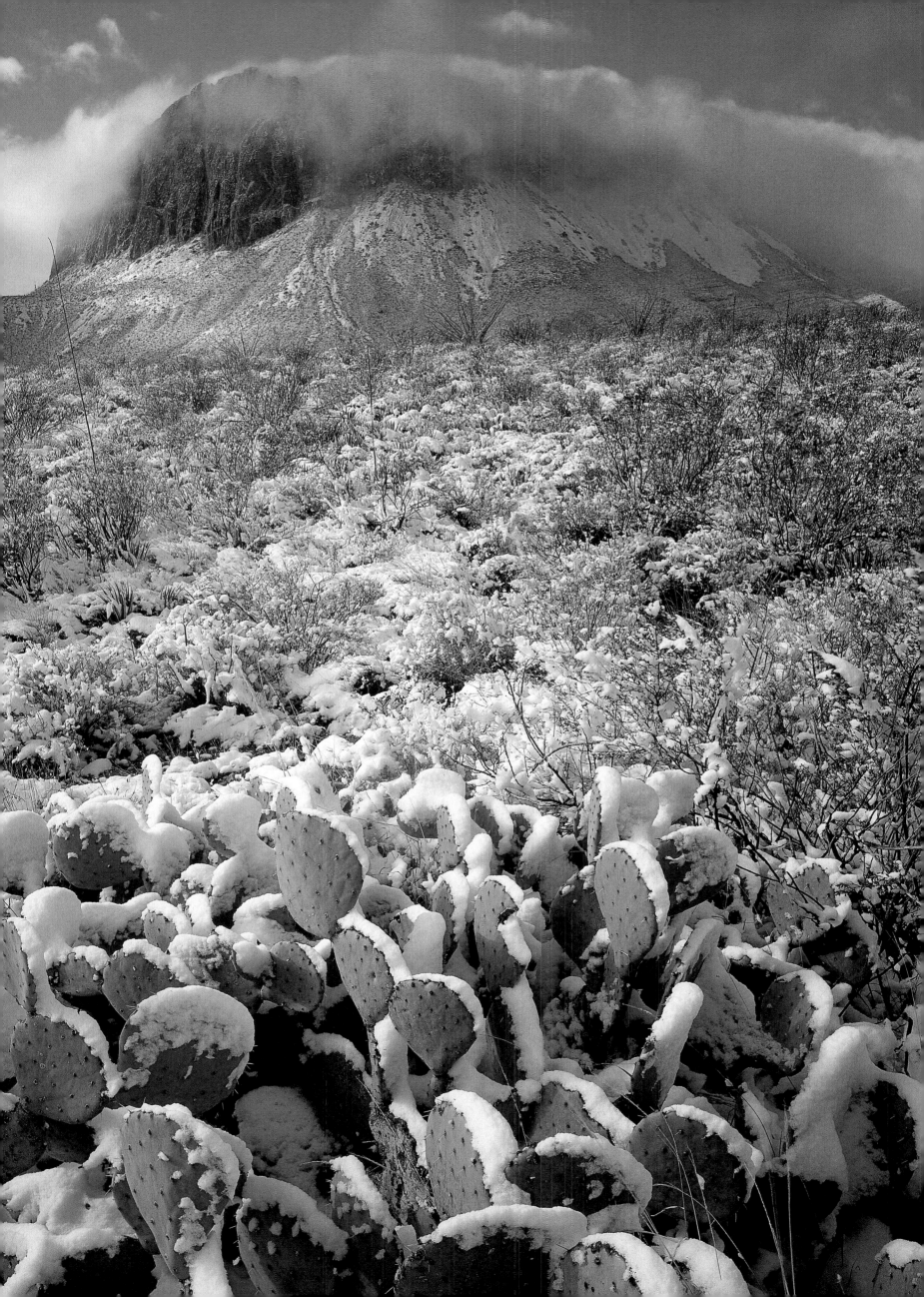

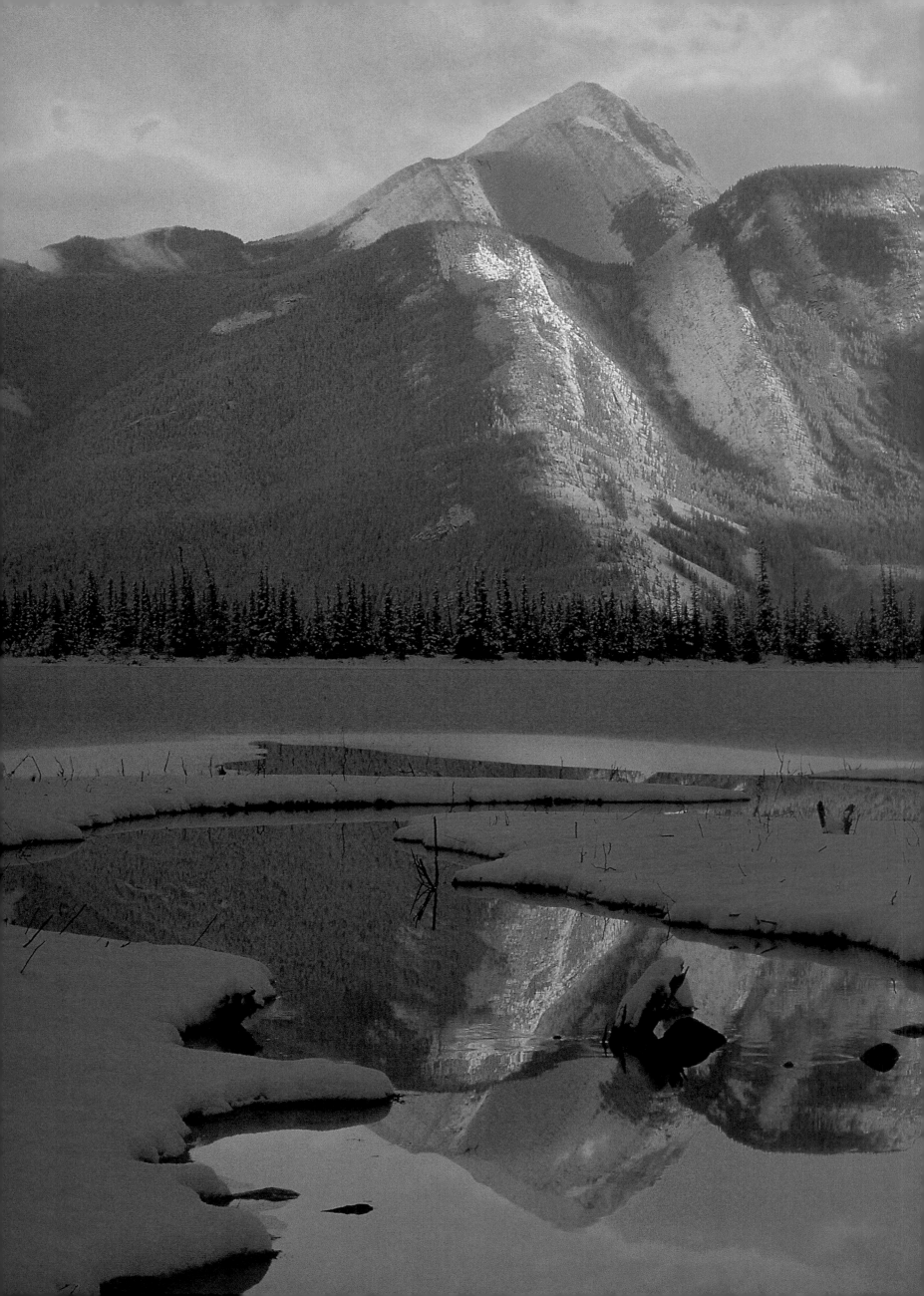

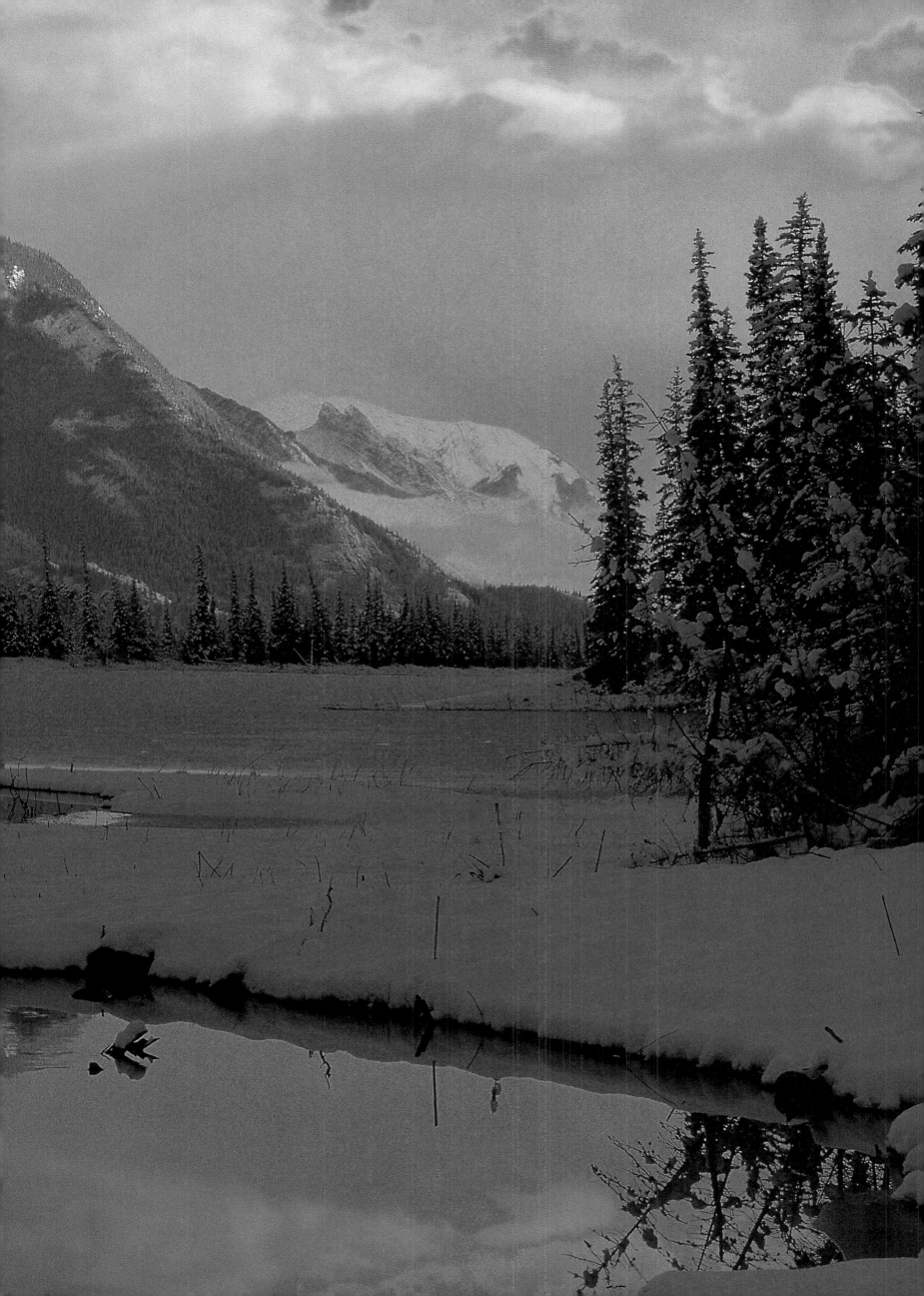

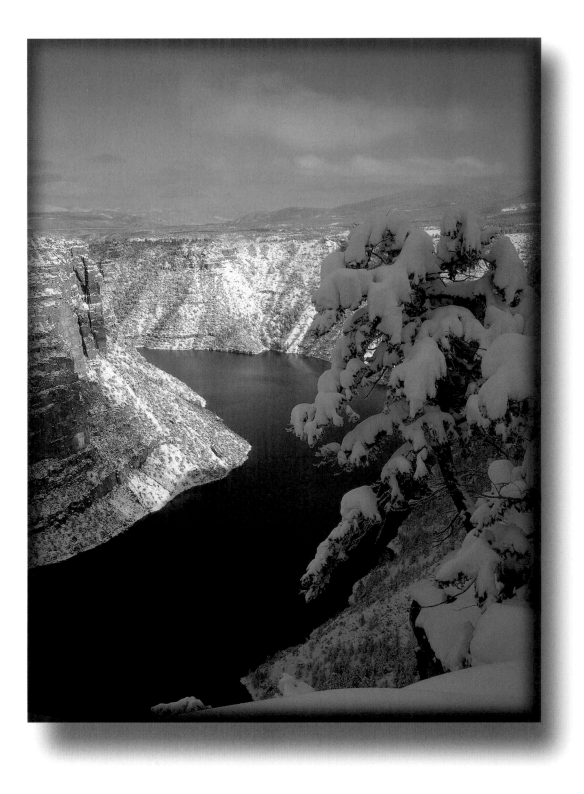

Flaming Gorge National Recreation Area, Utah

The Rockies hold a number of high, arid plateaus. Flaming Gorge is one of countless canyons that water has carved through the Colorado Plateau.

right: **Banff National Park, Alberta**

A snow-covered canoe on the dock at Moraine Lake symbolizes the transition from autumn to winter. Across the water, trees have colonized a cone-shaped scree slope that flows into the lake.

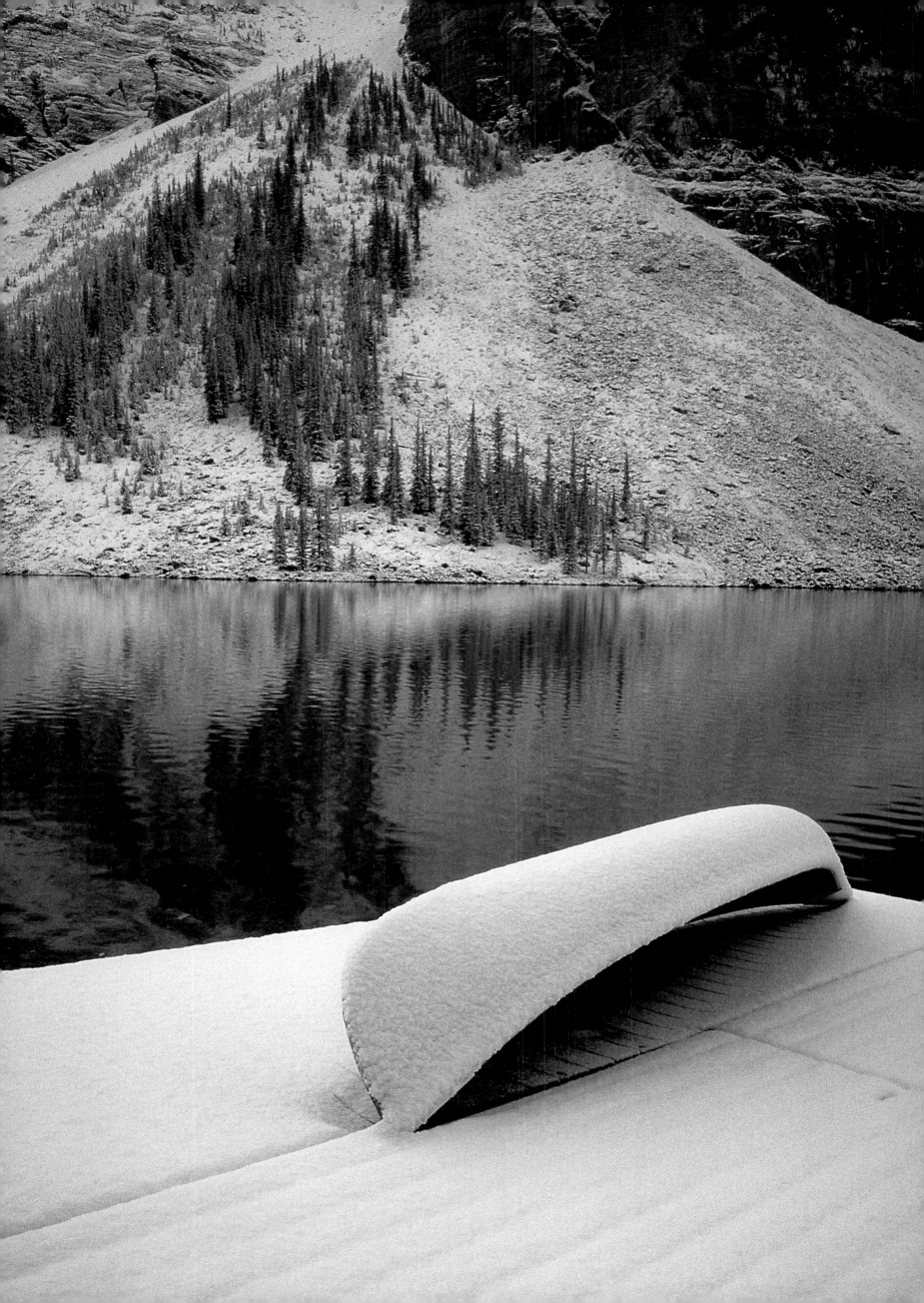

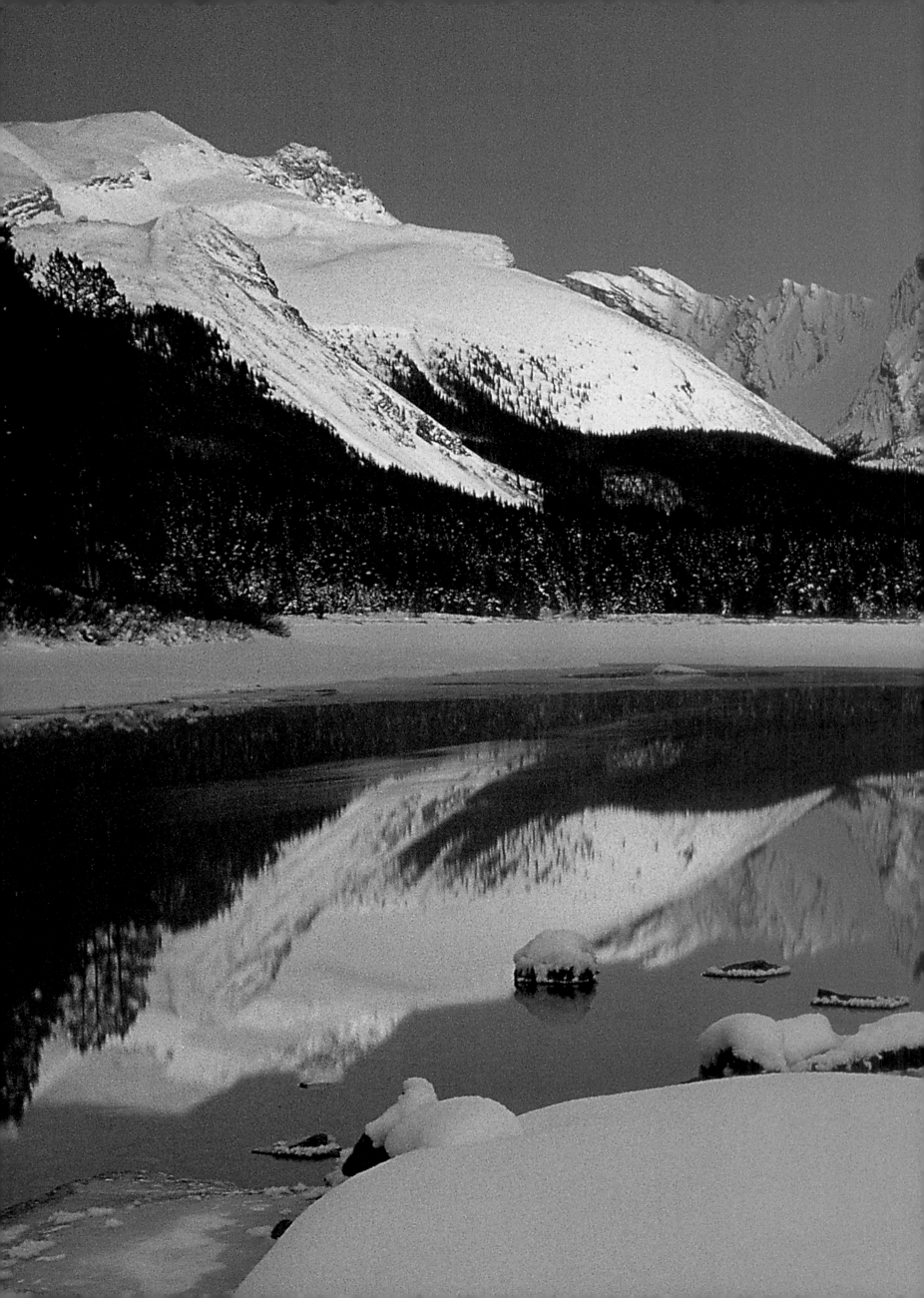

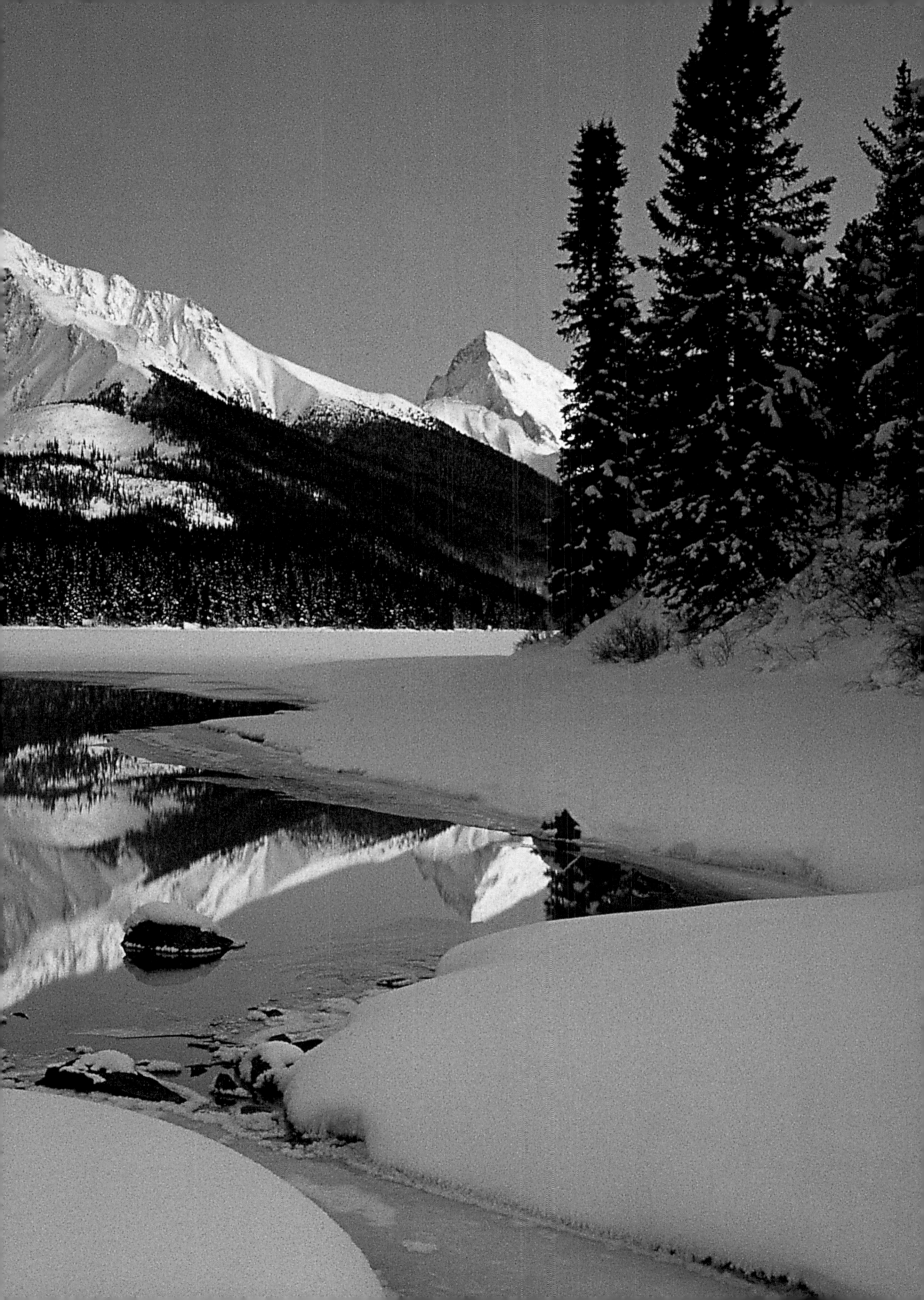

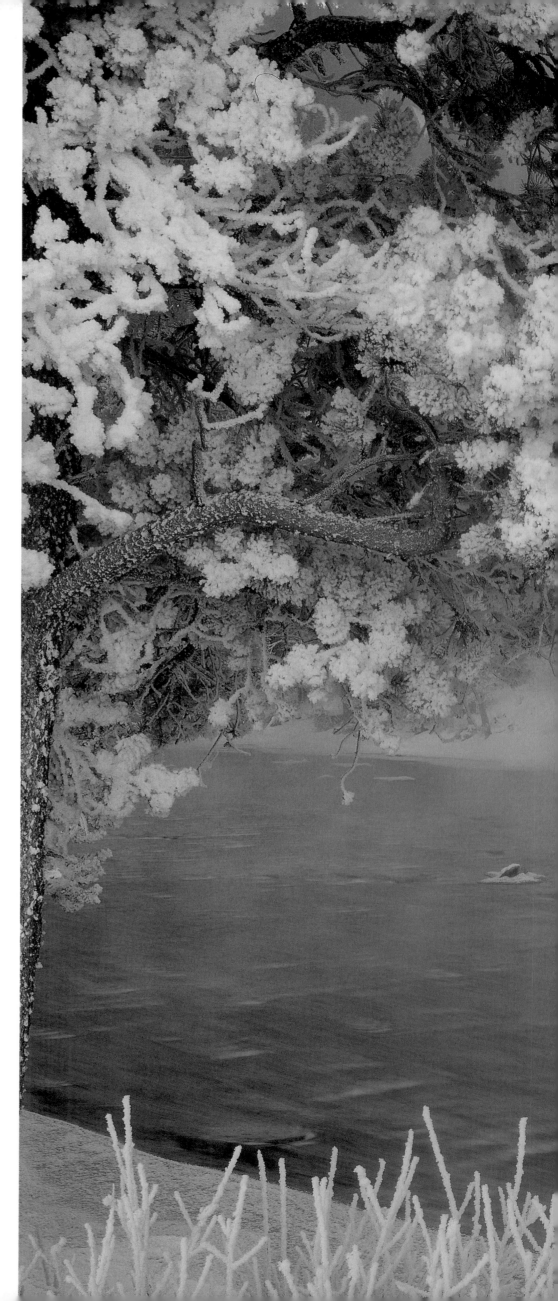

Salmon River, Idaho Steam rising from the relatively warm river water creates a sparkling layer of rime, or hoarfrost, on nearby trees and shrubs.

previous pages: **Maligne Lake, Jasper National Park, Alberta** Father Pierre de Smet christened the Maligne River in 1846 as a *maligne*, or "wicked," crossing when several of his pack horses were swept away. Later, the same name was given to the lake that the river drained.

overleaf: **Grand Teton National Park, Wyoming** A coating of frost makes the trees along the Snake River part of a magical landscape. Each year a great many people experience the scenic beauty of this river, travelling by canoe, kayak, or white-water raft.

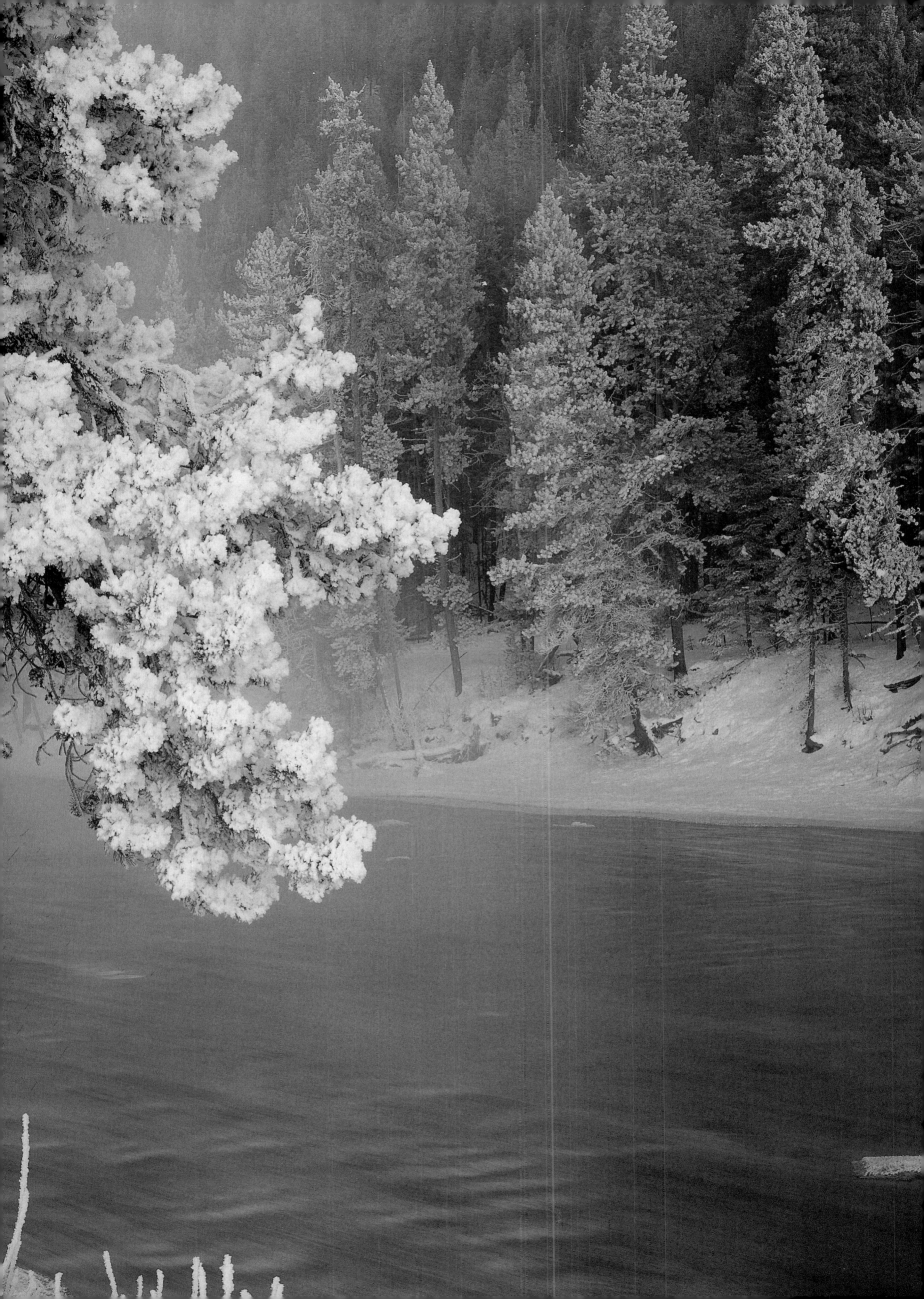

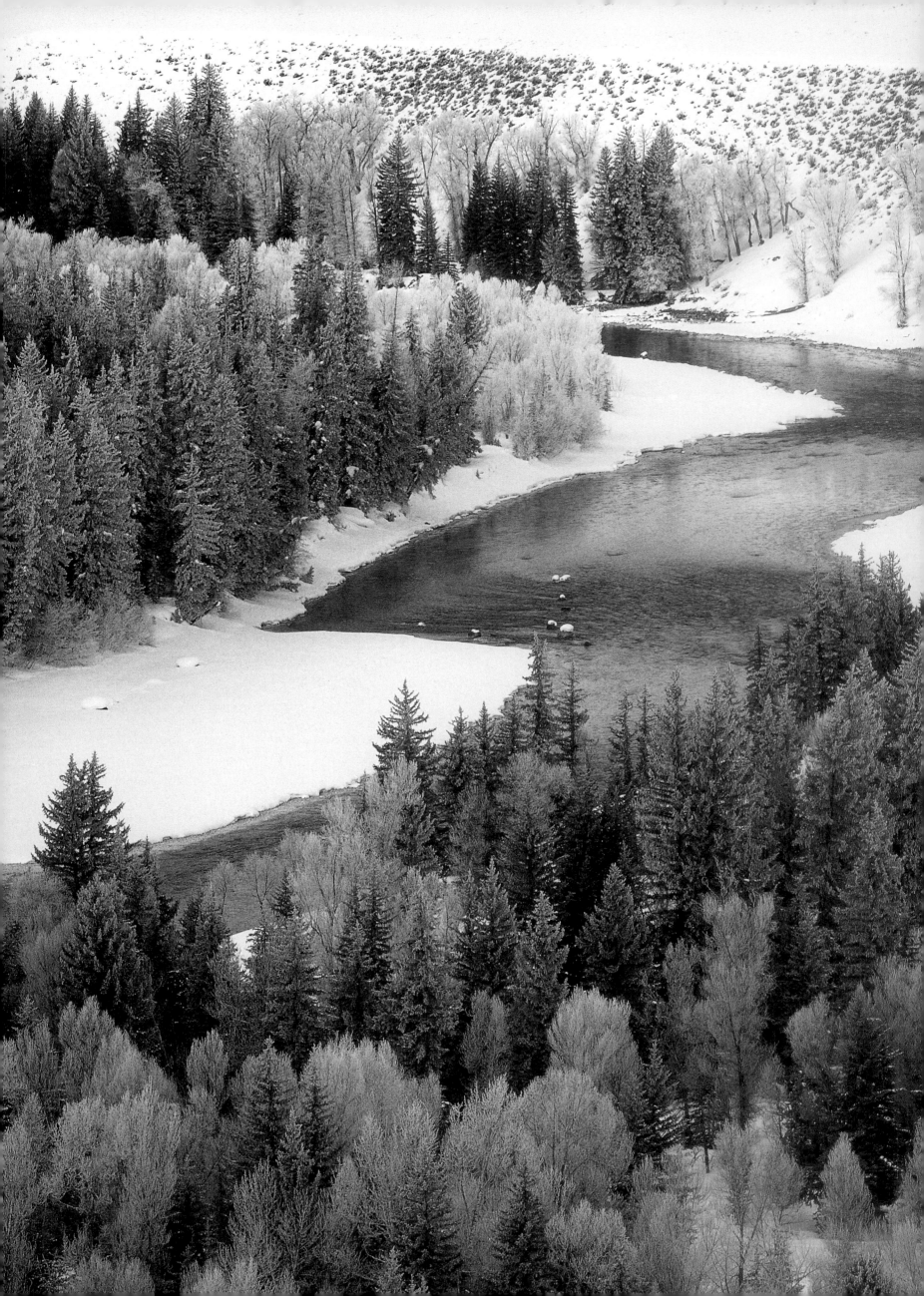

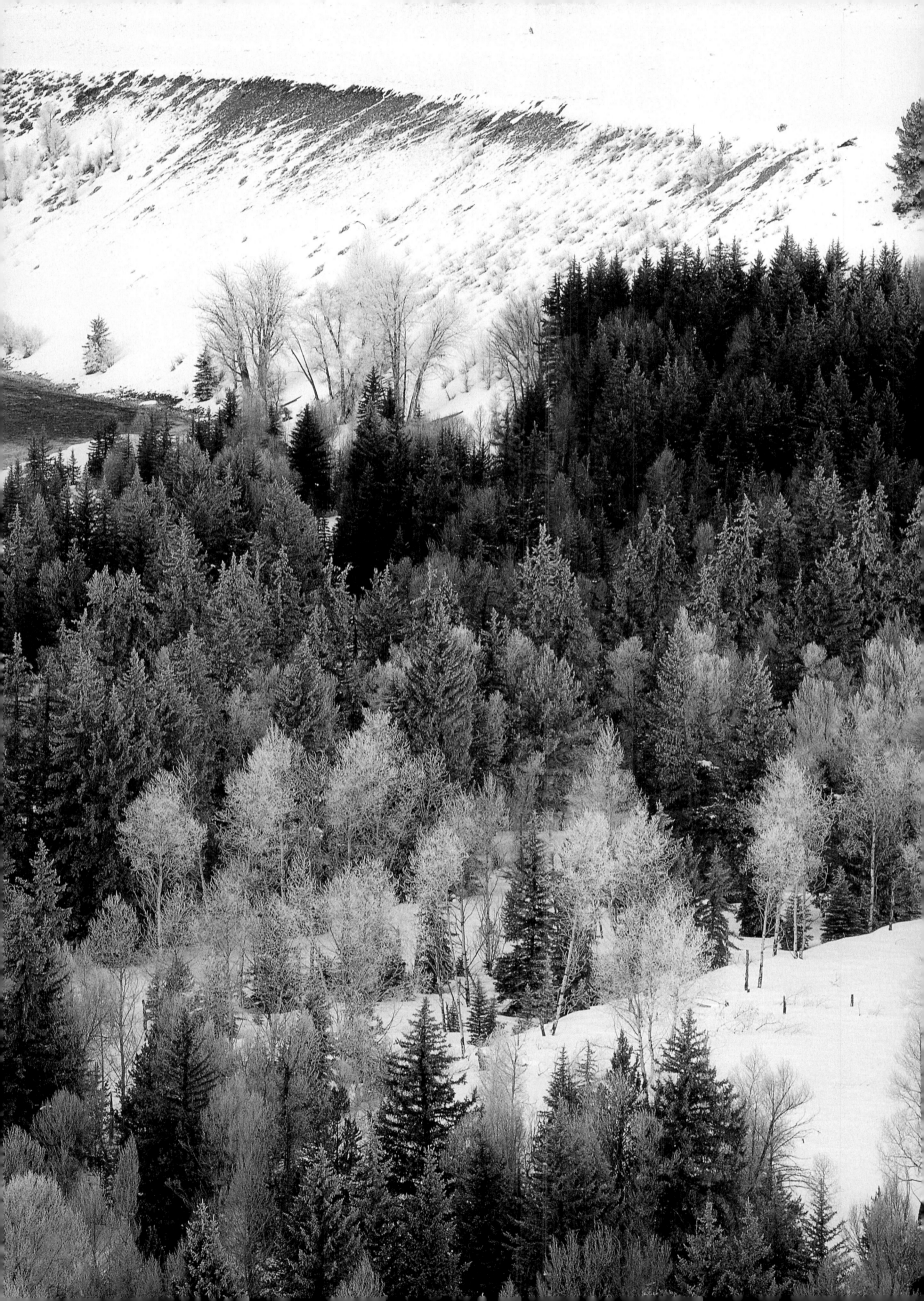

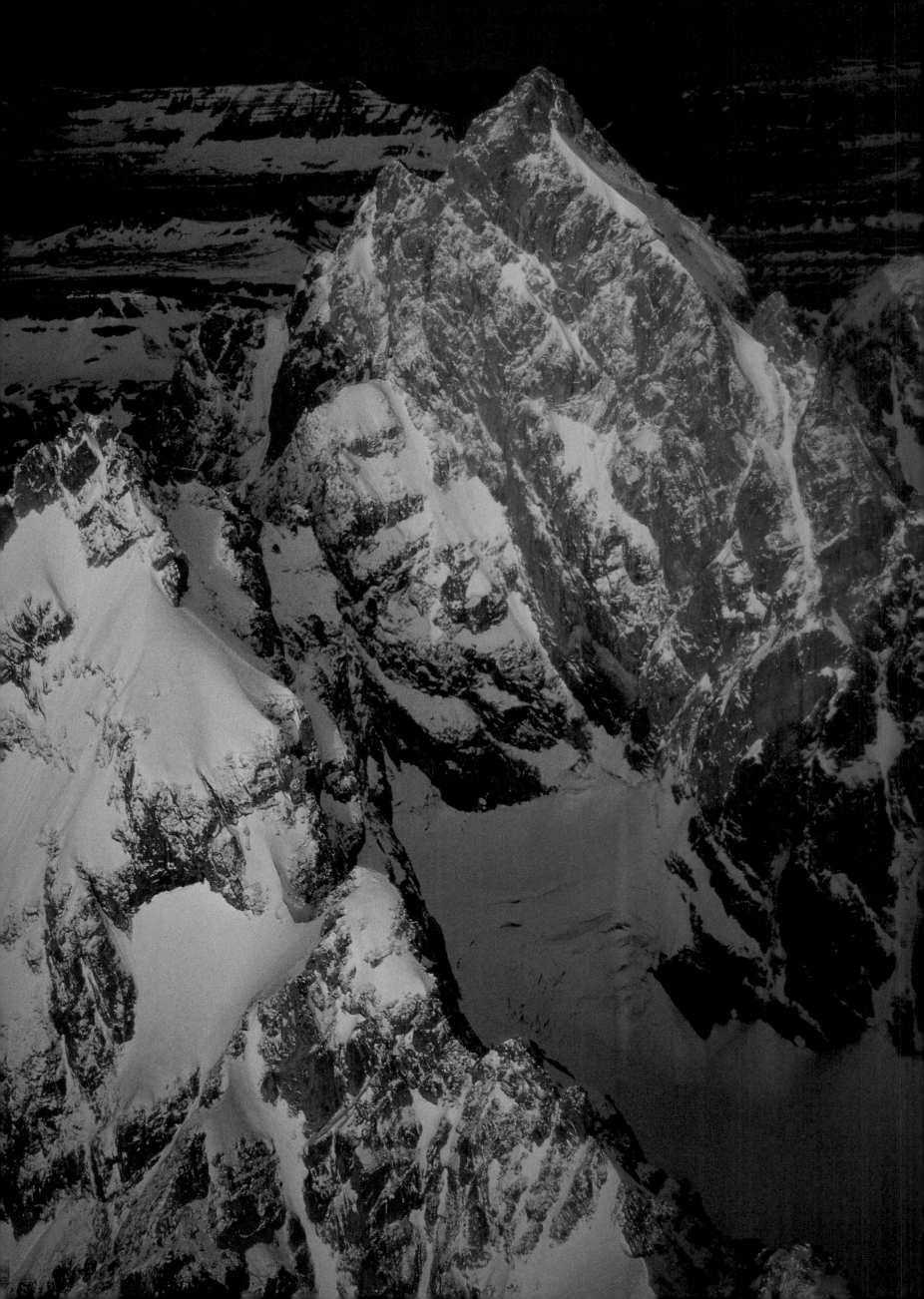

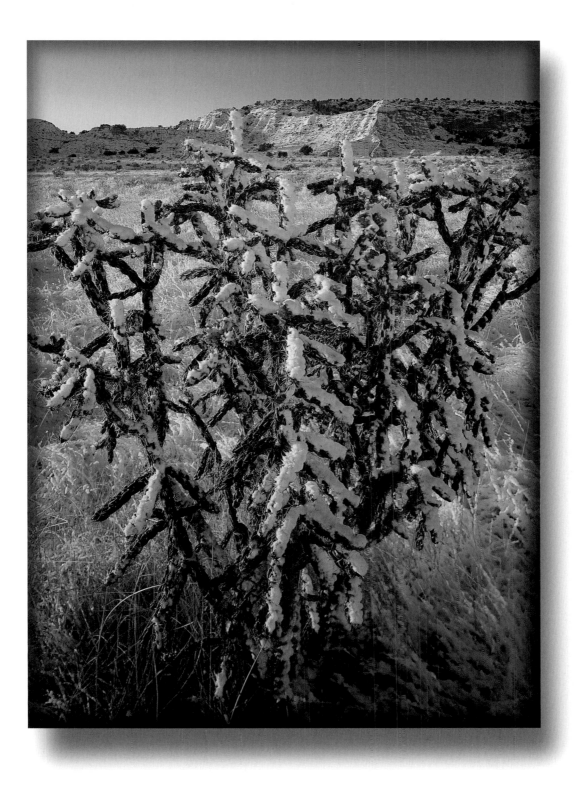

Ojito Wilderness Study Area, New Mexico

This cholla and other plants that grow on high, dry plateaus must be able to cope
with the extreme variation in temperature from summer to winter.

left: **Grand Teton National Park, Wyoming**

The Grand Tetons are relatively young mountains, beginning their rise only
8 to 10 million years ago, but they are formed from some of the continent's oldest rock.
These spectacular mountains are still rising today.

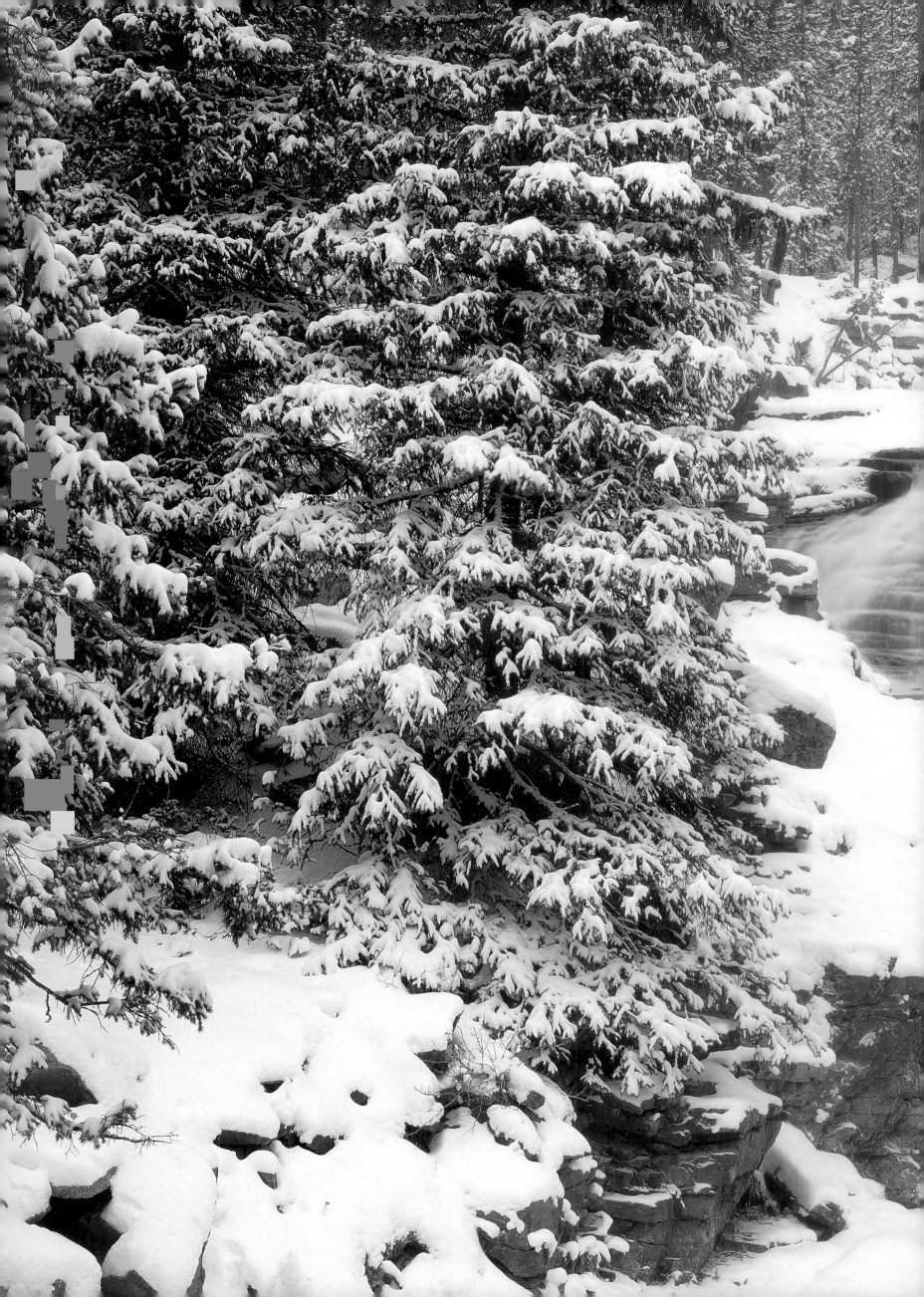

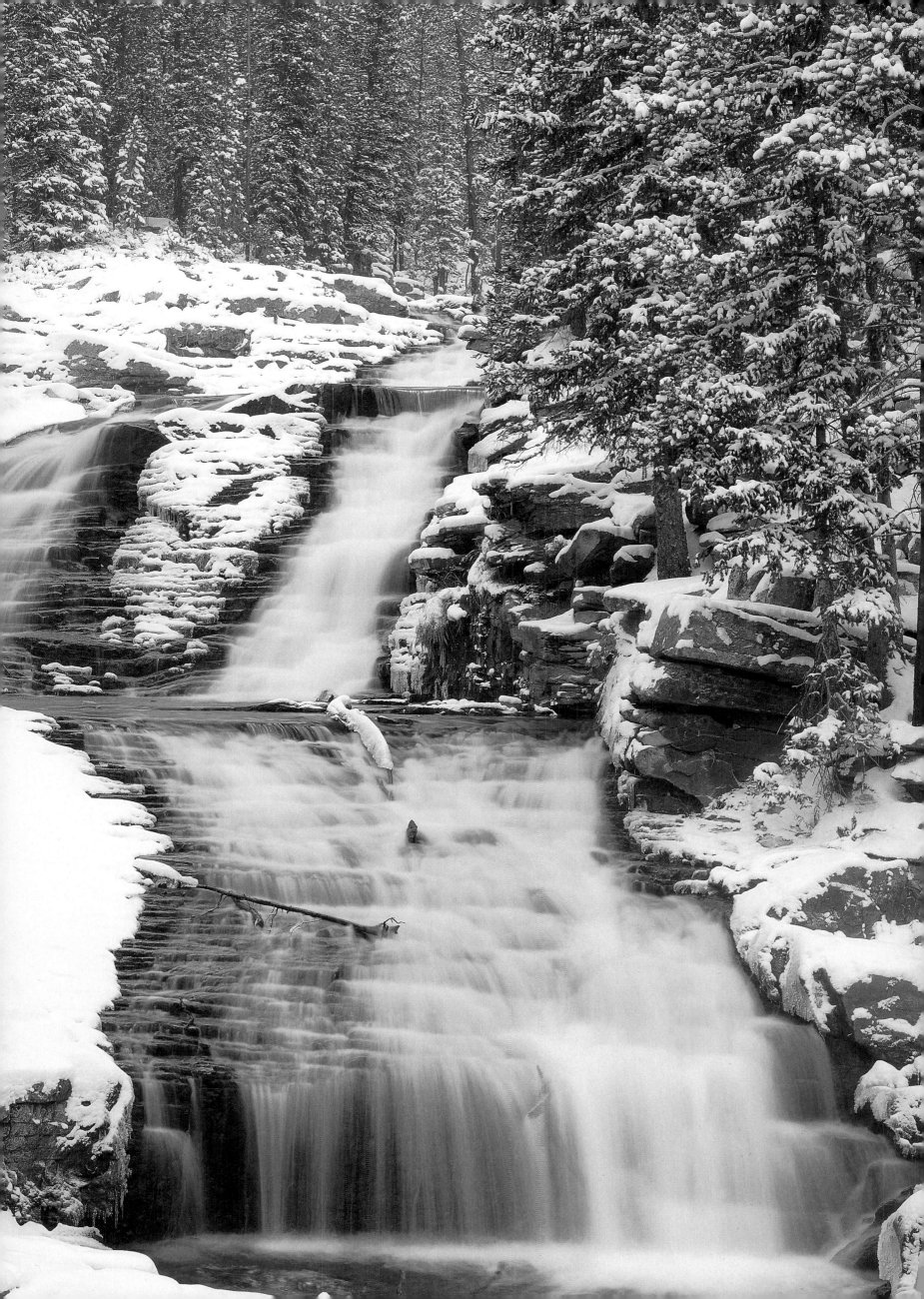

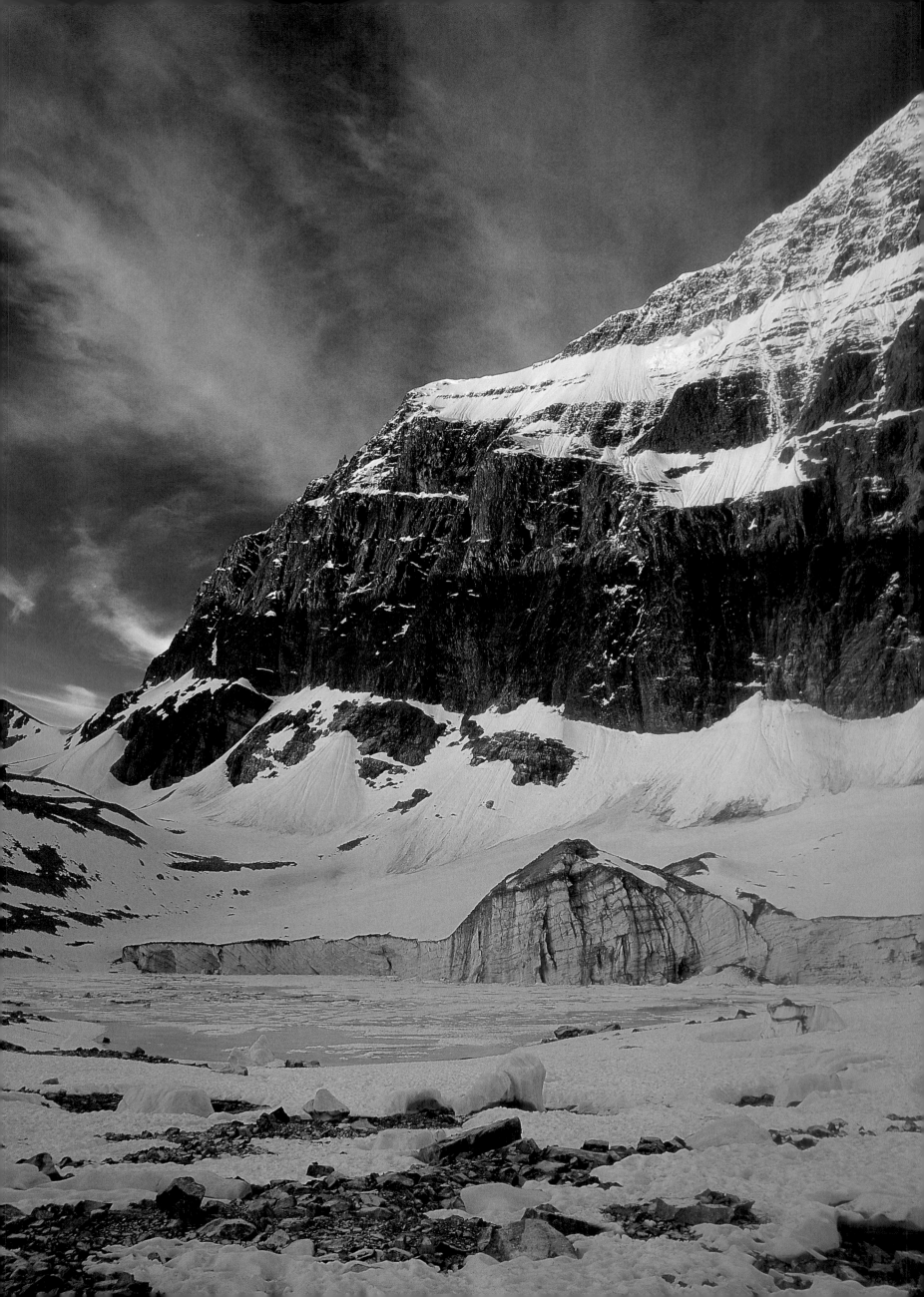

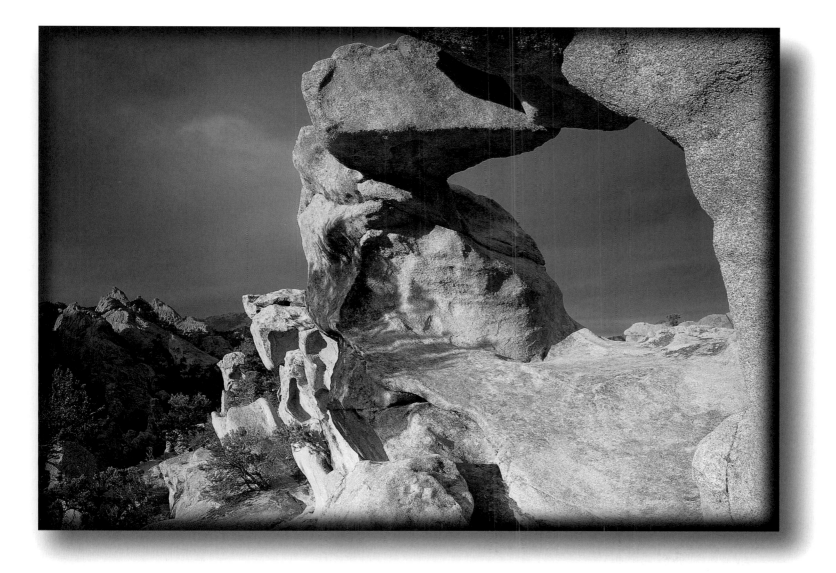

City of Rocks National Reserve, Idaho

Natural arches form when meandering streams or rivers embedded in canyons
cut through the rock to make cutoffs, reducing the distance the water must travel.
Once an opening has been created, wind erosion may help to enlarge it.

left: **Jasper National Park, Alberta**

Often called the queen of the Canadian Rockies, Mount Edith Cavell stands just over
11,000 feet (3,360 meters) tall. Surveyor A. O. Wheeler named the peak to honor the
British nurse who was executed during World War I for allegedly helping prisoners
of war escape from Brussels after the city fell to the Germans.

previous pages: **Wasatch/Cache National Forest, Utah**

In early winter, the Upper Provo River Falls continue to flow. As the cold intensifies,
many waterfalls throughout the mountains transform into glittering icefalls.

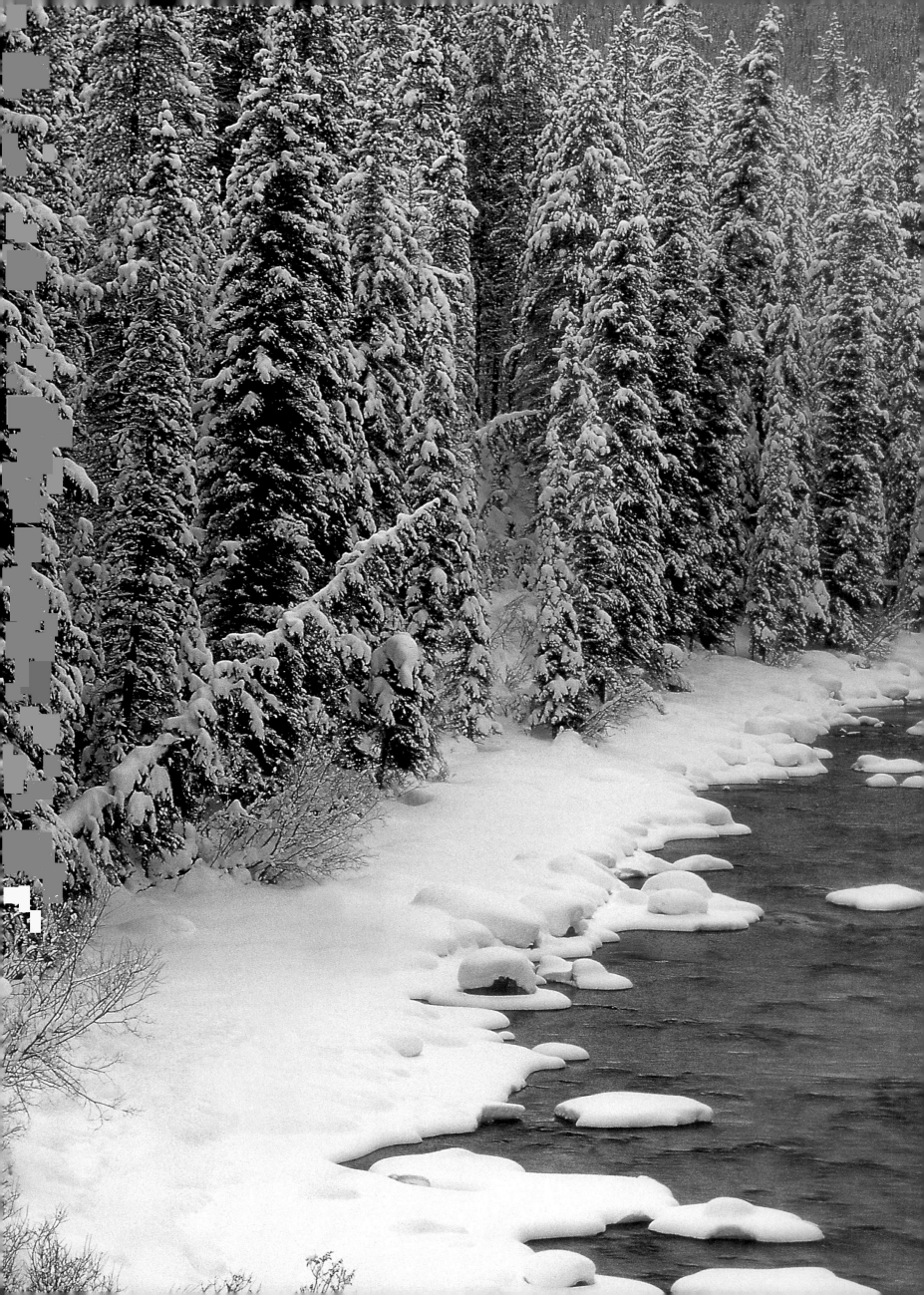

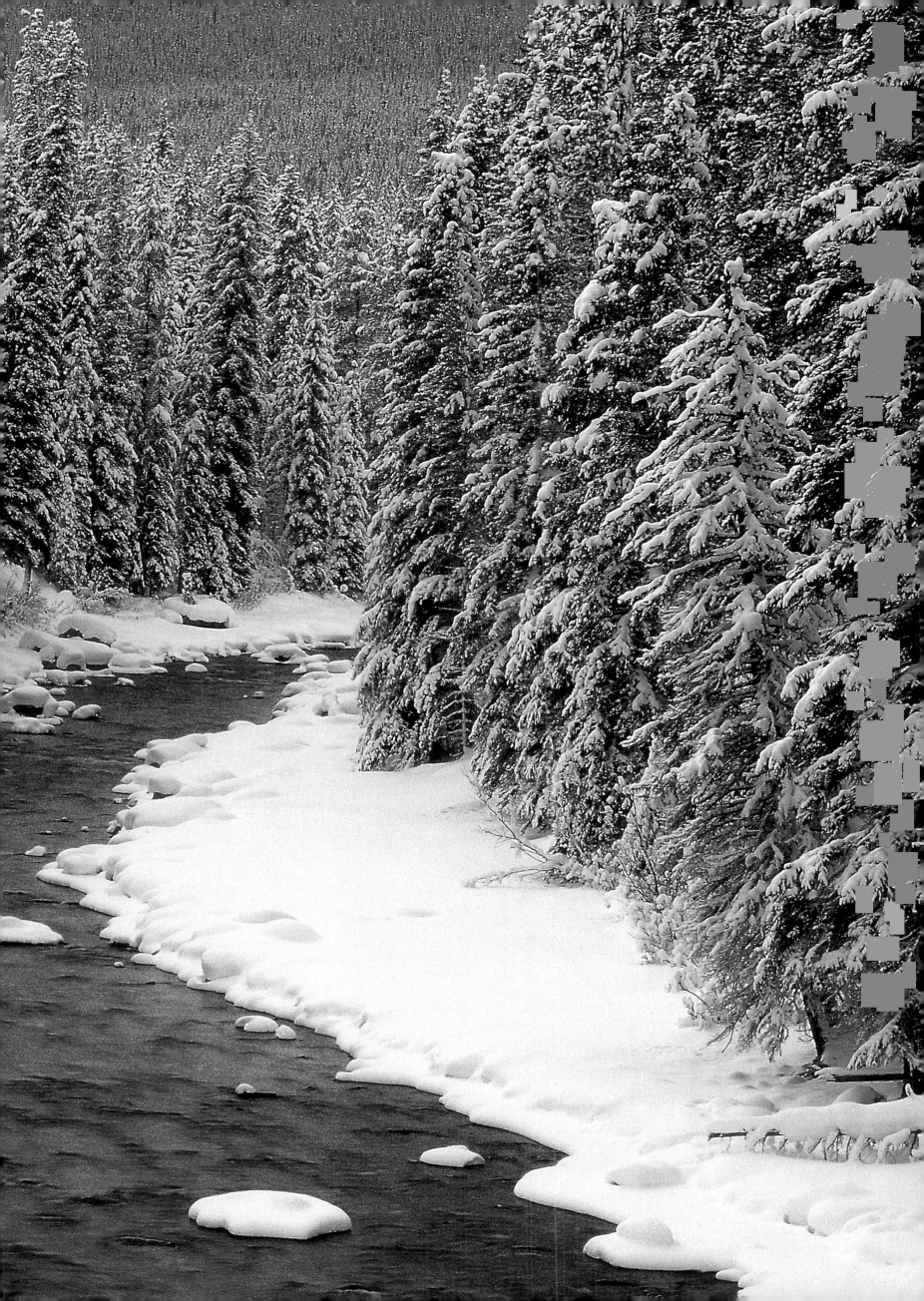

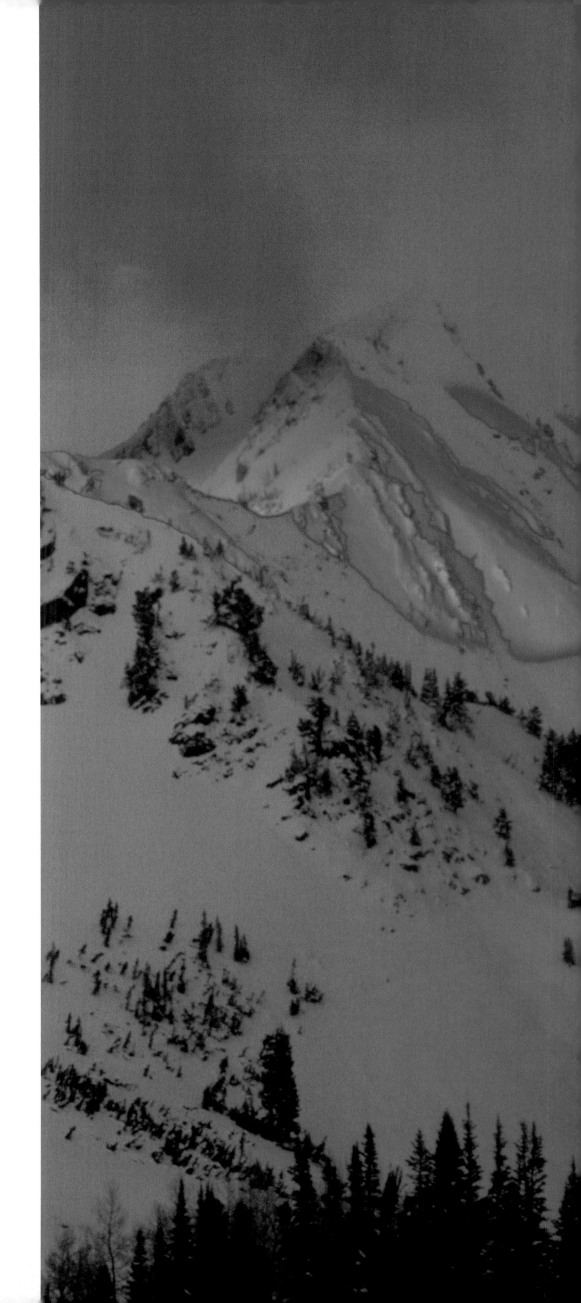

Twin Peaks Wilderness, Utah
Although the calendar may say spring
is just around the corner, the slopes
illuminated by sunrise on Superior
Peak still belong to winter.

previous pages: **Jasper National Park,
Alberta** The open waters of the
Maligne River are a sign that spring
is on its way and that the cycle of
seasons in the Rockies is turning
once again.

overleaf: **Kananaskis Country, Alberta**
White, gray, and black: the stark
simplicity of an aspen forest in
winter. In a few months, a blend of
gentle greens will creep into the
scene, softening its somber mood.

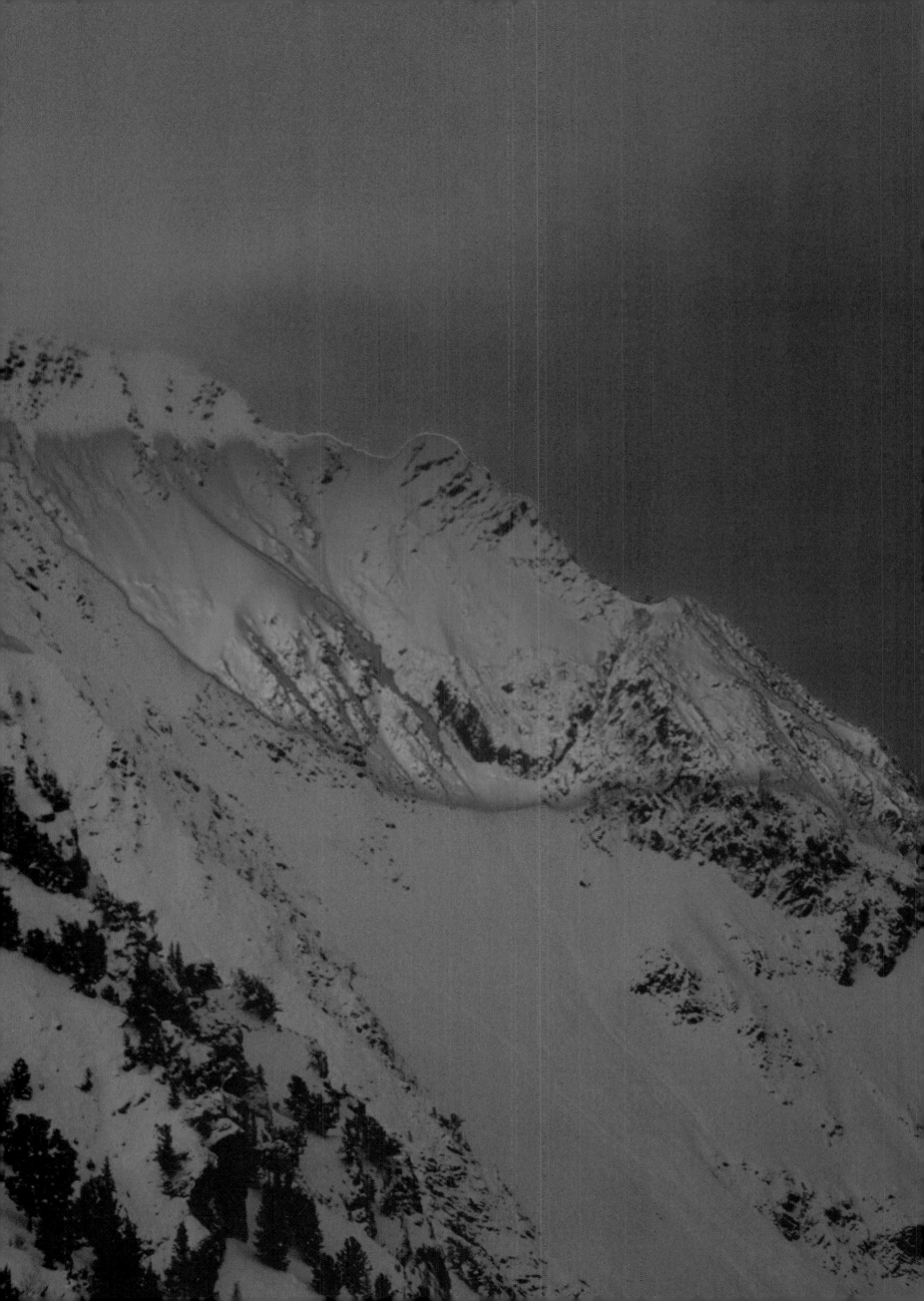

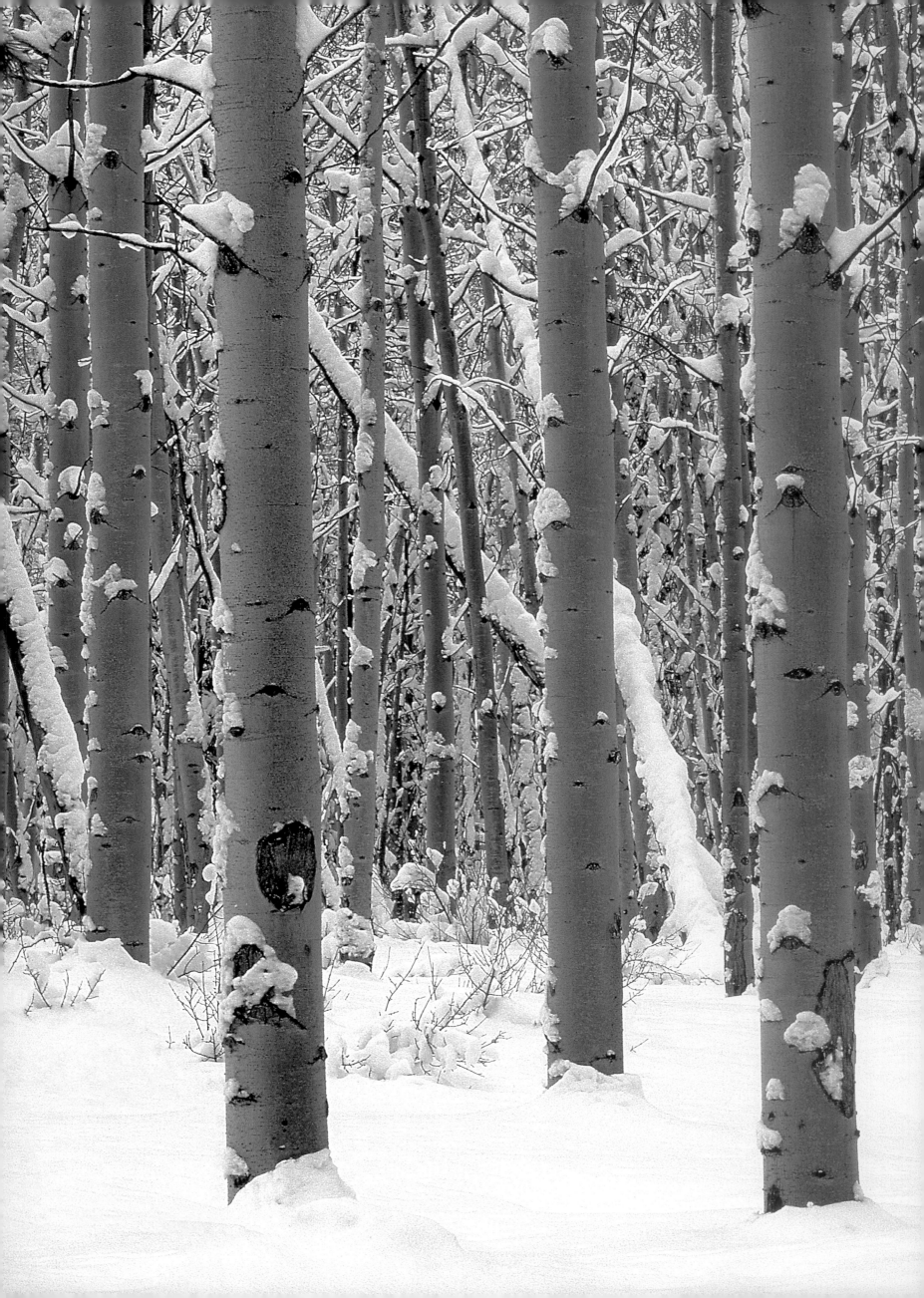

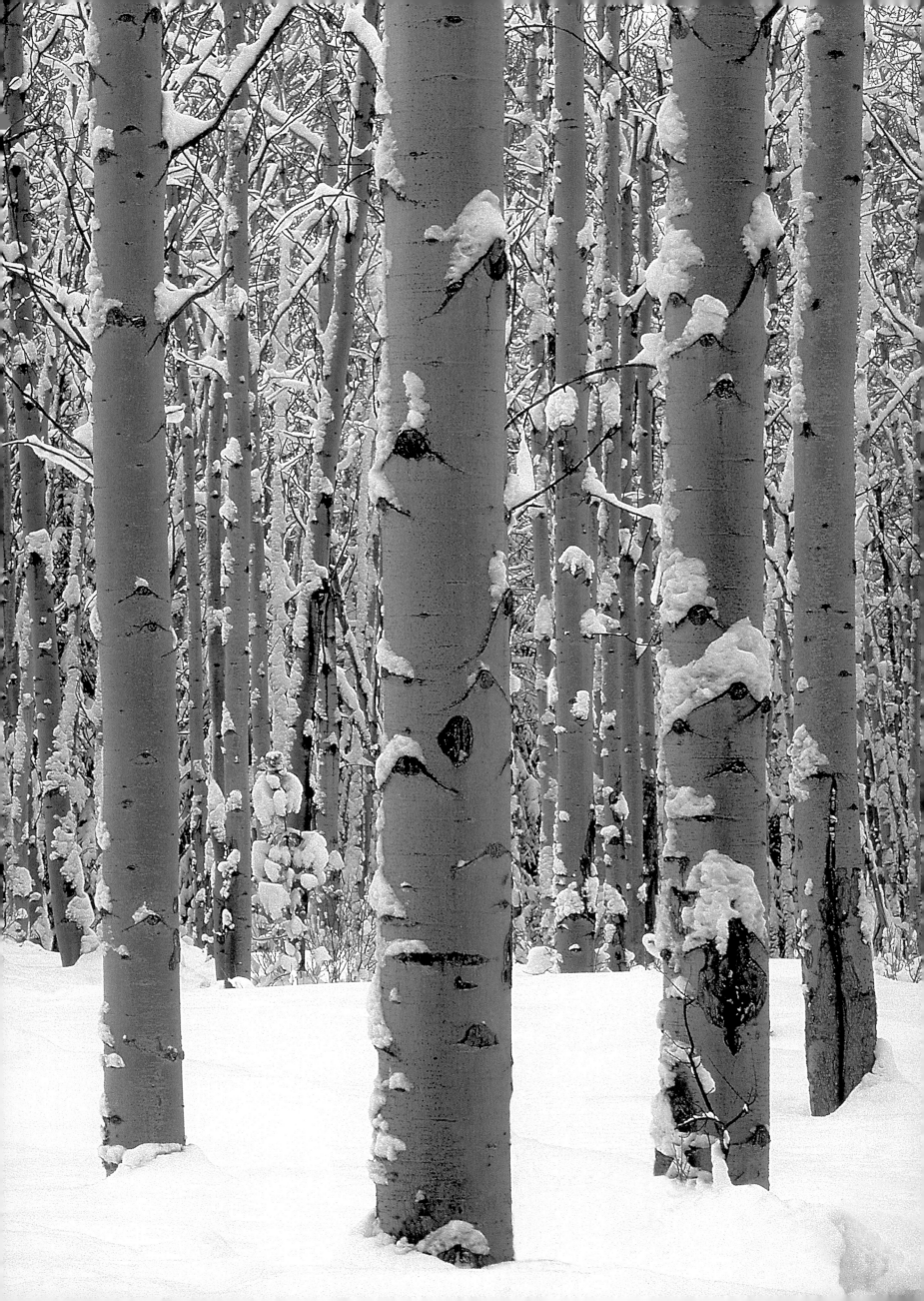

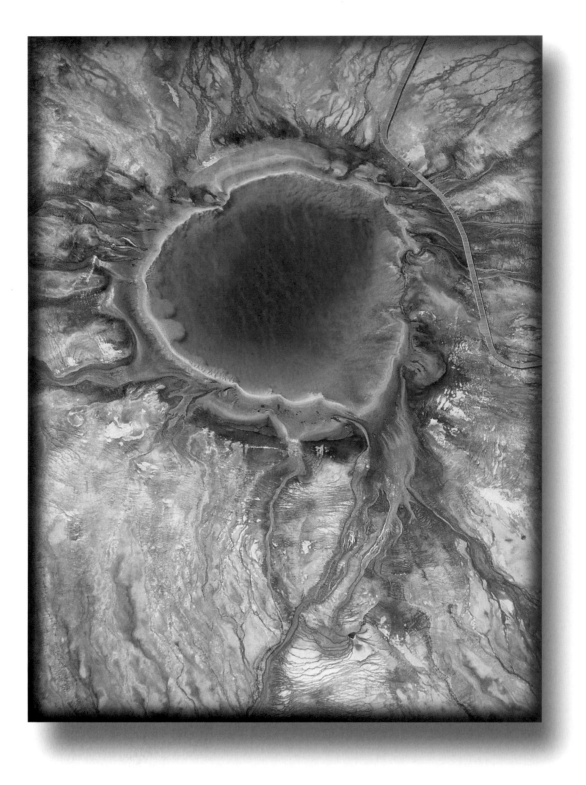

Yellowstone National Park, Wyoming

Seen from the air, Grand Prismatic Spring becomes an abstract work of art.
The brilliant oranges and yellows are due to algae living in the cooler water
at the edge of the pool.

right: **Yellowstone National Park, Wyoming**

At Firehole River Falls, the combination of flowing water, clouds of steam and
a landcape encased in white create an almost mystical scene.

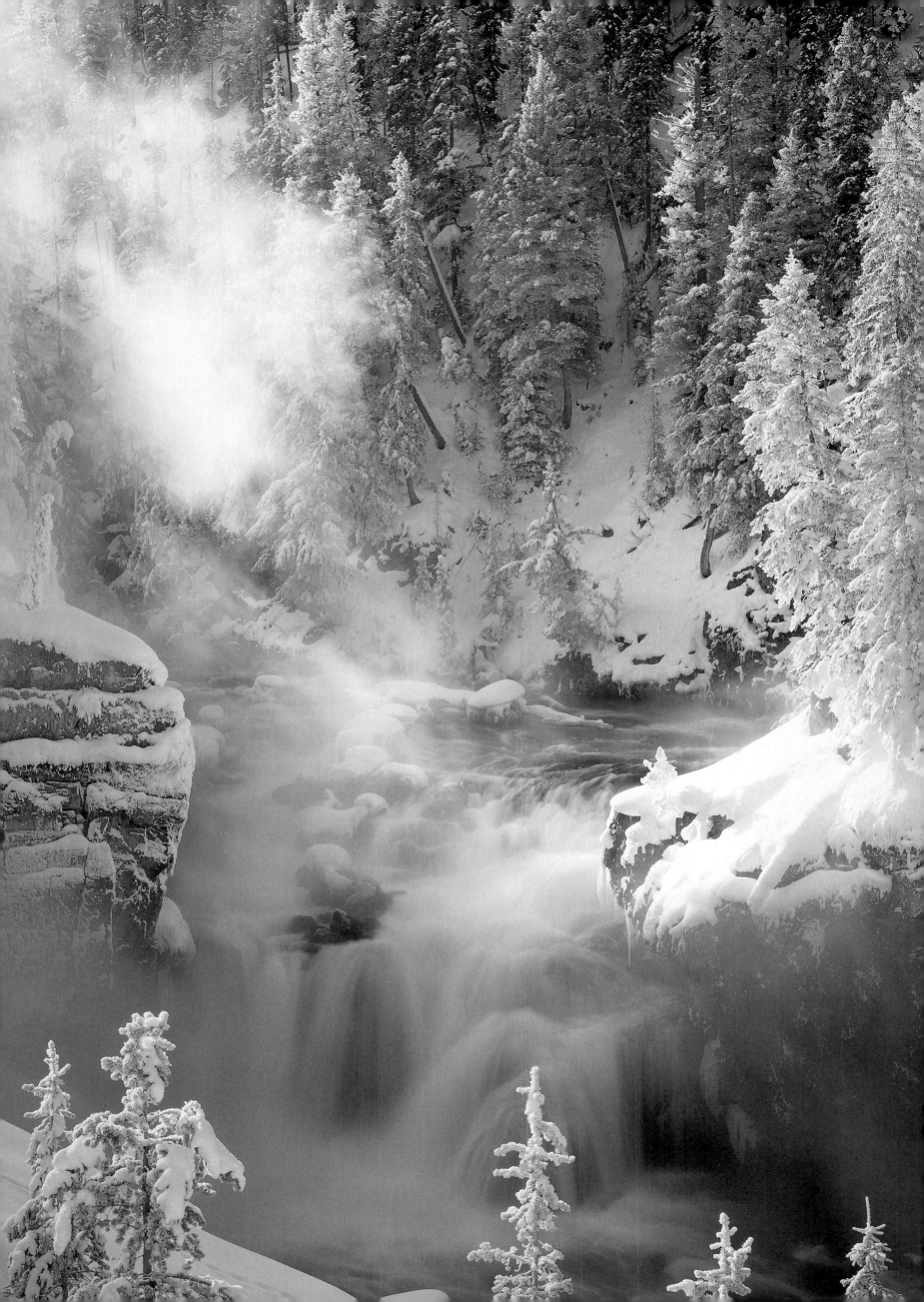

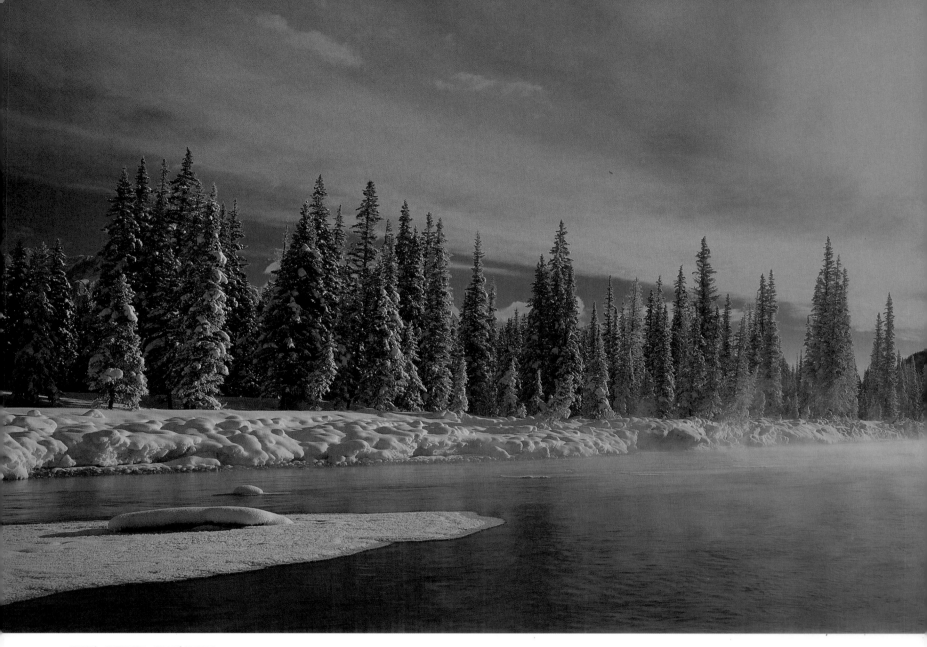

INDEX

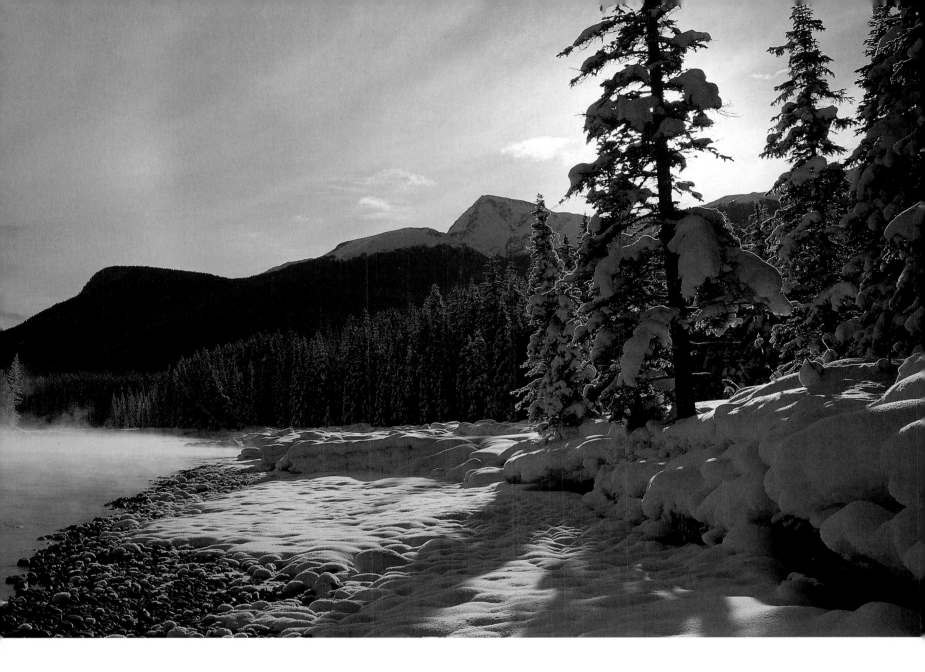

PHOTO CREDITS

Darwin Wiggett 2, 6, 10-11, 14-15,
16-17, 18, 20-21, 22-23, 26-27, 30-31, 33,
38, 39, 40-41, 49, 50-51, 52, 54-55, 61,
64-65, 66-67, 68, 72, 74-75, 77, 83, 87,
90-91, 96-97, 100, 104-105, 110-11,
114-15, 116, 118-19, 120-21, 122, 124-25,
127, 128-29, 130-31, 132-33, 136-37,
144-45, 148-49, 155, 156-57, 160-61,
170-71, 172-73, 176-77, 180-81, 182-83,
186, 187, 188-89, 194-95, 196, 198-99,
206-207, 210-11, 214-15, 217, 218-19,
228, 230-31, 234-35, 238-39, 240

Tom Till 1, 24, 25, 28-29, 32, 34-35,
36-37, 42, 44-45, 46-47, 48, 53, 58-59, 60,
62-63, 70-71, 73, 76, 78-79, 80-81, 82,
84-85, 86, 88-89, 93, 94-95, 98-99, 101,
102-103, 106-107, 108, 109, 112, 113, 117,
123, 126, 138, 139, 140-41, 142-43, 146,
147, 150-51, 152-53, 154, 158-59, 164-65,
166-67, 168, 169, 174-75, 179, 184-85,
190-91, 192-93, 197, 202-203, 204-205,
208, 209, 212-13, 216, 220-21, 222-23,
224, 225, 226-27, 229, 232-33, 236, 237

Glen & Rebecca Grambo 5, 19, 43, 69,
92, 162-63, 178

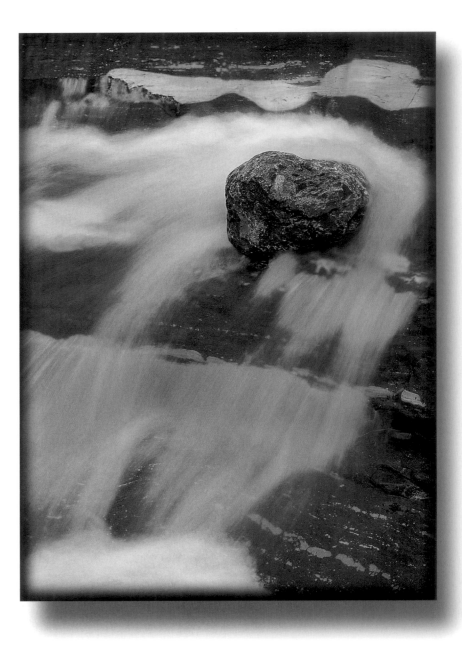

above: **Red Rock Canyon, Waterton Lake National Park, Alberta**